Michelangelo

HERBERT VON EINEM

Michelangelo

TRANSLATED BY RONALD TAYLOR

LONDON
METHUEN & CO LTD
11 NEW FETTER LANE . EC4

First published in 1959
by W. Kohlhammer Verlag, Stuttgart
© *1959 by Verlag W. Kohlhammer GmbH, Stuttgart*

Revised, English edition first published in 1973
by Methuen & Co Ltd
11 New Fetter Lane, London EC4
© *1973 by Methuen & Co Ltd*
Printed in Great Britain
by W & J Mackay Limited
Chatham, Kent

SBN 416 15140 X

Distributed in the USA by
HARPER & ROW PUBLISHERS, INC
BARNES & NOBLE IMPORT DIVISION

Contents

LIST OF PLATES *page* ix
LIST OF FIGURES xv
FOREWORD xvii
TRANSLATOR'S NOTE xix
INTRODUCTION: THE FAME OF MICHELANGELO I

Part I Early Years 1475–1505

CHAPTER I FLORENCE AND BOLOGNA 1475–1496 9
Madonna of the Stairs – Battle of the Centaurs – Hercules –
crucifix for S. Spirito – figures for the shrine of St Dominic
in S. Domenico, Bologna

CHAPTER 2 ROME 1496–1501 16
Bacchus – Pietà

CHAPTER 3 FLORENCE 1501–1505 25
Bruges *Madonna – David – Battle of Cascina – Taddeo Tondo –*
Doni Tondo – Pitti Tondo

Part II Years of Maturity 1505–1534

CHAPTER 4 ROME – FLORENCE – BOLOGNA 1505–1508 39
First design for the tomb of Julius II – *St Matthew*

CHAPTER 5 ROME 1508–1512 49
The Sistine ceiling

CHAPTER 6 ROME AND FLORENCE 1513–1520 75
Design of 1513 for the tomb of Pope Julius – the façade of
S. Lorenzo in Florence – further work on the tomb: the
design of 1516

CHAPTER 7 FLORENCE 1520–1534 92
I The Medici Chapel

CHAPTER 8 FLORENCE 1520–1534 III
II Biblioteca Laurenziana – fortifications

CHAPTER 9 FLORENCE 1520–1534 120
III Further work on Pope Julius's tomb – the *Captives* in the
Boboli Gardens – *Victory – The Risen Christ – Apollo –* drawings
for Tommaso Cavalieri

Contents

Part III Final Period Rome 1534–1564

CHAPTER 10 141
Last Judgement

CHAPTER 11 160
Drawings for Vittoria Colonna – bust of *Brutus*

CHAPTER 12 169
Completion of the tomb of Pope Julius

CHAPTER 13 176
Frescoes in the Cappella Paolina – *Christ and the Traders*

CHAPTER 14 189
Palazzo Farnese

CHAPTER 15 197
Capitoline Hill – Cortile del Belvedere

CHAPTER 16 207
Porta Pia

CHAPTER 17 209
St Peter's

CHAPTER 18 228
S. Giovanni dei Fiorentini

CHAPTER 19 233
S. Maria degli Angeli

CHAPTER 20 237
Cappella Sforza

CHAPTER 21 241
Pietà in Florence – *Rondanini Pietà* – last drawings

CONCLUSION: THE INCOMPLETE AND THE UNCOMPLETABLE 256
BIBLIOGRAPHY 266
NOTES 271
INDEX 319

List of Plates

ALL PLATES APPEAR AT THE END OF THE BOOK

1 *Madonna of the Stairs*. Marble. Florence, Casa Buonarroti
2 *The Battle of the Centaurs*. Marble. Florence, Casa Buonarroti
3 Giacomo Rocchetti, design for Pope Julius's tomb, 1513.
 Pen and ink. Copy after Michelangelo, lost. Formerly in
 Berlin, Kupferstichkabinett
4 Crucifix in wood. Florence, Casa Buonarroti
5 *Bacchus*. Marble. Florence, Museo Nazionale
6 *Pietà*. Marble. Rome, St Peter's
7 *Madonna and Child*. Marble. Bruges, Notre Dame
8 *David*. Marble. Florence, Accademia
9 Bastiano da Sangallo, *The Battle of Cascina*. Copy (partial) after
 Michelangelo. Grisaille. Holkham, Lord Leicester Collection
10 *Taddei Tondo*. Marble. London, Royal Academy
11 *Doni Tondo*. Tempera on wood. Florence, Uffizi
12 *Pitti Tondo*. Marble. Florence, Museo Nazionale
13 *St Matthew*. Marble. Florence, Accademia
14 Sistine Chapel. Interior. Rome, Vatican
15–43 SISTINE CEILING. FRESCOES
 15 Zechariah
 16 Joel
 17 Isaiah
 18 Ezekiel
 19 Daniel
 20 Jeremiah
 21 Jonah
 22 Delphic sibyl
 23 Erythraean sibyl
 24 Cumaean sibyl
 25 Persian sibyl
 26 Libyan sibyl
 27 Youth on right of Jeremiah
 28 Youth on left of Joel

List of Plates

29 Youth on left of Libyan sibyl

30 *The Mockery of Noah*

31 *The Flood*

32 *Noah's Sacrifice*

33 *The Fall and the Expulsion from Paradise*

34 *The Creation of Eve*

35 *The Creation of Adam*

36 *The Creation of the Creatures of the Sea*

37 *The Creation of the Sun and Moon and of the Fruits of the Earth*

38 *Let There be Light!*

39 *David and Goliath*

40 *Judith and Holofernes*

41 *The Crucifixion of Haman*

42 *The Brazen Serpent*

43 Lunette

44 *The Struggling Captive.* Marble. For Pope Julius's tomb. Paris, Louvre

45 *The Dying Captive.* Marble. For Pope Julius's tomb. Paris, Louvre

46 *Moses.* Marble. For Pope Julius's tomb. Rome, S. Pietro in Vincoli

47–51 STUDIES FOR THE FAÇADE OF S. LORENZO IN FLORENCE

47 Giuliano da Sangallo, drawing. Florence, Uffizi, No. 277A

48 Michelangelo, sketch. Florence, Casa Buonarroti, No. 44a

49 Michelangelo, sketch. Florence, Casa Buonarroti, No. 47a

50 Michelangelo, sketch. Florence, Casa Buonarroti, No. 43a

51 Michelangelo, wooden model. Florence, Casa Buonarroti

52–63 MEDICI CHAPEL OF S. LORENZO IN FLORENCE

52 Interior of the chapel

53 Exterior of the chapel

54 Lantern

55 Tomb of Lorenzo de' Medici. Marble

56 Tomb of Giuliano de' Medici. Marble

57 *Lorenzo de' Medici.* Marble

58 *Giuliano de' Medici.* Marble

59 *Evening.* Marble

60 *Dawn*. Marble

61 *Night*. Marble

62 *Day*. Marble

63 *Medici Madonna*. Marble

64–71 BIBLIOTECA LAURENZIANA, FLORENCE

64 Vestibule. Design. Florence, Casa Buonarroti, No. 48a

65 Reading-room. Design. Florence, Casa Buonarroti, No. 42a

66 Vestibule, west wall

67 Vestibule, south wall

68 Vestibule, staircase

69 Reading-room

70 Reading-room, door

71 Cloisters of S. Lorenzo with exterior view of Biblioteca Laurenziana

72–75 BOBOLI CAPTIVES

72 *Bearded Giant*. Marble. Florence, Accademia

73 *Young Giant*. Marble. Florence, Accademia

74 *Atlas*. Marble. Florence, Accademia

75 *Awakening Giant*. Marble. Florence, Accademia

76 *Victory*. Marble. Florence, Palazzo Vecchio

77 *The Risen Christ*. Marble. Rome, S. Maria sopra Minerva

78 *Apollo*. Marble. Florence, Museo Nazionale

79–84 DRAWINGS FOR TOMMASO CAVALIERI

79 *Tityus*. Black chalk. Windsor, Royal Library

80 *Ganymede* (copy). Pencil. Windsor, Royal Library

81 *The Fall of Phaeton*. Black chalk. London, British Museum

82 *The Fall of Phaeton*. Black chalk. Venice, Accademia

83 *The Fall of Phaeton*. Black chalk. Windsor, Royal Library

84 *Bacchanal*. Red chalk. Windsor, Royal Library

85–90 LAST JUDGEMENT. FRESCO. ROME, SISTINE CHAPEL

85 General view

86 Sketch. Black chalk. Bayonne, Musée Bonnard

87 Sketch. Black chalk. Florence, Casa Buonarroti, No. 65f

88 Christ in judgement

89 Resurrection of the dead

90 The damned

List of Plates

91–92 DRAWINGS FOR VITTORIA COLONNA
91 *Pietà*. Black chalk. Boston, Isabella Stewart Gardner Museum
92 *Crucifixion*. Black chalk. London, British Museum
93 *Brutus*. Marble. Florence, Museo Nazionale

94–96 TOMB OF POPE JULIUS. MARBLE. ROME, S. PIETRO IN VINCOLI
94 General view
95 *Rachel*. Marble
96 *Leah*. Marble

97–99 FRESCOES IN THE CAPPELLA PAOLINA. ROME, VATICAN
97 *The Conversion of St Paul*
98 *The Crucifixion of St Peter*
99 *Christ and the Traders*. Sketch. Black chalk. London, British Museum

100–107 PALAZZO FARNESE, ROME
100 Main façade
101 Main window above the portal
102 Cornice
103 Hall
104 Gallery in front of the hall
105 Courtyard. Side façade. Detail
106 Courtyard. Rear façade. Completion by Giacomo della Porta
107 Courtyard. Rear façade. Design by Michelangelo. Engraving of 1560

108–112 CAPITOL, ROME
108 Ground plan of the piazza. Engraving of 1567 from *Speculum Romanae magnificentiae*
109 Plan of the piazza. Engraving by Dupérac of 1569
110 General view of the piazza
111 Palazzo del Senatore and portico of the Palazzo Nuovo
112 Palazzo dei Conservatori

113 Cortile del Belvedere. Rome, Vatican. Drawing ascribed to Dupérac. From *Disegni de le Ruine di Roma*, Vol. I. Formerly London, C. W. Dyson Perrins Collection
114 Porta Pia, Rome

115–125 ST PETER'S, ROME

115 View from the Vatican Gardens

116 South side

117 Interior of dome

118 Exterior elevation of the south wall. Engraving by Vincenzo Luchino, 1564

119 Façade. Drawing ascribed to Dupérac. From *Disegni de le ruine di Roma*, Vol. I. Formerly in C. W. Dyson Perrins Collection, London

120 South façade. Engraving by Dupérac, 1569

121 Section. Engraving by Dupérac, 1569

122 Dome. Exterior view

123 Study for dome. Drawing. Haarlem, Teyler Museum

124 Study for dome. Drawing. Lille, Musée des Beaux-Arts

125 Wooden model of dome. Rome, Vatican, Museo Petriano

126–130 S. GIOVANNI DEI FIORENTINI, ROME

126 First design, 1559. Drawing. Florence, Casa Buonarroti, No. 121a

127 Second design, 1559. Drawing. Florence, Casa Buonarroti, No. 120a

128 Third design, 1559. Drawing. Florence, Casa Buonarroti, No. 124a

129 Drawing by Dosio of Michelangelo's model. Modena, Biblioteca Estense

130 Final model. Engraving by Régnard, 1684

131–132 S. MARIA DEGLI ANGELI, ROME

131 Interior view

132 Interior view. Engraving of 1703

133–137 CAPPELLA SFORZA IN S. MARIA MAGGIORE, ROME

133 Interior view

134 Diagonally set piers and columns with side apse

135 Diagonally set piers and columns. Detail

136 View of an apse and ground plan. Eighteenth-century engraving

137 Altar chapel and ground plan. Eighteenth-century engraving

138 *Pietà*. Marble. Florence, Duomo

List of Plates

139 *Rondanini Pietà*. Marble. Milan, Castello Sforzesco

140 Studies of the entombment and *pietà*. Chalk. Oxford, Ashmolean Museum

141 *Crucifixion*. Charcoal. Paris, Louvre

142 *Crucifixion*. Charcoal. London, British Museum

143 *Crucifixion*. Pencil. Windsor, Royal Library

144 *Crucifixion*. Charcoal. Oxford, Ashmolean Museum

145 *Crucifixion*. Chalk. London, British Museum

146 *Annunciation*. Chalk. Oxford, Ashmolean Museum

147 *Mother and Child*. Black chalk. London, British Museum

The author and publishers wish to thank the following for permission to reproduce the plates that appear in this book:

Accademia, Venice, for Plate 82

Alinari, Florence and Rome, for Plates 1, 2, 13, 19, 22, 23, 25, 39, 42, 43, 46, 51, 66, 67, 68, 69, 71, 76, 85, 88, 89, 90, 94, 106, 110, 111, 122, 127, 138

Anderson, Rome, for Plates 5, 7, 11, 14, 15, 16, 17, 18, 20, 21, 24, 30, 31, 37, 55, 56, 63, 77, 93, 95, 96, 97, 98, 100, 101, 102, 114, 125, 133, 139

Archivio Fotografico delle Gallerie e Musei Vaticani for Plate 105

Ashmolean Museum, Oxford, for Plates 140, 144, 146

Biblioteca Estense, Modena, for Plate 129

Biblioteca Hertziana, Rome, for Plates 103, 107, 108, 109, 112, 113, 116, 118, 119, 120, 121, 128, 130, 132, 136, 137

British Museum, London, for Plates 81, 92, 99, 142, 145, 147

Brogi, Florence, for Plates 10, 26, 27, 28, 29, 32, 33, 34, 35, 36, 38, 40, 41, 52, 70, 72, 73, 74, 75, 78

Gabinetto Fotografico Firenze for Plates 3, 6, 47, 48, 49, 50, 64, 65, 87, 126

Gabinetto Fotografico Nazionale, Rome, for Plates 104, 115, 117, 131, 134, 135

Isabella Stewart Gardner Museum, Boston, for Plate 91

Professor Dr Isermeyer, Hamburg, for Plate 53

Kupferstichkabinett, Berlin, for Plate 12

Laurati, Florence, for Plates 4, 57, 58, 59, 60, 61, 62

Lord Leicester Collection, Holkham, for Plate 8

Musée Bonnard, Bayonne, for Plate 86

Musée des Beaux-Arts, Lille, for Plate 124

Musée du Louvre (Cabinet des Dessins), Paris, for Plates 44, 45, 141

Royal Academy, London, for Plate 9

Teylers Museum, Haarlem, for Plate 123

Windsor Royal Library for Plates 79, 80, 83, 84, 143 (all reproduced by gracious permission of Her Majesty the Queen)

List of Figures

a Sala del Gran Consiglio. Florence, Palazzo Vecchio. After
 Johannes Wilde. *page* 30
b Pope Julius's tomb. Design of 1505. Reconstruction. 40
c Sistine ceiling. Rome, Vatican. Plan. 52
d Sistine ceiling. Rome, Vatican. Plan of first design (after Erwin
 Panofsky). 54
e Sistine ceiling. Rome, Vatican. Plan of variant of the first design
 (after Erwin Panofsky). 57
f Pope Julius's tomb. Design of 1513. Reconstruction. 77
g Pope Julius's tomb. Design of 1516. Reconstruction. 89
h Biblioteca Laurenziana, Florence. Ground plan and elevation
 (after James Ackerman). 113
i Pope Julius's tomb. Design of 1532. Reconstruction. 122
j Pope Julius's tomb. Modification of the design of 1516. 124
k Palazzo Farnese, Rome. Ground plan (after James Ackerman). 192
l St Peter's, Rome. Ground plans (after James Ackerman). 210
 (1) Bramante, 1506.
 (2) Bramante-Raphael, 1515–20.
 (3) Antonio da Sangallo, 1539.
 (4) Michelangelo, 1546–64.
m S. Maria degli Angeli, Rome. Ground plan (after Herbert
 Siebenhüner). 234
n Cappella Sforza in S. Maria Maggiore, Rome. Ground plan (after
 James Ackerman). 238

Fig. a is reproduced from Johannes Wilde, 'The Hall of the Great Council of Florence', *Journal of the Warburg and Courtauld Institutes*, Vol. VII (1944), Fig. 18.

Figs. b, f, g, i and j are reproduced from Charles de Tolnay, *Michelangiolo* (Florence, 1951), Figs. 398–401, with alterations.

Fig. c is reproduced from Charles H. Morgan, *The Life of Michelangelo* (London, 1960), with alterations.

Figs. d and e are reproduced from Erwin Panofsky, *Die Sixtinische Decke* (Leipzig, 1921), Figs. 2a and 2b.

Figs. h, k, l, m and n are reproduced from James S. Ackerman, *The Architecture of Michelangelo*, Vol. I (London, 1961), Figs. 5, 9, 11, 13 and 14.

Foreword

For this English version of my *Michelangelo* (Stuttgart, 1959) the original German text has been revised and extended, and the whole work, including the bibliography, brought up to date as far as possible. In addition new chapters have been added on Michelangelo's architectural works.

I have been concerned to provide an overall picture of Michelangelo's creative personality, not an abstract study in the history of style. Modern criticism has tended more and more to detach the work of art from its creator and interpret it in the context of the historical forces that have conditioned its content, its meaning and its function. The biographical approach, on the other hand, has receded into the background, and even books giving an artist's name in the title do not always turn out to be proper biographies. In this book I have attempted to absorb the modern view of the role of criticism into a biographical work in the old sense. Each work of art is treated, not merely as an item in a great artist's career but as a concrete manifestation of forces whose impact is felt far beyond the personal plane. And over and above this, it is the totality of Michelangelo's artistic achievement that I have set in the centre of the discussion.

It is my hope that this book will lead its readers back to the Sistine Chapel, the Medici Chapel and the other places in which Michelangelo's masterpieces are preserved.

My thanks are due to the Biblioteca Hertziana in Rome, to Dr Hildegard Giess for her assistance over the illustrations, and finally to Mr Anthony Forster and Mrs Linden Stafford for the care with which they have prepared the book for publication.

Bonn HERBERT VON EINEM

Translator's Note

Michelangelo's poems are quoted from the edition by N. Girardi (Michelangelo Buonarroti, *Rime*, Rome, 1960). The translations of the sonnets are taken from the edition by Elizabeth Jennings (Folio Society, London, 1961), those of the other poems from *The Complete Poems of Michelangelo* translated by Joseph Tusiani (New York, 1960). The passages from Vasari's *Vita di Michelangiolo Buonarroti* are quoted in the translation by George Bull (Folio Society, London, 1971). My gratitude to the publishers of these works for permission to quote from them is hereby acknowledged.

I am also grateful to Professor Herbert von Einem for so willingly elucidating points of detail in his original text.

I affectionately dedicate this translation to my wife.

Eusserthal/Pfalz R.T.

Introduction

The Fame of Michelangelo

There have been three phases in the rich history of Michelangelo criticism[1] – his impact on his immediate contemporaries, the subsequent appraisal of his work by aesthetic criteria, and modern attempts at an assessment in historical terms.

The dichotomy of his appeal was already felt during his lifetime: the *divinità* of his art aroused an irresistible enthusiasm, but its *terribilità* caused fear and uneasiness. 'I do not doubt that angels will descend from Heaven to guide your hands,' said Luca Signorelli, as he found Michelangelo working on the figure of *The Struggling Captive*, now in the Louvre.[2] In his *Orlando Furioso* Ariosto writes: 'Michel più che mortal, Angelo divino'.[3] In the introduction to Part Three of his *Lives of the Most Excellent Sculptors, Painters and Architects* (1568) Vasari comments:

> The one genius who surpasses all others, both past and present, shedding his brilliance on all around him, is Michelangelo Buonarroti, the divine master not only in one art but in three. He is the superior, not only of those masters who almost succeeded in conquering nature but also of those famed artists of antiquity who were praised for their victory over nature: and as the sole victor over these two, he is also the sole victor over nature herself, who could scarcely have given birth to anything so strange and so involved that he, through the power of his divine spirit and by virtue of his creative energy, his skill, his intellectual power and his felicitous elegance, could not have far surpassed it.[4]

However vague, even inappropriate, this panegyric may sound today, it is extremely revealing in the context of its time. Michelangelo, the divine artist, is portrayed as superior, not only to his contemporaries and predecessors but also to the Greeks and Romans, even to nature herself. There can hardly be higher praise than this. In a passage on Michelangelo the architect Vasari adds, with a keen eye on the realities of his historical

achievement: 'He cut the cord and tore asunder the chains that had hitherto bound all artists to the narrow pathway of tradition.'[5]

The opposing view took as its point of departure Michelangelo's *Last Judgement*, in which Pietro Aretino, writing about 1550, found immorality, offences against Christian dogma and a reprehensible sense of artistic ambition: 'It is with shame', he wrote, 'that, as a Christian, I observe the unpardonable liberty which you have arrogated to yourself in your expression of that final judgement which is the true goal of our faith. Is it really that Michelangelo . . . desires to display as much religious irreverence as artistic perfection . . . just because he sets art above faith?'[6] This was the tone of criticism adopted during the Counter-Reformation: under Pope Paul IV, indeed, the *Last Judgement* was in danger of being destroyed.[7] When a marble copy of the *Pietà* in St Peter's was placed in the Riccio-Baldi chapel in S. Spirito in Florence in 1549, it became known as the *capriccio Luterano*. 'May God send down His saints to destroy such idolatry,' we read in an anonymous letter of the time.[8] Once again Michelangelo is charged with having set art above religion.

Religious objections were matched by aesthetic objections. In the earliest of these, Lodovico Dolce (*Dialogo della Pittura* (1557)) accuses Michelangelo of creating stereotyped characters, unlike Raphael: 'If you have seen one of Michelangelo's figures, you have seen them all.'[9] As often happens, the critical view is here more perceptive than the statement of pure admiration, for uniformity is undoubtedly one of the characteristics of Michelangelo's art.

From critical views such as this we pass to the second phase in the history of Michelangelo criticism, that of the judgement of his work by aesthetic criteria. The classicist aesthetics of the seventeenth and eighteenth centuries (Giovanni Pietro Bellori, Roland Fréart de Chambray, Félibien, Roger de Piles, etc.) raised contemporary criticism to the level of dogma. Michelangelo, it was said, despite his greatness, was the destroyer of art: it was not to him, as Vasari had claimed, that Raphael owed the grandeur of his style, but to antiquity. Winckelmann writes in the same classicistic spirit:

Michelangelo's imagination was too fiery for delicate emotions and graceful charm. He regarded the pleasing, a product of feeling rather

than of knowledge, as inferior to the ponderous and the extraordinary, seeking these latter solely in art. His feeling for beauty thus became rigid, insensitive . . . His strong, muscular forms are superb, but the gestures and actions of his youths and his female figures belong to another world . . . The recumbent figures on the Medici tombs lie in what is a most unusual and unnatural pose for living creatures; indeed, by being deprived of their human character, they are left with virtually no character at all and have lost all charm . . . Michelangelo has paved the way for the degradation of artistic taste: the paths that led him to the edge of precipices and into uncharted wastes led Bernini into bogs and ditches.[10]

Even more violent are the charges made by Francesco Milizia in his *Dell'arte di vedere* (1781), and the only voice of dissent in the chorus of classicistic disapproval is that of Sir Joshua Reynolds: 'It is not without satisfaction that I record the knowledge that all my addresses bear witness to my admiration for this truly divine man. I believe that the final word I shall utter as President of this Academy will be the name – Michelangelo.'[11]

Not until the late eighteenth-century cult of the creative personality, with its revolt against academic classicism, do we meet the beginnings of a fresh evaluation. Thus Heinse in his novel *Ardinghello* (1787): 'No one will have seen in real life such God-like figures as Michelangelo's, but has modern art any nobler forms to show? Have they not that quality which the common man associates with magic? . . . Their sublime quality strikes one like a shaft of lightning . . . His prophets and sibyls radiate an ardent grandeur and a passionate inspiration.'[12] In his *Lectures on Painting*, Johann Heinrich Fuseli, a pupil of Reynolds, maintained: 'The child, the female, meanness, deformity were by him indiscriminately stamped with grandeur. A beggar rose from his hand the patriarch of poverty; the hump of his dwarf is impressed with dignity; his women are moulds of generation; his infants teem with the man; his men are a race of giants.'[13]

Goethe, the supreme figure in the German 'cult of greatness' at this time – and the first to transcend it – admired the assurance and masculinity of the Sistine Chapel. 'Its grandeur is beyond description,'[14] he

said, and his stay in Rome even took away his delight in nature, which he feared he could not view with such penetrating and admiring eyes as Michelangelo's.[15] The highest place in Goethe's canon of art, however, was reserved, not for grandeur but for beauty, and later Michelangelo was to cede pride of place in his Pantheon to Raphael and the artists of classical antiquity.[16]

Even though the end of the eighteenth century saw a break with the dogmatic rejection of Michelangelo's art, and the way seemed clear for an unprejudiced assessment of his achievement, the general view of him had hardly changed. His art continued to be seen in the first instance as the expression of a personality both powerful and violent. Even the late nineteenth century, for all its intensive historical study of his works, his character and his age, did not change this, and in Jacob Burckhardt's writings the old notion of *terribilità* comes to dominate the scene again. 'The initial impression made by many of his figures is not of something noble and humane but of something potentially demonic,' wrote Burckhardt in his *Cicerone*.[17] 'Subjectivity, the characteristic feature of the past three centuries, here assumes the form of unrestrained creativity.'[18] In a collection of lecture-notes, as quoted from by Wölfflin, Burckhardt added to this disquiet in the presence of Michelangelo's violence the tone of apprehension to be found in his *Weltgeschichtliche Betrachtungen*:

> It seems a reflection of one's own vigour if one praises this extraordinarily vigorous master and spurns Raphael, by comparison, as a milk-and-water artist. . . . We can expect in the coming years a mass of pretentious nonsense about Michelangelo from small-minded, swollen-headed idiots in northern countries – until world events suddenly put an end to it all. It makes a great impression today if, flying in the face of tradition and even of propriety, one gives one's uncritical approval to a man of such power . . . If one can responsibly accord any pre-eminence to Michelangelo, then one will do so by keeping one's eyes firmly on his works and forgetting his unjust and violent character.[19]

Stendhal, Delacroix and Rodin approached him differently. In his essay *Sur le jugement dernier* Delacroix wrote: 'Michelangelo is the father of modern art . . . it is he who marks the final end of what I call Gothic art.'[20]

'Michelangelo', said Rodin, 'is the last and the greatest of the Gothic artists. The soul turned in upon itself, suffering, distaste for life, struggle against the dominance of matter – such are the elements of his inspiration.'[21]

But not until the development of historical consciousness in the present century did it become possible to move beyond the judgements of past ages and lay the true foundations for the study of Michelangelo. Dilthey's words are appropriate here: 'The life of an historical personality consists of an interaction between the individual and his environment: he receives stimuli from the world outside, develops his personality in contact with these stimuli, and thus affects in turn the nature of his surroundings.'[22] Modern scholarship no longer starts from the assumption of a firmly delineated personality but seeks in the first instance an understanding of the conditions in which the artist lived and worked, the conditions that determined the course of his activity. It is our task to trace the formative influences upon him, and to follow their course both in his own career and in the significance of his art for the future. Even a genius needs to be understood in terms of his place within a tradition.

This change of attitude towards the concept of personality is part of the general change of attitude towards history which began at the end of the nineteenth century, a change which has had profound consequences for our understanding of Michelangelo. Antiquity had hitherto been regarded as something absolute; historicism now made possible the unprejudiced study of its influence, so that we could trace that influence in areas which had formerly appeared to represent a reaction against it.

Western civilization has always been faced with the problem of its relationship to antiquity, and Michelangelo too faced this problem.[23] But what started as a question of aesthetic principle became a question of history. The rediscovery of the Middle Ages brought about a change in our view of the Renaissance, which was now seen to contain medieval as well as classical features, and this enabled us to follow Rodin and Delacroix in seeing in Michelangelo not only a disciple of the Greeks but also a disciple of the Middle Ages. The belated discovery of Mannerism as an independent stylistic epoch standing between the classicism of the High Renaissance and the Baroque synthesis of classicism and anti-classicism – a discovery made in the 1920s, and not unrelated to the

expressionist art of that time – made possible a historical understanding of Michelangelo's late works, while the recognition of the decisive change of direction in European history at the end of the eighteenth century caused the periods between the Middle Ages and baroque to be foreshortened and combined in a single unit, with a deeper sense of cohesion underlying their apparent differences.[24] This continuity of thought is also one of the prime characteristics of Michelangelo's art.

Finally we must consider the changed attitude towards art history that finds expression in Wölfflin's *Die Jugendwerke des Michelangelo* (1891). Wölfflin excludes biographical information and concerns himself solely with the sequence of the works themselves. This is the first attempt in the history of art to regard the power of genius as the agent of supra-personal stylistic forces.

Our broader and deeper knowledge of the historical pressures to which Michelangelo was exposed has prevented Burckhardt's gloomy prophecy from being realized. Michelangelo has never appeared to the twentieth century as an apostle of arbitrariness or of violence. In his power and his greatness he has remained within his own age, unique and inaccessible. Yet can there be a higher task for the historian of art than to preserve for posterity the living treasures of his genius?

Impossible as it may be to retain the picture of Michelangelo's personality in which scholars used to believe, there are outlines of character which modern scholarship is in danger of blurring. There is no one point in time from which, using the stylistic concepts evolved by recent art history, one can grasp Michelangelo's art in its entirety. There are more characteristics that estrange him from his age than link him to it. One must therefore always try to uncover the point of origin of each individual work, and although his progress reflects to a large degree the development of his century, it must at the same time be seen as the unfolding of his own personal destiny. It is his personality, moreover, that reveals the unity of his *œuvre*, from his earliest works to his last, for Michelangelo is the first artist in whom the urge to self-expression is as important as the subject-matter that he is portraying. One of the main tasks of Michelangelo scholarship is to assess the true relationship between the execution of a commission and the manifestation of an inner creative urge.

Part I

Early Years 1475-1505

Chapter 1

Florence and Bologna 1475-1496

Madonna of the Stairs – Battle of the Centaurs – Hercules –
crucifix for S. Spirito – figures for the shrine of St Dominic
in S. Domenico, Bologna

Michelangelo Buonarroti, son of a well-established Florentine family, was born on 6 March 1475 in Caprese, in the upper valley of the Tiber, where his father Lodovico was *podestà*. He spent his childhood partly on the small family estate at Settignano and partly in his parents' house in the Santa Croce district of Florence. In spite of many difficulties and frictions he remained greatly attached to his family throughout his life; particularly moving are the long poem written on the death of his father in 1531 and a number of his letters, in particular those to his nephew Lionardo, son of his favourite brother.

At the age of seven or eight he was sent by his father to Francesco Urbino's school in Florence,[1] but it soon became apparent, as Benedetto Varchi put it in his funeral oration, 'that the boy preferred going into churches and copying the paintings to going to school and studying grammar. He frequently played truant in order to watch painters at work, and sought the company rather of those who drew than of those who studied.'[2] So in 1488, through the recommendation of the young Francesco Granacci, Lodovico apprenticed him to Domenico Ghirlandaio, who had just been commissioned by the banker Giovanni Tornabuoni to paint a series of frescoes from the lives of the Virgin Mary and John the Baptist for the choir of S. Maria Novella.[3]

It was from Ghirlandaio that Michelangelo must have learnt the painter's craft. Here lie the foundations of such monumental works as the ceiling of the Sistine Chapel – notwithstanding his disclaimer that he was a sculptor, not a painter. Under Ghirlandaio he was initiated into the classical tradition of the schools of Giotto and Masaccio and also came into contact with the world of antiquity; a sketch-book has been

9

preserved from Ghirlandaio's workshop containing numerous drawings of classical buildings, decorative motifs, reliefs and figures, including the Apollo Belvedere.[4] It was presumably also Ghirlandaio who recognized Michelangelo's ability as a sculptor and, as Vasari records,[5] arranged for him to enter Bertoldo's 'school for sculptors' in the Medici garden on the Piazza di S. Marco in 1489.[6]

We have disappointingly little information about Michelangelo's training as a sculptor. Ascanio Condivi, whose biography is based on Michelangelo's own statements in his old age, records that Granacci took the young Michelangelo to the Medici garden;[7] Lorenzo de' Medici had had a number of classical statues placed in the garden, and Michelangelo, 'seeing these works of art and observing their beauty', did not return to Ghirlandaio's studio but stayed in the garden the whole day – 'the best school for learning such things'. Varchi also states that Lorenzo 'opened his garden as though it were a school or a studio'[8] – although formal institutions of this kind belong to the sixteenth rather than the fifteenth century.

Vasari, however, specifically refers to a school in the Medici garden. 'Lorenzo had a passion for painting and sculpture,' he writes. 'It offended him that, while there were many excellent and highly esteemed painters, there was not a single great sculptor, and so he decided to found a school.'[9] Bertoldo di Giovanni – not mentioned by Condivi – a former pupil of Donatello and now an old man, was charged by Lorenzo with the task of 'assembling a body of first-class sculptors and painters and instructing them in the proper ways of art'.[10]

In his biography of Torrigiani Vasari adds to this picture: 'The Medici garden was full of splendid sculptures and antiques, the loggias, paths and spaces being lined with fine marble statues, paintings and other works by the best masters from Italy and beyond. Apart from their decorative value, all these objects virtually made up an academy of art for young painters and sculptors.'[11] This account is, however, hardly credible, and Vasari's information about the artists he claims attended this academy, about Bertoldo as a teacher and about the works displayed in the Medici garden cannot be taken as reliable.[12]

Where, then, did Michelangelo learn the sculptor's craft? Where was the workshop in which he was instructed in the use of tools, in model-

ling, in the handling of stone and marble, in wood-carving and in bronze casting? As yet we cannot answer these questions satisfactorily. We may assume that he first encountered original works of classical art in the Medici garden, and that Bertoldo acted as his mentor, possibly also bringing him into contact with the Donatello tradition, but there is nothing in this of the formal study and instruction that every artist of the late fifteenth century must have received. Bertoldo died in 1491, when Michelangelo was only sixteen. Could he have gone to Benedetto da Maiano, whose late works (a Madonna and a St Sebastian) in the Oratorio della Misericordia in Florence seem to anticipate his own?[13] Condivi's biography makes it clear that Michelangelo wanted to be seen as self-taught, and he himself appears to have drawn a veil over his early years. Nor do we know anything for certain about the beginnings of his career as an architect.

The year 1490 found Michelangelo as a house-guest in the Medici palace, where he lived with the sons of Lorenzo il Magnifico – Piero, whose expulsion by King Charles VIII of France in 1494 led to the fall of the house of Medici; Giovanni, later Pope Leo X; and Giuliano, whose tomb in the Cappella Medicea he was later to carve. It was at this time that he must have become acquainted with the ideas of Platonism and Neoplatonism which play so important a part in his art and his poetry.[14] Among the tutors to Lorenzo's sons were the poet Angelo Poliziano, the philosophers Marsilio Ficino and Pico della Mirandola, and the humanist scholar Cristoforo Landini, famed for his commentary on Dante. On Lorenzo's death in 1492 Michelangelo returned to his parents' home.

This was the time when the Dominican prior of S. Marco in Florence, Girolamo Savonarola, began his career, a career which reached its climax in the years between 1494 and his violent death in 1498. Condivi emphasizes that Michelangelo was greatly attracted to Savonarola and read his vivid writings with great enthusiasm.[15]

At the beginning of October 1494 Michelangelo, sensing the imminent fall of the Medici, and perhaps also alarmed by Savonarola's admonitory sermon on the text 'Behold, I will send the waters over the land' and by Landini's *Disputationes Camaldulenses*, fled from Florence to Venice, then to Bologna. This sudden flight reveals for the first time

Michelangelo's impulsive nature, which asserts itself not only over his personal courage but also over any feeling of gratitude towards his patrons. In 1495, however, we find him back in Florence.

The earliest of Michelangelo's sculptures that have survived show their indebtedness to Bertoldo. The *Madonna of the Stairs* (Florence, Casa Buonarroti, Pl. 1) stands in the tradition of the devotional image as created by Bertoldo's teacher Donatello, a form that enjoyed great popularity in the late fifteenth century, while the relief *The Battle of the Centaurs* (Florence, Casa Buonarroti, Pl. 2) probably owes its existence to a classicistic work by Bertoldo himself; yet already in both these early works there is a marked independence.

For his low-relief the *Madonna of the Stairs*,[16] his first work, Michelangelo went back to the old motif – one uncommon, however, in fifteenth-century Florentine art – of Mary suckling the Christ-child, which he was to develop in all its glory in his *Madonna* for the Medici Chapel. The Child seems to have fallen asleep on His mother's breast; instead of looking at Him tenderly, the Madonna is gazing gravely into the distance, as though her mind were already clouded by thoughts of death.

In form Michelangelo has turned away from his immediate predecessors Rossellino, Desiderio da Settignano and Mino da Fiesole and gone direct to Donatello. Donatello's relief, the *Madonna in the Clouds* (Boston, Museum of Fine Arts),[17] completed some seventy years earlier, with its heroic intensity and visionary expressiveness in the so-called *rilievo schiacciato* manner, is Michelangelo's starting-point – yet what originality he displays! He sets the Virgin apart in the forefront of the picture, with firm, bold outlines, confining the cherubs to a more remote plane. The motif of the enveloping shroud – if it is meant as such – has been converted into action, and the subsidiary theme subsumed into the expression of the work as a whole. The profile of the pensive Virgin derives its impressive power from its contrast to the rear view of the Child Jesus – a new and unusual motif – as He clings to His mother. The background has been left unfinished. The lifelessness of the Virgin's left arm and virtually her whole left side, uncertainties in the Child's posture and a number of individual features such as the Virgin's

deformed right foot – all this suggests the work of a beginner. It bears a striking resemblance to certain fourth-century Greek works, but it is not possible to take the parallel further.

The unfinished relief of *The Battle of the Centaurs* (Pl. 2) – considered by Michelangelo in his old age to be the best of his early works[18] – owes its existence to a suggestion from Politian and evidently represents the story of the centaurs' struggle with the lapiths on the occasion of Peirithous' marriage to Hippodamia, as recounted in Boccaccio's *Genealogy*.[19] The centaur Eurythion stands in the centre, with Theseus on the left preparing to hurl a rock at him; on the right, between Peirithous and a centaur, is Hippodamia. The theme of the relief is rape and aggression as forces in life; the outcome of the struggle is not intimated. The theme is also communicated through the nakedness of the figures, itself a striking and unusual feature.

As in the *Madonna of the Stairs*, Michelangelo seeks inspiration in the art of earlier generations. In Bertoldo's bronze relief *The Battle of the Horsemen* (Florence, Museo Nazionale), for example, which Michelangelo certainly knew, the figures are set against the background in such a way that if they were removed, the background would still remain as an independent plane. Michelangelo, on the other hand, has covered the surface uniformly, fusing figures and background into a single, multi-dimensional entity. The central group can hardly be separated from the tense supporting figures of the fighters. These features recall Nicola and Giovanni Pisano, the earliest artists in whose works (pulpits) the Roman style of relief had been revived, while individual motifs may well have been taken direct by Michelangelo from classical sources.

Both these reliefs, unique of their kind, are anticipations of what was to come. The *Madonna of the Stairs* points forward to the *Madonna* in the Medici Chapel, and *The Battle of the Centaurs* to the *Battle of Cascina*, the *Flood* and even the *Last Judgement*.

These same years see the creation of the first of Michelangelo's statues, namely a marble figure of Hercules and a crucifix in wood. The Hercules,[20] an uncommissioned work undertaken after the death of Lorenzo il Magnifico in 1492, and an anticipation of his *David*, has been lost since 1713 but it can be reconstructed from a drawing by Rubens in

the Louvre and from a wax cast in the Casa Buonarroti. Whether it was inspired by some piece of classical sculpture we cannot tell.

The crucifix (Pl. 3) was made, according to Condivi, for the prior of the Augustine monastery of S. Spirito, 'in gratitude, not only for many courtesies, including lodging, but also for the corpses which were provided so that he could study anatomy, than which he could conceive no greater pleasure. This marked the beginning of the anatomical studies which he pursued as long as fate was to permit.'[21] The crucifix, long unidentified by scholars, was rediscovered in S. Spirito by Margrit Lisner in 1962 and is now on display in the Casa Buonarroti. According to Vasari, its original position was 'sopra il mezzo tondo dello altare maggiore': it was thus intended to be viewed from below. In type – and Michelangelo did not repeat it until a sketch for Vittoria Colonna many years later – it follows Florentine crucifixes of the fifteenth century, such as those of Andrea Pollaiuolo, Benedetto da Maiano and Giuliano da Sangallo. It is particularly akin to the crucifix in S. Onofrio in Florence, probably an original work of Benedetto da Maiano, and this again raises the possibility that Benedetto was Michelangelo's teacher. The kinship derives above all from the shape and expression of the face – the lips are not twisted in pain but closed in the profound serenity of death. Michelangelo departs from Benedetto, however, in his shaping of the delicate, youthful body and by showing, for the first time in art, Christ's legs as crossed.

The fact that a dignitary of the Church helped a young artist to embark on the study of anatomy enables us to dispose of a frequent misunderstanding. The Church did not categorically forbid the dissection of corpses, although it did prohibit the desecration of graves and similar abuses under pain of severe punishment. The first Florentine artists known to have dissected corpses were Antonio Pollaiuolo and Andrea del Verrocchio, and Verrocchio's pupil Leonardo da Vinci interpreted the results in a number of treatises. Michelangelo thus followed a tradition already established in Florence, putting it to his artistic purposes in a way no one before him had done.[22]

In Bologna Michelangelo was commissioned to complete the shrine of St Dominic in the church of S. Domenico, where the statuettes of St Proculus and St Petronius, together with an angel holding a candelabra,

remained to be finished.[23] Michelangelo was, as we see from this, by no means averse to contributing his part towards a larger, composite unity. Of more consequence during this period in Bologna was his discovery of the portal of the church of S. Petronio, the greatest work of the Sienese sculptor Jacopo della Quercia, which he was to recall during his work on the Sistine ceiling.

In 1495 and 1496 Michelangelo was again living in Florence, and Condivi[24] and Vasari[25] refer to a marble statue of St John as a young man and another of a recumbent Cupid, but both works are lost.[26] According to Condivi, the Cupid was the reason behind Michelangelo's first period in Rome, for it was sold to Cardinal Riario there as a piece of classical sculpture – whether Michelangelo knew of this or not, we cannot tell. The deception was uncovered and the statue returned. Nevertheless Michelangelo went to Rome, 'partly in rage', says Condivi, 'but partly also to see the city which, he had been told, offered the greatest possible scope for any man's abilities'.[27]

Bacchus – Pietà

For Michelangelo Rome was a new world. It had suffered as a result of the Babylonian exile of the Popes but since the middle of the fifteenth century it had been experiencing a revival. 'With Nicholas V [Pope from 1447 to 1455] that new monumental spirit which was characteristic of the Renaissance appeared on the Papal throne,' wrote Burckhardt in his *Civilization of the Renaissance in Italy*.[1] Nicholas pledged his brief pontificate to the re-establishment of Rome in all her former glory and planned, probably in consultation with Alberti, the restoration and decoration of the station-churches, the rebuilding of the city walls, the building of drainage systems and bridges, and the reconstruction of both the Papal palace and St Peter's.[2] The idea of pulling down the old basilica of St Peter's was mooted at this time, for the desire to erect a monument to the present was stronger than that to preserve for posterity one of the holiest shrines of Christianity.

But of greater attraction for Michelangelo than the world of modern art, which he already knew from Florence, was the world of antiquity, insights into which he had gained from the Medici collection as well as from the sketchbooks of Ghirlandaio[3] and also possibly of the architect Giuliano da Sangallo.[4] From the fifteenth century the feeling had been developing that antiquity did not simply consist of a legacy of isolated manifestations but was a living entity which had to be grasped *in toto* if the true living quality of its individual forms of expression were to be understood. Classical art began to acquire a remarkable fascination for the present. As Burckhardt wrote, concerning the 'discovery' on 18 April 1485 of the perfectly preserved body of a beautiful young Roman woman near the tomb of Caecilia Metella on the Appian Way: 'The touching point about the story is not the alleged discovery itself but the conviction that the classical body they believed they were seeing with

their own eyes must needs be more beautiful than anything of their own age.'[5] Vasari wrote:

> It was, however, a great revelation to artists when excavations un-covered some of the works of art counted by Pliny among the greatest, such as Laocoon, Hercules, the Belvedere torso, Venus, Cleopatra, Apollo and many others. These works, delicate yet precise, with their full, round contours like those of nature at her most beautiful, with their movements directed towards a single point of attraction – these works display a remarkable grace, and led to the rejection of that hard, dry, angular style which Piero della Francesca, Alessio Baldovinetti, Andrea del Castagno . . . Giovanni Bellini, Cosimo Rosselli, Domenico del Ghirlandaio, Sandro Botticelli, Andrea Mantegna, Filippo and Luca Signorelli, and others who lacked a sense of freedom and liveliness, had adopted through an excess of academic study.[6]

In a famous letter of 1518 Raphael – or one close to him – wrote to Pope Leo X:

> When I observe in the relics of ancient Rome the divine spirit of antiquity, it seems not unreasonable to me to believe that they found many things easy which we today find impossible. It will not be the least of Your Holiness's concerns to ensure that these few priceless relics of Italy's fame and greatness are preserved as a memorial to those divine spirits whose memory still has the power to rouse us to higher achievement, lest ignorant or evil men should damage or destroy them.[7]

This new attitude towards antiquity is reflected in the enthusiasm with which excavations were undertaken and collections assembled. In 1471 Pope Sixtus IV had a number of bronzes set up on the Capitol hill, dedicating them to the people of Rome so that, as the inscription ran, 'these outstanding works in bronze, testimonies to ancient skill and virtue, should be restored to the people in whose midst they were created'.[8] The most important collections of classical statuary in Rome at the time when Michelangelo arrived there were those of the two Cardinals Riario and Giuliano della Rovere (later Pope Julius II).[9]

17

Riario's collection had been on display in the Cancelleria since 1496, while Giuliano's were in his two palaces, one next to the church of the SS. Apostoli and the other by S. Pietro in Vincoli, where the Apollo Belvedere had stood before Giuliano, as Pope Julius II, had it taken to the Vatican. The collection of Jacopo Galli should also be mentioned; Jacopo's house was near the Cancelleria, and Michelangelo may well have stayed with him when he arrived in Rome.[10]

It was in Rome that Michelangelo discovered monumental classical sculpture, and he is the first modern artist to have sought this encounter with the art of antiquity and then to have striven to emulate it.

Two works of Michelangelo's have survived from this first period in Rome – the *Bacchus* for Jacopo Galli (Florence, Museo Nazionale, Pl. 4) and the *Pietà* for the French Cardinal of S. Sabina, Jean de Bilhères de Lagraulas (Rome, St Peter's, Pl. 5). Other works are known to us only from references. In spite of his connections with various cardinals, Michelangelo had no contact with the court of the Borgia Pope Alexander VI. Condivi records:

> Jacopo Galli had him carve a Bacchus in his house, some ten spans tall, like in form and appearance to the conceptions of the ancient writers in every detail. His face was jolly, his eyes leering and lustful, like those of all men who are excessively drawn to wine, women and song. In his right hand he holds a bowl which he regards with delight as he prepares to drink; . . . in his left he holds a tiger skin, together with a bunch of grapes which a little satyr at his feet, unnoticed by the god, is hastily and delightedly nibbling. He looks about seven years old, to Bacchus' eighteen.[11]

Michelangelo started work on the statue in 1497.[12]

A drawing by Maerten van Heemskerck shows it standing among classical figures in the garden of the Casa Galli.[13] There were people in the sixteenth century, according to Francisco de Hollanda in 1548,[14] who regarded it as 'a remarkable piece of antique art', and when it was moved to the Uffizi in 1572, it was put among the classical statuary.[15]

The garden of the Casa Galli seems to have been its intended location, for in contrast to almost all other statues by Michelangelo, it is conceived as a free-standing figure. The plinth, like a rock embedded in the ground,

is carved in such a way as to compel one to walk round the figure. The satyr at the side cannot be satisfactorily seen from the front. The last statue that Michelangelo had carved in Florence had been taken for a piece of classical sculpture, and his *Bacchus* seems to have been commissioned as an imitation of the classical style; at all events it is most readily understood as such. The tree stump and the satyr recall Roman copies of Greek bronzes.

Its classical quality is not, however, only a matter of subject and motif but also derives from its forms. Michelangelo has overcome the 'dry, hard, angular manner' disapproved of by Vasari, and his lines have become flowing. His concern is no longer simply with outlines but with plastic form as a whole, no longer simply with surfaces but with the whole living, vibrant organism. Stance, gesture and expression – the gloating eyes, the open mouth, the mood of the fleeting moment – are intertwined. The motions are natural, not posed. For the first time the classical *contraposto* is not merely a motif but the very foundation of the form, while the absence of colour is also due to classical influence.

There is, however, a difference. The *contraposto* has been reversed. The right shoulder is bent forwards, not backwards; the right leg is taken together with the raised arm, while the left leg, bearing the main weight of the body, is taken together with the hanging arm. The figure is swaying and struggling to regain its balance.

One is at first tempted to see this as a general expression of the theme of drunkenness, but this is not an adequate explanation, for even when portraying drunkenness classical artists never lost their innate feeling for equilibrium, whereas Michelangelo took this subject in order to challenge the newly gained freedom of independent, free-standing sculpture.

A further difference lies in Michelangelo's treatment of the nude. However successfully he may have overcome the 'dry, hard, angular manner' of his predecessors, he was not able to throw off entirely the naturalism of the Quattrocento, and it almost seems as though he were working from a living model as well as from a classical statue. With exaggeration, but not entirely without reason, Justi speaks of 'the debauched young man, growing fat in his excesses',[16] and Wölfflin goes so far as to say: 'One almost feels that the artist's intention was merely

to make as powerful an impression as possible through his portrayal of the formless and the offensive.'[17]

Finally one must take account of the Gothic elements – the remarkable way the figure is held against a plane surface, the self-contained profile, the firmly rooted left side, with the weight on the left leg and the pendant left arm, and the 'Gothic vibration'[18] of the side view.[19] The right side too points inwards. A comparison with the *Bacchus* of Jacopo Sansovino in the Museo Nazionale in Florence[20] makes the Gothic features of Michelangelo's figure especially clear. The destruction of a sense of balance, the conflict between constraint and freedom of the will, a subject treated here for the first time, was to become a fundamental concern of Michelangelo's art.

The second major work of this period is the *Pietà* in St Peter's (Pl. 5). Michelangelo received the commission in the autumn of 1497,[21] and from the end of November till the end of December he was in Carrara quarrying the marble.[22] This was the first of his many visits to Carrara. On 27 August 1498 he made an agreement with the French Cardinal of S. Sabina to complete the work in a year.[23] Jacopo Galli, who had arranged the commission, maintained that the *Pietà* would be 'the most beautiful marble statue in Rome, and no living artist could better it.'[24]

Originally the group stood in a niche in the Chapel of S. Petronilla, the westernmost of the two round, late classical structures on the south side of Old St Peter's, on the right of the altar.[25] Since the cardinal, who died in 1499, is buried in this chapel – the so-called Cappella del Re di Francia – we may assume that the *Pietà*, in keeping with French custom, was intended for his tomb. Its present position in the Chapel of the Crucifix is a bad one; it is both too high and too far away from the observer.

Mary sits on a rock, her right foot slightly raised, with the limp body of Christ on her lap. Her right hand is under His shoulder, as though she were trying to draw Him gently to her. Mary is above life-size; Christ is of normal stature, and His frame is absorbed within hers. The hem of her garment follows the curve of His body. Vasari describes it thus:

No portrayal of a corpse can be more realistic, yet the limbs have a

rare beauty, and the muscles, veins and nerves stand out to perfection from the bone-structure. The face bears an expression of infinite tenderness, and all the joints, especially those which link the arms and legs to the body, have a wonderful harmony. So superb is the tracery of veins beneath the skin that it is a source of never-ending wonder how an artist could achieve such divine beauty.[26]

The Virgin is turned towards us but does not look at us. Her youthful countenance shows her immersed in her own thoughts, oblivious to time and space. It is as though Michelangelo were thinking of the prayer of St Bernard in Dante's *Paradiso*:

> Vergine madre, figlia del tuo figlio,
> Umile ed alta più che creatura,
> Termine fisso d'eterno consiglio,
> Tu sei colei che l'umana natura
> Nobilitasti sì, che il suo fattore
> Non disdegnò di farsi sua fattura.

> (O Virgin Mother, daughter of thy Son,
> Created beings all in lowliness
> Surpassing, as in height above them all;
> Ennobler of thy nature, so advanced
> In thee, that its great Maker did not scorn
> To make Himself His own creation.)[27]

Only with the left hand is any acknowledgement made of the presence of the observer: 'Is it nothing to you, all ye that pass by? Behold, and see if there be any sorrow, like unto my sorrow.'[28]

Michelangelo's group is the first independent *pietà* in Italian art, but there must be a long tradition behind it.

The origins of the *pietà* – the Virgin Mary, seated, nursing the body of her dead Son – are lost in history. Laments for the dead – Thetis and Achilles, Venus and Adonis, Eos and Memnon – are known to the art of antiquity but there is no sculptured group that could be seen as the predecessor of the Christian *pietà*. Sardinian folk-art has a number of small bronzes in which a woman is nursing a dead warrior, and these bear a striking resemblance to the medieval *pietà*.[29] This suggests that

there may have been a similar tradition in the folk-art – though not the 'official' art – of classical antiquity.

In Christian art the motif of the *pietà* is anticipated in portrayals of Rachel holding her dead child in her lap,[30] and in the miniature depicting the story of the son of the Shunammite woman (2 Kings 4) in the illuminated French thirteenth-century manuscript known as the *Bible moralisée* – where, however, the son is shown as dead, not alive, as the Bible story would require.[31]

The fusion of this motif with the figures of Jesus and Mary takes a different course in the south from the north. In the former it becomes incorporated, in the course of the thirteenth century, into the scene of the lament over the dead Christ, whereas in the latter it leads, after the thirteenth century, to the magnificent German creation of the carved *pietà*, which then spread from Germany to England, France, the Netherlands, Spain and Italy[32] – in the case of the last-named it remained, with a few isolated exceptions, a German import until the mid-fifteenth century.

> The lamentation of Mary was not one of the subjects treated in the great sculptures of the early Italian Renaissance, particularly in Tuscany, and the contemporaries of Ghiberti and Donatello appear to have ignored it as a composition not suitable for their purposes. The situation remains basically the same in the second half of the century, for neither Michelozzo nor the Robbias, neither Mino nor Verrocchio makes use of the subject.[33]

The artists both of antiquity and of the Italian Renaissance must in some way have been repelled by the idea of combining two adult bodies to form a single composition, and Michelangelo was the first to overcome this southern resistance to what the Gothic north had evolved.

The few exceptions by Italian artists show how they viewed this German creation.[34] The outline of the composition becomes more tightly knit; instead of forming a rigid horizontal or diagonal, the body comes to rest by its natural gravity between the Virgin's knees. This is the line of development towards naturalness which only acquired a truly independent creative validity with the work of Michelangelo himself.

In its original form the *pietà* also includes the *arma Christi* – the instruments of castigation, the cross and the grave – and the Christ figure is not primarily the Jesus of history but the *corpus Domini*: 'For my flesh is meat indeed, and my blood is drink indeed' (John 6:55). Likewise Mary is not in the first instance a figure weeping at the foot of the cross but the Mother of God ruling in splendour. It is a scene in which beginning and end are mysteriously united. And alongside this theological meaning the figures have, for us as for the Middle Ages, a profound, unmistakable human significance in the lamentation of a mother for her son. Both these aspects are present in Michelangelo's own composition.

By commissioning Michelangelo to carve a *pietà* for a tomb, the French cardinal was following a national tradition, for the *pietà* had established itself in France since the end of the fourteenth century and is known to have been placed on tombs from that time.[35] Michelangelo, however, felt himself called upon to make it part of the Italian tradition,[36] while both respecting the old-established subject as such and satisfying the expectations of contemporary attitudes towards nature and beauty which had been fashioned through contact with antiquity. He succeeded in his task. Not only is his Roman *Pietà* the equal of the great early German examples; it also completely recasts the medieval form, yet without destroying its foundation.[37] It has for the history of the *pietà* much the same significance as has Leonardo's *Last Supper* for the history of paintings on that subject.[38]

The forms of the *Pietà* show more clearly the link with earlier Italian sculpture than does the *Bacchus*, which is an imitation of antiquity. The head of Christ recalls Verrocchio's *Christ* on the Forteguerri tomb in Pistoia[39] – which was Leonardo's starting-point for his *Last Supper*. It also bears a family resemblance to Michelangelo's own early crucifix in S. Spirito. The head of Mary resembles Quercia's Madonna in the main porch of S. Petronio in Bologna.[40] Quercia's influence is also apparent in the high degree of detail in the garments – Wölfflin refers to an 'a somewhat oppressive wealth of detail';[41] on the other hand, the beautiful body of the Christ-figure would have been impossible without Michelangelo's devotion to the gods of antiquity. Christ has merged with Apollo.

In this work Michelangelo, now a man of twenty-two, extended his powers to the utmost, proudly inscribing on the Virgin's sash the words 'Michael Angelus Bonarotus Florentinus faciebat'. It was the only occasion he signed his work. The conflicts in his nature are entirely absent: all is harmony – profound yet not obscure, a work complete in itself, without that mysterious sense of a task destined to remain for ever unfinished which was to leave its mark on his later works.

Chapter 3

Florence 1501-1505

Bruges *Madonna* – *David* – *Battle of Cascina* –
Taddeo Tondo – *Doni Tondo* – *Pitti Tondo*

Why Michelangelo returned to Florence from Rome after completing his great *Pietà* remains a mystery. However, in 1501 he settled again in his native city and stayed there until summoned to Rome by Pope Julius II in 1505.

Florence had greatly changed since he left. After the expulsion of the Medici a Grand Council, founded by Savonarola on the Venetian pattern, had ruled the city. Internal struggles filled the years 1494-8, but after Savonarola was burned at the stake in 1498, conditions became more settled, and in 1502 Pietro Soderini was elected head of the Grand Council for life. Earlier a member of the Medici circle, Michelangelo now came into contact with important new public bodies such as the Weavers' Guild, the Masons and the Grand Council itself. Once an unknown beginner, he was now an acknowledged master.

The greatest experience of these years in Florence was his encounter with the art of Leonardo da Vinci. The two men never knew each other closely, but it is clear that Michelangelo, who was twenty-three years Leonardo's junior, acknowledged the older man's greater mastery and was determined to put it to use in his own art. After the fall of his patron, Lodovico Sforza, Leonardo had returned from Milan to Florence and was at this time engaged on his painting of *The Virgin and Child with St Anne*. When he had finished the cartoon, according to Vasari, 'there was for two days a joyful procession of men and women of all ages to see the masterpiece which struck everyone dumb with admiration'. Michelangelo must have been among these admirers,[1] for it has left clear traces on his own art.

The first works that he undertook in Florence – it may even have been the reason for his return – were the fifteen statuettes for Andrea Bregno's

altar in Siena Cathedral; these had been commissioned in 1501 by Cardinal Francesco Piccolomini (later Pope Pius III) at the instigation of Jacopo Galli, and among the conditions was that they should be completed within three years, and that during this time Michelangelo should undertake no other work. However, he did not observe these conditions and only completed four of the figures, which he delivered to Siena in 1504.[2]

Also intended for this altar is the *Madonna and Child* (Pl. 6), smaller than life-size, which Michelangelo sold for some unknown reason to the city of Bruges in 1506.[3] It is intended to be placed in a high position: the full frontal view shows a pensive, unapproachable Mary sitting on a rock, a closed book held limply in her right hand; her left leg is somewhat raised, and the Christ-child, His eyes also cast down in reflection, nestles between her legs, His left hand grasping His mother's leg as a support and His right hand holding His mother's left hand. This is the first instance of the motif of the arm crossing the body which recurs time and again in Michelangelo's work.

The four figures for the Piccolomini altar – Peter, Paul, Pius and Gregorius – have a certain conventionality about them and are overshadowed by the Bruges *Madonna*. The theme of the Virgin on the throne was very popular in Florentine sculpture of the late fifteenth century; a noteworthy precursor of Michelangelo's statue is the *Madonna* by Benedetto in the Oratorio della Misericordia in Florence.[4] But as in his *Madonna of the Stairs*, Michelangelo draws more especially on masters from the beginning of the century: the forms of the heads, for example, together with those of Mary's cloak and head-dress, recall Quercia (cf. his wood-carving of the Madonna in the Louvre[5]). His particular model, however, seems to have been Donatello's *Madonna* in Padua.[6] Drawing on Byzantine art, Donatello had attempted to revive the devotional composition which the fifteenth century was in danger of losing. Michelangelo did not adopt Donatello's archaic manner but sought to derive the supernatural from the natural, as shown here by his transference of the Christ-child from Mary's lap to a standing position between her legs – a motif that recalls Signorelli.[7] The Virgin's mysterious expression, a blend of mourning and serenity, is reminiscent of Leonardo rather than of Donatello – indeed this is perhaps the work in which Michelangelo comes closest to Leonardo.

26

The Bruges *Madonna* continues in the same vein as the *Pietà* in St Peter's, in which Leonardo's influence is also detectable. In the Bruges work the Madonna's head is simpler, more relaxed, and the style is grander; her garments still have a certain restlessness characteristic of the late-Gothic period but their outlines are firmer, their folds more emphatic, and the body and its clothing more closely united, as though Michelangelo now found his treatment of the draperies in the *Pietà* too sumptuous, too decorative.

The reason for his casual attitude towards the work for Siena was his enthusiastic acceptance of a commission to carve a large statue of David in marble, the greatest task he had yet been set.

In 1404 the Operai of the Duomo in Florence held consultations on a plan to erect sculptures on the outer buttresses which supported the cupolas of the apses. The programme envisaged figures of prophets, together with a statue of Hercules as a classical counterpart to David. In 1408–9 Donatello carved a David for the north apse, and Nanni di Banco completed a figure of Isaiah at about the same time. However, both these figures turned out to be too small and had to be used elsewhere. Donatello's *David* was taken to the Palazzo Vecchio in 1416 (it now stands in the Museo Nazionale in Florence); in 1410 Donatello was commissioned to do a larger terracotta statue of Joshua, which was erected on one of the buttresses, but it has not survived, and the programme was abandoned. In 1463 the original programme was revived at the instigation of Donatello, who had recently returned from Siena and was now put in charge of the undertaking; at the same time Agostino di Duccio (Donatello's amanuensis) was commissioned to carve a Hercules for the south apse, and the figure was completed that same year. The following year Agostino was also commissioned to carve a David but he did not embark on the work; in 1476 the commission was offered to Antonio Rossellino, but he too declined. Then on 16 August 1501 the block of marble, which had already been chosen – 'olim sbozzatum per magistrum Augustinum . . . et male sbozzatum' ('already rough-hewn by Maestro Augustinum . . . and badly hewn') as the record has it – passed into the hands of Michelangelo, who was invited to complete a figure of David within two years. It was finished in 1504.[8]

The nude figure of the young David (Florence, Accademia, Pl. 7), his head aggressively thrust forward, stands on a rock, his weight on his right leg, his left leg slightly bent in athletic pose. His left arm is bent, and his sinewy hand grips the stone and the sling, whose thongs pass diagonally across his back; his right arm hangs easily by his side. A tree stump serves as a support behind his right leg, in the style of Roman marble copies of Greek bronzes. He is shown, not after the fight, with Goliath's head between his feet, but before it, his gaze fixed on his adversary and his sling ready for use.

Since the Middle Ages David had become a familiar figure as a herald of Christ, and his victory over Goliath was seen as the Old Testament counterpart to Christ's victory over Satan. He had also acquired political significance as a symbol of bravery, and these qualities had frequently found expression in art. Michelangelo knew of these associations, but his *David* differs from the works of Florentine sculptors of the early Renaissance. What Nicolas Pisano had achieved on a small scale with his statuette of Hercules on the pulpit of the baptistery in Pisa[9] – this also an allegory of bravery – becomes with Michelangelo the rediscovery of the grand classical idea of the naked youth. The head in particular reveals for the first time and in utter purity Michelangelo's conception of human beauty. Instead of portraying his hero standing triumphantly above his slain foe, like Donatello, Michelangelo shows him alert for the attack, poised between observation and action in a style proper to the sculptures of antiquity. This particular pose, one may note, can already be seen in Domenico di Niccolò's *David* of 1423 in the *pavimento* of Siena Cathedral.[10]

Michelangelo's *David*, heralded by his early *Hercules*, brings Roman antiquity to Florence. One can hardly imagine today how novel, how revolutionary the nude, athletic figure must have appeared to the Florentines. Without Michelangelo's detailed study of classical models in Rome such a figure would have been impossible. All the more surprising, therefore, are its non-classical features, particularly the naturalism derived from earlier Florentine artists. The contrast, indeed, between the ideal, typical style of antiquity and the naturalistic manner in which Michelangelo has handled the human body is here far more noticeable than in his *Bacchus*.

Furthermore there is here, more markedly than in the *Bacchus*, a Gothic element present in the slight inclination of the figure, in its flatness – perhaps due to the shape of the block – and in its accentuation of the head. Like Gothic artists, Michelangelo anchors one side of the body firmly to the ground and concentrates his entire attention on the other side; the figure has a linear as well as a plastic quality, and even the bent left arm is incorporated in the self-contained contours of the composition as a whole.

On a drawing for the lost bronze *David* that Michelangelo did for Marshall Gié Pierre de Rohan in 1501–2 (Dussler No. 213) there is a sketch for the right arm of the marble *David* with the words 'Davicte cholla fromba e io coll arco. [David with the sling and I with the bow.] Michelangiolo.'[11] Is it too much to assume that the figure of David is an idealized self-portrait? In Michelangelo's later works we do indeed find that their objectivity conceals many aspects of his own personality.

At the time Michelangelo received the commission for his *David*, the figure was intended for one of the buttresses of the south apse of the cathedral, but when it was almost finished, a statement said that a suitable place had still to be found for it. The character of the statue had changed in the course of Michelangelo's work, and instead of a structural sculpture in the medieval sense the cathedral found itself with a free-standing statue of classical type. At the request of the Operai and the Arte della Lana (Weavers' Guild) a commission of some thirty men met to decide the issue,[12] but since they could not agree, the Grand Council intervened and decreed, for political motives, that the statue should stand in the square in front of the Palazzo Vecchio (a similar political consideration was involved in the question of Donatello's *David* in 1416). 'As David had defended his people, guiding and ruling them with justice, so also the guardians of Florence shall defend their city and rule it justly.'[13] The plinth was designed by Simone del Pollaiuolo and Antonio da Sangallo. Michelangelo's *David* is the first free-standing statue mounted on a plinth since the end of the classical age.

In 1503 Michelangelo received a second important commission in Florence when the elders of the Arte della Lana requested him to do a set of statues of the Twelve Apostles in white Carrara marble, each between nine and ten feet tall, for the piers supporting the cathedral

dome.[14] One statue was supposed to be completed each year, but for some reason Michelangelo did not take up the commission, and in 1505, when he had already moved to Rome, it was withdrawn, 'since the Apostles have not yet been carved, and there appears little prospect that they ever will be'.[15] Michelangelo did, however, make a start on the figure of St Matthew the year after.

Michelangelo's final major commission during this period was for a battle painting for the assembly hall of the Grand Council in the Palazzo Vecchio. This led to a contest between the young Michelangelo and Leonardo, who was over twenty years his senior.

After the expulsion of the Medici in 1494 a popular government had seized power and, taking their lead from the Sala del Gran Consiglio in the Doges' Palace in Venice, had built a large hall in an annexe on the east side of the Palazzo Vecchio to serve as their council chamber. The building itself was finished in 1498 and the decoration of the interior begun in 1502 (the present building is a reconstruction by Vasari, dating from 1560[16]). Round all four walls ran a gallery with two rows of seats and a balustrade (Fig. a), and in the centre of the hall there were benches for the citizens. The altar was at the west end and the altar-piece was commissioned first from Filippino Lippi, then, after Lippi's death, from

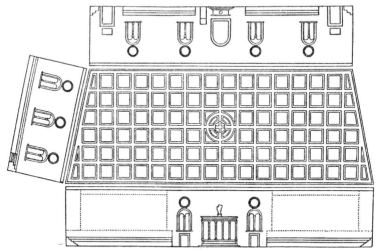

a Sala del Gran Consiglio. Florence, Palazzo Vecchio. After Johannes Wilde.

Fra Bartolomeo. The *gonfaloniere* and the elders sat between the two doors in the east wall. It was planned to have a lifesize marble statue of the Redeemer, shown as King of Florence, on the lintel above the *gonfaloniere*'s seat, to be executed by Andrea Sansovino, but whether the work was ever carried out we do not know. Fra Bartolomeo's *Virgin and Child with St Anne* for the altar-piece (now in St Mark's in Florence) could not be finished because of the collapse of the popular government.

Leonardo and Michelangelo were commissioned to decorate the east wall on either side of the *gonfaloniere*'s seat: the former was to paint the section on the right, the latter that on the left. These were enormous areas – some twenty foot high by over fifty foot wide – such as Italian artists had not confronted since the day of Guariento's *Paradise* in the Sala del Gran Consiglio in the Doges' Palace, and which were not to be found again until Raphael's Sala di Costantino in the Vatican.

Leonardo received his commission in 1503 and started on the cartoon the following spring. We do not know when the authorities approached Michelangelo, but we do know that he started work on the cartoon nine months after Leonardo. Neither work got beyond the preparatory stages. In 1505 Leonardo started work on the wall itself but the follow-ing year he requested three months' leave to go to Milan, and never returned. The part of the painting he had done – the so-called *Battle of the Standard* – was destroyed during Vasari's reconstruction work.

Michelangelo's work was interrupted by his summons to Rome. He completed the cartoon, which was completely destroyed in the seven-teenth century, but did no work on the wall itself.[17] It is, in fact, strange that he should ever have received the commission, for he had as yet executed no large-scale mural. But it must have been known that he was equal to such a task, and there is nothing to suggest that, as with the ceiling of the Sistine Chapel, he tried to avoid it. On the contrary, it directed his activity into a path that was to become of the greatest significance, for without this painting there would have been no Sistine ceiling and no *Last Judgement*.

The scene planned for the complete mural was closely connected with the political events of the time and intended not only as a glorifica-tion of the state of Florence and her citizens but also as a reminder of the challenge facing the present. Thus two subjects were chosen which

31

were relevant to the contemporary struggle of Florence against Pisa – the Battle of Anghiari (1441) and the Battle of Cascina (1364).

Our knowledge of how the completed work would have appeared rests solely on copies and sketches. But do these copies represent the whole or only parts? Instead of the Battle of Anghiari did Leonardo perhaps plan only the *Battle of the Standard*, and instead of the Battle of Cascina did Michelangelo design simply a scene depicting the raising of the alarm by the side of the River Arno? The dimensions alone make this latter notion untenable,[18] so do general historical considerations, for however freely and independently the great artists of the Renaissance treated tradition, they did respect the subjects they were set, showing their originality in their efforts to reveal more fully the true significance of those subjects. To regard the surviving copies as more than partial sketches would be to ignore the conditions under which these artists worked, and to pretend that they would have made free with the terms of the official commission they had received.

The most reliable starting-point, if one wishes to reconstruct Michelangelo's fresco, is a small grisaille discovered by Fuseli at Holkham Hall in Norfolk, which is either the original grisaille or a copy of it made by Bastiano da Sangallo in 1542 at Vasari's instigation (Pl. 8).[19] If this were a copy of the whole work, Michelangelo could only have depicted the prelude to the battle, in the shape of the call to arms of the soldiers bathing in the Arno, an animated group of figures, most of them naked; and in this case we would have to conclude that Michelangelo, who sought to portray every subject at the height of its vitality, had made a grotesque attempt to turn a genre painting into a work of monumental proportions. That this scene, though a principal motif in the whole painting, is not complete in itself is clear from Vasari's description of the cartoon, where he refers to 'innumerable figures on horseback charging into battle'.[20]

There is a close description of the battle in Filippo Villani's *Chronicle*.[21] The day before the Pisan attack on the Florentine camp at Cascina, the victor of the Battle of Leghorn, Manno Donati, raised a false alarm in order to impress on the Florentine General Galeotto Malatesta, who was suffering from a fever, the poor state of preparedness and discipline in the camp. Exhausted by the heat, the soldiers had

stripped off their armour and were bathing, lying in the sun or other-wise relaxing; the commander was sick in bed and the camp unguarded. Then Donati rushed through the camp, shouting: 'We are lost!' In this way he made them set up defences and stay on guard. The next day the Pisans charged – and Donati attacked their flank and defeated them.

The event has thus an historical foundation which belongs not to the day of the battle itself but to the day before. If this were all that Michel-angelo had portrayed, the grisaille in Holkham would need no addition. Can one believe, however, that for this official civic commission he would only have depicted the prelude to the battle, with its far from flattering presentation of the Florentines' valour and discipline, and not the battle itself?

It seems more likely that, freely interpreting the elements of the story, he turned the false alarm of the day before into a genuine alarm on the day of the actual fight, thereby forging a motivational link between the bathing scene and the battle and introducing a moment both of intensification and of contrast. 'The bathing motif', wrote Goethe, 'is a powerful symbol of enervation, standing in contrast to the acts of violence which the soldiers are about to be called upon to per-form.'[22] It is as though, in one bold stroke, Michelangelo had fused various historical moments into one, thus transcending the battle-subject in its traditional form. We must therefore conclude that the bathing-scene needs to be followed by other motifs, chiefly towards the right-hand side. We recall Vasari's 'innumerable figures on horseback charging into battle'.

The grisaille allows us to imagine something of the artistic character of the work. The bathers form a tightly knit group, with the three figures on the left making up a triangle, and another group of three figures, diagonally above them to the right, drawing our attention to the right of the picture and to its planned continuation. The centre is occupied by a man with a headband, but he does not dominate the scene. The individual groups are closely interlocked and set against the back-ground as in a relief, recalling the *Battle of the Centaurs*. As in this early work fighting and plundering were manifestations of the vitality of life, so now also the call to arms is shown, not simply as an event at one particular moment, but as representative of the vital forces of life itself.

The attractive freedom of the earlier work has, however, been lost, and the treatment of the human body, whether in motion or in repose, has an air of artificiality and virtuosity about it, for all that it surpasses everything that had gone before. It was with the Sistine ceiling that Michelangelo was to transcend this virtuosity and discover the powers which were the expression of his innermost nature.

Since both Leonardo's and Michelangelo's pieces for the Gran Consiglio remained unfinished, all trace of the originals lost and their reconstruction uncertain, we cannot pass judgement on the contest between the two men, but it is certain that the differences between their personalities and their contrasted gifts would have clearly emerged. From Leonardo we would have expected a bold, sweeping conception in pictorial terms, possibly at the cost of the attention given to plasticity of detail; Michelangelo, on the other hand, would have given us 'a dazzling display of his knowledge and power',[23] as though to make us suspicious of his opponent. For Leonardo this mural followed the *Last Supper* and the cartoon of *St Anne*, works of his maturity; Michelangelo was still following in Leonardo's footsteps, seeking to emulate his principles of composition but not yet able to exploit them with complete freedom. Yet in his re-creation of the story behind the painting he would have been not merely Leonardo's equal but his master.

Michelangelo's artistic rivalry with Leonardo is also reflected in the tondi of the Virgin Mary which he did at this period. The first of these is the unfinished *Taddei Tondo*, a marble relief now in the Royal Academy (Pl. 9).[24] The seated Madonna is portrayed in a relaxed pose leaning against a rock, while the child Jesus, frightened by the fluttering wings of the little bird which the young John the Baptist is holding, seeks the protection of His mother's arms. She comforts him lovingly but turns at the same time towards John and strokes his cheek. The marble has been left quite unpolished, and the hachure lines are everywhere clearly visible.

No other work of Michelangelo's is so serene, so idyllic, even graceful. Yet at the same time there is an unmistakably sinister overtone in the Child's frightened expression. The presence of Leonardo can be felt in the delicacy with which the composition as a whole has been conceived.

At the end of the year 1503 or the beginning of 1504 Michelangelo

painted a tondo of the Holy Family (*Doni Tondo*) for the wedding of Angelo Doni and Maddalena Strozzi (Florence, Uffizi, Pl. 10).[25] This is the only authentic panel painting of his we possess. Mary is seated on the grass, a book in her lap, and turns to take the Child from Joseph, who is sitting behind her. Naked youths are in the background, and the young St John is moving away behind a wall which separates foreground from background. The frame[26] consists of carved medallions of Christ, two prophets and two sibyls, between which runs a decorative frieze, with the heads of Pan and of open-mouthed satyrs, together with various fabled beasts. These medallions may be the work of Baccio da Montelupo.

Michelangelo's tondo is related to that by Luca Signorelli in the Uffizi, and we can detect Signorelli's influence right down to Michelangelo's late works. The tondo form, the motifs of the barefoot Virgin in full figure and of the ignudi in the background are all found in Signorelli, and the ideas conveyed in the two pictures are similar. Moreover the motif of the Christ-child already presages the subject of the passion. In Signorelli's picture Mary is teaching her Child to walk and seems already to know that these first steps will lead to the crucifixion – *Ecce agnus Dei*; in Michelangelo's it is St John who is going away. The motif of boys at play, as in the *Taddei Tondo*, has gone, and Joseph is anxiously watching the Child's movements, while Mary, in Vasari's words, 'gazes rapturously upon the beauty of her Son'.[27] Jesus is looking down at His mother. The ignudi, like those of the Sistine ceiling, represent only incidental moments of free, poetic invention, as with Signorelli.

Artistically Michelangelo's method is quite different from Signorelli's, in that the central figures are not merged with the landscape but boldly superimposed upon it, and the strict manner in which the formal elements are integrated removes any suggestion of the casual or the contingent such as we find in Signorelli. The torsos have a heroic quality – Joseph is like a Greek philosopher, Mary, her arms bare for the first time in the history of art, is a classical heroine, and even the Child Jesus has the body of a young Hercules.

Artists of such a cast of mind, said Burckhardt in his *Cicerone*,[28] ought to give up painting pictures of the Holy Family. And in Justi's view: 'An idyll of family happiness has been turned into an exercise in

gymnastics.'[29] How can one explain the frightening artificiality of the composition?

Again we see Michelangelo in rivalry with Leonardo, seeking to emulate the latter's *Virgin and Child with St Anne* and achieve, in a quite different subject, the same blend of movement in the particular with repose and self-containedness in the whole. However, one must observe that the attempt is not without its elements of distortion and imprecision – Mary's right arm is too long, Joseph's right leg is not properly executed and there is a vagueness about his right arm. As in *The Battle of Cascina*, Michelangelo sets pictorial brilliance against precise draughtsmanship, and his emphasis on plastic values again seems to imply a criticism of Leonardo. There is no chiaroscuro, no creation of atmosphere, but bright, translucent tempera colours with soft shadows, one next to the other, yellow contrasting with crimson, a brilliant bright blue with brown-green and blue-grey. The flesh is painted in tones of bronze, the plastic form of the whole is set against the light in order to intensify the outlines, and the surrounding landscape – the grey and brown of the ground, the flesh of the naked youths, the bright green and blue of the background – seems to pick up and repeat the colours of the central composition.[30]

Did Michelangelo achieve a victory here over Leonardo? That fusion of freedom and necessity which characterizes Leonardo's compositions also defines the content of his pictures. Idea and form are one. Michelangelo, however, approached Leonardo's art essentially from the point of view of composition, and his tondo lacks the inner unity of Leonardo's work. Indeed, he was in danger of falling victim to formalism, and one needs to appreciate the nature of this danger in order to understand his achievement in the great Sistine ceiling.

The unfinished *Pitti Tondo* (Florence, Museo Nazionale, Pl. 11) is the most mature of this group of Madonna tondi. In it the degree of plasticity increases from John to Jesus, and from Jesus to Mary. Yet for all its plastic quality, the head of the Virgin is still held fast to the background surface. The artificiality of the *Doni Tondo* has been left behind, and the Virgin's proud, noble expression anticipates the figures of the sibyls in the Sistine ceiling. The Christ-child is like a classical spirit of death – again the Passion stretches out its shadow towards us.

Part II
Years of Maturity 1505-1534

Rome – Florence – Bologna 1505-1508

First design for the tomb of Julius II – *St Matthew*

In March 1505 Cardinal Giuliano della Rovere, who had become Pope Julius II in 1503, invited Michelangelo to Rome, probably at the suggestion of his architect, Giuliano da Sangallo, who had known Michelangelo in Florence.[1] Julius certainly knew Michelangelo's *Pietà*, and this invitation from the *pontifice terribile*[2] – now a man of sixty-two but with a close affinity to Michelangelo's own nature, both when they agreed and disagreed – opened new avenues of promise. The relationship between the two men was to become an intensely personal one.

The Pope's written commission of March 1505 for Michelangelo to carve his tomb has not been preserved, but we know that the fee was to be 10,000 ducats[3] and that the work was to be completed in five years. Michelangelo must have started on his design immediately and quickly reached the point at which the marble could be ordered.[4] In April he went via Florence to Carrara, and the following January the first blocks arrived in Rome. He set up a workshop by the piazza of St Peter's, engaged apprentices and workmen and started on his task, working in the first place, presumably, on individual parts of the masonry. The Pope took great interest in the work and even had a gangplank laid across to the workshop so that he could watch Michelangelo unobserved.[5]

But suddenly, to judge from Michelangelo's own remarks, Julius seems to have ordered work to be suspended. On a number of occasions he refused to see Michelangelo, who, 'in a feeling of desperation',[6] threw down his tools and fled to Florence – the second such flight in his life. This was the beginning of what Condivi calls 'the tragedy of the papal tomb'.[7]

The date of his flight was 17 April 1506. The following day the Pope laid the foundation-stone of New St Peter's.[8]

The first design for the tomb can be reconstructed from Condivi's and Vasari's descriptions, from later, small-scale sketches and from the greatly reduced piece as it now stands in S. Pietro in Vincoli (Fig. b). The massive work, consisting of an upper and a lower storey, would have been some thirty-five foot long and twenty-two foot wide;[9] the lower storey would have been about eleven foot high.[10]

The four sides of the lower storey have a regular pattern of niches alternating with pilasters crowned with herms;[11] in the niches are female figures with men at their feet, and on pedestals between the niches are nude male figures bound to the pilasters. The oval burial chamber in the centre is accessible from the middle of the front and rear

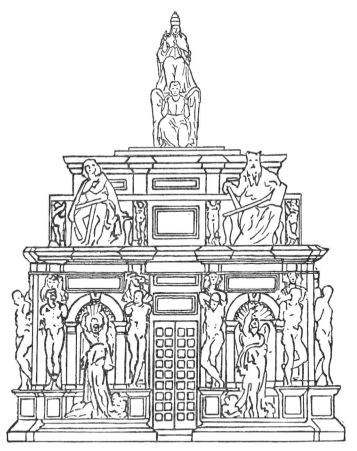

b Pope Julius's tomb. Design of 1505. Reconstruction.

walls. These features can be seen from two drawings, the one formerly in Berlin but destroyed by fire during World War II (Pl. 12), the other in Florence, which, though actually reproductions of Michelangelo's design of 1513, appear to retain the basic features of the lower storey as it was in 1505.[12] They also show the outlines of the figures in the niches and in front of the pilasters. The only parts to be completed were a few pieces of the ornamental masonry, and these eventually found their way into the work as it now stands.[13]

These sources do not, unfortunately, reveal Michelangelo's iconographical programme. Vasari calls the figures in the niches 'naked symbols of victory (*victoriae*) with their captives' – though the sketches show the figures as clothed – and the captives in front of the herms he calls 'provinces'.[14] Condivi, on the other hand, makes no reference to the figures in the niches but sees the captives as the arts – 'painting, sculpture and architecture, each with its distinguishing characteristic'. 'Michelangelo's intention', continues Condivi, 'was to portray all these gifts as having perished with the Pope, since never again would they find a man who would encourage and sustain them as he had done'.[15] Condivi's account, incomplete though it is, appears on the face of it the more credible of the two.

Michelangelo's plan seems to have been stimulated by Antonio Pollaiuolo's tomb of Pope Sixtus IV, Julius's uncle, in St Peter's, where the sarcophagus contains representations of the arts and sciences as well as of the virtues.[16] If this is so, Michelangelo was evidently seeking new forms through which to rival antiquity, for the *artes liberales* had never before been presented as male nudes. That the captives should be bound – a motif for which Condivi and Vasari can find only very artificial explanations – is a new feature for a tomb. Similarly in his portrayal of the virtues – as we may assume them to be from Sixtus's tomb – he has departed from tradition and used classical motifs in the medieval subject of the struggle between the virtues and the vices.

The uncertainty shown by Condivi and Vasari in interpreting this scene stems from the strangeness of Michelangelo's figures. But there may also be another reason. Could his original intention of following the programme of Sixtus's tomb have been diverted by a new idea? The fact that the figures of the virtues alone have been replaced by the fight

between the virtues and the vices suggests that, in its final form, the scene would not merely have related to the person of Julius himself, as with the tomb of Sixtus, but had a general symbolic meaning. Likewise Condivi's interpretation of the arts and sciences which have perished with the Pope who patronized them may only be relevant to Michelangelo's initial idea, whereas eventually they became allegories of human bondage, rather like the figures on Antonio Federighi's font in Siena Cathedral, which Michelangelo must have known. An allegorical presentation of human bondage before Redemption would have been an appropriate subject for a work whose upper storey was to embody the higher world of grace.

Our only sources of information about this upper storey are Condivi and Vasari. Condivi says:

> Above the figures of the lower storey a cornice ran round all four sides of the tomb, on which stood four large statues, one of which – that of Moses – can be seen in S. Piero ad Vincula. The tomb rose above this cornice, and on the top were two angels bearing a sarcophagus: one appeared to be smiling, as though rejoicing that the Pope's soul had been received into the company of the blessed; the other seemed to be weeping, as if lamenting the loss to the world of such a great man.[17]

As well as the statue of Moses Vasari tells us that there were statues of St Paul, and of the *vita activa* and the *vita contemplativa*:

> The tomb rose above the cornice in gradually diminishing steps, with a decorated bronze frieze and other figures, putti and ornaments all round. At the summit, completing the structure, were two figures, one of them Heaven, smiling and supporting a bier on her shoulder, the other Cybele, goddess of the Earth, also bearing the bier, but appearing to be grief-stricken at having to remain in a world robbed of all virtue through the death of so great a man, while Heaven rejoiced that his soul had passed over into celestial glory.[18]

We cannot know exactly to what extent these accounts by Condivi and Vasari represent a transference of their impressions of later designs to the first project of 1505. The names of the four seated figures cannot

42

therefore be taken as definite at this stage. At the same time it seems certain that the figures were meant to represent a higher world than those of the lower storey, namely the world of grace and of redemption through the Word of God.

As to the sarcophagus or bier with the angels, the admittedly vague information Vasari and Condivi give may well be true.[19] An effigy of the deceased must have been set on this sarcophagus; the only question is whether it was seated or recumbent (as provided for in the contract of 1513). The word *bara*, 'bier', used by Vasari could, according to Erwin Panofsky, also mean *sella gestatoria* or 'litter' in the sixteenth century.[20] If one adds to this the fact that after Michelangelo's death there was found in his workshop 'a blocked-out, unfinished statue of St Peter in papal robes' – a work that was later turned into a seated figure of St Gregory which is today to be seen in the Oratorio di S. Barbara in the church of S. Gregorio Magno[21] – the most reasonable assumption is that the figure on top of the tomb was seated in a litter borne by two angels.

According to Vasari, 'the beauty, splendour and artistry of the tomb would have surpassed those of the tomb of any Roman emperor.'[22] So hardly had Michelangelo arrived in Rome for the second time than he embarked afresh on a campaign to outdo the artists of antiquity, this time not through a single figure but through a whole set of figures. So high-flown, so gigantic were his plans at this time that while in Carrara, he entertained the idea of carving a Colossos out of one of the rocks that faced the sea, 'so that', says Condivi, 'the sailors could see it from afar'.[23]

Michelangelo's design of 1505 represented something quite new in the history of papal tombs.[24] There were already a number of mausolea in St Peter's, the most important of which, as far as the tomb of Julius is concerned, was the chapel of Sixtus IV in the chapel on the south side of the choir in Old St Peter's, with the Pope's sarcophagus in the centre. But Michelangelo's is the first plan for a free-standing monument, accessible from all sides, with monumental sculptured figures determining the structure.[25]

Vasari's allusion to the mausolea of Roman emperors cannot of itself afford an explanation, and one thinks rather of the traditional

conception of Christ's tomb in Jerusalem, which Michelangelo knew from Leon Battista Alberti's reconstruction in the Cappella Ruccelai in Florence[26] – though in contrast to Alberti his style is dominated by classical ideals. The contemporary Roman work closest to Michelangelo in the construction, proportions and ornamentation of the lower storey of Julius's tomb, as well as in the motif of the seated figures above and the monochrome nature of the whole work (in contrast to the bright colours used in early Renaissance tombs), is Andrea Sansovino's wall-tomb for Ascanio Sforza in S. Maria del Popolo, commissioned by Julius II in 1505.[27] At the same time the base also draws on Roman sarcophagi, such as that from the Villa Montalto-Negroni-Massimi in the Vatican,[28] with its niches, its door in the middle, and its busts above the heads of the naked figures standing on plinths around the sides. The reconstruction of the upper storey, however, is too uncertain for the question of classical models to be brought in.[29]

There does not seem to have been from the beginning any definite place for the erection of the tomb.[30] According to Condivi, Michelangelo first thought of setting it in the Rossellini Chapel in the new apse of Old St Peter's, which had been begun under Nicholas V. Giuliano da Sangallo, the chief papal architect of the time, proposed building a separate chapel outside St Peter's. Gradually, however, says Vasari, the idea of constructing a chapel turned into the plan to rebuild St Peter's itself, and this was the point at which Bramante appeared. Bramante, according to Vasari, caused a great deal of delay by his endless discussions and his intense involvement in the plan, until finally the task of reconstruction was assigned to him, whereupon nothing more was heard of the erection of Julius's tomb.

If, therefore, we are to accept Vasari's account, it was the question of the tomb for Julius that finally precipitated the decision to rebuild St Peter's, and the bold plan for a free-standing tomb that led to the equally bold conception of a basilica in the tradition of the martyry. The papal tomb would thus have become one with the tomb of St Peter himself, and Michelangelo's work would have become the central point of the cathedral.

This may be the explanation behind the change in Michelangelo's programme, for if the tomb were to be erected above the grave of St

Peter, its features could not refer exclusively to Pope Julius; the connection with the tomb of Sixtus would have had to be abandoned, and the particular converted into the universal. The crowning figure on Michelangelo's monument could then have become St Peter himself, 'in papal robes'.

Perhaps the connection between the erection of Julius's tomb and the rebuilding of St Peter's also helps to explain Michelangelo's sudden flight on the day before the foundation-stone was laid, for the building of the new cathedral could not but take precedence over the question of the papal tomb. Moreover, although Michelangelo's monument as planned would have suited Nicholas V's plans for the new cathedral, it would have been far too small for the cupola envisaged by Bramante, and when it was decided to carry out the reconstruction programme on Bramante's scale (Michelangelo's tomb may well have been Bramante's point of departure), any idea that the tomb as planned in 1505 could have become the central point of St Peter's was inevitably stultified. This would explain Michelangelo's lifelong hatred of Bramante. 'All the differences that arose between Pope Julius and me', he wrote in 1542, 'were caused by the jealousy of Bramante and Raphael, and this was why the Pope's tomb was never completed – just to ruin me.'[31] But Raphael was not in Rome at this time.

When the Pope saw himself compelled to postpone the tomb in favour of the new cathedral, he found another task for Michelangelo, namely to paint the ceiling of the Sistine Chapel. But here also the two men seem to have had differences of opinion. 'Michelangelo said more than once', wrote Pietro Rosselli, 'that he had no intention of painting the ceiling, and that although Your Holiness wanted to impose the task upon him, he would not undertake any other work than the tomb.'[32] Even threats did not at first succeed in making him return to Rome, and he sent a message to the Pope complaining that the faithful service he had rendered was being poorly rewarded by his being driven away from Rome like a criminal, and that since His Holiness had no further interest in the tomb, he, Michelangelo, considered himself relieved of his obligations and did not feel like undertaking any others.[33]

Michelangelo stayed in Florence until November 1506, and appears during this time to have taken up the work again for the Gran Consiglio,

completing the cartoon of *The Battle of Cascina*. He also started his *St Matthew* (Florence, Accademia, Pl. 13), one of the set of twelve apostles commissioned for the Duomo by the Arte della Lana. This undertaking may have been something of a compensation to him for the abandoned tomb of Julius, affording an outlet for his pent-up creative energies; the figure of *St Matthew*, indeed, has reminiscences of the bound figures we know from drawings of the tomb. But in November 1506 he stopped work on the project to go to Bologna, where the Signoria had sent him – 'with the noose round his neck', as he put it[34] – to make his apologies to the Pope. He was back in Florence in March 1508, but in the same, or possibly the following, month he was summoned to Rome again; the apostles for the Duomo were commissioned from other artists in the course of the following years,[35] and the unfinished *St Matthew* was all that Michelangelo contributed to the set.

There is a drawing in the British Museum (Dussler No. 170)[36] which gives a first idea of certain of the apostles, including Matthew, and shows that Michelangelo followed the classical tradition of statues of orators and philosophers as embodied in the figures of apostles and saints in Or San Michele and in the campanile in Florence – the tradition represented, for example, in Donatello's *St Mark*. This drawing was apparently made before Michelangelo went to Rome in 1504; the figure has a natural, easy movement and is completely self-contained.

As to the sculpture, it follows the sketch except for the right arm, but the manner of execution is quite different. Here for the first time, as he had sought to do in the figures of the captives for Julius's tomb, he passes beyond the stage of classical imitation which still in part characterizes his *David*. The shape of the block now determines the contours and restricts the figure's freedom of movement, making it either conform to the nature of the block or resist it, and the view becomes strictly frontal. What it has lost in natural freedom it has gained in spiritual expression, and its immense energy seems to spend itself in an agonized struggle against the bonds that hold it.

The fact that the statue is unfinished enables us to examine more closely Michelangelo's mode of working, as Vasari and Benvenuto Cellini have described it.[37] The parallel grooves made by the pointed chisel bring life to the dead marble, and even the roughly carved parts

46

are full of character. At a later stage the gradine would have been used, its 'mysterious halftones'[38] resembling the hachures in a drawing.

The figure is half-embedded in the block, the back of which is still intact. The curve of the left thigh is fully formed, while the lower part of the right leg is only hinted at. The feet, in Friedrich Kriegbaum's phrase, 'stand as though in thick mire',[39] while Justi compares the figure to 'a miner edging his way painfully forwards through the clinging earth'[40] – applying to the world of Michelangelo the language of the world of Meunier (a trait revealing both of Justi himself and of his age). And as Michelangelo worked his way layer by layer into the stone, we see that it was not the line of the body or any such organic conception that was the primary consideration but the nature of the block itself, with its straight sides imposing their character on the work.

All Michelangelo's statues are characterized by the dichotomy between restriction and freedom. His *Bacchus* had challenged the freedom of the classical sculpted figure, although at that time the subject still asserted itself over the underlying spiritual conflict. In his *David* the dichotomy is between the Gothic technique of making one side of the figure fast and developing the dynamic qualities of the other side, and the overwhelming power conveyed by the tension of the head. In his *St Matthew* it emerges openly for the first time as the true inner subject of the work, quite unrelated to the person of the saint himself. Michelangelo's figures do not express natural freedom: they are held in captivity, prisoners of a destiny against which they rebel or to which they sadly submit. The tangible presence of the block, from *St Matthew* onwards, acts as a kind of all-encompassing world, and it is to this world, not ours, that his figures belong.

Michelangelo's efforts were constantly directed towards recreating for his own age the independent classical carved figure which had been subjected to the demands of architecture in the Middle Ages and had only begun to reassert itself in the early Renaissance. His *Bacchus* was conceived as just such an independent figure, and his *David* is the first statue since the end of classical times to stand free on its own plinth. His *St Matthew* too has this new spirit of freedom. Yet antiquity is now no longer a goal in itself but a stage in development. The importance of the block, together with the unidimensional emphasis, harks back to the

Middle Ages, and these features acquire ever greater importance in his later works.

In January 1506 the *Laocoon* group was discovered in Rome near the Baths of Titus.[41] Michelangelo went to see the statue immediately after his return from Carrara, before starting work on Pope Julius's tomb, and greatly admired it. His *St Matthew* is the first work to show the marks of the encounter. Another influence present is that of the antique *Pasquino*, an influence evidenced by the figure of Menelaus with his head turned to one side, by the more erect posture of the torso than would originally be expected and by the folds of the garment.[42]

Equally important, however, is the renewed influence of Donatello. The tension between static outline and inner movement in *St Matthew* recalls Donatello's *The Sacrifice of Isaac* on the east side of the campanile:[43] Abraham hearkens to the voice of God, and it is also from this motif that Michelangelo's *St Matthew* draws its spiritual power.

While in Bologna Michelangelo received a commission from Pope Julius to make a seated effigy of him in bronze for the porch of S. Petronio. The figure, over twelve foot high, was erected in February 1508 but destroyed in December of that year by the citizens of the town[44] and replaced by a figure of God the Father with the inscription: 'Scitote quoniam Deus ipse est Dominus' ('Know that God himself is the Lord'). This figure, of which we can gain an impression from a drawing by Bandinelli,[45] anticipates the prophet Daniel in the Sistine ceiling. Indeed, the world to which the ceiling belongs was already taking shape during this period in Bologna, as is seen also from the further influence of Quercia's Old Testament reliefs – Michelangelo's second encounter with this fifteenth-century master.

Chapter 5
Rome 1508-1512

The Sistine ceiling

In the spring of 1508 Michelangelo was again summoned to Rome – to learn with bitter disappointment that the Sistine ceiling was now to take the place of the tomb for Julius. This disappointment can still be felt in Condivi's account of this change in the course of events, for here we read that, after finishing his bronze of the Pope in Bologna, Michelangelo

> went to Rome, where Julius, who, determined not to proceed with the tomb but yet to use Michelangelo in some way, was persuaded by Bramante and other rivals of Michelangelo to have him paint the ceiling of the chapel of Pope Sixtus IV . . . leading the Pope to believe that the result would be superb. This they did out of malice, so as to distract the Pope's attention from sculptural projects, and because they were convinced either that Michelangelo would not accept the commission, in which case he would bring down the Pope's wrath upon his head, or that, if he did accept it, he would be far less successful than Raphael, whose every virtue they extolled out of antipathy towards Michelangelo.[1]

There is no better description of Michelangelo's state of mind at the beginning of this third stay in Rome than that given by Carl Justi:

> At the height of his power as a sculptor Michelangelo, then a man of thirty, had plunged into the work of planning, together with the Pope, this gigantic plan for the papal mausoleum, which was to include, it was said, some forty statues. Now he was suddenly told to stop. This was a blow that would have shaken the maturest of men. He took flight, refusing to return unless he were allowed to resume the work. Yet he did return, and consented to undertake this new

49

task, which was not, he said, 'his real art'. Then suddenly his resent-ment turned into a fever of activity. The man who had angrily sub-mitted to a despot's will now found the scope too small for what he sought to offer to the Pope and to the world. A glance at the sketches for the papal tomb gives us the key to the remarkable *volte-face*. His profuse ideas now find expression in new forms, and his creative imagination is transformed. Very well, he seems to say, if you want to force me to become a painter, I will paint you a chapel of marble figures according to my own taste. And taking the mass of statues of which they had deprived him, he transferred them to the ceiling.[2]

The Sistine Chapel, standing north of St Peter's, was built by Pope Sixtus IV della Rovere between 1475 and 1481 as a ceremonial papal chapel and dedicated on 9 August 1483 to the Assumption of the Virgin Mary. The simple rectangular building is of brick, with cornices and window-frames of travertine. The chapel itself occupied the middle floor, with the comptroller's quarters below and those of the papal guard above. The roof was originally crenellated.[3]

Like St Peter's, the chapel is entered from the east, with the altar at the west end (Pl. 14). The only division is that of the chancel from the nave, where there is a marble screen which was originally some sixteen foot nearer to the altar than it is today. The beautiful coloured stone floor reveals further subdivisions: the nave has a large circular pattern; a step then leads to the cardinals' precinct, and four further steps to the sanctuary, with the papal throne on the left. A marble bench runs round all four walls, and on the right behind the screen is the *cantoria*, sur-rounded by a delicate marble balustrade (originally this was partly behind and partly in front of the screen).

The side walls, which were intended from the beginning to be deco-rated, are divided horizontally by three cornices and vertically by seven pilasters in each of the three storeys. The middle cornice is the most prominent and serves as a gallery. The flattened vault of the ceiling rests on the uppermost cornice, and the arched windows reach up above this cornice into the lunette zone.

In the years that separated the completion of the chapel from its dedi-cation the most famous Florentine and Umbrian artists of the day were

commissioned to paint the walls with scenes from the Christian tradition. Tapestries (later including Raphael's) were hung in the lower part, historical scenes from the Old and New Testaments were painted in the middle, and full-length portraits of the Popes filled the areas between the windows. The lunettes and spandrels were at first left empty. The ceiling, to judge from a sketch by Pier Matteo d'Amelia,[4] appears to have been made into a blue sky with golden stars.

The nature of the decoration was determined by the fact that the chapel was planned as a papal sanctuary.[5] The historical scenes portray, through the juxtaposition of the *tempus legis* and the *tempus gratiae*, the Pope's power as teacher, priest and ruler. Moses and Jesus are depicted as the Pope's antecedents. The most important of the Old Testament scenes is *Moses receiving the Ten Commandments*, while for the New Testament it is the *Sermon on the Mount* together with the *Cleansing of the Leper*. The first pictures in this cycle – the *Discovery of Moses* and the *Birth of Christ* – were subsequently obliterated by Michelangelo when he painted his *Last Judgement* on the wall behind the altar. The portraits of the Popes consist of twenty martyrs, from Clement I to Marcellus I, who were later canonized and are here arrayed as the present incumbent's noble forebears; it seems as though the sequence started on the wall behind the altar with the figures of Peter and Linus on either side of Christ,[6] but these also vanished when Michelangelo came to embark on his *Last Judgement*. A similar fate befell Perugino's fresco of the Assumption of the Virgin Mary – the only point at which the dedication of the chapel was made explicit.

The decoration of the chapel had not been completed by the time of its dedication in 1483. Whether scenes had been planned for the lunettes and spandrels but not yet executed, or whether no definite plans had yet been made, we do not know, but at all events these areas were left empty.

Michelangelo started his preliminary work in May 1508[7] and took until the end of July to set up his scaffolding and prepare the surface. From then until September he was making sketches, cartoons and studies. Then his assistants arrived from Florence. Whether, as Condivi and Vasari say, he sent them all home again, is doubtful, for it seems that he received help on the constructional framework and certain subsidiary

sections of the work.[8] Nevertheless the bulk of the work was done by him alone.

In January 1509 he began work on the ceiling (Fig. c) – not, however, in historical sequence but, as Anton Raffael Mengs has observed,[9] at the east end, above the entrance. Having overcome such initial difficulties

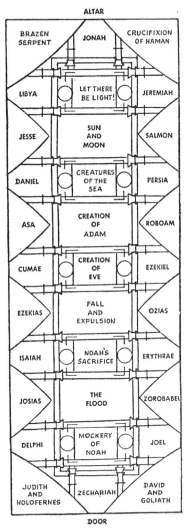

c Sistine ceiling. Rome, Vatican. Plan.

as dealing with the mould that had formed on some of the paintings already started, and familiarizing himself with what was to him the new technique of fresco painting, he went quickly to work. By the autumn of that year the first half was finished, and by the end of the following August the whole ceiling was complete except for the lunettes.

Then came an interval of about a year. Twice he had to visit the Pope, who had gone to Bologna, to ask for more money. Then on 14 August 1511, after the Pope had returned to Rome – it was the day before the feast of the Assumption – there was a kind of unveiling ceremony, and immediately afterwards Michelangelo must have started work on the lunettes. The finished chapel was opened on 31 October 1512.[10]

The story of how Michelangelo came to receive this commission remains a mystery. The contract has not survived, and our sole source of information is a passage in a letter of December 1523 to Giovanfrancesco Fattucci, where Michelangelo writes:

> The first project was for the twelve apostles in the lunettes, together with an arrangement of panels filled with decorations in the usual manner. But after I had started, this seemed to me a poor idea, and I told the Pope that, if I were to do only the apostles, the result would be very poor. He asked why. I said, because the apostles themselves were poor. Whereupon he charged me to do what I liked, saying that he would see that I was satisfied, and telling me to continue my paintings downwards to include the historical pictures.[11]

Another version of this letter does not mention the apostles but only the plan for the decorations and 'a few figures';[12] however, after the reference to 'doing what he liked' there occurs here the phrase 'which amounted to about the same quantity again'.

At the time he wrote this letter Michelangelo was under pressure from the family of the late Julius II, and wanted to prove that what had started as a small project had been extended at his own initiative. It cannot, therefore, be taken as an absolutely objective statement. It also contains inaccuracies – 'lunettes' for 'spandrels', and 'historical pictures' for 'Popes'. We may, however, assume that the commission did involve the painting of the whole ceiling and not merely the completion

of the fifteenth-century paintings in the lunettes and spandrels, and that the original plan was in fact extended, probably at Michelangelo's petition. But this does not mean that one can interpret 'doing what he liked' in the free, modern sense of the phrase.

There is a sketch in the British Museum (Dussler No. 163)[13] which shows *inter alia* a section of the ceiling above one of the spandrels (Fig. d). There is a figure seated on a throne, with vaulted arches on either side; the upper part of the throne has two pilasters, in front of which stand two winged spirits, and two volutes. Above the throne is a diamond panel, the corners of which merge into medallions; on either side is a square enclosing a sphere, and above it a rectangle.

Since Wölfflin[14] it has been customary to regard this sketch as part of

d Sistine ceiling. Rome, Vatican. Plan of first design
(after Erwin Panofsky).

the first plan mentioned by Michelangelo in his letter to Fattucci. But does it follow that the middle of the ceiling was intended to be left free? And would it not have been strange to choose Michelangelo to carry out so elaborately ornamental a project? We know from the letter of Pietro Rosselli already mentioned that, after Michelangelo had fled from Rome in May 1506, Bramante said to the Pope apropos the Sistine ceiling that 'Michelangelo lacked confidence, for he had had little experience of painting figures, especially on a ceiling and foreshortened: this is something quite different from painting at ground level.'[15] So in 1506 there already appears to have been talk of a plan which involved more figures than just those of the twelve apostles. The same conclusion is suggested by Michelangelo's statement to Fattucci that the project eventually amounted to about twice the original plan. And indeed, the historical scenes on the ceiling, the prophets and sibyls, and the panels with the ancestors of Christ would add up to far more than twice the ornamental design together with the twelve apostles.

Around 1480 excavations uncovered Nero's *Domus aurea*.[16] Its ceiling – the so-called *Volta dorata* – inspired the ceilings of the Appartamenti Borgia in the Vatican (Sala del Credo and Sala delle Sibille), of the cathedral library in Siena and of the chancel of S. Maria del Popolo in Rome, to name only the most important. Like the *Volta dorata*, some of these ceilings have figures within the ornamental framework: for instance, in that of S. Maria del Popolo, commissioned by Julius II, the coronation of Mary is portrayed, together with evangelists and sibyls.[17] Michelangelo's phrase 'in the usual manner' may be an abbreviated way of referring to familiar patterns of this kind, in which case one would have to conclude that such figures need to be added to complete the ornamental frame shown in the British Museum sketch. Moreover the original pattern may well have been that which was eventually carried out, and this would match Bramante's statement about the figures as they appeared from ground-level.

The same may also be true of the sides, as well as of the spandrels and lunettes. That Michelangelo later refers to the twelve apostles instead of to the prophets and the sibyls may be an error, and his explanation of 'a poor idea' can scarcely be taken seriously. When the Pope later asked him to enrich the ceiling with gold and other colours, he in fact defended

its 'poverty', according to Vasari: 'Holy Father, people did not adorn themselves with gold in those days, and the men portrayed here were not rich citizens but saints, because they renounced all splendour'.[18]

Edgar Wind[19] and Frederick Hartt[20] have put forward two different ideas about Michelangelo's first design. Wind interprets the British Museum sketch as a diagram illustrating the Stem of Jesse, while Hartt suggests that it is a diagram of the Tree of Life, with the apostles as mystical branches. Both theories presuppose an extensive theological programme[21] but fail to take seriously enough the consideration that the decorative pattern of the British Museum sketch, which was not completely given up even later, stands in the tradition of the recently discovered classical models. Perhaps we should see Michelangelo's first design rather as a classicistic pattern of the then fashionable type, with which the figures found in the work as it later became could have been amalgamated.

If this is so, 'doing what he liked' would refer not to the substance but to the form; which is to say, Michelangelo would have succeeded in being allowed to carry out the commission in his own way. One will look in vain in the sixteenth century for another case where the decision about so important an undertaking in so prominent a place was left to the whim and fancy of the artist himself.

In a variant of the first design in Detroit (Dussler No. 5, Fig. e)[22] the decorative tracery gives way to a symmetrical alternation of large and small panels with the wall linked to the ceiling by means of transverse ribs leading upwards from the pilasters. The influence of the classical ceiling begins to recede and be replaced by the medieval preference for making the structural principles visible. The medallions and the ignudi also begin to look more like their finished form, and only the octagonal panels were later changed. There is no question here of the Stem of Jesse or the Tree of Life, although the figures may be assumed to be the same here as they were later.[23]

'Anyone who has not seen the Sistine Chapel can have no real idea of what a single mind can achieve,' wrote Goethe from Rome.[24] And indeed the Sistine ceiling is one of the marvels of art. Before venturing to consider the details, we must experience the work as a whole. When we turn our gaze from the brilliant, small-scale work in the murals to

e Sistine ceiling. Rome, Vatican. Plan of variant of
the first design (after Erwin Panofsky).

the ceiling itself, it is as though a raging sea were pulsating above our
heads, wild yet completely under control. How are we to understand
the work as an entity?

Although the Detroit sketch comes close to the work in its finished
form, the entire conception is thought out again before that point is
reached.[25] The large figures are no longer in niches but displayed on
rectangular panels set on a plane wall. Diagonals and curves are less in
evidence, and even in the spandrels horizontal platforms have been
added. Similarly the octangular panels in the middle of the ceiling have
been replaced by rectangles.

The ornamental motifs, which must be conceived as being brightly
coloured, have given way to monumental shapes in yellowish marble –
indeed, the ornamental design has become an architectural structure,

without, however, failing to leave its marks on the finished product. The figures are now the most important element, and the sculptor has taken over from the painter.

When we look up at the ceiling, our eyes first light on the walls on either side, with figures seated on massive thrones. Then come the medallions, borne by ignudi. From here the transverse stone bands lead to the centre of the ceiling, where, as though in a different region, the scenes of Creation and the childhood of man are found.[26]

The painted architecture of the Sistine ceiling has been compared with the open-air temple of antiquity – 'one could imagine that the open temple had been covered over with tapestries'.[27] But such an illusionistic view is untenable. The relationship between a finite space created by architecture and the infinite space of the heavens has to be understood in intellectual terms. It would also be a mistake to imagine that Michelangelo was imitating the illusionism of Pompeiian and Roman mural painting.[28] Rather he developed this relationship in his own way by transforming what had started as an ornamental programme into an architectural programme, exercising the freedom of approach that the Pope had allowed him.

Was there not something contrary, however, about adding so much architectural work to the ceiling instead of adopting a conventional form of decoration? This is a mystery which only the uncompleted tomb of Julius II can help to unravel, for the tomb design of 1505, in spite of its profusion of ornamentation, is closely linked with the architectural values of the Sistine ceiling.

There are twelve throned figures – the four major prophets (Isaiah, Jeremiah, Ezekiel and Daniel), three lesser prophets (Joel, Jonah and Zechariah) and five sibyls (Libyan, Persian, Cumaean, Erythraean and Delphic); their names are engraved on the base of their thrones. The scenes in the middle tell the history of Creation, the story of Adam and Eve from the creation of Adam to the expulsion from Paradise, and the story of Noah (the Flood, his thank-offering to God and the mockery of Noah by his sons). The pictures in the four corner-spandrels show scenes from the salvation of Israel – in the east David's victory over Goliath and Judith's murder of Holofernes, in the west the brazen serpent and the crucifixion of Haman. In the medallions above the

58

thrones are scenes from Maccabees, Genesis, Kings and Samuel which, as Edgar Wind has shown,[29] exemplify in various ways the Ten Commandments. The lunettes and spandrels show the lineage of Christ according to St Matthew, and above the spandrels stand groups of bronze nudes.

Christ's ancestors appear to have been intended for their present position from the beginning; besides recalling the figure of the Virgin Mary, to whom the chapel is dedicated,[30] they carry further back into history the motif of ancestry already present in the series of papal portraits. The old and the new decoration meet at this point, but it must remain an open question whether the ancestors formed a part of the old design which had not been executed, or whether they belong to the new design. The order corresponds to that of the papal portraits, running not consecutively from west to east but from south to north, traversing the middle of the ceiling each time.[31] The prophets and the sibyls are also arranged in this transverse, as opposed to longitudinal, manner, an arrangement that emerges from the typological character of the Old and New Testament frescoes.

The prophets and sibyls are portrayed as the companions of Christ's forebears – a role often assigned to the prophets in presentations of the Stem of Jesse,[32] and one to which they are better suited than the apostles. The design as a whole also makes it clear that, when studying the ceiling, one must start with the seated figures at the sides, not with the historical scenes in the middle, to which the prophets and sibyls act as heralds, gazing upon these scenes as upon heavenly visions.

Of the three minor prophets portrayed, Zechariah, above the entrance, has particular importance in that he refers to the coming of Christ (9:9) and the events of Palm Sunday;[33] the Pope came through this entrance on Palm Sunday after having distributed palms among the people.[34] Jonah, who foreshadows the resurrection of Christ (Matthew 12:40), is opposite Zechariah on the west side above the altar, while Joel is the prophet of Pentecost. The vigil of Pentecost was celebrated in the Sistine Chapel, and the Mass of the Holy Ghost sung before and during the conclave.[35]

Of the major prophets, Ezekiel is set in the middle of the south side, and opposite him on the north side the Cumaean sibyl, who, according

to Virgil's fourth Eclogue,[36] foretold the Virgin birth of the redeemer of the world. The central panel between the prophet and the sibyl depicts the creation of Eve, herald of Mary and of the Church. On the floor of the chapel at this point stood the marble screen that separated the chancel from the nave, and the Pope entered the chancel through the door in the screen – which recalls Ezekiel's reference to a *porta clausa* (44:2).[37] In this way the presence of the Virgin is gently but perceptibly urged upon the mind of the beholder. The arrangement of the remaining prophets, however, does not seem to have any particular meaning.

The tradition of the sibyls stretches far back into pagan times.[38] For Christianity they are the bearers of divine decrees, pagan witnesses to the Christian doctine of the one and only true God. The most famous of them is the Erythraean sibyl, to whom St Augustine devotes a special chapter in his *Civitas Dei*: she was said to have foretold the Day of Judgement, and her utterance was repeatedly quoted in the Middle Ages, even being chanted as part of the Requiem mass down to the fourteenth century.[39] Next in importance was the Cumaean sibyl, portrayed in Virgil's *Aeneid* as the guide through the underworld,[40] and credited with messianic powers in the fourth Eclogue. In the fifteenth century the number of sibyls was increased from ten to twelve, to match that of the prophets and the disciples. Why, in addition to these two, the Sistine ceiling should have included the three others, we cannot tell. All we can say is that the total number was limited by the space available and by the desire for a regular alternation of prophets and sibyls.

As the murals portray, in a strict typological parallelism, the course of fallen man *sub lege* and *sub gratia*, so the scenes on the ceiling show the world *ante legem* – above the chancel God the Creator of man and the world, above the nave the temptation and the Fall.[41] As with the murals, the sequence runs from the altar to the chapel door. In subject the pictures must be taken simply for what they are, although one must also grasp their historical and typological significance. The mockery of Noah, for example, anticipates the mockery of Christ, and in Michelangelo's cycle it may symbolize in a special way, as the last stage in the human condition *ante legem*, man's perpetual exposure to sin and his profound need for salvation. It may even point forward to the Day of

Judgement. 'For the imagination of man's heart is evil from his youth' (Genesis 8:21).

This technique is made even more explicit in the corner-spandrels.[42] As *The Crucifixion of Haman* (not the usual hanging) and *Moses and the Brazen Serpent* above the altar are Old Testament precursors of Christ's crucifixion, so Jonah, set between them, heralds the Resurrection. In the same manner Judith, next to Zechariah, prophet of Mary, heralds the Virgin and the Church, as David heralds Christ.

The design for the Sistine ceiling corresponds basically to the elements of tradition. The actual execution, however, shows a richness of pictorial imagination and an independence of treatment that has no parallel in the art of earlier ages. Yet the ecclesiastical foundations are left intact – indeed, Western religious art celebrates in this work one of its proudest triumphs.

The seated figures of the prophets and sibyls show particularly clearly the transition from the tomb for Pope Julius. The design of the Sistine walls recalls the lower storey of the tomb, and the seated figures of the chapel show how those of the upper part of the tomb would have looked in the plan of 1505.

In the row of seated figures there is a perceptible break before Daniel and the Persian sibyl. The first three figures from the door all have ample space on their thrones, but the last two, in front of the altar, overlap the space taken up by the arm-rests. In other words, the figures assert themselves over the architecture; their size and the power of their movements have increased. The same phenomenon can be observed in the central scenes of the ceiling.

Michelangelo's prophets and sibyls draw on the immense store of saints and preachers, those in extremes of ecstasy as well as those sunk in contemplation, which Christian art had evolved from the traditional accounts of Greek and Latin writers, and in which the true spirit of Christianity, the permeation of the world by the divine spirit, finds moving expression. He found a spiritual kinship above all with the prophets and sibyls of Giovanni Pisano's pulpits in Pistoia and Pisa,[43] Luca Signorelli's figures of Church fathers and evangelists in the Sagrestia della Cura of Loreto Cathedral,[44] and Donatello's statues of the prophets for the campanile in Florence.[45]

Yet however vital the concepts and visions of the past, there is nothing that Michelangelo did not completely reshape and rethink in response to his new experience of antiquity, his now deeper understanding of nature, and the spiritual tension within his own personality. The art of the High Renaissance rested on the principle of objectivity, but in Michelangelo we now detect a note of subjectivity which was to grow with time. His figures acquire a new contemporaneity: the observer experiences the visions and thoughts which his prophets and sibyls experience and seek to master. Only rarely – the Libyan sibyl is a case in point – does the formal element prevail over the content, and the danger of formalism which one senses in the *Doni Tondo* seems to have been overcome.

Through the alternation of prophet and sibyl and the hint of relationships between the figures one senses an underlying law which the individual figures obey, yet at the same time each has to be seen as an independent character. Michelangelo is by no means always concerned to illustrate particular texts but seeks prophetic moments, instants of agitation and reflection, the sudden impact of inspiration as the figures read, ponder or write. The way he individualizes these figures by motif and gesture, by the alternation of book and parchment and by the movements of the putti, is extraordinary.

The aged prophet Zechariah, bald and with a long beard, has turned to one side and is apparently looking for a particular passage in the thick volume he is holding (Pl. 15), while the youths look anxiously on. This, the earliest of the prophets to be painted, is the flattest; as we move towards the west the posture and gestures of the figures become fuller and freer.

Joel, portrayed full-face and with features that put one in mind of Goethe in his old age, is absorbed in a parchment roll (Pl. 16). The youth on the left, who is holding an open book, is looking at the parchment over the prophet's shoulder, while the boy on the right has a book under his arm and seems to be shouting to his friend. Is he perhaps saying that the books can be put away, now that the prophecy is recorded on the parchment? The figure of Joel here anticipates that of Moses in the 1513 design for the tomb of Julius.

Isaiah, here a young man, has finished reading (Pl. 17) and now hears

the voice of God, to which one of the two youths excitedly draws his attention: 'Behold, a virgin shall conceive, and bear a son, and shall call his name Immanuel' (Isaiah 7:14). The book is closed beside him but his fingers are still held between the pages, marking a particular place, and his head is turned slightly to one side, his lips apart, as though he is suddenly elated by the glad tidings he hears. His left arm, held in a position reminiscent of Leonardo, follows the direction of his head. His body, however, is turned in the opposite direction, giving the contrapuntal effect already found in the satyr in the *Bacchus* and in the Child Jesus of the Bruges *Madonna*.

Ezekiel (Pl. 18) appears to be shown at the moment of his vision of 'the likeness of four living creatures' (1:5): he gives a start, and his expression mirrors his terror. With great boldness Michelangelo has transformed a seated figure into a portrayal of movement. Similarly the two youths convey agitation: one appears to be fleeing, while the other points upwards with both hands.

With Daniel (Pl. 19) there is a change of proportion: the figure overlaps the sides of the throne and also touches the architrave with his head. The young prophet has in his lap a large open book which rests on the back of a boy, and he seems to be copying something from it on to a sheet of parchment to his right – a motif found in Signorelli's portrait of Dante in Orvieto[46] – while his left arm rests heavily on the book. Like Joel, Daniel seems held in the grip of prophetic inspiration.

Jeremiah (Pl. 20), sunk in thought, cups his chin in his right hand in a powerful pose that was to recur in Michelangelo's *Il Pensieroso* for the Medici Chapel. The prophet is shown as the author of the Lamentations, which were sung in the Sistine Chapel in Holy Week:[47] 'The Lord hath afflicted me with sorrow in the day of his fierce anger' (Lamentations 1:12).

The most challenging of these figures of the prophets is that of Jonah, above the altar (Pl. 21). Wherever one stands in the chapel, one's eyes move towards this figure, which, as Wölfflin put it, 'breaks down all structural divisions by its power'.[48] The prophet is leaning on his right elbow, his body is twisted back towards the left, and with lips open he stretches his head defiantly upwards as though reproaching God with His misdeeds. The opposing movement of head and arm, also found in

the figure of Isaiah, is here at its most intense. Behind him are the leaves and branches of a wild gourd (Jonah 4:6), and on the right is the whale (1:17). The child shrinks away from the angry prophet, and the young woman casts her eyes down.

Justi called Michelangelo's Jonah 'a blaspheming urchin'.[49] The motif of rebellion is found in the Bible:[50] called by God to be a prophet, Jonah fled, then rebelled against God's mercy, declaring: 'I do well to be angry, even unto death' (4:9). Jonah's anger had never been made the subject of a painting before Michelangelo, driven by his own wilfulness of spirit, dared to set his portrayal of it above the altar – of all places – of the Sistine Chapel.

The sibyls, too, are portrayed in their role as prophetesses. The Delphic sibyl (Pl. 22) unrolls her scroll with her raised left hand, while her right lies in her lap. She gazes wide-eyed into the distance with brooding intensity – the children, however, ignore her. Michelangelo's model for this sibyl is Quercia's *Sapienza* at the Fonte Gaia in Siena,[51] but his figure has an immeasurably greater freedom and independence than its fine predecessor. The outline has lost its restrictedness, and the body has suddenly acquired a new vitality. Again we meet the counterpoint of arm and head, from which the conception of the head receives its power, yet presiding over all this movement is an ever-present serenity.

The Erythraean sibyl (Pl. 23) is pensively turning over the pages of the book at her side. One of the putti behind the lectern is lighting a lamp, another is sleepily rubbing his eyes. Signorelli's fresco *The Testament of Moses* in the Sistine Chapel anticipates the motif,[52] but only in Michelangelo's treatment do the individual elements spring from the character of the work as a whole. The limp right arm, for example, emphasizes the strength of the outstretched left arm.

Michelangelo depicts the Cumaean sibyl (Pl. 24), who is called *horrenda* in Virgil,[53] as an old woman; she is also portrayed thus in the mosaic floor in Siena Cathedral.[54] In Michelangelo's hands old age acquires a sinister quality – not through decay but through the passage of time. The sibyl is not actually reading from the large book she is holding but musing on its contents, while the putti look on attentively.

The Persian sibyl (Pl. 25) marks the beginning of that change of proportion already observed in the corresponding figure of Daniel. Michel-

angelo is the first to follow the written tradition in making her an old woman – her attire, her shortsightedness and her reluctance to face the observer (a particularly bold motif) are the means by which he conveys this. It would be a mistake to interpret her shortsightedness as symbolizing the loss of her prophetic powers, as some have done.[55] The putti are silent and motionless.

The Libyan sibyl (Pl. 26), a lithe figure, has turned her body and appears to be closing the book and putting it away, as Vasari suggests.[56] She is looking downwards. Has she come to the end of her search? The youths are moving away. The style hints, for the first time, at Mannerism – though Wölfflin, laconically and somewhat unjustly, says of the figure: 'Much ado about nothing.'[57]

In these prophets and sibyls Michelangelo has probed more deeply than any artist before him into the individual character of each figure. Yet they retain a resemblance to each other in that fate has laid the same charge upon them. In their different attitudes and situations they are probably the most profound representations of the prophetic calling in the whole of European Christian art.

Above the pillars on either side of each throne stands a pair of youths (Pls. 27, 28, 29), threading pendants through the frames of the bronze medallions, which they also seem in places to be decorating with oak garlands (the oak was the emblem of the Rovere family). Condivi and Vasari call them 'ignudi', 'nudes'. Structurally they belong to the thrones, but because they are not, like the thrones, viewed from above, they come to form part of the central ceiling.[58]

In the fifteenth century artists had revived decorative motifs from the celebration of triumphs in the ancient world and used them in tombs, altars and ceilings. For Pope Julius's triumphal entry into Rome on Palm Sunday 1507, for instance, a triumphal arch in classical style was erected in front of the Vatican, and triumphal spirits bearing palms greeted him.[59] Instead of using the decorative motifs themselves, Michelangelo portrays the act of decorating; drawing freely on classical and pseudo-classical carved gems,[60] as well as on certain motifs from his *Doni Tondo* and even his *Madonna of the Stairs*, he assembles a celestial choir of figures and celebrates in rich profusion the beauty of naked youth. 'Their bodies are in his power, because he controls their joints.'[61]

From the prophets and sibyls at the sides the eye moves to the pictures in the centre of the ceiling, which represent both events in time and space and revelations of temporal and spatial infinity. In these works Michelangelo, the greatest master of nature in the spirit of antiquity, regained that capacity for supernatural expression which the preceding age was in danger of losing. Like the prophets and sibyls they belong in a tradition that starts with the frescoes in the Roman basilicas of St Paul's and St Peter's, and lives on through the Middle Ages on both sides of the Alps.[62] Among the immediate forerunners of the Sistine figures are Quercia's portal in the Church of S. Petronio in Bologna,[63] Ghiberti's Porta del Paradiso of the Baptistery in Florence,[64] and Uccello's frescoes in the cloisters of S. Maria Novella.[65] Each scene is both an objective statement and a personal confession, the one inseparably linked with the other.

As the prophets, sibyls and ignudi belong to the world of the tomb for Pope Julius, so the histories in the centre hark back to Michelangelo's early Florentine paintings, above all the *Battle of Cascina*, but the religious subject-matter compelled him to abandon any display of his recently developed virtuosity and to harness his immense artistic power to the expression of the religious message.

From the style we can clearly see that he started work at the east end. The first two narrow panels – *The Mockery of Noah* and *Noah's Sacrifice* – are in the style of reliefs, and the first large panel – *The Flood* – has comparatively small figures. With the second large panel, however – *The Fall and the Expulsion from Paradise* – the style changes, and the figures become larger and more statuesque; also the relief-character is no longer present in the small panels. The change of style is the same as that which we observed with the prophets and sibyls.

This change of style is no justification for reversing the sequence of the story.[66] As Carl Justi says: 'If one were to discover that the scenes of a drama had been written in a different order from that in the completed work, would one propose performing them in that order? Should one put Faust's thoughts of suicide in Goethe's drama *after* the Dungeon scene, and follow it with the Easter Walk, the Pact scene and the Prologue in Heaven?'[67]

The order of the first three scenes at the east end brings up again the

problem of the first design: *Noah's Sacrifice* should follow *The Flood*, not precede it. Perhaps these panels were conceived, not chronologically but as a triptych, with the principal picture in the centre flanked by two smaller pictures. It is also possible that they represent part of an earlier stage in the overall plan, such as that revealed by the two extant sketches.[68] But we can no longer tell.

Michelangelo's imagination left traditional expectations far behind, but he did not simply ignore them; rather he looked beyond the immediate past towards earlier ages, reviving long-forgotten motifs and creating new ones, filling his paintings with the spirit and the poetry of the Old Testament. Here too we should follow his progress from east to west, i.e. in the opposite direction from the events of the narrative, if we wish to witness the unfolding of his powers.

The Mockery of Noah (Pl. 30). Noah, in a drunken stupour, lies on the floor of his hut in front of a large wine-vat; his youngest son has fetched his brothers and is pointing at their naked father. In the left background Noah is digging in the fields[69] – a reference to the need for man to help God in His work of redemption. As in his cartoon of the bathing soldiers Michelangelo presents nude, rather than clothed, figures – though there is no need to seek any hidden meaning in this. The figure of the drunken Noah, who looks like a Greek river-god, anticipates the recumbent figures in the Medici Chapel.

The Flood (Pl. 31).[70] As the waters cover the earth, the people seek refuge on two pieces of higher ground; the boat can hardly stay afloat, and figures are seen clinging to the Ark, from which Noah looks out and stretches his arms upwards to Heaven.

The mass of agitated naked figures recalls the cartoon in Florence, and Michelangelo was probably able to incorporate some of his Florentine studies in this thematically related work. But a greater subject has led to a greater work. This is Michelangelo's first large-scale painting.

While Ghiberti, following the old tradition, still portrays the creatures leaving the Ark, Uccello, in the cloisters of S. Maria Novella in Florence, is the first to show the Flood in all its horrors, but he did not succeed in producing a unified composition from the various discrepant elements. This is precisely what Michelangelo, while introducing yet

more new motifs, succeeded in achieving. His theme is the rising flood, which drives the desperate people to try – in vain – to save themselves by clinging to the few remaining hillocks. His concern was not so much punishment as suffering: dispensing with the aspect of destruction, he concentrated his sympathy on the survivors. Painfully they clamber upwards, carrying the remains of their chattels: a man is carrying his wife on his shoulders; a young mother is holding a baby in her arms while an older child weeps and clings to her legs; a man and a woman hold each other in their arms, a young man tries to climb a tree, and an old man gives a child to its mother. In the foreground a woman bewails her fate, and similar figures lie on a rock to the right. An old man drags up the body of a youth – the only corpse in the picture. Love and sacrifice predominate: only the boat and the Ark reflect the urge to self-preservation.

Certain details derive from tradition: the mother with her children – a new motif for the Flood – goes back to the relief of Eve in S. Petronio,[71] the man carrying his wife on his back recalls the classical theme of Aeneas and Anchises, while the old man dragging the corpse has his predecessor in the statue of Patroclus and Menelaus. But these traditional themes are absorbed into Michelangelo's new creation and given modern significance.

Noah's Sacrifice (Pl. 32). 'And Noah builded an altar unto the Lord . . . and offered burnt sacrifices on the altar' (Genesis 8:20). Noah's wife is on his left, one of his daughters-in-law on his right, while his sons and his other daughter-in-law are preparing the burnt offering; on the left are the animals that have left the Ark. The motif of sacrifice harks back to classical reliefs.[72] There is a greater profusion of motifs than in the corresponding *Mockery of Noah*, but the formalism of the *Doni Tondo* is still evident.

The Fall and the Expulsion from Paradise (Pl. 33). There is nothing here of the fecundity of the Garden of Paradise: apart from the Tree of Knowledge all we see are stones and a bare branch. Michelangelo's concern is with human beings. Adam and Eve are on the left of the tree. The motif of man's temptation by woman has been superseded by the equal guilt of both. Eve, crouching at Adam's feet and almost becoming part of him, turns back towards the tree, attracted by the solicitations of the

serpent, and takes the apple; Adam has leapt to his feet and also reaches out greedily for the fruit.

For the subject of the expulsion Michelangelo drew on the examples of Masaccio[73] and Quercia.[74] Adam is broken yet retains his composure; Eve is cowering and seeks his protection, her once glowing features now aged and harsh.

The principle of linking two scenes by the use of the same figures is an old one, but Michelangelo puts it to new use. The tree, with its thick trunk and the serpent twined round it, fills the centre; following the curve of the vaulting, the movement of the picture starts on the left, leads towards the tree and then continues on to the right, where there is a great, yawning gap – 'like a moment of silence in a work by Beethoven'.[75]

The Creation of Eve (Pl. 34). This is the last of the relief-type compositions, but the figures are very large for the size of the panel: God the Father, for example, cannot even stand fully upright. Adam has fallen asleep by the foot of a tree-stump; with his head resting on his shoulder he recalls the figure of Christ in Michelangelo's Roman *Pietà*. As God approaches, Eve springs out of Adam's side, her hands folded in prayer and her lips parted in amazement.

Michelangelo's starting-point is Quercia's relief,[76] but whereas there God is touching Eve, both blessing and admonishing with the two fingers of his outstretched right hand, here He draws his robe around Him with His left hand, His power concentrated in His open right hand, symbol of creation. Michelangelo has not yet freed himself from the Quattrocento image of God the Father but his imagination takes one far beyond the limits of that image.

The Creation of Adam (Pl. 35). Adam, with a powerful body of beautiful proportions, lies on a rock and stretches out his arm towards God, the giver of life, with an expression signifying both the dull restrictedness of his animal existence and his aspiration to divine power. On the other side the figure of God the Father, borne by angels and enveloped in a huge robe, as though in a cloud, drifts towards him. He looks straight into Adam's eyes, and from the outstretched finger of His right hand the spark of His spirit enters him. His left arm is round a young figure that also has its gaze fixed on Adam – maybe this is the as yet un-

created Eve.[77] Adam is held by the forms of the earth; the Lord floats freely through the heavens, meeting with His powerful, yet infinitely tender eyes man's imploring gaze.

With this conception Michelangelo leaves the painters of the Quattrocento, even Quercia, far behind, turning instead to the early Christian depiction of the Creation in St Paul's in Rome, which he must have known through its restoration by Pietro Cavallini.[78] Only here did he find what matched his own vision – the vision of the creation of man as a cosmic event. The early Christian painter of this picture had only the conventionalized, cliché-ridden style of late antiquity on which to draw, and could no longer convey cosmic meaning through figures but only through ideographs, such as the sphere. Michelangelo was the first to do so through physical action, leaving the representation in St Paul's far behind and approaching the true poetic quality of the scene.

The Creation of the Creatures of the Sea (Pl. 36). This scene already raised difficulties for contemporary critics. Condivi saw it as depicting the fifth day of Creation:[79] 'And God said, let the waters bring forth abundantly the moving creature that hath life.' Vasari, on the other hand, took it to refer to the second day:[80] 'And God made the firmament, and divided the waters which were under the firmament from the waters which were above the firmament.' Modern opinions are equally divided.[81] Condivi's view seems the more likely. That Michelangelo, contrary to the pictorial tradition, has only shown the sea is not surprising, for he restricted himself to essentials and rejected almost entirely the non-human aspects of his subjects. His sole concern was with the act of creation.

In the small panels also Michelangelo now turns to spatial compositions. The Creator, considerably foreshortened, is wafted across the scene, again shrouded in a cloak and surrounded by angels, and blesses the sea with both hands, his eyes cast down upon it: 'And after the fire a still, small voice' (1 Kings 19:12).

The Creation of the Sun and Moon and of the Fruits of the Earth (Pl. 37). In this picture Michelangelo has combined the events of the third and fourth days of Creation. On the right the Lord rises from the depths as though in a rushing, mighty wind and with imperious gesture assigns the sun and the moon to their places. Angels attend Him, and one of

them is dazzled by the brilliance of the firmament. On the left He is shown hastening onwards to perform new tasks, creating the fruits of the earth almost *en passant*.

Michelangelo's early Christian model has the same content,[82] including the combination of the two acts of creation, but what had been a formal symbolic language capable only of illustrating the biblical events, has now become the vehicle of a living, modern message. The partial figure, motionless and with His star-studded halo, has been turned by Michelangelo into a complete representation of activity and movement.

Let there be Light! (Pl. 38). Above the altar – the first in sequence but the last to be painted – hangs the consummation of Michelangelo's work: his portrayal of Creation itself. His arms lifted high above His head, the Lord is shaping the form of His earth.

The biblical conception of a *deus creator* was unknown to antiquity,[83] but only after the revival of classical art did it become possible for Christian art to give visual shape to the conception. This is Michelangelo's achievement. For the first time he leaves tradition behind and strikes out into regions never before explored in art. From the formal point of view the figure of God is developed from that of *St Matthew*:[84] as there, the movement of the body is the expression of spiritual strain, of suffering. Not only the bliss of creation but also its agony finds expression here.

From this first scene in the story our eye returns to the last. Again we must realize that the drama which Michelangelo unfolds is not portrayed in immediate, tangible form. Like the role of the sibyls and the prophets, we must see it as the reflection of a process of redemption which runs its course on a higher plane. 'The battle still rages in the temporal world of appearances, but to the spirit it is already won.'[85]

The four corner-spandrels were painted at the same time as the central pictures: *David and Goliath* (Pl. 39) and *Judith and Holofernes* (Pl. 40) come at the beginning, *The Crucifixion of Haman* (Pl. 41) and *The Brazen Serpent* (Pl. 42) at the end. A stylistic development is apparent in Michelangelo's increasing skill in handling areas of irregular shape: in the first pictures, for example, the lower triangular space is left empty, whereas in the later ones it has been almost completely filled; also, the importance of the centre of each picture has become merely notional.

71

The significance of these corner-spandrels is primarily typological, but Michelangelo has given them an almost Shakespearian psychology and drama. The subject is presented as an action-sequence. David falls on the giant and prepares to strike, while in a desperate final effort Goliath half-raises himself and looks up at his adversary. Holofernes lies on his bed, secretly and hastily slain, his head lying on a platter which the servant is carrying on her head; as she makes to cover Holofernes' head with a cloth, Judith glances back at his dead body, which still seems to be moving; on the left a sentry is still asleep.

The same dramatic atmosphere is found in the two spandrels at the west end.[86] Here Michelangelo gives up the relief technique and adopts, as in the final scenes in the centre of the ceiling, a bold spatial composition which looks beyond the High Renaissance towards Mannerism. *The Brazen Serpent* (Numbers 21:8) is an early example of the new anti-classical style which only became typical over a decade later. Its manner is that of his formalistic late Florentine works: the individual figure counts for little, and the bodies seem to be driven on by some external force. The foreshortening has a violent quality about it, and a gulf has opened up between foreground and background. These are features which were to inform much of Michelangelo's later work.

The spandrels and the lunettes were painted at different times[87] – the former at the same time as the ceiling, the latter between 1511 and 1512, i.e. after an interval of a year. In terms of content, however, they belong together – it is only the date of execution that separates them.

Their subject is the ancestry of Christ down to Abraham, as given by St Matthew. Since the Bible only gives a list of names, and the iconographical tradition provided only individual figures or the emblematic formulae of the Stem of Jesse from David onwards, Michelangelo's imagination was given free rein – Vasari refers to 'a mass of remarkable new fancies'.[88]

Nowhere in representational art before Michelangelo is there so free a treatment of a biblical subject. Starting from the concept of life as a pilgrimage – 'For here we have no continuing city . . .' (Hebrews 13:14) – and perhaps recalling the words of Savonarola: 'The poor and needy are the true family of Christ' – he has depicted scenes from the life of the people instead of individual portraits to match those of the

Popes on the walls.[89] The spandrels show nomadic scenes, the lunettes scenes of home life (Pl. 43). Husband and wife, parents and children, grandparents and grandchildren are shown in simple family settings.

Michelangelo's melancholy disposition imparts a note of tragedy to these scenes. 'The couples are silent and gloomy, the children are more of a burden to their parents than a joy, and even sleep comes, not as sweet and refreshing but as a force that drives the weary bodies into violent, contorted shapes which suggest death rather than sleep.'[90]

> La mia pittura morta
> Difendi orma', Giovanni, è'l mio onore,
> Non sendo in loco bon, nè io pittore!
>
> (Defend my painting dead,
> Giovanni, and my honour which grows fainter:
> This place is bad; besides, I am no painter.)[91]

Thus Michelangelo mocked himself and his work as a painter. But we must, as it were, defend him against himself. He was not only a great sculptor but a great painter, and his mastery of colour is of an importance equal to that of his intellectual conception, his draughtsmanship and his pictorial invention.[92] The flowing figures emerge from the yellow tones of the marble structure, the flesh colours of the figures of men and women, young and old, prevailing over the orange, green, golden yellow, sky-blue, violet and wine-red of their robes. The sky is a bluish grey, the ground a matt green. Gold is only found in the bronze medallions and – in the early stages of the work – in the balusters of the thrones; for the later thrones gold has given way to dull yellow.

Like the overall conception, the colour-scheme also falls into three zones. The uppermost, visionary zone has comparatively pale and delicate tones; the lower we come, the deeper, stronger, more varied the colours. The chiaroscuro shows the same distinction: the central pictures, with their blue-grey sky, are light and airy; the chiaroscuro is more pronounced in the prophets and sibyls, until in the spandrels and lunettes, where the colours are heavy, subdued, almost dull, the shade is almost more prominent than the light. As for the design as a whole and the sequence of the scenes, so also for the colour-scheme one must

assume an overall plan, but as the work progressed, the artist found himself moving ever further away from the separate groups of colours in favour of a single, overall shade.

Nor does Michelangelo disguise his descent from Ghirlandaio in this, the first of his great achievements in painting. Furthermore behind Ghirlandaio stands the even greater figure of Massaccio, whose cycle of frescoes in the Brancacci Chapel of S. Maria del Carmine in Florence is the greatest forerunner of the Sistine ceiling from the point of view of colour. These are the only frescoes to show a unity of tone-colour that can be compared in intensity with Michelangelo's – though Michelangelo goes far beyond Massaccio in range and subtlety.

Chapter 6

Rome and Florence 1513-1520

Design of 1513 for the tomb of Pope Julius – the façade
of S. Lorenzo in Florence – further work on the tomb:
the design of 1516

I DESIGN OF 1513 FOR THE TOMB OF POPE JULIUS
Michelangelo himself had regarded his work on the Sistine ceiling as a
most unwelcome interruption in his work on the papal tomb. The ceil-
ing now completed, he looked forward to returning to work on the
tomb. At the end of September or the beginning of October 1512 he
wrote to his father in Florence: 'I have finished painting the chapel, and
the Pope is very satisfied with it. But my other affairs are not going as
well as I thought. For this I blame the times, which are very inauspicious
for my art.'[1] The 'other affairs' must mean Julius's tomb.

But on 20 February 1513, before these difficulties could be settled,
the Pope died. This was a heavy blow for Michelangelo, for Julius had
been his most important patron. At his own request the Pope was pro-
visionally laid to rest in the mausoleum of his uncle, Pope Sixtus IV,
behind the altar[2] – in fact, he was never interred in the finished cenotaph
in S. Pietro in Vincoli.[3]

Whether before Julius's death a new agreement was made concerning
the tomb we do not know,[4] but on 6 May 1513 the Pope's executors,
Leonardo Grosso della Rovere, Cardinal of Agen, and the Pope's secre-
tary, Lorenzo Pucci, later Cardinal of Santi Quattro, drew up a fresh
contract with Michelangelo.[5] This marks the beginning of the second
part of the 'tragedy' – for this plan was never carried out either.

Michelangelo undertook to complete the work in seven years instead
of five and to accept no other commitment during this period. The fee
was raised from 10,000 ducats to 16,500. He rented a house at the
Macello dei Corvi, near Trajan's Forum, had the marble taken there
and engaged a number of stonemasons; on 9 July he charged Antonio da

Pontassieve to do the architectural and ornamental work, which the latter embarked on immediately.[6] Shortly afterwards he wrote to his father: 'I am so occupied that I cannot even find time to eat.'[7]

In 1513 he was working on his *Struggling Captive*, now in the Louvre.[8] We learn that 1515 also was a busy year, but there now appears a new danger. A letter to his brother in June 1515 reads: 'I must make a great effort to finish my work this summer, because afterwards I think I shall have to put myself at the Pope's disposal.'[9] The conflict between the new Medici Pope, Leo X, and the head of the house of della Rovere, Duke Francesco Maria of Urbino, which cost the latter his duchy the following year,[10] was already brewing, and this threatened the peaceful progress of Michelangelo's work. But he was still working on the project of 1513 down to the end of April 1516.[11]

We can form an impression of this project from a sketch of Michelangelo's (Fig. f) made after the contract had been settled (probably 6 May 1513[12]), from the subcontract between Michelangelo and Antonio da Pontassieve,[13] and from the Berlin sketch already mentioned (Pl. 12). The plan now is not for a free-standing tomb but for a panel-tomb, and the idea of a mausoleum, as planned in 1505, has been abandoned. The lower storey is no longer designed as the tomb itself but as a monumental plinth, with the sarcophagus resting on the top; behind the sarcophagus there was to be a kind of tall altar-piece (*cappelletta*). Nothing is known about where the tomb was to be erected.[14]

The dimensions differ in Michelangelo's sketch and the subcontract. The latter, probably more accurate,[15] puts the frontal width at thirty palms (about twenty feet) and the height of the base at seventeen palms (about eleven feet). Michelangelo's sketch gives the length as thirty-five palms (twenty-five feet). Thus compared with the design of 1505, the tomb is now smaller, and both Condivi[16] and Vasari[17] confirm this, but in later letters[18] Michelangelo refers to its being bigger.

The membering of the lower storey together with its ornamentation has remained substantially the same, though the architrave above the herms seems to have been removed.[19] Since the idea of a mausoleum has been given up, the central door is replaced by a relief in bronze or marble, and there are similar reliefs in the centre of the sides.

Similarly the upper storey is basically unchanged. The actual sarco-

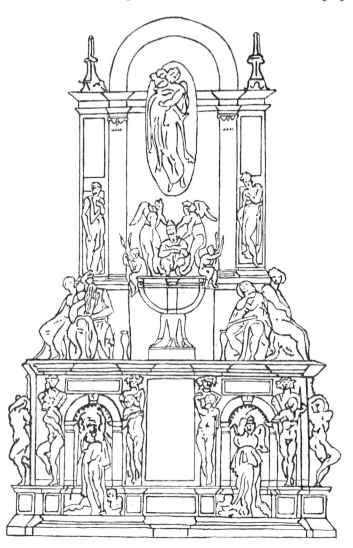

f Pope Julius's tomb. Design of 1513. Reconstruction.

phagus, no longer a bier but a coffin mounted on four feet, rests end-on
on the platform; 'Pope Julius was to lie here, two figures supporting his
head, another two figures at his feet. All five figures, the Pope and his
attendants, were above life-size – indeed, almost double life-size.'[20] Six,
not four, figures are seated on pedestals around the sarcophagus. The

little pedestals that can be seen in the Berlin and Florence drawings at the side of the seated figures are evidently part of the 1505 design and are now superfluous.

But now comes a complete change. 'On top of the platform and against the wall there is a *cappelletta* some thirty-five hands high [twenty-five feet], containing five figures: these are larger than all the other figures because they are farthest away.'[21] One can form an approximate idea of this *cappelletta* from the Berlin drawing. It remains uncertain, however, whether it was planned simply as a form of shallow mural decoration or as a projection from the wall resting on the platform: in the former case the two figures not shown on the Berlin drawing could have been intended for the two vacant upper niches; in the latter case they could have stood at the two sides of the structure, which are not visible in the drawing. It is also uncertain whether the Madonna in the centre is meant to be a relief or a statue; as it stands in the drawing, it can only be a relief, or even a painting, but in the subsequent execution it was to become a statue.[22]

If one compares the free-standing tomb of 1505 with the wall-tomb of 1513, the latter cannot, despite its smaller overall dimensions – and in contrast to later designs – be considered a smaller-scale work. The increased number of figures in the upper tier (six seated figures instead of four; four figures by the sarcophagus instead of two) and the addition of the *cappelletta* with its five new figures, entitle Michelangelo to speak, as he does, of a larger work – though to what this increase is attributable remains an open question.

It is hardly plausible to regard the 1513 design as belonging to the series of sketches – among them, no doubt, one for a panel-tomb – that Michelangelo made for the Pope in 1505,[23] for it clearly presupposes the existence of the project for a free-standing tomb and is to be seen as an attempted synthesis of the two, an attempt which, for all its splendour, has not produced a really satisfactory result. For in spite of Michelangelo's concern to make the figures of the *cappelletta* taller – 'because they are farthest away', as he said – there remained a discrepancy between the *cappelletta* and the massive projecting base, which, now that the tomb was no longer to be a mausoleum, had lost its point. The problems connected with this earliest wall-tomb design must be borne in mind when

one comes to assess the subsequent designs, not only as contractions but also as developments and as attempts to master such problems. The project of 1516 clearly reveals this.

Compared with the project for a free-standing tomb, the wall-tomb of 1513 shows only slight modifications in the lower storey and the upper platform. The former retains its earlier importance: the groups symbolizing the virtues and vices remain in their niches, and the captives still stand in front of the herms – though this time, perhaps (as suggested by the symbolic objects with the two *Captives* in the Louvre – the capital (?) in *The Struggling Captive* and the ape in *The Dying Captive*), as allegories of the arts.[24] The upper part depicts once more the kingdom of grace in the community of the saints. The figure of Moses is clearly apparent. In place of the seated figure of the Pope as described by Vasari we now have the ancient motif – found already in classical times – of the ascent into the heavens, which occurs on medieval tombs, including those of Popes, and which finds its greatest early expression in Giovanni Pisano's tomb for Queen Margareta in Genoa.[25] 'Command Thy Holy Angels to receive the soul of the departed and lead it to Paradise,' runs the Requiem mass.

The design of the *cappelletta* is new. Michelangelo's sketch gives no indication of the names of the five figures, but from the Berlin drawing we can at least identify the figures of the Madonna and Child, set in a vesica, as they hover down from the sky – a motif that may have been taken from the tomb of Sixtus IV.[26] In pictorial terms it bears a remarkable resemblance to Raphael's Sistine Madonna painted for Julius II.[27]

Also belonging to the tomb project of 1513 are the façade of the lower storey as it stands in S. Pietro in Vincoli (except for the few parts dating from 1506 and the later additions such as the larger herms, the volutes and the socle), the two *Captives* in the Louvre and *Moses*. Apart from a few alterations, probably including the removal of the architrave above the herms, the façade corresponds to the 1505 design; the sculptures, on the other hand, show the development represented by the Sistine ceiling.

A pen-and-ink drawing in the Ashmolean Museum (Dussler No. 194), dating from the same period as the later parts of the Sistine ceiling, contains six sketches of slaves which are far more restless than the

comparatively calm figures in the design of 1505. Like *St Matthew* before them, they show the influence of the *Laocoon*. Also recognizable among these drawings is that of the slave with herm and battle-emblems (helmet and armour).

The Struggling Captive (Pl. 44) is unfinished. With his right foot on a stone (symbol of his bondage), 'he makes as if to burst his muscles and wrench his shoulders apart as he strains at his thongs'.[28] His arms are tied behind his back and his head turned to one side in agony. The drawing in the Ashmolean Museum shows that, departing from the frontal view taken for granted in the fifteenth century, Michelangelo means him to be seen from the left; only thus can one fully grasp the conflict in the figure between captivity and rebellion. The figure was probably intended for the left corner-pillar at the front:[29] the head picks up the outward movement of the body and directs it inwards. As with the ignudi in the Sistine ceiling, the individual movement is caught up in the movement of the scene as a whole.

Apart from the seated bronze of the Pope for Bologna, which is lost, this is Michelangelo's first monumental figure since the *St Matthew* of his Florentine days. Again we sense the strong influence of late Hellenistic art, specifically of the *Laocoon*.[30] But the *Laocoon* theme of suffering is given here, as in his *St Matthew*, a Christian connotation, and the classical theme of the prisoner, which Michelangelo knew from originals, as well as from drawings by his friend Giuliano da Sangallo of Roman triumphal arches and from similar works of the Italian Renaissance,[31] here seems to merge with the Christian figure of St Sebastian. In fact it was this figure of Michelangelo's that Lodovico Carracci and Guido Reni took as their model for their pictures of the saint.[32]

The Dying Captive (Pl. 45), intended for one of the central pillars and therefore in frontal view, is on the point of giving up the struggle against the thongs that bind him and sinking exhausted to the ground. His eyes are closed, and his head, resting against his upheld left hand, hangs back over his right shoulder; his right hand is held limply in front of his breast. Behind the captive crouches the unfinished figure of an ape, holding a round object – possibly a mirror.

Not since his *Bacchus* had Michelangelo revelled with such delight in a single figure, in the ideal beauty of the young, naked body, or given

the marble such delicate, glowing, flesh-like tones. But his *Captive* is more thoroughly steeped in nature, its ideal quality far greater. The classicistic style of the early work has given way to true classicism.

The interpretation of the figure, beyond its significance as a symbol of the captive human soul, has caused a good deal of difficulty. Is the slave dying, or sleeping, or awaking? Or are we, as Carl Justi has suggested, in a twilight zone between life, sleep and death, 'as though death, like a compassionate brother, had brought him unexpected relief, and the artist had caught his image in that fleeting instant before he sank to rest'?[33]

As with Michelangelo's early works, we must not seek a specific point of reference but restrict ourselves to the realm of the typical. Fifteenth-century Italian statues of St Sebastian, such as Antonio Rossellino's in Empoli[34] and Benedetto da Maiano's in the Oratorio della Misericordia in Florence,[35] seem to have given Michelangelo his point of departure, for these already show the transformation of the classical theme into a Christian one. But by portraying the captive's eyes as closed, he has given the head an entirely new meaning, and intensified this meaning by the movements of the arms and the motif of the heaving breast. We recall the dying son in the *Laocoon*, or the dead child of Niobe (Florence).[36] Michelangelo has portrayed, not a man on the point of death, or a sleeping figure on the point of waking, but a man in agony, and the figure must be interpreted as a symbol of suffering against which it is useless to struggle but which also lends wings to the soul.

The statue of *Moses*[37] (Pl. 46), which later became the main figure in the lower storey of the tomb, was originally intended for the upper storey. It has to be viewed from twelve or thirteen feet below. The Berlin drawing sets it above the right niche at the front, but one wonders whether, in the final design, it ought not to stand rather above the left niche. Only when seen from the right does it reveal its true form and dynamism: the left leg drawn back, thus turning repose into action; the right leg solidly planted, bearing the weight of the body; the bent left arm, and above it the head, smouldering with passion. Even the barely visible right arm, with the right hand resting firmly on the tablets of the law, acquires definite form when the figure is viewed from this angle.

Moses is wearing a sleeveless tunic; his legs are covered – *all' antica*,

as Condivi says[38] – by the kind of hose and stockings worn by prisoners on Roman triumphal arches, and draped over his right knee is the scarf which he uses to shroud his divinely inspired features.

Already known to Michelangelo was Andrea di Firenze's fresco *The Triumph of St Thomas* in the Spanish Chapel by the church of S. Maria Novella in Florence, which depicts Moses on the saint's right between Matthew and Luke and Isaiah and Solomon.[39] He is shown, in frontal view, sitting with his hands on the tablets, a broad robe draped round his shoulders, with horns like tongues of flame, an image of grave, almost threatening prophetic power. The Berlin drawing shows him very similar, thus indicating that here too Michelangelo started from a pre-existing composition, though going far beyond it in the course of his own work.

But the strongest influence on the emergence of the statue from the sketch – we know nothing, unfortunately, about the various phases in the development – is that of another work in Florence, Donatello's seated figure of *John the Baptist* for the Cathedral façade, now in the Cathedral Museum.[40] The right hand resting firmly on the upright tablets, the left hand lying across his lap, the deep fold of the cowl across his knees – these features suggest Donatello's figure. But what a difference! Donatello's *Baptist* is portrayed from the front, and the figure is hardly independent of the robe, which is the dominant feature. With Michelangelo, however, it is as if the figure had come to life, communicating its central power to all the details of the composition. The frontal aspect has gone, and by drawing on the understanding of nature that he had gained from his studies of late Hellenistic art, such as the Belvedere torso, Michelangelo has given his own individuality to the theme taken from Donatello, sacrificing nothing, however, of the typical characteristic nature of the subject. Among Michelangelo's own works the prophets *Joel, Jeremiah* and *Daniel* from the Sistine ceiling are the greatest predecessors of his *Moses*.

Although there can be no doubt that the statue *is* a representation of Moses, Michelangelo has blended, as always, a strain of subjectivity into his objective statement, incorporating both himself and Julius in the figure, as Herman Grimm has observed.[41] Indeed, it may have been this merging of the figure of the Pope with that of the mighty prophet that

led him in spite of all his aesthetic doubts to make it the centre-piece of the tomb in its final form. Yet one must not overlook the elements of self-portrayal: the experience of creation, even of *terribilità*, that is expressed here was his own experience.

As a complete project, the design of 1513 suffered the same fate as that of 1505, and in the summer of 1516 it was abandoned altogether. Instead, an architectural project, that for the façade of S. Lorenzo in Florence, occupied his attention. So the 'tragedy of the tomb' for Pope Julius continued on its course – a tragedy now all the greater in that the more fragments there were, the more difficult a coherent solution became. By 1516 there were already in existence the façade of the lower storey, the two *Captives* and *Moses*, all of which imposed their obligations on the artist. If the basic plan were changed, would they have to be jettisoned? Or should the new figures be determined by the old?

2 THE FAÇADE OF S. LORENZO IN FLORENCE

As sculptor and painter, Michelangelo is one of the founders of the Italian High Renaissance. However personal, however inimitable his style from the beginning, it is he, and no other, who brought the High Renaissance to its full flowering. As architect, however, Michelangelo conquered the Renaissance style and became the herald of Mannerism, even of baroque. He was forty-one years old when, by his own choice, he undertook his first big architectural task – the design of the façade of S. Lorenzo. This work shows him resisting the early and High Renaissance adherence to rules and asserting his freedom from them. His buildings – and this remains true right down to his last years – can only be judged by their own standards, not by the classical norms by which the Renaissance was bound.

There is a great difference between his first architectural works done in Florence and his late works done in Rome. For in spite of the independence of mind that he displayed from the beginning, the *genius loci* had a considerable influence. The façade of S. Lorenzo, the New Sacristy and the Laurentian Library all breathe the spirit of Florence; his late Roman buildings, on the other hand, are solely the product of his encounter with the spirit of antiquity that had been bequeathed to Renaissance Rome.

Our earliest examples of the art of Michelangelo the architect are the 1505 project for the lower storey of Pope Julius's tomb and the structural design of the Sistine ceiling. In both cases the forms are those of the High Renaissance of Rome – those of the former recall the prelatial graves of Andrea Sansovino in S. Maria del Popolo, with their delicate Renaissance ornamentation. It is possible that Michelangelo, together with Giuliano da Sangallo, Bramante and others, was involved in the first plans for New St Peter's, and although the sources make no reference to it,[42] his later indebtedness to Bramante, and his own design of 1505, do suggest something of the kind. About his training as an architect we know nothing. He himself said on a number of occasions that he was not an architect,[43] and Condivi reports that 'he never intended to make a profession of architecture'.[44] Once more it appears that he wanted to draw a veil over his beginnings.

In 1515 it was proposed that the Medici church in Florence, Brunelleschi's new S. Lorenzo, which still had no façade, should be completed. It seems to have been Giuliano da Sangallo who aroused the interest of the new Pope Leo X de' Medici, with whom Michelangelo had grown up in the house of Lorenzo il Magnifico, in this idea,[45] and when the Pope visited Florence in November 1515 – for which occasion Jacopo Sansovino and Andrea del Sarto hastily erected a mock façade for the still unfinished cathedral – he decided to carry out the plan. A kind of competition seems to have developed between Giuliano da Sangallo (who died the following year but who had apparently already made a number of sketches),[46] Antonio da Sangallo the Elder, Andrea and Jacopo Sansovino, Raphael and the cathedral architect, Baccio d'Agnoli,[47] as well as Michelangelo.

The documentary sources do not tell us how it came about that Michelangelo received the commission.[48] Some twenty-five years later, in a letter to Aliotti (end of October 1542), Michelangelo himself gave the impression that it was only because Leo wanted to interrupt his work on the tomb of Julius, whom Leo had detested: 'Pope Leo did not want me to work on the tomb, saying that he wished me to build a façade for S. Lorenzo, and demanding my release from Cardinal Aginense. The latter had no alternative but to consent, though he stipulated that I should continue to work on the tomb while I was in Florence.'[49]

Likewise Condivi emphasizes that it was the Pope's initiative:

Michelangelo, who had applied himself to the tomb of Julius with great enthusiasm, resisted Leo's approaches, pointing out that he was under an obligation to Cardinal Santiquattro and Cardinal Aginense, and could not fail them. But the Pope was quite determined, and replied: 'Leave them to me; I will satisfy them.' So Michelangelo, in tears, left the tomb and went to Florence.[50]

But these accounts of Michelangelo's and Condivi's do not appear to correspond entirely to the facts. Indeed, disturbed by the disagreements between the new Pope and the house of Rovere, he actually seems to have applied for the attractive task of designing the façade in his native city.[51] 'I am confident', he wrote from Carrara in 1517, 'that I could make this façade into a mirror of the sculpture and architecture of the whole of Italy [*lo specchio di tutta Italia*].'[52] In a letter from Seravezza he writes: 'With God's help, I will create the finest work in all Italy.'[53]

In October 1516 the Pope invited Michelangelo and Baccio d'Agnolo to undertake the work. But the two men could not co-operate. Michelangelo, for example, called the model in wood which Baccio had made from his drawing, 'a children's toy' (*una cosa da fanciulli*),[54] and in March 1517 the Pope decided to put Michelangelo in sole charge, although the contract was not concluded until January 1518.[55] The years 1516 to 1519 were spent in Carrara, Rome, Florence and the new quarries in Seravezza. In 1518 he transferred his residence from Rome to Florence. When the planned façade came to naught and the Pope revoked the contract in 1520, Michelangelo called it 'a monstrous insult' (*vituperio grandissimo*).[56]

Michelangelo's façade elevations for S. Lorenzo (drawings and a model in wood) show clearly the derivation of his formal concepts from Giuliano da Sangallo, who was probably his teacher. His first design, of which only copies have survived, is developed from Sangallo's (Uffizi No. 277a; Pl. 47).[57] Giuliano was an enthusiastic student of classical art and the first in Florence to convert the Tuscan tradition of S. Miniato and S. Maria Novella into the full classical style of the High Renaissance. His façade elevation corresponds to the basilical character

of the church: a main storey covers the full width of the three-aisle building, and above it is a mezzanine surmounted in the centre, above the nave, by a classical order with entablature. Paired pilasters on high socles show the main stress-points, and the upper order, independent in itself, repeats the lower order. The wall-surface, in contrast to the flatness still found in Leon Battista Alberti's façade for S. Maria Novella, has a marked plastic quality as a result of the projecting pilasters, the prominent cornices, the niches, tondi, reliefs and statues.

Michelangelo's earliest design (Casa Buonarroti No. 44a; Pl. 48)[58] is a continuation of this: it has a main storey with paired pilasters, a mezzanine or attic with corner tabernacles, and an upper order over the centre aisle with triangular gabled roof. But even here Michelangelo gives these elements an expressiveness derived less from his model than from his own personality. Thus the balance between load and support which Sangallo was concerned to create is disrupted by Michelangelo's emphasis on load; the socle is almost completely eliminated, the mezzanine, tabernacles and upper order – after various recalculations – made higher. Here for the first time we see the pediment of the main lower order stretching into the mezzanine – a motif later to acquire considerable importance in baroque architecture.

A variant of this earliest design (Casa Buonarroti No. 91A)[59] shows a looser relationship to Sangallo. The tabernacles are done away with and the mezzanine made heavier; the overlapping lower-order pediment is also absent. The result is not very satisfactory. A second variant (Casa Buonarroti No. 47a; Pl. 49)[60] shows the first design in its most developed form. It is closer to Sangallo but makes decisive corrections in the structural calculations. The socle is again reduced, tabernacles emphasize the corners, and the mezzanine is higher and heavier; instead of the lower-order pediment projecting into the attic zone, we have a new upper order with its pilasters set above those below. This is the first time we meet a colossal order in Michelangelo, though it had already been used by Alberti in his façade elevation for S. Andrea in Mantua. Later it was to become one of the main features of his architectural style, as in St Peter's and the palaces on the Capitoline Hill – a counterpoint of forces to set alongside Giuliano da Sangallo's balance between load and support.

Michelangelo's second design (Casa Buonarroti No. 43a; Pl. 50)[61] also starts from a design by Sangallo (Florence, Uffizi No. 279).[62] Here Sangallo divided the façade into two almost equal stories, giving it the appearance of a square; the pilasters were arranged as in the first design. Building on this idea, Michelangelo again increased the downward thrust, keeping the socle low but interposing an attic zone between the two stories and above this a further socle for the upper storey; there is a central triangular pediment, and in place of Sangallo's statues at the top he has set candelabra, tall ones by the sides of the pediment, smaller ones above the outer corners of the façade.

As so often in his later architectural works, Michelangelo here does not see the columns and pilasters of colossal orders as discrete units standing in front of a wall but links them to the wall-surface by pilaster strips to form a single entity. To a greater extent than Sangallo and the other masters of the High Renaissance, he seeks a totality of effect and turns the colossal orders – which he, like the others, respects – into what have been called 'symbols of the strength residing in the architectural mass as a whole'.[63]

There is a further novelty about this elevation. The façade is not simply superimposed on the wall of the church like a veneer but, like Alberti's S. Sebastiano and S. Andrea in Mantua, is a three-dimensional structure in its own right, a narthex. We do not know how the inside would have looked, but the outer walls are clearly visible, and from the wooden model in the Casa Buonarroti we can see that the order of the front would have been continued on the sides.

This second sketch may be regarded as the final one. The model in the Casa Buonarroti (Pl. 51)[64] – which is not the *modello di legname* mentioned in the contract – adheres to it but reduces its size: the additional socle for the upper storey, for example, has been removed.

Like Giuliano da Sangallo, Michelangelo planned for a considerable number of statues. According to the contract,[65] there were to be six standing figures for the centre and six for each of the sides of both the upper and lower storeys (the lower niches have not been drawn in the sketch), and six seated figures in the attic zone; in addition, there were to be six figures in relief above the niches in the upper storey. The 'five scenes in rectangular panels and two in tondo form' referred to in the

contract would have been placed in the attic (above the doors) and in the upper storey.

The identity of most of these figures – they were chosen by Cardinal Giulio Medici – is known from a letter to Michelangelo written by Domenico Buoninsegni on 2 February 1516:[66] the standing figures were to be St Laurence, patron of the church, John the Baptist, patron of Florence, Peter and Paul, the principle saints of Rome, and Cosmas and Damian, patron saints of the Medici family; the seated figures were the four evangelists, while the reliefs probably portrayed the legend of St Laurence and – as emerges from a drawing by Giovanni Battista Nelli in the Uffizi[67] – the crucifixion of Peter and the conversion of Paul. It is even possible that, as Tolnay suggests, Michelangelo's phrase 'lo specchio di tutta Italia' refers to this series of figures.

3 FURTHER WORK ON THE TOMB: THE DESIGN OF 1516

Michelangelo's façade elevations for S. Lorenzo are his first steps away from the classical world of the High Renaissance and towards the anti-classical world of Mannerism. His 1516 design for the tomb of Pope Julius shows him following the same path.

On 8 July 1516 a new contract was drawn up.[68] The period for completion was extended to nine years, and Michelangelo was to be allowed to work on it in Rome, Florence, Pisa, Carrara or wherever he wished. When he moved to Florence in 1518, he had the *sbozzati* taken there from Rome but left behind the completed lower storey, together with the statues he had already finished.

The scale proposed in the new contract is considerably smaller than that of the project of 1513 (Fig. g). The front of the lower storey remains the same but the sides are reduced to a length of about ten feet; in fact the measurements in the contract of 1516 correspond to those in the subcontract of 1513.

The upper storey is now completely changed. In place of the twenty-five-foot high *cappelletta* we find a complete new upper structure some fourteen foot high, with applied columns standing on ornamental socles; the seated figures at the sides are no longer exposed but set in rectangular niches, and in the centre is a so-called *tribunetta* (small platform). This upper storey is crowned by a cornice, above which

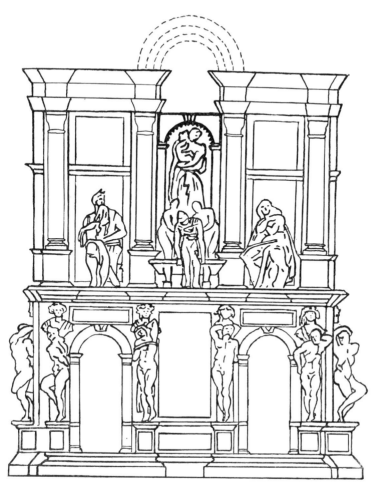

g Pope Julius's tomb. Design of 1516. Reconstruction.

there would probably have been some form of lunette or pediment.[69]

There has also been a reduction in the number of figures compared with 1513: single figures replace the earlier groups (virtues and vices) in the tabernacles of the lower storey, but we know nothing of their identity. A bronze relief occupies the central position. There are now four seated figures in the upper storey (two at the front, one on either side), not six, with a bronze relief above each. We may assume that *Moses* was one of these four – the only one to be completed.[70] The

89

tribunetta was for a statue of Pope Julius, flanked by two other figures, together with a standing Madonna. Six further figures, therefore – two at the side of the sarcophagus and four by the *cappelletta* – are omitted here. A bronze relief was intended for the space above the Madonna.

The 1516 design, however, cannot be seen merely as a smaller version of that of 1513. It is clearly Michelangelo's desire to offset his disappointment at having to scale down his plan by increasing the wealth of tectonic detail, and above all to solve the problems posed by the earlier version. The 1516 design is certainly the more satisfactory, and beyond this it offers something quite new in the history of the wall-tomb as represented by Andrea Sansovino's prelatial tombs. Finally, in spite of all the changes that were yet to come, it is here that one finds the roots of the work that eventually came to stand in S. Pietro in Vincoli.

The adoption of a two-storey design, and the relationship of the two parts to each other – the upper storey is fourteen foot high, the lower storey a little over ten foot[71] – make for a close relationship to the designs for the façade of S. Lorenzo. The question of priority here is not an easy one: the relationship only becomes apparent with the second façade elevation made in spring 1517 (Casa Buonarroti No. 43a), but as Michelangelo seems to have been working on the project from the end of December 1515,[72] we may perhaps conclude that it was his work on the façade that helped him to redesign the tomb.

As with the façade, so also with the tomb design of 1516 Michelangelo may be assumed to have started from Giuliano da Sangallo. But again we see Michelangelo's tendency to unsettle the balance between load and support at which Sangallo had aimed. The heavy upper storey bears down upon the lower part, and from being mere ornamental additions, like the orders of the façade, the sculptures in the lower part are made symbols of the strength that typifies the whole structure. It is also characteristic that the architrave above the herms should now disappear and that the herms should touch the cornice above them; in fact, Michelangelo even seems to have considered dispensing with them altogether and making the captives in front of the pilasters into atlantes. The figures who in the 1513 design are seated independently on their thrones in the upper storey are now put into the rectangular niches between the

columns, the sarcophagus is set parallel to the wall, and the motif of the ascent into Heaven gives way to the motif of the *Rondanini Pietà*.[73] The group of figures round the Pope is crowned by the figure of the Madonna.

Michelangelo still does not appear, however, to have settled down to continuous work on the tomb. There are references to two statues in 1518[74] which were to be finished by the summer of the following year, and to four more statues in that year itself.[75] But in 1520, after his contract for S. Lorenzo had been terminated, Michelangelo accepted a new commission for a funerary chapel for the Medici family in the same church, and the prospect of ever finishing Julius's tomb, even in its smaller form of 1516, became more and more remote. Yet the contract of 1516 remained in force until 1532.

Michelangelo devoted fifteen years to the Medici Chapel of S. Lorenzo in Florence. Yet this project too ended in tragedy: changes of patron, financial difficulties, the problem of working on this new commission and the tomb for Pope Julius at the same time, other assignments, above all that for the Medici library – all these conspired to delay the completion of the work. The political events of the years 1527-30 brought his activity to a complete standstill on occasion. Florence was ravaged by the plague and invaded by Spanish and German troops; there was a rebellion against the Medici; Michelangelo acted as military engineer to the anti-Medici forces during the siege of Florence, then fled – for the third time in his life – as the city fell, afterwards returning and receiving a pardon. The final blow came with the Pope's command that he should paint a *Last Judgement* for the Sistine Chapel. In 1534 he went back at last to Rome. 'No power on earth could move him to give thought to the Medici Chapel, let alone to complete it, either now or later, however hard Cosimo, the second Duke of Florence, tried.'[1]

But the years he spent on the chapel were of great importance for his development as an artist, for they embrace the change, already felt in his façade for S. Lorenzo and the 1516 design for Julius's tomb, from High Renaissance to Mannerism, and prepare the way for his later style. His figures increasingly lose their individuality to the incursion of alien forces which give their movements an unnatural, often agonized intensity expressive of a dark, unfathomable melancholy. Without losing its influence, antiquity seems to take second place to the spirit of the Middle Ages. Moreover these years mark the increasing dominance of his artistic thought by the values of architecture.[2]

In 1516 Giuliano, youngest brother of Pope Leo X, died at the age of

thirty-eight; three years later the Pope's nephew Lorenzo, who was only twenty-eight, also died. These were serious blows to the political prospects of the House of Medici, for as early as 1513, only six months after his coronation, Pope Leo, in a solemn ceremony on the Capitoline Hill, had raised them to the ranks of the Roman aristocracy: Giuliano, who had become Duke of Nemours through his marriage to Philiberta of Savoy, was made *generalissimus* of the Church (hence the rod of authority that Michelangelo gives him), and had prospects of gaining the kingdom of Naples with the help of France; Lorenzo – dedicatee of Macchiavelli's *The Prince* – had been made Duke of Urbino after the fall of Francesco Maria della Rovere. He died in a state of insanity – Michelangelo portrayed him in a mood of deep introspection. On his death Pope Leo is said to have cried: 'Now we are no longer of the House of Medici but of the House of God!'[3]

At the instigation of his cousin, Cardinal Giulio de' Medici (later Pope Clement VII), Leo decided to erect a mausoleum in S. Lorenzo in memory of the two young Medici dukes, and to transfer there the bodies of the two Magnifici – Lorenzo il Magnifico and his brother Giuliano, murdered in 1478 – which had been lying in the Old Sacristy. To this end, and as a counterpart to Brunelleschi's Old Sacristy with the tombs of his grandparents Giovanni d'Averardo and Piccarda da Buggiano, and his brothers Giovanni and Piero, he founded a second family chapel in the so-called New Sacristy. (The later plan to have the bodies of the Medici Popes, Leo X and Clement VII, interred here also was never carried out.)[4]

The New Sacristy stands on the north side of the choir of S. Lorenzo. For a long time little was known of its history, but recent research has uncovered some information.[5] Above all, we now seem entitled to believe that, though complementary to Brunelleschi's Old Sacristy, it is entirely the work of Michelangelo and not, as had often been maintained, a project begun by Brunelleschi and merely completed by Michelangelo. For the main body of the chapel Michelangelo apparently had to use the remaining foundations of the massive transept, with its chapels,[6] six planned by Prior Dolfini (Brunelleschi's predecessor) to stand behind the Romanesque church and laid in 1419.[7] New foundations were required only for the altar chapel and the two chambers on either side of it.

The idea of erecting a counterpart to the Old Sacristy appears to have been mooted about 1516, possibly in connection with the project to build a façade. A plan of S. Lorenzo in Giuliano da Sangallo's Siena sketch-book shows just such a chapel,[8] and in June 1519, shortly after Duke Lorenzo's death, the decision to build a funerary chapel there was finally made.

How Michelangelo came to receive the commission, and how he set about it, we do not know. The contract has not survived, and the various extant subcontracts, sketches, reports, letters and above all drawings all need detailed interpretation if they are to reveal their true significance.

In November 1520 Michelangelo sent his final design for the chapel to Cardinal Giulio de' Medici, the driving force behind the enterprise,[9] and according to the plan, building must have started the same year.[10] It went on till 1524. The work on the tombs, however, did not start until 1524, partly because of the Cardinal's financial difficulties, partly because of the slowness with which the marble was quarried at Carrara, and partly because of the problems of transporting it.[11] During the years between starting the designs and actually beginning work on the tombs Michelangelo made full-scale wooden models.[12] In 1526 political conditions in Florence forced him to interrupt the work, and it was not started again until 1530. From 1532 to 1533 Giovanni da Udine applied the stucco to the coffers in the dome and decorated them with scrolls, birds and masks, but these were painted over by Vasari in 1557.

The New Sacristy (Pl. 52) is Michelangelo's oldest completed building. Its square plan surmounted by a dome, with an altar chapel and side-chambers, corresponds to that of the Old Sacristy. All four walls of the altar chapel are articulated alike – pilasters of dark-grey Tuscan sandstone (*pietra serena*) framing the white stuccoed surfaces – which emphasizes the unitary construction (as in Brunelleschi's Pazzi Chapel). The walls are recessed under the large central sham arches and edged in *pietra serena* which is part of the membering rather than of the wall. One is left with the impression that the pilasters in *pietra serena* are backed by the same material – the same effect as in the fusion of columns and wall-surface found in the second design for the façade of S. Lorenzo.[13]

The cornice and the introduction of a middle storey with tabernacles

which continues the membering of the lower storey are not taken from the Old Sacristy but from another Florentine model, namely Giuliano da Sangallo's sacristy in S. Spirito.[14] But whereas Sangallo keeps the two storeys apart, Michelangelo links them by the monumental central arches in a manner which is found in Central Italian altars and tombs from 1480 onwards, and which he knew from Siena (the Piccolomini altar) and Rome (Andrea Sansovino's prelatial tombs).[15] One may also recall the Pantheon in Rome.[16]

In the pendentive zone Michelangelo finally leaves the Florentine tradition behind. The oculi are confined to the pendentives, but the lunettes each have a tabernacle window tapering towards the top, with segmental pediment; the pattern of pendentive and oculus leads the eye upwards to the coffered dome which crowns the whole structure. The altar chapel, with its oculi, pendentives and flattened cupola, closely follows Brunelleschi. To the *pietra serena* work in the sacristy Michelangelo added contrasting elements in veined white marble, including the figures for the tombs themselves.

The illumination of the chapel is interesting.[17] The east and south windows of the middle zone and the south window of the tambour are blind-windows: the only light comes through the north and west windows of the middle zone and the north, west and east windows of the drum. In both stories the windows are higher on the outside than on the inside. In this very non-traditional way – which he also adopted on a number of later occasions – Michelangelo beamed the light into the chapel, not horizontally but diagonally downwards into the area where the tombs stood.

As it now stands, the chapel is little more than a rump. To gain a true impression of its real character one must realize that the entrance wall was intended to have the same marble design as the side walls, that there were to be statues not only on the sarcophagi and in the central recess but also in the side niches, on the floor beneath the sarcophagi and even in the attic zone, and that the lunettes were to be filled with frescoes.

The external north and east faces of the building (Pl. 53), which stands on a slightly projecting base of hewn stone, have a pattern of pilasters and entablatures which picks up the sham arch pattern of the nave; the west side, originally virtually hemmed in by houses, was left

unrendered (it has since been worked over). The drum rests on a square base: in the middle of three of its sides are tall, rectangular windows with simple frames – the windows which, with those in the lunettes, admit light into the chapel. At the top of the drum is a prominent dentilated cornice, and above this the hemispherical cupola surmounted by a decorative lantern in the style of Brunelleschi's lantern for the Duomo in Florence. Michelangelo's lantern (Pl. 54) is a dodecahedron supported on a balustrade with a column at each of its angles; above a heavy cornice is a series of oculi and a concave conical roof joined to the cornice by means of short volutes. At the very top are an orb and a cross. This lantern was later to become the model for that of St Peter's in Rome.

As with the monument for Pope Julius, Michelangelo first planned a free-standing tomb for the two Magnifici and the two Medici dukes which would occupy the centre of the chapel and be in the form of the classical *arcus quadrifons* requested by Cardinal Giulio.[18] We are again put in mind of the unhappy earlier history of the memorial to Julius: the two works are intimately connected, and the latter unthinkable without the former. At the same time Michelangelo considered the possibility of a wall-tomb which should embody some of the characteristics of a free-standing tomb: he first envisaged two double tombs[19] (one for the Magnifici, the other for the dukes), then two single tombs and one double.[20]

We have sketches of the tombs but not of the interior of the chapel as a whole; nevertheless, in contrast to the monument for Julius, the tombs and the interior architecture are intimately connected, although there is no reason to assume that the interior of the chapel was to have been drawn into the same iconographical programme.

This programme – as we can see from the sources – was not laid down at the start but developed in the course of the planning. For instance, the idea of showing the seated figures in the upper zone as idealized likenesses did not emerge until the end, nor were the allegorical figures on the sarcophagi there from the beginning. But in general it is difficult to follow the development of the iconography from the sketches; nor do we know for certain which of the two figures of the dukes was done first, or how to date the individual statues. Since the period between the

award of the commission and Michelangelo's return from Rome covers over fourteen years, we can only answer these questions – which are important for a knowledge of his artistic development – on stylistic evidence.

When Michelangelo abandoned the work in September 1534, the statues of the dukes had just been erected, but not the allegorical figures or the three statues by the entrance wall. The membering of this wall had not yet been started, nor had the statues at the side of the throned figures, the river-gods beneath the sarcophagi, the figures in the attic zone or the paintings in the lunettes. From 1537 Duke Cosimo I de' Medici made repeated attempts to have the chapel finished but Michelangelo would not co-operate. In the mid-1540s Cosimo had the allegorical figures erected, and by 1548 – possibly even 1545 – the bodies of the two dukes were laid to rest there; also buried in Lorenzo's sarcophagus was Duke Alexander, Cardinal Giulio's much-hated illegitimate son, who had been assassinated in 1537.[21] The bodies of the two Magnifici were interred by the entrance wall in 1559, and above them, between the two patron saints of the Medici, Cosmas and Damian (carved by Montorsoli and Raffaello da Montelupo after Michelangelo's models), was set the figure of the Madonna. At the same time Vasari laid the floor and had the front wall stuccoed. This is the chapel as it again stands before us today.

Lorenzo's tomb (Pl. 55) stands against the west wall of the chapel, Giuliano's (Pl. 56) against the east wall. The walls are divided by the *pietra serena* into three bays: the centre bay, slightly inset, contains the tomb, while the two narrower side-bays have doors.

Architecturally both the central and the two side-bays have two stories, and the centre bay is divided in turn into three.

The centre bay, framed by two broad pilasters, projects beyond the two empty tabernacles on either side. On a plinth in front of this centre bay stands the sarcophagus, with volutes on its curved cover. The upper tier rests on an architrave with a pattern of palmettes which also runs over the capitals of the lower pilasters. Of the three niches the two at the sides have segmental pediments, while above the central, slightly wider niche is a blank space intended for an inscription.[22] On either side of the centre niche stands a pair of slender, fluted pilasters – of about the same

width of the lower pilasters – which carry the movement upwards and support the attic zone. There are delicate strips at the sides and signs of a further mitred cornice round the entablature – a bold motif which gives particular point to the tension between the membering of the wall and the architecture of the tomb. The attic zone consists of two ornamented thrones above the pilasters and two cartouches decorated with festoons; in the centre between the thrones is a plain panel with a single voluted decorative motif. The dolphin motifs above the segmental pediments of the side-niches in Lorenzo's tomb are missing from that of Giuliano.

Above the doors in the side-bays are tabernacles – a motif found in the Old Sacristy but here in a quite different form. For while in the former the natural balance between load and support is observed, in the latter the relationship between the door and the niche has been reversed: the tabernacles are larger and more ornate and seem to grow out of the doors, forcing themselves up against the architrave. The projection of the frame members into the pediment zone and the mouldings on the pediment anticipate the style of the Biblioteca Laurenziana. It was in connection with this kind of fantastic ornamentation, 'which contains more of the grotesque than of rule or reason', that Vasari said of Michelangelo the architect: 'He broke the fetters and chains that had previously bound all artists to the creation of traditional forms.'[23]

The centre niches are occupied by the seated statues of the dukes, and on the curved roofs of each sarcophagus beneath them lie two allegorical figures – one man and one woman.

Although the chapel as a whole, like the individual walls, has remained unfinished, Michelangelo's conception of the tombs is clear. The architecture and the sculpture act one upon the other, forming a single indivisible unit. The architrave of the lower level seems to be bearing down upon the recumbent figures, and only their heads project above it. The dukes, on the other hand, are freer, more relaxed, though they too sit brooding within the confines of their narrow niches. The allegories are closer to us, are part of our own world, whereas the dukes are above us, living in their own realm. Every single movement, however matter-of-fact, has its significance for the movement of the piece as a whole. The three figures themselves form a pyramid.

At the same time there is a counterpoint between the figures and the architecture. As the architrave of the lower zone presses down on the figures, the emphasizing of the side-niches by their pediments and their voluted consoles, runs counter to the pyramidal formation of the three figures in the centre, while the segmental pediments and the volutes echo the form of the sarcophagi. On the other hand, the architecture also moves parallel to the figures in places: the pilasters on either side of the centre niches pick up the movement of the allegorical figures, and as the latter overlap into the middle level, so the pilasters penetrate into the attic zone and lead the eye upwards.

Such a relationship between architecture and sculpture is something quite new. The 1505 and 1513 projects for the monument to Julius use architecture primarily as a containing framework: the zones are kept strictly separate, and the sculpture is fitted into the architecture. The project of 1516 and the façade for S. Lorenzo show the beginnings of a change, and by the time of the Medici Chapel the natural relationship seems to have been completely destroyed: the allegorical figures are now quite independent of the architecture – indeed they obscure it – and sculptural motifs from the figures are taken up by architectural motifs in the upper zone, bringing about an interplay between the organic forms of sculpture and the structural forms of architecture.[24]

The High Renaissance has now been left completely behind. But does this incorporation of sculpture into architecture revive a medieval tradition? The differences are considerable, for Michelangelo remains the disciple of antiquity, and his figures, though bound to their context, are free and independent creatures; free by nature, they suffer under, and rebel against, the fate that binds them.

The independence and self-sufficiency of the figures entitles us to consider them apart from their context, and this is the point at which the question of their chronology arises.

The seated figures of the dukes in the garb of Roman generals follow the line that leads from Michelangelo's bronze statue of Pope Julius II for S. Petronio in Bologna (destroyed in 1511) through the prophets and sibyls of the Sistine ceiling to the figure of *Moses* in the monument for Pope Julius. Their subject is agitation of mind matched by composure of body. *Lorenzo* (Pl. 57), *il Pensieroso*,[25] though outwardly relaxed, sits

deep in thought. His weight rests on his left side – his left leg is firmly planted on the ground, his left shoulder is lowered and he leans on his left elbow. His right side has an open quality: his right leg is crossed almost casually in front of the left, and his right arm – twisted in a manner first found in the *Madonna of the Stairs* and later in the sleeping figure of Adam in the Sistine Chapel and the Christ of the Florentine *Pietà* – rests limply against his thigh, while his head too is slightly inclined to the right. *Giuliano* (Pl. 58), on the other hand, *la Vigilanza*,[26] his general's baton across his knees, has his head turned sharply to his left; there is the same unequal distribution of weight between the legs – similar to *Moses* – and the same difference in the level of the shoulders.

A letter of Michelangelo's to Fattucci on 17 June 1526[27] says that he started work on the 'second duke' in 1526, but the work was put on one side after this and not resumed until 1531. Most of the work on the 'second duke' was probably done after 1531 – but we do not know which of the two this is.

The two figures undoubtedly form part of a single conception,[28] each corresponding to the other in form but contrasting with the other in personality. The differences between them are not due to their having been carved at different times but are the product of artistic intent. At the same time one can detect a stylistic variation in that in the figure of Giuliano the natural force of gravity has been transformed into an almost circular movement; the contours do not merely delineate but have their own power of expression. One senses that Mannerism is near – in which case this would be a later work, and probably the 'second duke'.[29]

The allegorical figures on the sarcophagi are arranged in pairs – *Dawn* and *Evening* beneath *Lorenzo*, *Day* and *Night* beneath *Giuliano*. Only *Night* has a clear iconographic significance, but far more important, as with the *Captives* for the tomb of Julius, is the inspired character of the figures who portray lamentation – over the death of the dukes – and suffering – in their condition of slavery.

All strength seems to be ebbing out of the weak body of the aged figure of *Evening* (Pl. 59). The head is unfinished but the gloomy atmosphere of declining years and nostalgic musing is unmistakable. On the other side lies the maiden *Dawn* (Pl. 60), waking from sleep; with

her left foot she raises herself from her couch, and her left hand feels lazily for her veil, 'as though she wished to shield her eyes from the brightness of the day'.[30] This is Michelangelo's first sculpture of the female nude, a figure as beautiful as that of Eve in the Sistine Chapel but a tragic prisoner of her fate. 'She is held in the grip of bitter suffering,' as Vasari puts it.[31]

The iconographic sources of both these figures are to be found not only in antiquity[32] but also in Ghiberti's Gothic recumbent figures of Adam and Eve on the Baptistery doors in Florence.[33] The contrast with this work which shows how charm and consonance turn in Michelangelo's hands to melancholy and discord.

On the opposite wall, beneath *Giuliano*, lie *Day* and *Night*. The latter (Pl. 61) is one of Michelangelo's boldest and most puzzling conceptions. Iconographically its meaning can be understood from the traditional symbols of the half-moon, the star, the poppy-seeds, the owl and the mask. In 1545 Giovanni Strozzi wrote his well-known epigram on them:

> La Notte, che tu vedi in sì dolci atti
> Dormire, fu da un Angelo scolpita
> In questo sasso: e, perchè dorme, ha vita:
> Destala, se no 'l credì, e parleratti.

(The Night that you see sleeping in such loveliness was carved by an angel in this rock. Sleep is her mode of life. Wake her, if you do not believe it, and she will speak.)

To which Michelangelo, long since in Rome again, replied in the person of Night, thinking bitterly of the political fate of his native city:

> Caro m'è 'l sonno, e più l'esser di sasso,
> Mentre che l' danno e la vergogna dura:
> Non veder, non sentir, m'è gran ventura;
> Però non mi destar, deh! parla basso.

(While all about are harm and shame and woe,
How good to sleep and be but marble block!
Not to see, not to hear is my great luck;
So do not rouse me then, but please, speak low.)[34]

It is only the subsidiary motifs that belong to tradition: the figure itself explores mysterious new realms. Drawing on his own knowledge of life and nature, and not, as one might first think, on some pre-conceived notion, Michelangelo portrays 'a body ravaged by successive childbirths, almost emaciated and far beyond the bloom of youth'[35] as the embodiment of the nocturnal, the inscrutable and the maternal, a primeval symbol of human existence and human activity:

> MEPHISTOPHELES: Nach ihrer Wohnung magst ins Tiefste schürfen;
> Du selbst bist schuld, dass ihrer wir bedürfen.
> FAUST: Wohin der Weg?
> MEPHISTOPHELES: Kein Weg! Ins Unbetretene,
> Nicht zu Betretende; ein Weg ans Unerbetene,
> Nicht zu Erbittende.[36]

> (MEPHISTOPHELES: To find them you must plumb the cosmic vault;
> That we have need of them is your own fault.
> FAUST: Where is the way?
> MEPHISTOPHELES: No way! To the unvisited,
> Not to be visited; to the unsolicited,
> And not to be solicited.)

We are in the realm of the Mothers in Goethe's *Faust*.

There was, however, one classical work that Michelangelo could summon to his aid on his journey into the unknown, namely a repre-sentation of *Leda and the Swan* on a Roman sarcophagus,[37] and the boldness of his work becomes apparent when one appreciates this transference of the Leda motif of conception to the fecundity of the figure of *Night*. Only Michelangelo could have gone to the extreme of portray-ing such a nude female figure on a tomb in a Christian chapel without overstepping the bounds of propriety. Also linked with the theme of Leda is the theme of mourning. Vasari writes: 'Who has ever seen a work of sculpture of any period, ancient or modern, to compare with this? For in her may be seen not only the stillness of one who is sleeping but also the grief and melancholy of one who has lost something great and noble.'[38]

The virile figure of *Day* (Pl. 62) on the other side of Giuliano's sarcophagus was probably also meant to bear a characterizing symbol (a

garland with the sun's rays),[39] but here too Michelangelo freed himself from tradition and expressed his conception in terms of the elemental motifs of Herculean strength and the act of awaking. The head, with its wide-open eyes, acquires its strength from the counter-movement of the right arm and shoulder, like a vision of the sun rising from behind the hills or over the horizon of the sea.

There are marked contrasts between the two pairs of allegorical figures. *Dawn* and *Evening* offer themselves to the observer: their movement, though complicated, is outwards. In *Day* and *Night* this outward movement is countered: *Night* rests her right elbow on her left thigh; *Day* turns his body away from the observer while twisting his head and crossing his left leg forwards. This is a distinction that corresponds to that between the two dukes and has to be stylistically interpreted in the same manner. For like the statue of *Giuliano*, *Day* and *Night* seem to have received their final form in Michelangelo's second period of work on the chapel, i.e. after 1530[40] – although their conception, like that of *Dawn* and *Evening*, belongs to the first period. As we know from sources relating to the *Medici Madonna*, the earlier and later phases of the work have to be kept apart.

There are no convincing grounds for believing that the figures of *Day* and *Night* were originally intended, not for Giuliano's tomb but for the wall where the *Madonna* now stands, with their feet touching each other and lying on a horizontal surface.[41] A horizontal pose would weaken the effect of the counter-movements mentioned above. This applies especially to *Day*: the massive right shoulder surmounted by the parallel contour of the head, the twist of the torso towards the wall, the counter-movement of thigh and legs towards the front – all these features would be weakened. As far as *Night* is concerned, it is sufficient to point out that if the body were horizontal, the owl and the mask would no longer be in an upright position.[42] It is also clear that the curve of the bodies and the curve of the sarcophagi correspond to each other in both cases. Moreover, as *Day* and *Night*, in contrast to *Dawn* and *Evening*, are characterized by a counter-movement of forms, the complementary relationship between them – the woman turned to the front, the man to the back – only emerges when the figures are in their present position.

Finally *Day* and *Night* are as closely linked with *Giuliano* as are *Dawn* and *Evening* with *Lorenzo*. The inclination of the body of *Day* towards the back wall is offset by the inclination of the Duke's left shoulder towards the front, and the movement away from the wall by *Night* offsets the withdrawal of his right shoulder. Once again we have evidence for the late dating of *Day* and *Night*.

The only work of Michelangelo's hand for the double tomb of the Magnifici is the *Madonna* (Pl. 63). 'She is seated', writes Vasari,

> with her left leg crossed over her right and one knee placed on the other, while the Child, with His thighs astride the leg that is uppermost, turns in a most enchanting attitude, looking for His mother's milk. Our Lady, holding Him with one hand and supporting herself with the other, leans forward to give it to him. Although the statue remained unfinished, having been roughed out and left showing the marks of the chisel, in the imperfect block one can recognize the perfections of the completed work.[43]

Michelangelo worked on this *Madonna* for a long while. He began work on it in 1521[44] – the first of the sculptures for the Medici Chapel – and in 1531 it was still not finished.[45] As we can see from his sketches, he started from the conception he had employed in his Bruges *Madonna*,[46] and only in the course of the work did he settle upon its present form.[47]

What a contrast there is between the frontal aspect of the earlier work and the subtlety of movement here! The crossed legs – a motif from antiquity;[48] the turn of her body; the withdrawal of her right arm while her left moves to the front; the inclination of her head: all these movements are met by a counter-movement, yet an air of repose pervades the whole. The Child nestles against His mother's breast – but it seems unlikely that this represents, as Vasari suggests, the motif of *Maria lactans*. The rich contrasts are in the spirit of Mannerism, the melancholy · and the sense of repose are the marks of Michelangelo's own art. 'The apparent simplicity of the group', said Wölfflin, 'derives from its clarity and from the fact that one can take it in at a single glance; and it leaves an impression of serenity because its whole content is expressed in a single, comprehensive statement.'[49] Its expressiveness recalls that of the early *Madonna of the Stairs*, a work which here comes to full fruition

in the Virgin's devotion and fearful sense of the suffering and death that
were to come.

Of the works planned for the attic zone there are extant the figure of
The Crouching Boy (Leningrad, Hermitage),[50] which was possibly part
of the tomb of the Magnifici, and two battle-trophies carved by a pupil
of Michelangelo's (now in the passage leading from the chapel to the
New Sacristy). The *River-Gods* planned for the sides of the two sarcoph-
agi were never executed in marble but Michelangelo made two large clay
models for them, one of which can be seen in the Florence Academy.[51]

The Medici Chapel, which, like the church, the library and the
cloister, is part of the total complex of S. Lorenzo, bears the inscription
'Della Resurrezione del Nostro Signore'.[52] On 14 November 1532
Clement VII issued a papal bull instructing that at every hour, day and
night, except at morning mass, two priests should make intercession for
the living and the dead of the House of Medici, and that in addition at
least four masses should be read every morning for the two dukes.[53]
The dedication of the chapel to the Resurrection, together with the papal
bull, shows clearly the nature and function of the mortuary chapel:
'Requiem aeternam dona eis, Domine, et lux perpetua luceat eis.'[54]
This function must also have determined the character of the sculpture,
for one cannot imagine that ideas could have been conveyed which
ignored, contradicted or relegated to a subsidiary role the ideas of the
Church. This provides a firm foundation for interpretation.[55]

We have no documentary information about the development of
the programme for the chapel. The sketches show that Michelangelo
was not given any definite instructions and also that he himself had no
fixed plan from the outset but evolved the design in the course of the
work. This is a different situation from that of the Sistine ceiling, and
there is correspondingly greater scope for subjective interpretation.

The fundamentally ecclesiastical nature of the chapel is clear from the
sculptural features as a whole. The spiritual centre-piece is the *Madonna*,
set against the entrance wall above the graves of the Magnifici. It is on
her that the priest sets his eyes as he stands, in the manner customary in
the early Christian Church, behind the altar, at his sides the pelican,
symbol of Christ's sacrifice, and the phoenix, symbol of resurrection.[56]
The dukes are also turned towards her – *Giuliano* with his head, the pen-

sive *Lorenzo* with his whole body. This focusing of attention on one particular wall is something unknown in the art of earlier periods but it is a feature which the baroque age constantly sought to develop through the subject of the Adoration.[57] The observer is made to take up his position behind the altar – or, more precisely, the only observer is the priest standing behind the altar.[58]

The Madonna and Child symbolize the *lux perpetua* that shall shine upon the deceased. At the sides sit Cosmas and Damian, patron saints of the Medici;[59] in the lunette above there was to be a representation of the Resurrection of Christ.[60] Thus it was in this wall that the dedication of the chapel found its most concentrated expression.

The lunettes above the ducal tombs were presumably meant to contain representations of the Brazen Serpent, as prefiguration of the Passion, and of Judith, as prefiguration of Mary's victory over the Devil[61] – Old Testament themes which relate to events of the New Testament, again drawing the eye towards the Madonna and Child.

One may well ask why the figures of the two dukes are not likenesses but idealizations. What is the significance of their contrasting characters? Whom do the allegorical figures and the river-gods represent? What was the intention behind the two empty thrones in the attic zone? Is there a progress of meaning from one zone to another? And is the chapel as a whole intended to have some specific representational significance? In spite of its ecclesiastical nature, we can find no answers to these questions, and we know of no earlier Christian funerary chapel to which it can be compared. Once again Michelangelo has extended the bounds of the plastic arts, both in his conception as a whole and in the individual parts of that whole.

Among contemporary references to the iconography of the chapel we must consider first Michelangelo's own remarks. A drawing of the entrance wall (Dussler No. 153) bears the words: 'Fama preserves the epitaphs; she moves neither forwards nor backwards, for they are dead and have no more influence.'[62] This refers to the sketchy outline of a seated female figure above the sarcophagi of the Magnifici who is stretching out her arms towards the two epitaphs. At this time there was still no comprehensive programme for the chapel.

It is not easy to understand what Michelangelo means. The figure of

Fama did not long remain part of the design. It is important to note, however, that Michelangelo is thinking here in allegorical terms.

In the Casa Buonarroti there is a sheet of sketches for the socles of columns (Dussler No. 58) on which is written: 'Heaven and Earth, Day and Night speak, saying: "Swiftly we have led Duke Giuliano to his death. It is proper that he should avenge himself, and he does so thus: as we have killed him, so his death has taken the light from us; his unseeing eyes have closed our own eyes, which no more shine out over the earth. What, therefore, would he have done to us had he remained alive?"'[63]

As well as *Day* and *Night* – here shown again to be an integral part of Giuliano's memorial – we now have Heaven and Earth, which were to occupy the niches on either side of Giuliano himself. In his *Life of Tribolo* Vasari records that 'Michelangelo wanted Tribolo to do two nudes to put alongside his already finished figure of Duke Giuliano: one, garlanded with cypress-leaves, was to represent a sorrowful Earth lamenting with outstretched arms and bowed head the passing of the Duke; the other was to portray a joyful Heaven exulting, through the glory it had been vouchsafed, in the mind and spirit of this noble figure.'[64]

Again we find ourselves in the world of allegory, and again we find ourselves confronted with difficulties of interpretation. But it is at least clear that we are dealing with the transience of life and the swiftness of death, opposed to which are the concepts of resurrection and eternity: 'O Death, where is thy sting? O Grave, where is thy victory?'[65]

Michelangelo himself, in the spirit of Dante, described this dichotomy in his poem on the death of his father in 1531:

> Fortuna e 'tempo dentro a vostra soglia
> Non tenta trapassar, per cui s'adduce
> Fra no' dubbia letizia o cierta doglia.
>
> Nube non è che scuri vostra luce,
> L'ore distinte a voi non fanno forza,
> Caso o necessità non vi conduce.
>
> Vostro splendor per notte non s'ammorza,
> Nè crescie ma' per giorno, benchè chiaro,
> Sie quand' el sol fra no' il caldo rinforza.

(Vicissitudes of time can never soar
To where you are, while here we still are crushed
By doubt of joy and certainty of war.

By no dark cloud your light is ever hushed,
For our years, numbered, us alone defeat –
Us, tossed about by time and sorely anguished.

Your splendour, oh, no night will ever split,
Nor can the rising morning make more clear
As it does here, where dawn soon turns to heat.)[66]

These lines, written during the years when he was working on the Medici Chapel, almost seem like a key to the 'mystery of the Medici tombs'.[67] The symbols of earthly transience, *Day* and *Night*, lie on the graves, with *Dawn* and *Evening* (these appellations already come in the first edition of Vasari's work in 1550[68]) as their counterparts. They lament the brevity of life, which ends in death; they cannot enter the gates of Heaven but are confined to the grave, to the realm of death, condemned to endure this slavery for ever. Above them, liberated from the tyranny of time, the glorious dukes turn their eyes to the Virgin and Christ, from whom come salvation and the certainty of resurrection and immortality. And above the dukes the empty thrones[69] – symbols of the presence of God – mark the transition to the lunettes with their depiction of man's salvation.

Michelangelo's thoughts are matched by Condivi's description of the tombs: 'On the sarcophagi lie two figures, a man and a woman, both above life-size, representing day and night; together they personify the inexorable march of time.'[70]

There are at the same time contemporary examples of the cult of the glory and praise of the Medici; this even seems to be present in Michelangelo's own statements on the tomb of Giuliano, and both in the *Due Lezioni* (1549) of the Florentine humanist Benedetto Varchi[71] and in Vasari[72] it is the central consideration. This represents a change of attitude towards life which can be seen in Italian tombs from the fourteenth century onwards and which reveals itself in the introduction of biographical and eulogizing elements such as scenes from the life of the deceased, portrayal of the virtues, the liberal arts and so on.

However, this must surely be a subsidiary, not a main theme. Can one conceive that Michelangelo, of all people, would have put 'the urge of Renaissance princes for immortality'[73] above traditional religious attitudes? We only need think of the symbolism of the tomb for Pope Julius to see how impossible this is.

More important is the question frequently raised by modern scholars as to whether Platonic or Neoplatonic ideas have influenced the design of the Medici Chapel, in total conception or in detail.[74] For example, are the four river-gods – as in Plato's *Phaedo* (but also in Dante's *Inferno*[75]) – the four stages of punishment and absolution through which man must pass after death? Or, as in the Florentine Neoplatonists, do they represent the four elements of matter to which man is subject at the moment of his birth?[76] Is the chapel a microcosm of the universe, with the different zones symbolizing the cosmic hierarchy?[77]

As one can see from his poems, Michelangelo was certainly acquainted with Platonic and Neoplatonic thought. But where his painting and sculpture are concerned, one is only entitled to consider this influence if the iconographical tradition itself does not contain everything that one needs for an explanation. It seems in principle unlikely that Michelangelo would have based his design for a chapel dedicated to the Resurrection on the ideas of Neoplatonism instead of on traditional Christian concepts. And it is even more unlikely that his ecclesiastical patron would have agreed to such a plan.

The combination of river-gods and the times of the day is found in antiquity and would have been known to Michelangelo from the reliefs on the Arch of Constantine in Rome.[78] The rivers are the companions of the times of the day; as such, they represent the passing of time, and have their place on the lowest plane of the hierarchy. The empty thrones are similarly part of an iconographical tradition,[79] and do not need to be seen as 'the ethereal thrones of the just'.[80] The contrasting figures of the two dukes probably reflect the antithesis of the *vita activa* and the *vita contemplativa*, which we shall also find in the final form of the tomb of Pope Julius, and in this case we are justified in calling on Neoplatonic ideas to help in the interpretation:[81] Giuliano, holding his sceptre and with two coins in his left hand, is portrayed as the son of Jupiter (*Jupiter dat magnanimitatem animi*); Lorenzo, pensive, his face in the

shadow, with his left elbow resting on a closed money-box, is the melancholy son of Saturn. This also gives a new meaning to the allegorical figures: Giuliano, child of Jupiter, is flanked by *Day*, figure of virility, and *Night*, figure of fertility, while Lorenzo, child of Saturn, receives the creatures of the twilight zones – *Dawn*, the virgin, and the aged *Evening*.

But this is as far as Neoplatonic interpretation can be allowed to go. Above all, if one attempts to find a Neoplatonic pattern in the arrangement of the chapel as a whole, with the soul leaving 'the tumult of the material world' behind and ascending to the realm of brightness above, rather than the traditional Christian antithesis of life and death, temporal and eternal, one encounters great difficulties.[82] Indeed, the very fact that the altar – like the priest – stands at floor-level would make it impossible to regard this, the lowest level, as symbolizing Hades, the realm of the departed spirits.[83]

Chapter 8

Florence 1520-1534

As well as the Medici chapel Michelangelo designed a further structure for the complex of S. Lorenzo, namely the Biblioteca Laurenziana – parts of which, however, were not finished till later.[1]

The core of the library of the Medici was a collection of some six hundred manuscripts belonging to Cosimo Vecchio, who had handed most of them over to the monastery of S. Marco for study purposes, where they were lodged in Michelozzo's reading-room. After the fall of the House of Medici in 1494 Savonarola, then Prior of S. Marco, had the remainder of the collection, which had grown considerably larger in the meantime, also transferred to the monastery. But in 1508 Cardinal Giovanni de' Medici, later Pope Leo X, bought the collection back and had it taken to Rome, where he considerably added to it. Finally Pope Clement VII, the second of the Medici Popes, had it brought back to Florence and planned to rehouse it there.

The plan seems to have been mooted immediately after the enthronement of Clement VII in the fall of 1523.[2] In January 1524 Michelangelo wrote to Fattucci, the papal secretary: 'From your last letter I learn that His Holiness wishes me to design the library. But I have had no personal communication, nor do I know where he intends to have it built. Stefano mentioned something about it but I paid little heed. When he returns from Carrara I will inquire of him and put my knowledge to what use I can' – adding, as he had done before – 'even though it is not my *métier*.'[3]

To a considerable extent we can reconstruct from drawings (Pls. 64 and 65)[4] and from Michelangelo's correspondence with Fattucci[5] how the plan of the library developed. The first suggestions and discussions concerned the site: the south side opposite the Old Sacristy ('volta a

mezodì')[6] and the piazza in front of the church ('che va in sula piazza e inverso il borgo Santo Lorenzo')[7] were considered, but on 3 April 1524 it was decided to build it above the cloister in which were the priests' quarters.[8] The arrangement of the library was also discussed,[9] including whether the valuable Greek and Latin manuscripts should be housed separately.[10] Among the considerations were the Pope's concern that the monastic apartments below should not be disturbed, technical problems of load and support (which soon became apparent), the question of lighting and the need to avoid the risk of fire.

Michelangelo's first design,[11] made between January and April 1524, incorporated a vestibule and a reading-room under a single roof, with identical articulation of the interior walls and paired columns mounted between pilasters, and with a *crociera* (crossing or transept).[12] The final design (Fig. h), however, dating from the end of February 1526,[13] shows the vestibule and the reading-room in opposition to each other: the original interior articulation is now confined to the vestibule, and a membering of delicate pilasters is adopted for the reading-room; the vestibule was also to be made one storey higher.

Building started on the reading-room in August 1524 and on the vestibule in November 1525. By April 1526 the point had been reached at which plans could be made for the decoration of the interior. But by the summer of the same year there was talk of making economies, and by December work seems to have stopped altogether; it was only resumed in 1533, three years after the return of the Medicis,[14] and made slow progress. As the plaque above the door of the reading-room states, the formal opening of the library took place in 1571. The façade and upper storey of the vestibule were not finished until 1904.[15]

The almost square, sharply rising vestibule, the so-called *ricetto*, is entered from a staircase leading from the upper loggia of the first of the two cloisters, and consists of a base and two upper storeys (Pl. 66). The walls comprise an alternating series of projecting and recessed surfaces, each in its own frame; in the recessions of the base are pairs of enormous volutes. The base and the main storey are divided by a broad mitred cornice, on which stand, above each pair of volutes, a pair of columns set like captives (a typical Michelangelo motif) in a box-like recession

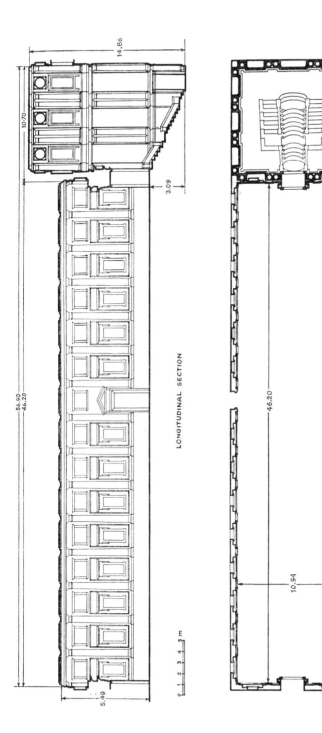

14.86

10.70

3.09

LONGITUDINAL SECTION

56.90
46.20

5.49

0 1 2 3 4 5 m

PLAN

46.20

10.94

1 Biblioteca Laurenziana, Florence. Ground plan and elevation (after James Ackerman).

between two barely visible pilasters; the plinths and capitals of the columns are almost non-existent.

In the corners there is a harsh confrontation of elements; in the base the two volutes stand at right-angles to each other; above them the two columns with the pilaster between them, the latter covering the corner, almost seem to collide.[16] The walls of the main storey contain tabernacles each framed by tapering pilasters and with alternating triangular and segmental pediments; the small platforms in them do not appear to have been meant for figures. Above the tabernacles are small rectangular niches with a broad upper cornice and framed by a narrow moulding; the symmetry of the moulding is broken at the top to allow a festoon to hang from one side to the other.

The massive entrance to the reading-room (Pl. 67) has a prominent arch with triangular pediment which overlaps the columns on either side. The corresponding part of the opposite wall has no tabernacle. A prominent mitred cornice, matching that below the main storey, runs round all four walls, separating the main from the upper storey, which latter displays a somewhat simpler, flatter form of the lower features: instead of the tabernacles there are rectangular windows (those to the reading-room side and on the opposite wall are blind windows) with frames which repeat in flat form the volute motif of the base, and in place of the rectangular decoration in the main storey there are roundels set in rectangular frames.

In all three stories there is a contrast between the light grey of the walls and the dark grey of the articulated design.

The original project for the vestibule envisaged a staircase[17] against each of the side walls, leading to a landing in front of the entrance to the reading-room.[18] In 1558, however, Michelangelo, now eighty-three, made a new design, which Bartolomeo Ammanati carried out in the following years.[19] The staircase (Pl. 68), which now occupies almost the entire space of the vestibule – it is the first example in architecture of a free-standing interior stairway and was often imitated in the seventeenth and eighteenth centuries – is divided into a lower and an upper part. The lower part has three parallel flights up to a common landing, the upper part one single flight which leads up from this landing 'like a narrow bridge',[20] under which one can pass, to the door of the reading-room.

The middle of the three lower flights was 'per signore'[21] and is clearly the centre of attention; the front of the stairs is curvilinear, with a volute-like decoration at either end. The forward edge and riser of each of the bottom three stairs is oval in shape, the third stair being deeper and acting as a kind of small landing. On either side of the main staircase is a balustrade which is continued, after a break for the landing up to which the two side staircases also lead, in the single upper flight; the side staircases were 'for the servants' and have rectangular steps linked in pairs by a lateral extension. Two great volutes on the central landing link the side staircases with the balustrades of the upper flight that leads to the door of the reading-room.

The vestibule – or *ricetto* – is one of the most original, almost perverse works in the whole of the history of architecture, and shows to what extent Michelangelo subjected the conventions of sixteenth-century Italian art to the power of his own will. For a long while writers found it impossible to characterize it favourably. Jacob Burckhardt wrote of it in his *Cicerone*: 'This vestibule with its staircase is an infinitely instructive piece of architecture, which for the first time in history deliberately mocked the meaning of all individual forms.'[22] Not until the development of an appreciation of anti-classical values did it become possible to evaluate this extraordinary work.

The first impression one receives is of something superhuman. That sense of moderation which was so important for the Renaissance seems to have been rendered impotent. The lighting from above serves to emphasize this. Instead of the spatial balance and control one would expect in an interior, plastic values obtrude, creating an atmosphere of restlessness and tension; moreover, the plastic forms themselves make one wonder whether one is dealing with indoor or outdoor architecture.

The individual motifs, too, are full of paradoxes. The large volutes on the walls of the base, for example, contrary to their traditional function, support no weight but their own. Likewise the main order does not seem to bear the weight of the cornice above but to stand without structural function, like statues in niches. However, as Ackerman has shown,[23] the wall behind these columns is so thin that it could not carry the cornice alone, so that the columns, like Gothic pillars, do in fact bear the weight. Also paradoxical is the fact that the pilasters which

frame the tabernacles taper downwards, not upwards, and that the capital is narrower than the shaft.

But the staircase itself is the most remarkable feature, and it has provoked some strange interpretations. Can one really see the central staircase as 'a falling cascade'[24] or 'like a mass of lava pouring from the door above'?[25] Michelangelo's own letter to Vasari[26] makes it already clear that his conception was of an *upward* movement. Yet countering this movement there is indeed a movement from top to bottom, for the way up is also the way down. The oval stairs of the middle flight reflect this, though the landing and the three broad oval steps at the bottom arrest the downward progress. It is as though the forces that are held in check in the walls are here set free, while the discords of the vestibule as a whole are resolved in the reading-room to which the staircase leads.

As the accent in the vestibule is on the vertical, so in the reading-room (Pl. 69) it is on the horizontal. Here nothing is left of the medieval tradition still alive in the library designed by Michelozzo for the monastery of S. Marco. It is a long, narrow room (length about 150 feet), simple and harmonious in its articulation and with an air of solemnity. The desks stand at right-angles to the walls on either side, with the manuscripts chained to them, but instead of being detached and independent, as was originally planned, they become part of the wall-membering as a kind of base. Above them are the Doric pilasters which divide the walls into narrow bays which, like those in the vestibule, have two parts: the lower part consists of a large rectangular frame round an inset panel in the centre of which is a rectangular window, while the upper part has a smaller rectangular cartouche. The window-frames have projecting cornices above and volutes at the sides, while the cartouches have cornices above and delicate balusters at the sides. The two end walls carry the same decorative pattern and have entrance doors in the middle.

These doorways (Pl. 70) – which Burckhardt criticized for 'creating a false impression of opulence by mere repetition'[27] – offer a good example, particularly in their finer details, of Michelangelo's powers of invention. In front of the porch with its overlapping segmental pediment is a solid block which partly obscures the columns; in front of this block is a stepped cornice and above this, without any apparent

structural relationship, a triangular pediment set into the segmental pediment behind and above it. The door-frame itself has a narrow fluting all round. None of these motifs is isolated: the one interlocks with the other, and the product has to be seen as a single unit, deriving its meaning from, and at the same time conveying its meaning to, each individual part.

The terracotta *pavimento*, its large rectangular panels inset with a pattern of ovals and enclosed festoons in rhomboid form, was done by Santi Priglioni from a design by Tribolo. The carved ceiling, which follows the pattern of the floor and corresponds exactly to the articulation of the room as a whole – pilasters, reading desks and central aisle – was executed by Marco del Tasso and Antonio Caroto from Michelangelo's own designs.

The contrast between vestibule and reading-room is also reflected in the colours. In the vestibule they are confined to light and dark grey; the reading-room has white walls, offset by the grey tone of the architectural features in *pietra serena*, with the red and white terracotta floor, the brown desks and finally the bright, two-tone arabesques of the windows, which accentuate the self-containedness of the room.

The façade of the library can be seen above the upper storey of the west side of the cloisters (Pl. 71). As in the interior the windows are set into recessed bays, here chiselled out of the wall itself, not superimposed upon it. A novel feature for external architecture, and one that can only be called Mannerist, is that these bays are only framed on three sides: they have no bottom ledge. Above the windows and part of the way down the sides runs a kind of broad moulding, and there is a heavy segmental pediment above. The same pattern is repeated for the vestibule, though here the windows are sham. The triangular pediments in the second storey were added during the restoration of the building at the beginning of the twentieth century.

In 1527, after the Sack of Rome by the mercenaries of Charles V and the imprisonment of Pope Clement VII, a popular uprising put an end to Medici rule. Michelangelo remained in the city. On 6 April 1529, he was appointed *Governator generale delle fortificazioni di Firenze* by the Signoria,[28] with the task of fortifying Florence against the imperial army, which had now joined the papal forces. But on 21 September

1529 he secretly left the city with two of his apprentices and fled to Venice. Condivi reports:

> He had been at work on fortifying S. Miniato when rumours began to circulate of a treason plot among the militia. Michelangelo, who had heard some of these rumours himself and had also had his attention drawn to them by some of his officer friends, went to the Signoria and reported what he had learned, pointing out the danger facing the city and telling them that there was still time to intervene, if they had a will to do so. But instead of showing him their gratitude, they abused him and called him a coward.[29]

Together with a number of other deserters, he was thereupon sent into exile.

But in October 1529 he was summoned back to Florence and re-instated, and in 1530 the city surrendered to the allied troops of the Emperor and the Pope. Vasari writes:

> After the peace treaty had been concluded, Baccio Valori, the Pope's emissary, received orders to arrest and imprison some of the citizens who had been politically active, among them Michelangelo. Suspecting this would happen, he had secretly fled to the house of one of his friends where he stayed hidden for several days until the tumult had died down. Then Pope Clement, mindful of Michelangelo's talents, ordered that everything possible should be done to find him, and that, far from being arrested, he should be given back his former offices.[30]

His main activity during the years 1529 and 1530 concerned the fortification of the hill of S. Miniato. 'Having assessed the situation,' records the *Breve Istorietta dell'Assedio di Firenze*,

> he proceeded to fortify the hill of S. Miniato and S. Francesco. And as he considered it too expensive to erect bastions – of the type erected by the Medici in 1526 and 1527 – round Giramonte as well, he started his bastions at the first tower outside the Gate of S. Miniato, in the direction of S. Giorgio, in that area which was subsequently more strongly fortified and has survived to this day.[31]

There are a number of pen-and-wash drawings, heightened with red, in the Casa Buonarroti[32] which show Michelangelo's fortifications for S. Miniato, the Porta alla Giustizia, on the other side of the river from the Colle S. Miniato, and other parts of the city. Apart from a few drawings of Leonardo's, they are the only such sketches from this period, and they show with what enthusiasm Michelangelo – 'excellente nella architettura', as the letter of appointment from the Signoria puts it[33] – undertook this work. 'The test of a good military architect', says the *Istorietta*, 'is to establish sound foundations and adapt his defences to the locality. His success in this showed that here too he was the most capable of them all.'[34]

III

Further work on Pope Julius's tomb – the *Captives* in the
Boboli Gardens – *Victory* – *The Risen Christ* – *Apollo* –
drawings for Tommaso Cavalieri

While he was engaged on the Medici tombs and the other tasks for S.
Lorenzo, Michelangelo's work on the monument for Pope Julius had
almost come to a standstill. But this obligation still weighed heavily on
his conscience. Leo X had died in 1521, and his successor Hadrian VI –
the Dutchman Adrian Florent – restored the Duchy of Urbino, left
without a ruler after the death of Lorenzo de' Medici, to the exiled
Francesco Maria della Rovere. He also issued a *motu proprio* demanding
either that the monument should be completed as envisaged in the plan
of 1516, or that the money already paid out should be returned.[1]
Hadrian's death in 1523 and the election of Giulio de' Medici as Pope
Clement VII removed any fear of charges being brought against Michel-
angelo, but he developed an ever-increasing reluctance, even antipathy,
to resuming work on it, and this attitude 'dominated the tragedy right
to the end', as Justi put it.[2] 'I cannot live, let alone work, in this condi-
tion.'[3] 'I have a greater longing to divest myself of this obligation than
I have to go on living.'[4]

In 1525 it was proposed – we do not know by whom – that the
monument should be turned into a panel-tomb of the kind made in the
Quattrocento for Pius II and Pius III (both now in S. Andrea della Valle
in Rome).[5] But this plan was soon dropped. In the disastrous year of
1527, when the Sack of Rome and the imprisonment of the Pope made
work on the Medici Chapel impossible, Michelangelo seems to have
turned his mind to the monument again for a while, but political events
made any concentrated work impossible.[6]

There followed a long, painful period of uncertainty in which

attempts were made to reconcile the claims of the Rovere heirs and the desire of Pope Clement VII, now that he had conquered Florence and pardoned Michelangelo, to continue to employ him, but Michelangelo repeatedly tried to divest himself of at least part of the responsibility.[7] Finally on 29 April 1532 a compromise agreement was drawn up which went back to the contract of 1516.[8]

Michelangelo was required to make a new model or a new drawing and to complete within three years six unfinished statues in Rome and Florence, together with all the remaining architectural work on the tomb. The six statues were to be his own work, but everything else could be executed by his assistants working from his drawings, and the Pope would allow him two months' leave in Rome each year in order to complete the work. If he failed to meet his obligations, the agreement would lapse and the old contract of 1516 would come into force again. From a letter written by Giovanmaria della Porta, emissary of Urbino, to his duke we learn that, as nothing had been decided about the erection of the monument since the first project had been abandoned, it was now to stand in S. Pietro in Vincoli, Julius II's titular church.[9]

From the end of August 1532 until June 1533, and again from the end of October 1533 until May 1534 Michelangelo was in Rome. During the second of these periods he was occupied with the new plans for the entrance wall and altar wall of the Sistine Chapel, which Pope Clement VII had commissioned him to prepare in the autumn of 1533, but apart from a few false starts and a little preliminary work in the church itself, he made no progress with Pope Julius's tomb. It must have been at this time that he made a further design for the upper storey which was finally constructed in 1542.

The model or drawing mentioned in the contract of 1532 has not survived (Fig. i). The form of the lower storey, however, is clear. The old façade, finished since 1513, though severely damaged when Michelangelo's house in Rome was broken into in 1531,[10] remained the same but was now to be put immediately in front of the wall. The upper storey, to judge from a drawing by Aristotile da Sangallo in the Uffizi,[11] was based on the 1516 design.

The new contract says nothing specific about the six statues which he was personally to complete, but his petition to Paul III in 1542[12] and

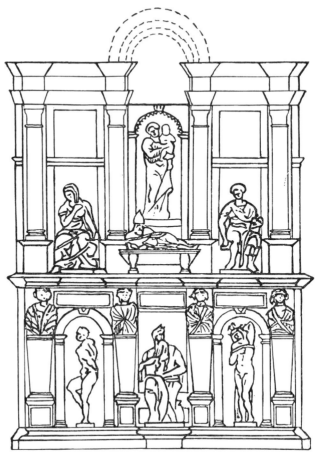

i Pope Julius's tomb. Design of 1532. Reconstruction.

Condivi's account of the Pope's visit to Michelangelo's workshop[13] make it fairly clear that they were the two *Captives* in the Louvre, *Moses*, a Madonna and Child, a prophet and a sibyl. Three of the figures were well advanced but only now does he appear to have started work on the others.[14] One must imagine that *Moses* was intended for the centre of the lower storey and the two *Captives* for the niches on either side,[15] while the other three figures were meant for the upper storey. There is no mention, strangely enough, of any statue of the Pope, although it seems likely that Michelangelo already had in mind the construction of a recumbent figure for the sarcophagus.

When Michelangelo returned to Rome, he left in his studio in Florence a number of statues, some well advanced, others only blocked-out, and a few blocks of marble. When he died there were still, in Vasari's words, 'a great number of statues in the Via Mozza, both finished and blocked-out'.[16] Among them were four *Captives* and the so-called *Victory*. After Michelangelo's death his nephew gave them to Duke Cosimo, who had them erected by Buontalenti in a grotto in the Boboli Gardens. The *Victory* was taken to the Palazzo Vecchio.[17]

These *Captives* (since 1908 in the Florentine Academy; Pls. 72–5) are very largely unfinished and in parts barely started. They are thus of particular importance for the study of Michelangelo's methods of work. The entire conception is his own; two wax models are preserved in the Casa Buonarroti and one in the Victoria and Albert Museum in London.[18] The transference of these models to the marble is the work of assistants,[19] with the master only touching up here and there – 'the head and body of the *Bearded Giant* [Pl. 72], a few chisel marks round the stomach muscles of the *Young Giant* [Pl. 73], whose head and left hand are particularly badly hewn, and probably nothing at all on *Atlas* [Pl. 74] and the *Awakening Giant* [Pl. 75]'.[20]

The figures form two pairs – the *Bearded Giant* and the *Young Giant* were intended as frontal figures, the other two as corner figures. They are enlarged versions of the *Captives* in the 1513 plan for the Julius monument: the *Young Giant* goes back to the *Dying Captive* in the Louvre, *Atlas* to the *Struggling Captive*. But the movement has become more tense, more involved; the figures stand out more starkly from the stone, and struggle, suffering and defeat are portrayed, not as individual states but as supra-personal symbols.

To which plan for the tomb of Pope Julius do these *Captives* in the Boboli Gardens belong? Are they perhaps parts of a design we know nothing about? When were they done? These questions have been posed time and again but no universally accepted answer has been given.

The project of 1516 had combined with the plans for the façade of S. Lorenzo to make the upper storey into the dominating part of the tomb. Is it perhaps possible that Michelangelo considered dispensing with the herms in the lower storey and turning the figures of the captives in front of the herms into atlantes bearing the weight of the upper

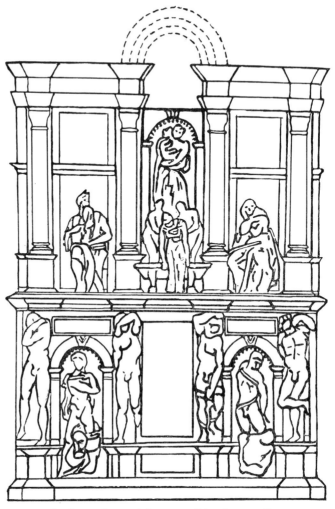

j Pope Julius's tomb. Modification of the design of 1516.

storey (Fig. j)?[21] This connection with the 1516 project affords no evidence, of course, as to the date of these *Boboli Captives*, because notwithstanding the intermediate design for a simple wall-tomb, the 1516 project was still the basis of the contract made in 1532 and remained so. The dating of the figures is thus not affected by the purpose to which they might have been put.

As these statues were carved in Florence and never taken out of the

city, they must belong to the years when Michelangelo was living there during this stage of his career, 1518–34. A drawing of 1518 in the British Museum (Dussler No. 152) shows the lower storey of the tomb as executed by Antonio da Pontassieve:[22] the herms are shown on this drawing, although they were not yet on the tomb itself. In 1518, therefore, they can still only have been in the planning stage, but Michelangelo seems to have begun work shortly afterwards on the figures of the *Captives* which may have been intended to replace the herms. In February 1519 there is a reference to four statues that were to be ready by the summer.[23] At the end of May or beginning of June Francesco Pallavicini was sent to Florence by the heirs of Pope Julius to inquire about the progress of the work, as Michelangelo describes in a letter written at the end of October 1542: 'The Cardinal of Agen sent the surveyor Francesco Pallavicini, who is now Bishop of Aleria, to urge me to work more quickly. He inspected the workshop, all the blocks and also the rough-hewn statues which are still there.'[24] Among these 'rough-hewn statues' which were still in Florence in 1542, i.e. had been left there when Michelangelo returned to Rome, must have been the *Boboli Captives*, on which he must therefore have been working in 1519. Giulio de' Medici, later Pope Clement VII, appears to have seen them in Michelangelo's workshop before the spring of 1523.[25] In the years that followed Michelangelo was fully occupied with the Medici tombs but it is possible that he resumed work on the figures after the Sack of Rome in 1527.[26]

The view that the statues belong only to the 1532 project[27] is contradicted by the fact that Michelangelo left them in Florence, whereas the agreement of 1532 expressly stipulated that the statues for the tomb were to be taken to Rome, and the tomb completed there, not in Florence.[28] Nor is it really conceivable that the two sets of *Captives*, those in the Louvre and those in the Boboli Gardens, belong to the same project. As already pointed out, the former, which were to have been replaced by the latter in the course of work on the 1516 project, were pressed into service for the later project and are among the six statues mentioned in the agreement.

It may be objected that there is a discrepancy between the documentary and the stylistic evidence, and that a date as early as the sources

seem to suggest is unlikely on grounds of style. To answer this one has only to think of the architectural features in the 1516 design. As these show Michelangelo turning away from the path of the High Renaissance to the path of Mannerism, so the same is true of these Florentine *Captives*. Indeed they were to bring about a modification in the design of the tomb, and they stand at the beginning of the line of development that leads to the new fusion of sculpture and architecture in the Medici tombs of S. Lorenzo.

The *Victory* group[29] (Pl. 76) portrays a naked youth, oak leaves (symbol of the Rovere) entwined in his hair, with his left knee pressing down on the head of an old, bearded man cowering at his feet. His right shoulder is inclined forwards and in the hand of his upheld right arm he holds the strap of the cloak that is draped over his back; his head is turned to one side, and his features have a strange, clouded expression. Has the victor somehow become the vanquished? Has triumph been turned in some profound way into mourning?

The subject, which is anticipated in Michelangelo's own groups of Virtues and Vices in the 1505 design for the tomb, recalls classical representations of Hercules' struggle with the Hydra or the Stag, which the early Renaissance in Florence had taken over from Roman sarcophagi.[30] Another model is the large classical group of Menelaus with the body of Patroclus: the inclined shoulder, producing a side aspect as well as a frontal aspect; the projecting arm; the twisted head; the wealth of movement and perspective, all within the requirements of a statue intended to stand in a niche – all these features make one think of the Menelaus group. Vasari speaks of the *Victory* – which, like the *Boboli Captives*, Michelangelo left in Florence – in the context of the monument to Pope Julius,[31] and the Rovere motif itself shows that he is right. But we cannot tell to which of the projects it belongs. Statues were planned for the niches in 1516 – but the 1532 design shows that it was probably the Louvre *Captives* that were meant.

Yet as the *Boboli Captives* appear to have been created as a result of a change in the 1516 design of the tomb, so Michelangelo might well have also entertained the idea of replacing the individual figures in the niches by groups portraying struggles of various kinds. Moreover the *Victory* is related to the *Boboli Captives*, in particular to the *Bearded Giant* and the

Young Giant, and may well have been done in the same period;[32] the Mannerist element in it is especially pronounced. If this assumption is correct, the *Victory* would take its place in the left niche of the façade of the tomb.[33]

Two more marble statues belong to these years 1518 to 1534 in Florence – *The Risen Christ* in S. Maria sopra Minerva in Rome (Pl. 77) and an unfinished *Apollo* in the Museo Nazionale in Florence (Pl. 78).

The commission for the statue of Christ came from Metello Vari (whose collection of antiquities is described by Aldovrandi[34]), Bernardo Cencio, canon of St Peter's, and Maestro Maria Scapucci in 1514.[35] It provided for a life-size standing figure, naked and holding the cross 'in a pose such as the master would deem appropriate'; the three patrons were to decide where in the church of S. Maria sopra Minerva the statue should stand, and Michelangelo himself was to provide the plinth at his own expense. Four years were allowed for the completion of the work.

He must have started the work immediately but he abandoned it when he went to Florence in 1516 because a black streak flawed the marble in Christ's face;[36] he did not begin work on a second statue until the second half of 1519, continuing through the early months of 1520. In 1531 this new statue was sent to Rome and unveiled in the church of S. Maria sopra Minerva at Christmas. The beard, hands and right foot were completed in Rome by Michelangelo's assistant Pietro Urbano, but Michelangelo himself worked over these parts again, so that the statue as a whole may fairly be regarded as the work of his own hand.

The naked figure of Christ stands erect, holding against His body the cross and the instruments of His castigation (the scourge, the rod and the sponge) in both hands, and with his head turned gravely to one side.

The statue was intended for a recently dedicated altar in the church, and its subject, familiar in Italian art, is that of the Man of Sorrows, as depicted, for instance, in Bramantino's fine sepia in Vienna or Vecchietta's *Man of Sorrows* on the tabernacle of S. Maria della Scala in Siena.[37] It is in terms of this eucharistic imagery that the meaning– and the problems – of Michelangelo's figure have to be seen.

Michelangelo has conceived the Man of Sorrows as a naked hero of antiquity. 'The knees of this statue are worth more than the whole of

Rome,' declared Sebastiano del Piombo.[38] But the subject is not a historical or mythical figure: it is a symbol, medieval in origin, of the healing power of the blood of the Redeemer,[39] a symbol, moreover, which the Middle Ages, starting not from nature but from spiritual concepts, found it easy to express in material form, namely as a suffering figure displaying his wounds.

The Italian artists of the early Renaissance, however, had tried to reconcile the old mystical subject with the new ideal of the beauty of nature, and portrayed the Man of Sorrows as a handsome, upright figure. Not until Michelangelo do we become aware of the problems facing Christian art when it seeks to draw on the art of antiquity and both to express the visions of mystical Christianity and to affirm the values and laws of nature. It is strange that Michelangelo, who had made no attempt to emulate the autonomy of classical sculpture since his *St Matthew*, should now have produced another free-standing statue. He was not yet prepared to give up the Apolline ideal of the beauty of the human body; this was a step he took only in his old age. In order to appreciate fully his renunciation of nature and classical ideals in late works such as the Florentine *Pietà* and the *Rondanini Pietà*, one needs to realize the ambivalence of the attitude that still made him cling to these ideals in the figure of *The Risen Christ*.

Yet one cannot doubt that Michelangelo had a profound understanding of the meaning of his chosen subject. A disciple of Savonarola's, he created here, for the Dominican Church in Rome, a warning against the secularization of the Holy City. 'Everything in the Church is now for sale,' said Savonarola. 'In Rome they even sell the blood of Our Lord.'[40] His tones are echoed by Michelangelo:

> Qua si fa elmi di calici e spade,
>> E 'l sangue di Cristo si vend' a giumelle,
>> E croce e spine son lance e rotelle;
>> E pur da Cristo pazienzia cade!
> Ma non c' arivi più 'n queste contrade,
>> Chè n' andre' 'l sangue suo 'nsin alle stelle,
>> Poscia che a Roma gli vendon la pelle;
>> E èci d' ogni ben chiuso le strade.

(Here they make helms and swords from chalices;
 The blood of Christ is sold now by the quart.
 Lances and shields are shaped from thorns and crosses,
 Yet still Christ pours out pity from his heart.

 But let him come no more into these streets
 Since it would make his blood spurt to the stars;
 In Rome they sell his flesh, and virtue waits
 Helpless, while evil every entrance bars.)[41]

In his *Last Judgement* Michelangelo was to put his art even more firmly at the disposal of the forces of religious revival.

Once more *The Risen Christ* seems to show the mark of Leonardo. The arm held across the body and the counter-movement of the head are found in Leonardo's *Leda* (the original is lost), 'the classical standing figure in Italian art', as it has been called.[42] The multiplicity of movement, with the variety of planes and aspects that gives the stationary figure a dynamic quality, made Leonardo's *Leda* something entirely new. One also finds it in Raphael's *School of Athens*. It occurs in Michelangelo's early sculptures (the figure of the satyr in his *Bacchus*, the Christ-child in the Bruges *Madonna*) but this is the first time that it dominates the work. In later life Leonardo gave it a religious, almost mystical significance (*St John*), and it seems to have been this latent expressive power that led Michelangelo to follow Leonardo's example: while preserving the deepest meaning of the subject, he strives to overcome the limitations of line and form which still characterize early Renaissance portrayals, Christ no longer offers His blood; He displays no wounds; He does not even betray suffering. He simply stands there, silent and composed, holding the symbols of his torment which, like His quietly averted head, still retain their meaning for the believer.

Michelangelo's unfinished *Apollo* in the Museo Nazionale in Florence (Pl. 78) was made on his return to Florence after his flight in the fall of 1530, and was to be given to Baccio Valori, victorious commander of the papal troops and detested Regent of Florence – 'to make Baccio Valori his friend,' as Vasari remarks.[43] Vasari describes the statue as 'Apollo drawing an arrow from his quiver', which seems more likely than the appellation 'David' in the catalogue of Duke Cosimo de' Medici's

collection.[44] The uncompleted hemispherical shape beneath the figure's right foot cannot represent either the head or the helmet of Goliath, nor does the attitude of the left arm or of the head seem appropriate for David the victor; furthermore one cannot imagine that Michelangelo would have used the symbol of 'just government' for the man who had destroyed freedom in Florence.[45] Against this we find that the pose of the figure is very similar to that of Apollo in Raphael's *School of Athens*, who stands with his right foot on a stone.[46] One also finds this position of the left arm in figures of Apollo.[47] The uncompleted object on the statue's back can be clearly seen from a sixteenth-century drawing to be a quiver.[48]

In his *Apollo* Michelangelo has taken the Leonardo-inspired motif of his *Christ* in S. Maria sopra Minerva and treated it in the Mannerist style of a *figura serpentinata*. Yet in its beauty and harmony the figure, which is less than lifesize, is very different from the figures of Mannerism: its contours, like its movements, are completely self-contained, and the youthful face, clouded by a hint of sadness, casts its eyes downwards. It is one of Michelangelo's most attractive creations.

During the late autumn of 1532, while Michelangelo was in Rome preparing to resume work on the tomb of Pope Julius, he met a young Roman nobleman called Tommaso Cavalieri.[49] It was one of the profoundest experiences of his life. This handsome young man – his beauty was praised by Vasari, Varchi and other contemporaries – roused a passionate ardour in Michelangelo. Letters, poems and drawings show how profoundly he was affected and reveal him as the 'amatore divinissimo' of whom Varchi glowingly writes.[50] The relationship between the mature artist and the young nobleman was broken only by Michelangelo's death, and Cavalieri was with him in his last hour.

In the first letter that has been preserved, dating from the end of December 1532, Michelangelo writes: 'When I left the shore, I found myself, not in a little stream but at the edge of the mighty ocean with its huge waves.'[51] And in September 1533 we read: 'My incessant desire, day and night, to be in Rome means for me a return to life itself.'[52]

If there is anywhere in the life and art of Michelangelo where Platonic or Neoplatonic ideas and attitudes appear, it is in his relationship

to Cavalieri. Love, the deepest power in life, was for Michelangelo love of beauty. Beauty is supreme, divine: the beauty of nature is the manifestation of the divine beauty of God, and the love of nature is the love of God, the link that binds us to God. This is the background to Michelangelo's poems and drawings for Cavalieri (Pls. 79–84):

Veggio co' bei vostri occhi un dolce lume,
 Che co' miei ciechi già veder non posso;
 Porto co' vostri piedi un pondo a dosso,
 Che de' mie' zoppi non è già costume;
Volo con le vostr' ale senza piume;
 Col vostr' ingegno al ciel sempre son mosso;
 Dal vostr' arbitrio son pallido e rosso;
 Freddo al sol, caldo alle più fredde brume.
Nel voler vostro ù sol la voglia mia,
 I mie' pensier nel vostro cor si fanno,
 Nel vostro flato son le mia parole.
Come luna da sè sol par ch' io sia;
 Chè gli occhi nostri in ciel veder non sanno
 Se non quel tanto che n' accende il sole.

(This glorious light I see with your own eyes
Since mine are blind and will not let me see.
Your feet lend me their own security
To carry burdens far beyond my size.

Supported by your wings I now am sped,
And by your spirit to heaven I am borne.
According to your will, I'm pale or red –
Hot in the harshest winter, cold in the sun.

All my own longings wait upon your will,
Within your heart my thoughts find formulation,
Upon your breath alone my words find speech.

Just as the moon owes its illumination
To the sun's light, so I am blind until
To every part of heaven your rays will reach.)[53]

Vasari wrote:

> Infinitely more than any other of his friends, Michelangelo loved the young Tommaso de' Cavalieri, a well-born Roman who was intensely interested in the arts. To show Tommaso how to draw, Michelangelo made many breathtaking drawings of superb heads, in black and red chalk; later he drew for him a Ganymede rapt to Heaven by Jove's eagle, a Tityus with the vulture devouring his heart, the chariot of the sun falling with Phaeton into the Po, and a Bacchanal of children, all of which are outstanding drawings such as the world had never seen. Michelangelo did a portrait of Tommaso in a life-size cartoon, but neither before nor afterwards did he do any other portrait from life, because he hated portraying any living subject unless it were of exceptional beauty.[54]

This cartoon, which later came into the possession of Cardinal Farnese, has not survived. According to Aldovrandi, who catalogued Cavalieri's important collection of antiquities,[55] the young nobleman was dressed in classical style, with a portrait or a medallion in his hand.[56] It may also have been Cavalieri's love of antiquity that led to the choice of classical subjects in the drawings that Michelangelo made for him. Nevertheless their personal significance is unmistakable, and it is no accident that their personal and symbolic content have given them qualities which outlive the interest of their classical setting.[57]

Tityus the giant is, with Tantalus, Ixion and Sisyphus, one of the worst criminals in Hades: he had assaulted Leto, mother of Apollo and Artemis, and was consigned to the underworld, where vultures (Homer says there were two) tore out his liver as he lay on the ground. Lucretius uses the myth as an allegory of suffering through an excess of passion,[58] and it has retained this meaning. 'The lover's misery grows', writes Cardinal Bembo in his *Asolani*, 'because as he feeds himself so he feeds his tortures. Such was Tityus, on whose liver the vultures fed.'[59] The subject of Michelangelo's drawing is the suffering of the unhappy lover; the classical myth has become a personal statement, almost a 'confession' in Goethe's sense.

Similarly the myth of Ganymede, the most beautiful of the mortals, whom the gods took to Heaven so that he could live there for ever, had

already acquired allegorical meaning in classical times. Plato believed that he justified the love between a man and a youth;[60] Xenophon saw him as proof that it was intellectual, not physical, qualities that gained the affection of the gods.[61] Roman sarcophagi show him as symbolizing the elevation of the human soul above the limitations of earth, while the twelfth-century enamel cross of Engelberg portrays him as symbolizing the air.[62] In the illustrated fourteenth-century French manuscript known as the *Ovid moralisé* he is a prefiguration of the risen John, Christ's favourite disciple, while Christ Himself is symbolized by an eagle.[63] And in Dante's *Purgatorio* IX, 19 ff., we find the following:

> Then in a vision, did I seem to view
> A golden-feather'd eagle in the sky,
> With open wings, and hovering for descent;
> And I was in that place, methought, from whence
> Young Ganymede, from his associates 'reft,
> Was snatched aloft to the high consistory.[64]

Drawing on older commentaries, the Neoplatonist Cristoforo Landini explains these lines as follows: 'Ganymede is the human mind, his associates the inferior attributes of the human spirit, and the eagle divine love; God loves the spirit and bears it, freed of its baser qualities, to Heaven, where, transcending the limitations of the body, it lives in contemplation of the mysteries of Heaven.'[65] In this Neoplatonist interpretation Ganymede has become a symbol of *furor divinus* and *amore sacro*.

Here too one sees the connection with Michelangelo's own life. As in Tityus he portrays the agony of a sensual passion that feeds upon itself, so in Ganymede he depicts the loving soul that ascends to God. The confessional nature of the two symbols emerges from their juxtaposition, for Michelangelo makes them aspects of a single tragic experience – the experience, repeatedly invoked in his poems, of being a captive in 'this earthly prison' and of yearning to transcend it.

The third subject in these Cavalieri drawings also comes from this symbolic realm. In Ovid,[66] Phaeton, son of Helius, the sun-god, begs his father to allow him to drive the sun-chariot for a day. But as he could not control the fiery steeds, the chariot careered upwards and downwards,

setting heaven and earth on fire. To prevent the destruction of the entire universe Zeus slew Phaeton with a bolt of lightning. Phaeton fell into the river Eridanos, where his sisters, the Heliads, and his friend Cycnus lamented his death; Cycnus was turned into a swan, the Heliads into alder trees and poplars.

The myth symbolizes the sin of hubris, the fate of the man who oversteps his proper bounds. It appears as such in the late fifteenth-century illustrated edition of Aristotle in the library of Duke Matteo III Acquaviva in Vienna, where it accompanies the discussion of virtue in Book Two of the *Nicomachean Ethics*.[67] Similarly Alciati's portrayal of the myth in his *Emblemata* (1551) has the inscription 'In temerarios'[68] and Dante's lines –

> Not greater was the dread, when Phaeton
> The reins let drop at random, whence high heaven,
> Whereof signs yet appear, was wrapt in flames[69]

– were interpreted by Landini in the same sense.[70] Once again Michelangelo found in this myth a parable of his own spiritual condition, for so great was his devotion to his young friend – 'a shining light, a unique figure', as he called him[71] – that his love seemed to have the same reckless temerity as that displayed by Phaeton.

The Cavalieri drawings are meticulously done in black and red chalk, and must be regarded as works of art in their own right.[72] *Tityus* and *Ganymede* were the first (end of 1532), followed by the *Phaeton* drawings and the *Bacchanal* (1533).

Tityus (Royal Library, Windsor; Dussler No. 241; Pl. 79)[73] incorporates classical elements which are already to be found in *The Creation of Adam* from the Sistine ceiling, but they are put to completely different use. We are here on the threshold of Michelangelo's late style. With a violence incomparably greater than anything found in the art of the High Renaissance or in his own *Creation of Adam*, he deliberately destroys the unity and tranquillity of the surface of the picture; the left side dominates the right, the top dominates the bottom, and the nude recumbent figure, set diagonally, has a harshness which seems to express all the pent-up power of the scene. This is a far cry from that perfect balance between plastic movement and beauty of line in *The Creation of*

Adam. A whole new world of expression opens up before us. And when we look forward to Michelangelo's frescoes in the Cappella Paolina, Caravaggio's paintings in S. Luigi dei Francesi and S. Maria del Popolo, Rubens's *Death of Argus* and Rembrandt's *The Blinding of Samson*, we can see how fruitful this new technique, used here for the first time, was to become.

Ganymede has only been preserved in a pencil copy (Royal Library, Windsor; Dussler No. 722; Pl. 80),[74] but even this reveals the dual character of the theme as the rape of Ganymede by the eagle and his ascent into the realm of the Father. Except for the statue in the Vatican, there is no classical potrayal of the subject that can be compared to Michelangelo's, but it has a remarkable affinity, despite the completely different artistic background, to the medieval Engelberg cross.

The climax of this group of drawings comes with those of *The Fall of Phaeton*, of which three, all of them originals, have survived.

The first is that in the British Museum (Dussler No. 1777; Pl. 81).[75] The subject assumes a precise knowledge of Ovid's *Metamorphoses*, while the composition is related to that found on a Roman sarcophagus discovered in the sixteenth century behind the church of the Ara Coeli in Rome and now in the Uffizi.[76] Michelangelo must have known this sarcophagus. A reproduction of it is to be found in the *Codex Escurialensis* (the sketchbook from Ghirlandaio's workshop).[77]

Leaving classical models behind, Michelangelo's drawing points forward to his *Last Judgement*, with which he was beginning to concern himself at this time. The horizontal format is exchanged for a vertical. Instead of depicting Phaeton's fall alone, Michelangelo shows the sequence of events from Jupiter's launching of the bolt of lightning to the fall and the ensuing lamentation; the focus of the action is space, and the unfilled areas between the top and the centre, and between the centre and the bottom, have acquired an independent meaning in terms of expression and formal composition. The contrast between the rearing horse and the plunging figure of Phaeton – a motif taken from antiquity – is retained and accentuated; however, the various motifs are not treated in isolation but made to serve a single dynamic purpose in which each movement has its pre-ordained function.

The *Phaeton* drawings bear a clear relationship to a sketch for the *Last*

Judgement in the Casa Buonarroti (Dussler No. 55). The motif of Christ in judgement – and Christ's gesture in the *Last Judgement* is almost identical with that of Zeus here – may have given Michelangelo the idea of including Zeus in his composition, and the authority of Zeus has found its way into the *terribilità* of Christ. The *Last Judgement* also has this tension produced by space, and shares the themes of fall and lamentation.

A second version of the *Phaeton* composition (Venice, Accademia; Dussler No. 234; Pl. 82)[78] is a complete revision. The link with antiquity is almost broken, and variety of movement and focus has given way to strict symmetry. Zeus now occupies the centre of the picture, and below him Phaeton has been hurled from his chariot by the shaft of lightning; on either side the horses, harnessed together in pairs, hurtle downwards with him. There is no counter-movement, all is formalized, even abstract, and the individual elements have lost their strength – indeed, their very life.

These features are significant for an understanding of the formal and spiritual characteristics of Michelangelo's late style. Yet it is not this but a further drawing in the Royal Library, Windsor (Dussler No. 238; Pl. 83),[79] that shows Michelangelo's final conception of this subject. Here he revives the links with antiquity, both in the design as a whole and in individual motifs, but without sacrificing the advantages of the second version. The emphasis on the centre is retained, and there is no counter-movement; in fact, the groups of figures have been brought closer together.

It is highly revealing that this final version should have turned back towards classical models. Even in the last period of his life he did not want to lose the stimuli that these models could give him, and it is they that were to breathe life into the abstract style of his last works.[80]

The final drawing in this group for Cavalieri is the *Bacchanal* (Royal Library, Windsor; Dussler No. 365; Pl. 84),[81] a work, also indebted to classical models, which has never been satisfactorily explained.[82] The closest to it are the orgiastic reliefs on the plinth of Donatello's *Judith*,[83] which, like Michelangelo's drawing, symbolize the life of self-indulgence. But whereas in the case of Donatello these scenes are confined to the plinth, while Judith rises above them as a symbol of 'a life pleasing to God' ('regna cadunt luxu, surgunt virtutibus urbes'),[84] Michelangelo's

drawing appears to make no such allusion to a higher sphere of virtue. Moreover it reveals with almost frightening clarity Michelangelo's melancholy. There is little joy in this representation of revelry. In its composition, its subjection of individual features to the linear movement of the whole and its removal of the foreground as a horizontal support, it points the way, like so much else in these drawings, to the works of his final period.

Part III

Final Period-Rome 1534-1564

Last Judgement

In the autumn of 1533, before completing the Medici tombs and having already resumed work on the tomb of Pope Julius II, Michelangelo was commissioned by Pope Clement VII to undertake a depiction of the Last Judgement for the altar wall of the Sistine Chapel and a painting of the Fall of Lucifer for the entrance wall.[1] He at once began to give thought to the work, but his main commitment was still the tomb, which the contract of 1532 required him to complete by 1535. 'Michelangelo was conscious of his obligation to the Duke of Urbino [Pope Julius's executor],' writes Condivi, 'and tried as best he could to avoid this new commission. But when he realized that it was impossible, he delayed the matter as long as he could by claiming that he was busy with the cartoon – which was partly true – although in fact he was also secretly working on the statues for the tomb.'[2]

Then on 26 September 1534, three days after Michelangelo's final return to Rome, Clement suddenly died. He was fifty-six. His successor, Paul III, was elected in October of the same year and renewed his predecessor's commission for the paintings in the Sistine Chapel. When Michelangelo protested that he first had to complete the tomb of Pope Julius, Paul flew into a rage: 'I have nursed this ambition for thirty years, and now that I am Pope, am I not to have it satisfied? I shall tear the contract up. I am determined to have you in my service, no matter what happens.'[3]

So once more work on the tomb was suspended. On 1 September 1535 the new Pope appointed Michelangelo chief architect, sculptor and painter to the Holy See, thus making him all the more subservient to him.[4]

The new contract with Pope Paul provided only for the execution of the *Last Judgement*; the picture of the Fall of Lucifer was not included.[5]

The cartoon of the *Last Judgement* was finished in September 1535.[6] Then came the preparation of the wall itself: the windows were walled up, the window-ledges removed and two frescoes of Perugino, together

with two of Michelangelo's own paintings in the lunettes, painted over. Also, as Vasari reports, Michelangelo 'had built a projecting wall of bricks, specially chosen and baked, which protruded about a foot at the top, to prevent dust and dirt from settling on the painting.'[7] He began work on the fresco in the spring or summer of 1536; the upper part was completed on 15 December 1540, and the whole picture in October 1541. It was ceremonially unveiled on All Souls' Day, like the ceiling a generation earlier.

How did the *Last Judgement* come to be commissioned? If we accept the accounts of Vasari and Condivi, Pope Clement appears to have wished to present the Holy City, as well as Florence, with a work by Michelangelo as a monument to his pontificate. Condivi writes: 'As a man of sure judgement, he pondered for a long while, finally deciding to have him paint a picture of the Last Judgement, on the grounds that the grandeur of the chosen subject must allow the man scope to display his powers.'[8] Following this line of thought, Justi sought to throw light on the psychological relationship between patron and artist. Pope Clement's experience of Michelangelo the sculptor had not been at all encouraging; perhaps the fact that neither Julius's tomb nor the tombs in the Medici Chapel had been completed made Clement decide to follow Julius's example and commission from Michelangelo, not a work of sculpture, which might again remain unfinished, but a fresco, which he would virtually be compelled to complete. Indeed, the Sistine ceiling was the only large-scale work that Michelangelo the sculptor had managed to complete – and it was a painting.

> No sculpture, therefore, but something in the style of the Sistine ceiling. Perhaps his earlier inspiration would return to him . . . and perhaps the unpredictable old man still had in his mind a whole set of strange, new images of human conditions and human relationships, a thrilling new vision which he could be encouraged in this way to expound to an astonished world. Clement was not to live long enough to see how right his feeling had been.[9]

The Sack of Rome, which had brought the Eternal City to the brink of destruction, combined with the doom-laden atmosphere that had surrounded the Pope's final years, gave the subject of the Last Judge-

ment a peculiar relevance.[10] We must not, however, see the matter solely in terms of the Pope's personal predisposition and desires, or solely in terms of Michelangelo himself as he set about giving expression for the first time to the religious change that had come over him in his later years, but must consider above all the actual position the painting was to occupy. The fifteenth-century pictures in the Sistine Chapel had portrayed the power of the Pope as teacher, priest and ruler by juxtaposing representative scenes from the Old and New Testaments; to these had been added a series of papal portraits, which Michelangelo had extended backwards in time to the earliest of the Holy Fathers, widening the range of motifs by including pictures of the Creation and the beginnings of the human race. The Fall already contained the theme of judgement, a theme present in the Old Testament scenes of the Crucifixion of Haman and the Brazen Serpent and also in the figure of the prophet Jonah – all these, significantly, being above the altar. Raphael's tapestries of 1519 continued this line of thought,[11] portraying the work of the Church through the stories of Peter, of Paul and of Stephen, the first martyr. Was the Sistine Chapel perhaps planned in its entirety from the beginning, to be executed step by step, and including the *Last Judgement* and the *Fall of Lucifer*?

Against this view is the fact that there was no room left for these two compositions: the first pictures of the original series had to be obliterated to make way for the *Last Judgement* and the final pictures would have had to make way for the *Fall of Lucifer*. This suggests that the commission in 1533 represented an extension of the original plan, but an extension in the spirit of the existing works of art in the chapel, above all the paintings on the ceiling, and it is in this context that one must consider the *Last Judgement*, without which the great climax of the whole cosmic drama would be missing.

As a rule pictures of the Last Judgement in churches are to be found on the interior or exterior entrance wall, but they may also be found, particularly in Italy, on the altar wall and be combined with the altar itself.[12] In the Baptistery in Florence, for example, the picture is above the altar. In the eleventh-century retable from the monastery chapel of S. Stefani ad beatum Paulum in Rome, now in the Vatican, and Cavallini's fresco on the west wall of S. Cecilia in Trastevere the altar is

portrayed in the picture itself: in the retable Christ stands behind the altar like the priest performing the mass, and thereby fulfils the dual roles of priest and judge. Similarly in the Sistine Chapel the linking of Last Judgement and altar seems to symbolize the Pope's functions as minister and arbiter: 'And whatsoever thou shalt bind on earth shall be bound in heaven; and whatsoever thou shalt loose on earth shall be loosed in heaven' (Matthew 16:19).

The Pope's claim to be the Regent of the Almighty and to pass judgement in His name was under considerable attack at this time.[13] Large areas of Germany, Switzerland and northern Europe (Denmark, Norway, Sweden) had denied the authority of Rome, and in 1533, the year Michelangelo received his commission for the *Last Judgement*, King Henry VIII of England refused to accept the jurisdiction of the Pope, proclaiming the complete severance of his kingdom from Rome in the following year.[14] It was the worry and suffering brought about by these events which, according to a contemporary report, caused Pope Clement's premature death.[15] Seen from this angle, the commission for a *Last Judgement* also acquires a political significance within the affairs of the Church.

Michelangelo's *Last Judgement* (Pl. 85) takes up the entire back wall of the chapel above the socle. A comparison with the copy (now in the Museo Nazionale in Naples) made, under Michelangelo's supervision, by Marcello Venusti for Cardinal Alessandro Farnese shows that part of the original picture is missing at the bottom.[16] This must have happened when the altar and the two doors were raised above their original level.[17] Venusti's copy is highly important for showing the extent to which Michelangelo's work has deteriorated and also the extent of the overpainting and restoration.

The first impression made by the fresco is of a gigantic explosion. At the top in the centre the majestic figure of Christ dominates the scene, appearing to set everything in motion with the imperious gesture of His right arm – the angels to left and right above Him with the instruments of His Passion, the saints gathered in fear and trepidation around Him, the angels sounding the trumpets of doom, the ascent of the blessed, the fall of the damned and the resurrection of the dead.

The frescoes of the Quattrocento are set firmly in their frames, and in Michelangelo's own Sistine ceiling the frame construction of the pictures is of considerable importance, but in the *Last Judgement* the confining framework seems to have burst open, and the cornices of the side walls jut out over the fresco itself. The whole scene is like a segment of infinity which catches us up in its turbulence. Michelangelo's later pictures in the corner-spandrels of the Sistine ceiling and Raphael's later frescoes for the Stanze in the Vatican also have this segmental quality but they do not challenge the power of the frame, whereas in the *Last Judgement* this power seems to have been broken.

This first impression, however, needs to be corrected by the realization that, for all the explosiveness of the picture, there are deep-seated laws at work beneath the surface. Christ is set in a circle; the ascending and falling figures also move in circular formation. But the circle is a symbol of rest, not of motion, of being, not of becoming. Space is boundless and cannot be encompassed by man but it is not simply the extension of physical reality. The limitations of finite time are also surpassed, and the depiction of the second coming of Christ becomes a depiction of His eternal rule.

Despite the initial impression of unity, the composition of the picture conceals the exploitation of divergent energies which the artist was concerned to fuse. The lunettes, for instance, are both in composition and colour set apart from the rest of the picture: 'The two lower cornices of the chapel are virtually continued through the fresco, serving the functions both of horizon and of frontier between space and Heaven.'[18]

Thus here too Michelangelo does not set himself above reality but engages in a dialogue with it, and the ultimate form of his work is the product of the tension between his original intent and the resistance to it generated by external circumstances. In other words, the wall is for the painter what the block of stone is for the sculptor. At the same time, this identification with the material realities of the situation only emerged at a late stage in the composition of the work: earlier stages show far greater degrees of freedom.

The number of sketches that have survived is strikingly small: Michelangelo seems to have destroyed the majority of them. The earliest is a

drawing in the Musée Bonnard, Bayonne (Dussler No. 246; Pl. 86), which is of great importance for the history of the picture.[19] In this, following the iconographic tradition, the seated figure of Christ is comparatively calm; His right hand is raised in judgement, His left points to the wound in His side. Behind Him the saints are grouped in a semicircle, while in front of Him, also in a semicircle, are the Apostles. On the left, her arms raised imploringly to Him, sits Mary. That the figures are looking downwards indicates that the ascent of the blessed was to be added on the left. The drawing, which is only of the upper part of the picture, keeps comparatively close to tradition (cf. Fra Bartolomeo's fresco in S. Maria Nuova in Florence), though one can sense an urge to give dramatic unity to the whole conception. There is a further drawing of part of the picture in its earliest form in the Uffizi (Dussler No. 294).

This earliest stage of the work is superseded by the sole surviving sketch of the entire composition (Casa Buonarroti; Dussler No. 55; Pl. 87), probably made in Rome in March 1534,[20] which shows Michelangelo at his furthest remove from the traditional conception. Abandoning the symmetry that characterizes the Bayonne drawing, he links the upper and lower halves by a great spiral motif unknown in any earlier work, which anticipates seventeenth-century baroque figurations like those of Rubens. This motif, which replaces the division into definite groups and areas, appears to derive from the gesture made by Christ. Moreover time, as well as space, is of significance here: it is as though we were actually witnessing the moment when Christ raises His arm in judgement. As in older representations, Christ is still seated but He seems to be on the point of jumping up; His right arm is held in the same position as in the Bayonne drawing but the demonstrative, symbolic movement has now become a powerful, inner-motivated gesture aimed rather at effect than at conceptual meaning. The left arm has also undergone a change: instead of just pointing to the wound, it now pulls the robe aside to display it.

The significance of the upper groups to left and right is unclear, and the figures seated around Christ are completely changed: the only recognizable figure is that of Mary, who, in a kneeling rather than sitting position, turns entreatingly towards her Son. Crowded behind her are the blessed, who are being supported and drawn upwards by those

who have already reached the clouds, while an endless procession of figures, some flying, some climbing, but all in full control of their movements, strives eternally upwards as though set on storming the gates of Heaven. There is movement on the right as well. In place of the fall of the damned there are scenes of fighting, while those who have risen from the dead and are striving upwards are cast down by the angels into the abyss in spite of their frenzied resistance.

Michelangelo appears to be thinking here in vertical terms. At this stage Perugino's altar-piece was to have been preserved, and above the frame of the altar we can see the figure of St Michael – which Michelangelo has overdrawn – with outstretched arms. Directly above St Michael is the figure of Christ. In front of St Michael an angel casts a devil down into hell. This group acquires special importance within the asymmetrical spiral movement of the whole composition and links the bottom right of the picture with the top left.

Related to this sketch is a study in the British Museum (Dussler No. 333) which consists of groups and individual figures belonging to a later stage of the composition. In particular the groups of the martyrs and of the Seven Deadly Sins closely resemble the final version.

Far from pursuing the dramatic, anti-symbolic tendency found in the Florence sketch, Michelangelo now turned back to the traditional conception of the theme while retaining his new-found power of expression. One element in this is the expansion which forced him to sacrifice not only his own lunette pictures but also – with far more problematical consequences as far as the nature of the chapel and the overall programme for its decoration were concerned – the altar fresco. In the Florence sketch all these pictures were still preserved.

At the same time one can observe a counter-tendency which turns Christ's personal act of judgement into an event of cosmic significance and seeks to restore the old symbolic content by relinquishing the asymmetrical design, reintroducing groups and zones and re-establishing an overall balance in the picture on a new level. Even the incorporation of the lunettes cannot be seen solely in terms of the extended conception, for it was in the nature of the composition as a whole to soar upwards and outwards, and the figure of Christ was in this way drawn more closely into it; the architectural sight-lines all point towards Christ,

147

thereby restoring to the lunettes what their incorporation into the whole had seemed to deny them.

These lunettes depict the angels with the instruments of the Passion. Whereas earlier these angels, whether motionless or in flight, had only been onlookers in the court of judgement, Michelangelo now draws them into the action. Those on the left are erecting the cross, recalling in their postures traditional Christian iconography and its classical predecessors, such as the *Gemma augustea* in Vienna;[21] those on the right are bearing the pillar at which Christ was scourged. In both lunettes the eye is drawn from the outside towards the centre. The angels, like all the others in the picture, are muscular, scantily clad youths, without wings, supported solely on the banks of clouds and clinging like swimmers to the cross and the pillar. Masters of their own strength, their motions are yet conditioned by the element that sustains them, and it is this dependence, in spite of their apparent freedom of movement, which characterizes the virtually inexhaustible wealth of motifs of action that occur in the fresco. The same is true of the mode of expression, which is not relaxed and effusive but grave, controlled, even tense.

The central figure of Christ (Pl. 88) has undergone a further complete revision since the Florence sketch. Now for the first time Michelangelo has given up the seated position: Christ is on the point of rising, but the suddenness that characterizes the earlier sketch is now toned down, and despite its movement the figure retains a timeless serenity. The left hand no longer pulls the robe aside but points almost casually towards the wound and at the same time bids the blessed welcome. As Condivi puts it: 'His left arm stretches to the right as though gathering the good spirits to Himself.'[22] Similarly the right arm embraces rather than turns away: it is to be taken together with the left and is the bearer not only of damnation but of blessing. The face, without beard and with the features of Apollo, is turned towards the damned, but the eyes are cast down and the expression is one of tranquillity, not of wrath. The gentle outlines of the figure both stand out from, and are encompassed by, the aureole, and seen from the front, the figure is the focal point of the entire movement within the picture.

The Virgin Mary inclines her body towards Christ 'as though in fright and as though she felt exposed to God's wrath and its mystery'

(Condivi).[23] Yet despite her fear and trembling she is cast in the role of intercessor; her arms are crossed in humility as she gazes compassionately upon the struggling souls below, seeking to light their path and allay their cares. Her head and that of Christ, both averted, are complementary – the two figures, indeed, share a secret unity expressed, not as matic assertion but as serene, underlying reality.

The choirs of saints are grouped like festoons round Christ and Mary, but before dealing with them, we should direct our attention to the scene of the judgement itself.

Some distance below Christ, in a different zone yet linked with Him, are the angels of the Apocalypse: the two in the front face those risen from the dead, and hold in their hands the books of judgement; the Book of the Damned is too heavy for one angel alone to carry.

At the bottom left the dead are rising from their graves; in the very front one is crawling out from beneath the gravestone, while others are struggling to rid themselves of their shrouds and fight their way upwards. Some are portrayed as skeletons; in the front is a hideous skull. Their movements are almost like those of animals encaged in heavy, oppressive surroundings and held as a mass, without individuality, within the confines of the horizon. We are here still in the realm of death; the only hint of consolation is the old man on the extreme left who is helping one of the figures to leave his grave. This old man probably represents Ezekiel, whose powerful vision of a valley of dry bones, as Condivi pointed out,[24] is reflected here. We read in Ezekiel:

> The hand of the Lord was upon me, and carried me out in the spirit of the Lord, and set me down in the midst of the valley which was full of bones. And caused me to pass by them round about: and behold, there were very many in the open valley; and lo, they were very dry. And he said unto me, Son of man, can these bones live? And I answered, O Lord God, thou knowest. Again he said unto me, Prophesy upon these bones, and say unto them, O ye dry bones, hear the word of the Lord. Thus saith the Lord God unto these bones; Behold I will cause breath to enter into you, and ye shall live; And I will lay sinews upon you, and will bring up flesh upon you, and cover you with skin, and put breath in you, and ye shall live, and ye shall

know that I am the Lord. So I prophesied as I was commanded; and as I prophesied, there was a noise, and behold a shaking, and the bones came together, bone to his bone. And when I beheld, lo, the sinews and the flesh came up upon them, and the skin covered them above; but there was no breath in them. Then said he unto me, Prophesy unto the wind, prophesy, son of man, and say to the wind, Thus saith the Lord God: Come from the four winds, O breath, and breathe upon these slain, that they may live. So I prophesied as he commanded me, and the breath came into them, and they lived, and stood upon their feet, an exceeding great army. (38:1 ff.).

In the Florence sketch the risen dead fly or clamber upwards in their efforts to storm Heaven, but in the final fresco this independent movement has given way to an urge for companionship and protection (Pl. 89): the bodies have not yet accustomed themselves to the new life and look for help from those who are further advanced; they are like swimmers who have left one bank of the river but not yet reached the other. These elements of help and comfort must not be overlooked in the midst of the shocks and horrors that dominate the judgement scene as a whole.

The Florence sketch shows the blessed stretching right up to the figure of the Virgin, with a semicircle of saints still higher, behind Christ. In the fresco the zones are divided, and the distance between the middle and upper zones seems endless. In this latter the saints are grouped round the person of Christ, facing Him but not permitted to touch the radiant aureole around Him. The motif of the companions at His side has been removed. The saints, each in his prescribed place in the hierarchy, wait in fear and trembling for the words of judgement.

The figures in the uppermost zone belong to a higher sphere. On the left are the patriarchs, among them, as Vasari seems to have correctly concluded,[25] the muscular, bearded figure of Adam, first of the mortals and forerunner of Christ, 'the figure of Him that was to come'.[26] On the right are the apostles. Opposite Adam and in a corresponding pivotal position stands the mighty St Peter, offering the keys of Heaven to Christ with both hands as though reminding Him of the words with which He had once entrusted the keys to him. Below Christ on the right

is the army of martyrs. At His feet, in the place of honour that was their due in the Sistine Chapel,[27] sit St Lawrence with the gridiron and St Bartholomew holding the skin on which Michelangelo has painted a distorted self-portrait; then, further to the right, come St Blasius with the woolcombers' iron (the head has since been completely overpainted), St Catherine with the wheel (originally a naked figure), St Simeon with the saw, St Sebastian with the arrows and two figures bearing a cross. The gestures of these martyrs have been variously interpreted, and it is hardly possible to say more than that each of them is present at the court of judgement with the symbol of his martyrdom.

Surrounding the inner circle of patriarchs, apostles and martyrs is an outer circle. On the left are the women – sibyls, described by Tolnay as 'exhausted figures anxiously listening to the distant thunder and sensing the impending catastrophe',[28] and virgins, equally uneasy and seeking reassurance from each other; at the front is a large female figure, possibly Ecclesia, protecting a young figure with her arm – this is the Niobe motif of the protective mother (the famous Florentine *Niobe*, however, was not discovered till 1583[29]). On the right are the men – Prophets, some of them blind, and confessors. 'A profound agitation fills them as they press forward: filled with ecstasy, they listen in silence as they gaze on the scene in fear – almost, indeed, as though they could not trust their eyes.'[30] The gamut of emotions stretches from sinister fear and foreboding to the bliss of a secure faith.

The Florence sketch had depicted, not the perdition of the damned, but their upward struggle to higher things, and this notion of struggle, with the angels defending above and the demons enticing below, is also prominent in the fresco. On the left, for instance, one sees a figure who is already near the top but is being dragged back again by demons, covering his face with his hand in despair (Pl. 90). On the right a figure has been repulsed by an angel and is being pulled head-first into the abyss by a demon; his purse and his keys show him to be the personification of Avarice, while at his side is an old man who personifies Lust.

Right at the bottom are the figures of Charon and Minos – they are not part of the Florence sketch – who, as Varchi, Condivi and Vasari all point out, derive from Dante (*Inferno* III, 109–11): 'In an attitude of frenzy', says Vasari, 'Charon is striking with his oar the souls being

dragged into his bark by the demons. Here Michelangelo was following the description given by his favourite poet, Dante:

> Charon, his eyes red like a burning brand,
>> Thumps with his oar the lingerers that delay,
>> And rounds them up, and beckons with his hand.[31]

In the right corner stands Minos, Prince of Hell, whose features, according to Vasari,[32] are those of Biagio da Cesena, Master of Ceremonies, who was the first to call the fresco obscene and offensive when he visited the chapel in the company of Paul III. When he complained to the Pope about the way Michelangelo had taken his revenge, the Pope replied: 'God has given me power in Heaven and on earth but I cannot control the affairs of Hell. *Ibi nulla est redemptio.*'[33]

There is no one single viewpoint, no all-encompassing horizon, in terms of which Michelangelo's *Last Judgement* as a panorama of events in time and space can be comprehended. Each group of figures has its own perspective, and the size of each group is determined, not by optical laws but, as in the Middle Ages, by the importance of what it represents. Thus what lies farthest away in terms of physical distance is largest, and seems to be growing still larger.

It is this 'unreality' of spatial conception that reveals most clearly the aesthetic character of the work and, as already in the ceiling frescoes, shows how far it leaves the past behind. Yet in that space is also portrayed as an attribute of the world beyond, apprehensible only through physical bodies and their movement, it acquires some of the qualities of the gold colour so fundamental to medieval paintings. It is these hidden relationships that explain the position of the fresco *vis-à-vis* the physical conditions imposed by the wall, together with the reintroduction of groups and zones and the restoration of an overall balance.

The depiction of the figures is intimately linked with the depiction of space. What mastery of the human form, what a wealth of motifs of action! There is nothing to equal what Vasari, with true perceptivity, called 'the frightening power' of this demonic, dangerous art.[34] Stripped of conventional formulae, it is an art of pure observation and knowledge of nature. As Vasari already observed: 'Anyone in a position to judge will also be struck by the amazing diversity of the figures which is re-

flected in the various and unusual gestures of the young and old, the men and the women. All these details bear witness to the awesome power [*terribilità*] of Michelangelo's art, in which skill was combined with a natural inborn grace.'[35] Condivi, describing Michelangelo's anatomical studies, speaks of his intention 'to write a book which should treat of all conceivable kinds of human stance and movement as well as of the joints'.[36] The *Last Judgement* is the visual counterpart to this unwritten book and became a veritable encyclopedia for artists in succeeding centuries. 'Behind this work,' writes Vasari, 'bound in chains, follow all those who believe they have mastered the art of painting; the strokes with which Michelangelo outlined his figures make every intelligent and sensitive artist wonder and tremble, no matter how strong a draughtsman he may be. It is as though some powerful demon had mastered the art of drawing.'[37]

Yet this infinite wealth of form was made to serve the dictates of a central expressive purpose. There is no bodily movement that is not at the same time expressive movement – movement, indeed, that can only be understood in terms of power of expression. When one recalls that this artistic freedom is derived not only from the study of nature but also from the study of antiquity, one is astonished to discover that classical means are here employed to achieve effects with which antiquity has nothing to compare. Where in classical art can one find such demonic, supernatural impulses or a conception such as that of bodies being drawn inexorably upwards?

So often has the picture been overpainted and so harsh have been the ravages of time that it is scarcely possible to gain an accurate impression of the composition of the original colours. The background tones have now become a dark grey-brown and a grey-blue, with the bodies in a brownish red and a pale, earthy brown. The sky is ultramarine with white clouds, and there are green, red-grey and yellow-grey tones above the earth. One has to supplement one's impressions by referring to the ceiling frescoes. There are no prominent bright colours but a harmonized pattern of sombre, almost earth-coloured tones over the whole surface.

In Michelangelo's *œuvre* the forerunners of the *Last Judgement* are the *Battle of the Centaurs*, the *Battle of Cascina* and the *Flood* of the Sistine

ceiling. The first-named already shows the compositional principle of the hero in the centre, the circular intertwining of the bodies, and the motifs of struggle, resistance, perdition and mourning. The *Battle of Cascina*, as Goethe pointed out,[38] bears a clear spiritual affinity to the *Last Judgement*, and in addition Michelangelo took over certain individual motifs such as that of the ascending and falling figures on the left. The relationship to the *Flood* is the closest, and is particularly evident in the vivid presentation of the catastrophe, in the sympathy for the human creatures caught up in it, and in individual motifs such as that of the mother with her children. It was only to be expected that the artist who, in the ceiling frescoes, gave such powerful expression to the opening scenes of the cosmic drama would be uniquely capable of bringing to life the drama of the Last Judgement.

Michelangelo's earlier *Phaeton* drawings also form part of this context, for Zeus sitting in judgement, Phaeton's plunge into the depths, and the lamentations below are all motifs that recur in the *Last Judgement*. In the Phaeton drawings, moreover, we first encounter the conception of contorted bodies fighting in vain against the power of gravity as they hurtle downwards.

The history of the *Last Judgement*, from the earliest sketches to the final execution, shows that Michelangelo first moved away from tradition and later returned to it, and the traditional aspects of the final fresco must be seen in this light.

The subject of the Last Judgement is one of the oldest in Christian art,[39] and the judgement theme is present in early Christian symbols such as the Second Coming and the empty throne, but it is not met as an independent subject before the ninth century. Since that time one can distinguish an eastern and a north-western type, the latter derived from the former. This north-western type was of great influence: it is represented by works such as the fresco in S. Angelo in Formis, Cavallini's fresco in S. Cecilia in Rome, Giotto's fresco in the Arena Chapel in Padua and various porches in French cathedrals.

The principle difference between the eastern and north-western types lies in the composition. The former has clearly defined zones with a strict succession of self-contained scenes; the latter seeks a central unity to which the separate scenes are related. The difference is most plainly

seen in the figure of Christ. The eastern tradition depicts Him as the same size as the apostles, intercessors and angels with whom He sits, or even somewhat smaller, whereas the north-western tradition (the church of St Georg in Oberzell on the island of Reichenau) shows Him as both the formal and the spiritual centre of the picture, over-shadowing all around Him.

In general terms Michelangelo's fresco belongs to the north-western tradition. He had a fundamental urge to give his works a central unity, and even the hovering angels can be seen as belonging to this tradition. Yet touches of the other tradition are also found. The figure of Christ, for example, is small in comparison to the picture as a whole and is incorporated in the zone occupied by His companions and the inter-cessors. We may assume that during his stay in Venice in 1529 Michel-angelo saw the mosaic on the entrance wall of the interior of Torcello Cathedral, and there seems to be a resemblance between his Christ and the Christ of the Anastasis in Torcello. Is it possible that the conception of a Christ rising to his feet in wrath might have sprung from this eastern model?[40] The identification of the powerful figure of Adam on Christ's left is also supported by the Torcello mosaic, for in the so-called *Gospel of Nicodemus* we read: 'Attraxit Adam ad suam claritatem'. Does not Michelangelo's Adam seem to be gazing in rapture upon the bright-ness of Christ?

The line of great Italian works on the subject of the *Last Judgement* which reaches its culmination in Michelangelo starts with Cavallini's fresco in S. Cecilia in Rome. It then leads to Giotto's fresco in the Arena Chapel in Padua, Francesco Traini's fresco in the churchyard at Pisa (where we first meet the gesture of judgement found in Michelangelo's Christ), Nardo di Cione's frescoes for the Cappella Strozzi in S. Maria Novella in Florence (which also contain an illustration of Dante's *In-ferno*, another important subject) and eventually to Signorelli's frescoes for the Cappella Brizio in Orvieto Cathedral and Fra Bartolomeo's fresco for the chapel in the churchyard of S. Maria Nuova in Florence (now in the Uffizi).

All these works were important for Michelangelo. Closest to him are the frescoes of Signorelli, an artist whose great significance for Michel-angelo we have already had occasion to observe. On the ceiling of the

Cappella Brizio Signorelli painted groups of patriarchs, apostles, Church fathers, martyrs and virgins, and on the walls the deeds of the Anti-christ, the end of the world, the resurrection of the dead, the damned, Charon, and the summoning and crowning of the elect. Never before had the end of the world been treated in such detail, and Michelangelo must have been deeply moved. He took over Signorelli's entire com-position: the particular power of the murals lay for him in their detail, their dramatic narrative quality, the equal importance given to the elect and to the damned, and the prominence of the nudes. Of individual motifs, those that particularly gripped his attention were found in the resurrection of the dead. Signorelli was the first to portray the resur-rection of the dry bones as related by Ezechiel.

There are, however, three aspects of Michelangelo's *Last Judgement* which cannot be adequately explained in terms of traditional icono-graphy:[41] the ascent of the blessed, the rebellion of the damned and the cosmological dimension. Has Michelangelo any predecessors here?

The ascent of the blessed is to be found in Fra Angelico's altarpiece for S. Maria sopra Minerva in Rome (Berlin, Staatliche Museen). It is a motif taken over from northern artists. A painting by Dierick Bouts for the council chamber of the town hall in Louvain (Lille, Museum) shows an almost endless procession of figures making their way upwards on all sides, the ranks thinning out towards the background; one of the blessed kneels on a cloud above and stretches out his arms towards the light. Hieronymus Bosch's pictures of paradise (Venice, Doge's Palace) show the figures, not walking but almost flying; the heavenly night is bathed in a mysterious glow, and the blessed spirits float upwards in positions and attitudes never before encountered. Could Michelangelo have seen any of Bosch's pictures in Italy?[42] Certainly, as a lover of Dante, he could not have failed to comprehend the world of Bosch, which is inseparable from the Dantean context. And when one re-members the classical foundations of Michelangelo's art, one realizes how unclassical is this motif of an upward floating motion. He employs classical means to realize an unclassical conception. Only Michelangelo could have done such a thing.

The rebellion of the damned may well be the product of the *Fall of Lucifer* which was planned for the entrance wall of the Sistine Chapel.

It already occurs in the Florence sketch. As to the cosmological signi-
ficance, this proceeds from medieval depictions of Christ as Creator and
Lord in the midst of a circular universe. The so-called 'Dalmatic of
Charlemagne'[43] in the sacristy of St Peter's shows that it had already
found its way into pictures of the Last Judgement, while a tondo from
the monastery of S. Stefani (now in the Vatican) – the circularity
symbolizes the *orbis pictus* – shows Christ as ruler above Christ as judge,
surrounded by a circular halo and set in majesty on a rainbow, in His
right hand a globe inscribed 'Ecce vici mundum'. Cavallini's fresco
needs to be supplemented in the same manner.

Thus, as these examples show, the theme of Christ's everlasting
dominion clearly forms part of the context of the Last Judgement and
was current in Michelangelo's day, which proves how natural this con-
text would have been to him.

Pictorial sources were far more important to Michelangelo than
literary sources, and it is they that showed him the path of his own
development. But his imagination was also stimulated by the Bible, by
the liturgy and by religious poetry.

One cannot consider his work without reference to the Bible, whose
influence was immediate and unqualified.[44] In the case of the *Last Judge-
ment* there was material to draw upon in both Old and New Testaments,
though the former was the more important for him, witness the vision
of Ezekiel. In the New Testament it is St Paul whose presence is most
keenly felt: 'For the Lord himself shall descend from Heaven with a
shout, with the voice of the archangel, and with the trump of God; and
the dead in Christ shall rise first; Then we which are alive and remain
shall be caught up together with them in the clouds, to meet the Lord
in the air; and so shall we ever be with the Lord.' (1 Thessalonians 4:
16–17.) This is the spirit of Michelangelo.

No work can equal the Bible in importance for the *Last Judgement*,
not even Thomas a Celano's *Dies irae*, and there is nothing to suggest
that this hymn served as his immediate source.[45] He had an intimate
knowledge of Dante – 'il suo familiarissimo', as Vasari calls him[46] – but
the relationship is rather one of similar assumptions than of detailed
references.[47] The theme of Charon can be traced back to earlier paintings.

The *Last Judgement* is the final act of the cosmic drama which had opened with the frescoes on the ceiling of the Sistine Chapel and been interrupted for decades, and its relatedness to these earlier paintings is more important than the differences caused by age and experience. There is no decline in the power of his imagination, and the same greatness of spirit pervades the *Last Judgement* as fills the frescoes on the ceiling. Now as then the paintings that may have stimulated him pale into insignificance in the presence of the power that fills his own creations.

There is nothing in Michelangelo's work as a whole to suggest any break or disagreement with the faith of the Church in which he grew up, and his biography, his own utterances, together with his letters and his poems, all confirm this. Yet there is more to the matter than this. In his youth he was profoundly affected by the life and death of Savonarola, and later he was in contact with the Italian reform movement represented by the 'Oratorio dell' Amore divino' founded in 1517, the 'Consilium de emendanda Ecclesia' of Pope Paul III, and by the circle of Juan Valdès, which, after Valdès's death in 1541, moved from Naples to the nunnery of S. Catharina in Viterbo (among the members of this circle were Valdès's pupils Cardinal Contarini and Vittoria Colonna).[48] This reform movement, which had links through Valdès with the Reformation in northern Europe, strove for a renewal of faith within the framework of the Catholic Church, believing with the Reformers that grace depended in the first instance not on good works but on faith.

Michelangelo probably first met Vittoria Colonna in the autumn of 1538. It was through her that he became acquainted with the doctrine of redemption by faith alone and the rejection of the concept of free will.

The first conception of the *Last Judgement* can be dated from 1533–4, so we cannot connect it with the change in religious attitudes brought about by his association with Vittoria Colonna. Yet in the completed fresco of 1541 one is frequently tempted to see the precedence of faith over good works (*sola fide*) in the attitudes of the saints, and the denial of the freedom of the will in the dictated movements of the blessed and the damned. It reveals Michelangelo's readiness to absorb the ideas of the Italian reformers and is in its final form virtually identical with the spirit of this movement.

In historico-religious terms the *Last Judgement* forms a parallel to this reform movement, but not to the Counter-Reformation. It is scarcely a coincidence that the Pope in whose reign it was painted, Paul III, is the man who elevated the most important members of the reform movement to the rank of cardinal, and that the Pope who virtually crushed this movement, Paul IV Caraffa, is the man who was only with difficulty dissuaded from ordering the fresco to be destroyed.

Drawings for Vittoria Colonna – bust of *Brutus*

Michelangelo's meeting with Vittoria Colonna, daughter of Fabrizio Colonna and the widow of Ferdinando Pescara – 'the two leading noblemen and generals of their day'[1] – ushered in a new period in his life.[2] The ideas of the Italian reform movement took hold of his mind and began more and more to change the nature of his art. His later works can only be understood in terms of his persistent efforts to make his art the receptacle of his new religious experience. There is now no longer any question of the glorious self-sufficiency of art.

Michelangelo was over sixty when he met Vittoria Colonna; she was almost fifty. Condivi writes:

He loved the Marchesa of Pescara deeply and was inspired by her divine spirit. She returned his love. He has in his possession many letters from her, full of the purest, most virtuous love such as could only spring from a pure and noble heart. He on his side then began to address numerous sonnets to her, full of *esprit* and sweet desire. Many were the times she would leave Viterbo, or some other place to which she had gone to relax or to pass the summer, just in order to see him in Rome. So deeply in love was he with her that I recall his saying that nothing caused him greater anguish than that, when he visited her as she lay dying, he had not kissed her forehead or her cheek as he had kissed her hand. Her death left him benumbed and drove him at times to distraction.[3]

She died in 1547.

Francisco de Hollanda has left a vivid account of their friendship in his recollections of the conversations that took place on Sundays in the church of S. Silvestro al Quirinale and in 'the little garden, surrounded by a wall, where the ivy-covered trees stood close by a rustling stream'.[4]

Vittoria's power over him is described in the following sonnet:

Da che concetto ha l' arte intera e diva
 La forma e gli atti d' alcun, poi di quello
 D' umil materia un semplice modello
 E 'l primo parto che da quel deriva.
Ma nel secondo poi di pietra viva
 S' adempion le promesse del martello;
 E sì rinasce tal concetto e bello,
 Che ma' non è chi suo eterno prescriva.
Simil, di me model, nacqu' io da prima;
 Di me model, per cosa più perfetta
 Da voi rinascer poi, donna alta e degna.
Se 'l poco accresce, e 'l mio superchio lima
 Vostra piestà; qual penitenzia aspetta
 Mio piero ardor, se mi gastiga e insegna?

(Whenever perfect works of art are planned,
The craftsman always makes a model to
Be the first simple part from which shall grow
The finished object underneath his hand.

Later, in living stone, more perfect still,
A lovelier thing is shaped; beneath the blows
Of the fierce hammer, he can feel the thrill
Of art emerging from its own birth throes.

So was I born as my own model first,
The model of myself; later would I
Be made more perfect, born of one so high.

If all my roughness, then, should be so blest
By your compassion, then what penance ought
My feverish ardour by your rules be taught?)[5]

Michelangelo worshipped natural beauty as a reflection of divine beauty. In another sonnet to Vittoria Colonna he writes:

Come dal foco el caldo esser diviso
 Non può, dal bell' etterno ogni mie stima,
 Ch' esalta, ond 'ella vien, chi più 'l somiglia.

> (Just as from fire the heat cannot be parted,
> Neither can I be separated from
> That Beauty in whose likeness she is made.)[6]

And if the beauty of nature is a victim of the passage of time, it is the task of art to overcome the power of the ephemeral:

> Com' esser, donna, può quel ch' alcun vede
> Per lunga sperienza, che più dura
> L'immagin viva in pietra alpestra e dura,
> Che 'l suo fattor, che gli anni in cener riede?

> (Lady, how can it be that what is shown
> Through long experience and imagination
> Endures so long in hard and mountain stone,
> While years enact the maker's consummation?)[7]

But Vittoria Colonna destroyed Michelangelo's faith in the power of art to achieve eternity. In one of her letters she writes: 'Most honoured Master Michelangelo, your art has brought you such fame that you would perhaps never have believed that this fame could fade with time or through any other cause. But the heavenly light has shone into your heart and shown you that, however long earthly glory may last, it is doomed to suffer a second death.'[8] From this moment the idea of a 'second death' enters Michelangelo's thoughts, and it is no longer the urge to fame that sustains him but solely the desire to come close to God and to partake of His grace:

> Onde l' affettuosa fantasia,
> Che l'arte mi fece idol' e monarca,
> Conosco or ben quant' era d' error carca,
> E quel ch' a mal suo grado ogn' uom desia.
> Gli amorosi pensier, già vani e lieti,
> Che fieno or, s' a duo morte m' avvicino?
> D' una so 'l certo, e l' altra mi minaccia.

> (Now I know full well it was a fantasy
> That made me think art could be made into
> An idol or a king. Though all men do
> This, they do it half-unwillingly.

The loving thoughts, so happy and so vain,
Are finished now. A double death comes near –
The one is sure, the other is a threat.)[9]

The profound struggles that preceded this transformation are
apparent from the self-revelations in his later poems. The tension
between the world of eternity and the world of nature never left him:

Le favole del mondo m' hanno tolto
 Il tempo data a contemplare Iddio;
 Nè sol le grazie suo poste in oblio,
 Ma con lor, più che senza, a peccar volto.
Quel c' altri saggio, me fa cieco e stolto,
 E tardi a reconoscer l' error mio.
 Scema la speme, e pur crescie 'l desio
 Che da te sie dal propio amor disciolto.
Ammezzami la strada c' al ciel sale,
 Signior mie caro, e a quel mezzo solo
 Salir m' è di bisognio la tuo 'ita.
Mettimi in odio quante 'l mondo vale,
 E quanto suo bellezze onoro e colo,
 C' anzi morte caparri eterna vita.

(By the world's vanities I've been distracted,
And thus have squandered hours which should have been
Reserved for God. His mercy I've rejected,
And my misuse of it has made me sin.

The knowledge which makes others wise has made
Me blind. I recognize my faults too late.
Hope lessens, yet, before desires fade
Of friend, dissolve my self-love and self-hate.

And God, divide, I beg, the road that leads
To Heaven; I cannot climb its length alone,
I need your help through all the snares and strife.

Help me to loathe the world and all its deeds;
I'll cast its beauties out but to atone,
And find the promise of eternal life.)[10]

Yet this transformation, which threatened to lead Michelangelo away from art, did not stifle his creative activity. His greatest architectural achievements, above all his continuation of New St Peter's in Rome, were still to come, and in the realm of painting too he was yet to produce some glorious works. His religious creations are dominated by the concepts of grace, inspiration and the mystery of redemption.

For Vittoria Colonna Michelangelo did two drawings and, it seems, one oil painting: Condivi and Vasari[11] both mention a *pietà* and a Crucifixion, and Vasari also refers to a design on the subject of Christ and the Woman of Samaria.

The drawing of the *Pietà* (Boston, Isabella Stewart Gardner Museum; Dussler No. 378; Pl. 91)[12] shows the seated figure of the Virgin on a raised surface in front of the cross – a cross, according to Condivi, that reproduces the so-called Cross of the Plague (i.e. the Plague of 1348) in S. Croce in Florence.[13] Inscribed on the upright are Dante's words: 'Non vi si pensa quanto sangue costa'.[14] Mary's face is turned upwards to Heaven and her arms are stretched out in supplication. The dead Christ slumps on the ground at her feet, held between her legs, His arms hanging limply across her knees and held on each side by a cherub to prevent Him falling. His head hangs forward and His legs are bent at an acute angle.

Michelangelo's marble *Pietà* in St Peter's had been carved many years before, but whereas in the earlier work Mary is the principal figure, as in the typical northern *pietà*, here Christ occupies the centre of the picture. The concept of the Man of Sorrows and of redemption through the blood of Christ, which was scarcely present in the earlier *Pietà* and not fully convincing in *The Risen Christ* in S. Maria sopra Minerva, now dominates the scene.

A further difference lies in the composition of the group as a whole and its relationship to the viewer. The harmonious unity of the earlier work has given way to a rigid verticality. The emphasis lies on the upright position in which the body of the dead Christ is held and on the contrast between this position and the lifelessness of the corpse. The vertical movement is continued and heightened in the figure of the Virgin; offsetting this is the parallelism of the outstretched arms of Christ and Mary. The sculpture in St Peter's lives in its own world; the

Virgin has eyes only for her Son. The drawing for Vittoria Colonna speaks directly to the viewer and directs his thoughts towards Golgotha in reverence and worship.

How did this change of conception come about? It is anticipated by two works of Sebastiano del Piombo, with both of which Michelangelo was indirectly involved. One is the *Pietà* in S. Salvador in Ubeda,[15] in Andalucia, which, although commissioned as a successor to Michelangelo's sculpture in St Peter's, shows Christ being lifted up; in her right hand Mary holds the nails, in her left hand the bandage, and the emphasis lies on the symbolism of the individual elements. It is only slightly earlier than Michelangelo's drawing for Vittoria Colonna, and the most important link between the latter and the *Pietà* in St Peter's. The other work of Sebastiano's is the somewhat earlier *Pietà* in Viterbo (Museo Civico),[16] which, though rather less closely related to Michelangelo's drawing, still cannot be thought of apart from him. According to Vasari he both conceived the motifs and prepared the cartoon.[17] Christ is shown on the ground, with Mary, weeping bitterly, sitting above Him.

One may also refer in this context to an engraving by Marcantonio after Raphael (B. 34)[18] and to an engraving by Agostino after Andrea del Sarto (B. 40).[19] The latter combines the theme of the *pietà* with that of the Throne of Grace, as found in Dürer's woodcut of 1511, and this latter theme became important for Michelangelo also.

However, the real root of Michelangelo's *Pietà* drawing for Vittoria Colonna lies not in the *pietà* motif but in the motif of the Man of Sorrows. This motif, in which the body of Christ is held by two angels, is frequently met with in northern European art from the end of the fourteenth century onwards, and early forms of it occur in Giovanni Pisano's lectern (Berlin, Staatliche Museen)[20] and in a slightly later marble relief by Donatello in the Victoria and Albert Museum.[21] This latter work depicts only a half-length figure, whereas Michelangelo, following Dürer, portrays the whole body of Christ, but Donatello brings us very close to Michelangelo.

The *pietà* theme itself is intensified by the addition of the theme of supplication, which is found only once before, namely in the early fifteenth-century French Book of Hours, the *Grandes Heures de Rohan*.[22]

But although the motif is the same, there can hardly be any question of a relationship between the two. 'As she holds her Son in her arms, His head crowned with thorns and His side pierced by the spear, she is moved by her anguish to beg for grace for stricken mankind.'[23]

The *Crucifixion* mentioned by Vasari and Condivi appears to be that claimed by Deoclezio Redig de Campos to be in a panel in a private house in Rome.[24] There is a preliminary sketch, presumably by Michelangelo himself, in the British Museum (Dussler No. 329; Pl. 92). The subject recalls his carving for S. Spirito in Florence but now, as Condivi says, he portrays 'the living Christ, His head turned as though to His Father, as He cries: "Eli, Eli". His body is not that of an abandoned corpse but rather like that of a living man who is racked and tormented by the cruel pain.'[25] The head, thrown back in agony – the first time this is found in depictions of the Crucifixion – owes something to the *Laocoon*.

Michelangelo enclosed the following poem with a letter to Vittoria Colonna which seems to refer to this work:[26]

Ora in sul destro, ora in sul manco piede
Variando, cerco della mia salute:
Fra 'l vizio e la virtute
Il cor confuso mi travaglia e stanca;
Come chi 'l ciel non vede,
Che per ogni sentier si perde, e manca.
Porgo la carta bianca
A' vostri sacri inchiostri,
Ch' amor mi sganni, e pietà 'l ver ne scriva:
Che l'alma da sè franca
Non pieghi a gli error nostri
Mio breve resto, e che men cieco viva.
Chieggio a voi, alta e diva
Donna, saper se 'n ciel men grado tiene
L'umil peccato che 'l superchio bene.

(Turning right and then left,
My salvation I seek.
Bewildered, lost between virtue and love,

My heart is wearying me. I am like one
Who does not look above,
And goes from dark to darker path, astray.
O take my paper, blank,
And write on it your words of sanctity,
So that love stop its cruel tyranny,
And pity may at last show me the truth;
And, cleansed and free, no more shall my soul yield,
In my last days, to all my old mistakes,
And I shall walk, less blind, my life's last field.
Lady divine and pure, oh tell me, please,
Whether in heaven a repented sinner
Is less rewarded than a constant winner.)[27]

Here too we find the concept of *sola fide*, together with the mystery of grace and redemption, and it is from this standpoint that we must view the change that Michelangelo made in the iconographic tradition. At the same time we can see that here, as in his *Risen Christ* in S. Maria sopra Minerva, he is not yet in a position to transmute his mystic vision into aesthetic form. The power and intensity of physical emotion have not yet been overcome. This point was to be reached with his last drawings of the Crucifixion.

Michelangelo's bust of *Brutus*, now in the Museo Nazionale in Florence (Pl. 93), belongs to the years 1539–40, during which he was at work on the *Last Judgement*. It probably owes its existence to a suggestion by his friend Donato Gianotti, a statesman and historian, and was done for Cardinal Niccolò Ridolfi.[28] However, it never came into the cardinal's possession. Gianotti became Ridolfi's secretary in 1539; both men were so-called *fuorusciti*, émigrés from Florence after the Medici regained power in 1530. In 1537 Duke Alessandro de' Medici was assassinated by his cousin Lorenzino, who was hailed by the Florentine patriots as *Bruto nuovo* and *Bruto toscano*. A coin was even minted showing him as Brutus. This is the contemporary situation – in which Michelangelo, himself a Florentine who was to be found in the company of the *fuorusciti* in Rome, was intimately involved – against which the bust of Brutus has to be viewed. It is a political work, and the only bust he did.

It is unfinished, except for the robe,[29] and was given by Michelangelo to Tiberio Calcagni to complete. The reason it was left unfinished emerges from the inscription on the pedestal, ascribed, rightly or wrongly, either to Gianotti or to the Venetian humanist Cardinal Bembo:

> Dum Bruti effigiem sculptor de marmore ducit,
> In mentem sceleris venit et abstinuit.

(While the sculptor was hewing the effigy of Brutus out of the marble, he came to feel the spirit of crime and turned away from the work.)

Sympathy for the Florentine *fuorusciti* may well have led Michelangelo to welcome Gianotti's suggestion but, as is clear from Gianotti's conversations with him on Dante, he opposed the idea of assassination and turned his back on the work. In the second dialogue he says to Gianotti: 'It is an act of arrogance to murder the leader of an official government, be he just or unjust, if one cannot be certain that good will come of his death. . . . I cannot tolerate those who think that the only way to bring about good is to start with something bad, that is, with killing.'[30] This is precisely what the inscription on the pedestal says. That Michelangelo left the work unfinished is an act of conscience. He shrank from the thought of paying homage to an assassin.

Vasari refers to the likeness of Brutus on a 'cornelian of great antiquity belonging to Giuliano Cesarino' as the model for Michelangelo's bust,[31] and there is on the fibula a profile which could be taken for a copy of this cornelian. In the bust, however, Michelangelo has turned an individual likeness into an idealized likeness. The head is turned sharply to one side and, viewed thus in semi-profile, conveys a sense of controlled energy. In frontal aspect it expresses a barely restrained hatred, rage and bitter scorn. There are Roman busts, such as that of the Emperor Caracalla in the Museo Nazionale in Naples,[32] which also show a head in profile on shoulders that face forwards, as well as an interplay between the posture of the head and the folds in the drapery, but to translate this into the realm of the typical is quite un-Roman.

Chapter 12

Completion of the tomb of Pope Julius

The contract of 1532 stipulated that Michelangelo should complete the tomb of Pope Julius by May 1535. But the date came and went, and the monument was not finished. On 17 November 1536 a papal brief dispensed him from his obligations to the house of Rovere and required him to work on the *Last Judgement*,[1] and in 1539 Guidobaldo, Francesco Maria's son and the new Duke of Urbino, released him from his work on the tomb for as long as he was occupied on the fresco. However, Guidobaldo also told him that he expected him to devote his entire energies to the tomb after finishing the fresco and to make up for lost time by redoubling his efforts. 'I cannot think', he wrote, 'that you are not spurred on by a similar desire, and as I take you for a man of your word, we consider it unnecessary to subject you to pressure so long as you have the health and strength to pay homage to the sacred bones of him who paid homage to you during his lifetime.'[2]

But when the *Last Judgement* was completed in 1541, Pope Paul III did not release Michelangelo. Instead he immediately commissioned him to paint two frescoes for the newly-built Cappella Paolina in the Vatican palace.[3] Duke Guidobaldo was therefore compelled to content himself with three figures by Michelangelo – *Moses* and the two *Captives* – instead of six, and to agree that the other three figures – Madonna, prophet and sibyl – should be done by Raffaello da Montelupo.[4]

Michelangelo now, however, found himself in difficulties. The plan of 1532 to put the two *Captives* (now in the Louvre) in the niches on either side of the statue of Moses no longer seemed to him suitable. So although they were almost finished, he rejected them and started work, of his own volition, on two new statues, one of Rachel, the other of Leah, allegories of the *vita contemplativa* and the *vita activa* respectively. Then, already at work on the frescoes for the Cappella Paolina, he again felt a sense of alarm and besought the Pope to relieve him completely of the burden of the tomb of Julius. 'As the selfsame Master Michelangiolo

169

has again been approached by His Holiness', he wrote to Paul III on 20 July 1542,

> and urged to carry out certain works in His chapel, large-scale works which demand a man's complete and utter attention; furthermore, as the said Master Michelangiolo is now an old man and wishes to serve His Holiness with all the powers still at his command; furthermore, as he is being compelled to do this work for His Holiness yet cannot do so before he is completely relieved of the tomb for Pope Julius, which responsibility weighs upon him like a stone; so he begs His Holiness, who has commissioned him to do this work, to negotiate with the noble Duke of Urbino for his release from the said tomb and for the annulment of the existing obligation.[5]

This would mean that the two allegorical figures would also be left for Raffaello da Montelupo to carve: Michelangelo's own contribution would consist only of the figure of Moses, and for the rest he would satisfy himself with 'a general supervision of the statues and the ornamentation'.

So on 20 August 1542 a new and final contract was drawn up, superseding that of 1532.[6] Michelangelo himself was to provide only the figure of Moses; the remaining five figures were to be left to Raffaello da Montelupo. The contract quotes the figure of Mary as being finished, those of the prophet, the sibyl and the two allegories (Rachel and Leah) as 'bozzate e quasi finite' ('blocked-out and almost finished').

But not all the difficulties were yet overcome. The Duke of Urbino was reluctant to ratify the contract, reducing Michelangelo once again to desperation. In a letter to Luigi del Riccio, written before 24 October 1542, he says bitterly: 'For being loyal these thirty-six years, and for having of my own accord put my services at the disposal of others, I deserve nothing else. All my painting and my sculpture, all my efforts and my loyalty have ruined me, and things are going from bad to worse. My youth would have been better spent in learning how to make matches.'[7] At the Duke's insistence he finally consented to complete the two allegorical figures himself,[8] and at the end of 1542 the Duke ultimately confirmed the contract.[9]

The architectural work in the church of S. Pietro in Vincoli was

completed by the end of 1544. In January 1545 Raffaello da Montelupo's figures were put into place, and the following month those of Michelangelo.[10] The 'tragedy of the tomb of Julius' had reached its conclusion.

The lower storey of the monument (Pl. 94) is that virtually completed by Antonio da Pontassieve in 1513–14. In place of the original female herms we now find four half-length patriarchal figures wearing a kind of toga, and in place of the captives standing on the plinths we now find four large volutes; a socle some two foot high has also been added to the base.[11]

The upper storey was executed some time after 1542 by Michelangelo's assistant Francesco da Urbino from a sketch apparently made by Michelangelo in 1533.[12] The papal insignia, also from a sketch of Michelangelo's, were done by Donato Benti da Urbino.[13] The candelabra appear to be part of the project of 1516.[14]

Except for the statue of the Pope, all the figures on the monument are mentioned in the contract of 1532. The *Moses*, carved between 1513 and 1516, and the two allegorical figures of *Rachel* and *Leah*, started in 1542 and probably completed in 1545, are Michelangelo's own work.[15] In 1810 the statue of Moses was moved forward in error: Salamanca's engraving in Lafreri's *Speculum Romanae magnificentiae* shows that it should stand further back in its niche.[16] Of Raffaello da Montelupo's three figures in the upper storey, that of the Madonna was partly executed by Sandro di Giovanni Fancelli, known as Scherano da Settignano,[17] but since the contract of 1532 refers to these figures as 'cominciate ed non finite',[18] and in Michelangelo's subcontract with Raffaello of 27 February 1532 they are said to be 'bozzate da mia mano',[19] they must have been begun by Michelangelo in Florence before 1532; probably they formed part of the 1516 project (the *Madonna* is mentioned in the contract of that year),[20] although in style they belong to the period of the Medici tombs. The *Madonna* was completed in August 1542 and the *Prophet* and the *Sibyl* in January 1545.[21]

The statue of the recumbent Pope on the sarcophagus, probably part of the design of 1532 but not mentioned in the contract either of 1532 or of 1542, is the work of Maso di Boscolo, a pupil of Andrea Sansovino, and follows Sansovino's Sforza tombs in S. Maria del Popolo.[22] There

is a reference of 21 August 1542 which states that Michelangelo was going to touch up the face of the statue.[23]

The tomb as it now stands against the south transept wall of S. Pietro in Vincoli is a compromise in many respects – a compromise between artist and patron, between different projects, between old and new elements, between Michelangelo's own handiwork and that of his pupils and assistants. Yet it would be wrong to pass a negative judgement on the work as a whole. The conception of the work in its final form, as in its earlier forms, is Michelangelo's own, as are its construction and its programme, and there is a clear desire to create a unified work of art. Even in its final reduced form it occupies an important place among memorial tombs of the sixteenth century.

The contrast between the earlier and later stages of the work is strikingly apparent, particularly in the construction. The lower part, built in 1505 and 1513 and covered with delicate Renaissance ornamentation, is in a warm ivory shade; the upper part, plain and undecorated in Michelangelo's late manner, is in white marble with grey veins. But Michelangelo must have intended this contrast. The project of 1532 still had an order of applied columns in the upper storey; these organic plastic forms are now replaced by abstract, herm-like figures mounted on completely plain pillars which taper towards the base.

The monument as a whole still remains part of the architecture and is not an independent display-piece. The niches are set into the wall, while the lunette – which was originally to have been larger[24] – and the windows, which lead into the chapel behind the transept wall,[25] were only built in combination with the tomb, the dimensions of which are exactly accommodated to the membering of the wall. The lower storey, which was too low, is now set on a base, and the cornice of the upper storey now coincides with the springing-line of the transept. The pilasters of the upper storey match those of the walls of the church, and the chiselled lines of the herms are picked up by the groins of the vaults. This interplay of church and tomb emerges particularly clearly in side view.[26]

As already planned in 1532, the figure of *Moses* is shown as the Old Testament forerunner of St Peter and thus also of the Pope; more specifically it becomes an idealized likeness of Julius II. In the words of

Herman Grimm: 'It is as though this figure were the transfiguration of all the powerful passions that filled the Pope's soul, a representation of his ideal character in the image of the mightiest leader who ever guided his people out of slavery to their true greatness.'[27] The two *Captives* of the 1532 design had lost their significance, now that the allegorical figures of the virtues and vices had been done away with, and in their place came the figures of *Rachel* and *Leah*, symbolical of the *vita contemplativa* and the *vita activa*. Thus we arrive at a new pattern of meaning. The Pope, seen in ideal perspective, is accompanied by the two aspects of the religious life, with Rachel symbolizing faith and Leah symbolizing love in action.

For the upper storey the original design has been retained, albeit on a smaller scale, with the *Madonna and Child* flanked by the *Prophet* and the *Sibyl*. The least satisfactory figure is that of the recumbent Pope – a far cry from the entombment and the theme of the resurrection that had been envisaged in 1516. Boscolo's recourse to Sansovino's tombs of the Sforza family as his models shows his lack of confidence, and even if Michelangelo himself had worked over the detail of the facial features, it would not have improved anything.

Rachel (Pl. 95) and *Leah* (Pl. 96) are the first true examples of the sculpture of Michelangelo's last period. The statues are completely finished and polished to give a matt surface; the shaped platforms on which they are standing were added when the figures were erected and serve to reduce the height of the niches.

Rachel is in a semi-kneeling position, her left knee on a prayer-stool; her trunk is turned slightly to the right, while her shoulders and head are inclined to the left as she gazes upwards, her hands folded in prayer. She wears a long habit like that of a nun, and a head-dress covers her shoulders and hangs down behind her.

Leah, in full frontal view, is standing quietly. She is wearing a long robe and over it a cloak; the robe is gathered up and held by a waistband. 'Her hair is waved in classical style with a central parting; there are two plaits knotted above the parting and a long tress hanging down over her right shoulder.'[28] In her left hand she holds a laurel wreath, in her right a diadem (not, as Condivi and Vasari have it,[29] a mirror), through which the tress of hair has been threaded.

These two figures, the one in prayer, the other deep in thought, are quite different from all Michelangelo's other female statues and belong to the realm of emotion into which Vittoria Colonna had led him.

Condivi quotes lines from Canto XXVII of Dante's *Purgatory* as Michelangelo's source:[30]

A lady young and beautiful, I dreamed,

Was passing o'er a lea; and as she came,
Methought I saw her ever and anon
Bending to cull the flowers; and thus she sang:

'Know ye, whoever of my name would ask,
That I am Leah; for my brow to weave
A garland, these fair hands unwearied ply.

To please me at the crystal mirror, here
I deck me. But my sister Rachel, she
Before her glass abides the livelong day,

Her radiant eyes beholding, charmed no less,
Than I with this delightful task. Her joy
In contemplation, as in labour mine.'

The mirror into which Rachel gazes is God, and in the statue she is lost in contemplation as she prays; Leah is engaged in beautifying herself, and the adornments with which she chooses to deck herself before the mirror – that is, before God – are her works. By preferring laurel to Dante's blossoms, Michelangelo lauds the value of works (the *vita activa*).[31]

These two figures represent the final affirmation of Michelangelo's position in the conflict between faith and good works. Both are equally essential and equally valuable, for Rachel and Leah are sisters. It is a position shared by the leading minds of the Italian reform movement. It was said of Vittoria Colonna before the Inquisition that she followed the counsel of Cardinal Pole by professing her faith as though her salvation depended on faith alone, and by performing deeds as though her salvation depended on deeds alone.[32]

It was natural for Michelangelo to make the Old Testament figures

of Rachel and Leah the companions of the Old Testament figure of Moses, rather than the New Testament sisters Mary and Martha. This also makes for a further link with Dante.

The composition combines a variety of stimuli in a free, independent manner. There are classical overtones in the serene figure of Leah and a medieval atmosphere round the pious Rachel – the Middle Ages come to play an ever-growing role in Michelangelo's thoughts during his last years – the two influences fusing in a work of indissoluble unity. And what a contrast there is between these two figures and that of Moses, done so much earlier! Where Moses, for all his composure, smoulders with passion and threatens to break out of the marble block, Rachel and Leah accept their environment and the limitations of their situation.

The folds of Rachel's robe show for the first time a change from concrete reality to linear abstraction. As in the Middle Ages, it is not the body but the folds of the garment that determine movement and expression, and the involved lines of the body, simplified in full frontal posture, follow these folds from the bottom upwards. Yet despite these medieval characteristics, *Rachel* also retains a classical quality, as *Leah*, who is closer to antiquity, also reveals medieval features – the strong outline, with the figure anchored on one side (cf. the Gothic influence in Michelangelo's *David*), the inward gesture of the raised right hand, the linear emphasis in the robe and the inclination of the head, which gives the figure an attractive air of quiet devotion.

Jacob Burckhardt refers to the 'wonderful neutrality and impersonality' of the heads, which is like 'an echo of the art of early antiquity'.[33] The medieval element in Michelangelo does indeed seem to incorporate an element of early antiquity, though this is a subject – important as it is for Michelangelo's relationship to antiquity – which for the present lies beyond our historical knowledge.

The statues conform very strictly to the architectural design. Again we find Michelangelo striving not for contrast but for harmony. The figures of the virtues and vices would have reached to the top of the niches, but the figures of *Rachel* and *Leah* leave the arches empty, enhancing the impression of tranquillity.

Frescoes in the Cappella Paolina – *Christ and the Traders*

On the orders of Pope Paul III[1] Antonio da Sangallo the Younger undertook extensive works in that area of the Vatican Palace which was of particular importance for ceremonial purposes: the area occupied by the Sala Regia, the Cappella Paolina and the stairway leading to the Cortile del Maresciallo. The old, flat-roofed Aula Prima – known from the time of Julius II as the Aula Regia and now called the Sala Regia – was given a barrel vault and generally laid out in a way that befitted the most impressive building in the Vatican Palace, one used for receiving foreign emissaries. The Cappella del Sacramento (Cappella parva S. Nicolai) on the east side of the Aula Prima, which had been extensively restored under Pope Eugene IV (1431–47) and decorated with frescoes of the life of Christ by Fra Angelico during the pontificate of Nicholas V (1447–55), was destroyed to make way for the steps leading to the Cortile del Maresciallo, which were now extended and made symmetrical. The sacrament was transferred to the Cappella Paolina, which was built on the south side of the Sala Regia and also used for the meetings of the conclave. Work on the new Sala Regia started in 1538, and the Cappella Paolina was probably begun in the same year;[2] mass was already being said in the chapel in January 1540, so at least the shell must have been standing by this time.

The Cappella Paolina has a rectangular nave with a barrel vault; the chancel, which is both lower and narrower, also has a barrel vault. The walls of the nave are membered by pilasters mounted on socles of uniform height: two pairs of pilasters divide each of the side walls into three bays, the centre bay being wider than the other two and recessed by the thickness of the pilasters, with a second pair of flat pilasters serving as a frame. Set in the vault above these centre bays are lunettes, of which only that on the right now admits light into the chapel. The width of the centre bays and the lunettes corresponds to that of the chancel, as does that of the lunette in the entrance wall.

In August 1542 Perino del Vaga was paid to carry out the stucco

work on the vaulting – according to Vasari the designs were Michel-angelo's – but it does not appear ever to have been done; what is there now belongs to the 1570s and 1580s.

Michelangelo was commissioned in 1541 to paint two large frescoes for the centre bays, and embarked on the work either late in 1542 or early in 1543. On 12 July 1545 the Pope inspected the chapel, by which time one of the frescoes appears to have been finished – which one, we cannot tell. Michelangelo started on the second fresco in March 1546, and when the eighty-two-year-old Pope visited the chapel again on 13 October 1549, a few weeks before his death, the work would have been complete.

Michelangelo was now seventy-five. 'These scenes', writes Vasari, 'were the last pictures he did; and they cost him a great deal of effort, because painting, especially in fresco, is no work for men who have passed a certain age.'[3]

The left wall shows *The Conversion of St Paul* (Pl. 97), the right wall *The Crucifixion of St Peter* (Pl. 98), and from Vasari's account we can deduce that Michelangelo also made designs for the vault. A depiction of *Christ and the Traders*, sketches for which are preserved in the British Museum (Dussler No. 165–7; Pl. 99), may have been originally intended for the lunette in the entrance wall.[4]

Further work on the chapel was delayed after Michelangelo's two frescoes were finished. Then Vasari was commissioned by Pope Gregory XIII to complete the murals – the outer panels of the side walls and the lunette in the entrance wall – and the vaulting; the design was provided at Vasari's request by Vincenzo Borghini, whose detailed reply to Vasari has been preserved.[5] Borghini's design follows the *Biblia pauperum* and proceeds from Michelangelo's frescoes, but Gregory XIII rejected both the design and Vasari's sketches.

The final execution of the work was left to Lorenzo Sabbatini in 1573 and, after Sabbatini's death in 1580, to Federigo Zuccari. By 1582 everything was finished. On the left of Michelangelo's *Conversion of St Paul* Sabbatini portrayed *The Martyrdom of St Stephen*, on the right *The Baptism of Saul by Ananias*; on the right of Michelangelo's *Crucifixion of St Peter* he portrayed *The Fall of Simon Magus*. On the left of *The Crucifixion of St Peter* are *The Baptism of Cornelius the Centurion* and

177

the *Vision of the Unclean Beasts* by Zuccari, who, together with his assistants, is responsible for all the remaining additions to the legends of St Peter and St Paul. Unlike Borghini's typological programme, Zuccari's is traditional and historical.

To paint *The Conversion of St Paul* and *The Crucifixion of St Peter* on opposite walls is highly unusual. As a counterpart to the former one could expect a portrayal of St Peter receiving the keys of Heaven, and as a counterpart to the latter a portrayal of the martyrdom of St Paul. In the first edition of his *Lives of the Painters* (1550) Vasari writes: 'Having completed the Sistine Chapel, Michelangelo was engaged to work on a second chapel, the sacramental Cappella Paolina. For this latter he painted two pictures, one of St Peter, the other of St Paul: the one shows Christ giving the keys of Heaven to Peter, the other shows the conversion of the terrified Paul.'[6] This may have been an error on Vasari's part – one that sheds considerable light on the unusual coupling of the two subjects as they now stand. In the second edition (1568) he refers correctly to the crucifixion of Peter.[7]

Paul III appears to have conceived the programme for the chapel partly as a reflection of its sacramental function and its use by the conclave, but partly also with a regard for the situation of the Church in its struggles with the Italian reform movement, and for his own personal fate.[8] There are papal coins that indicate this. One shows the conversion of Paul with the inscriptions 'Saule, Saule, quid me persequeris?' and 'Vas electionis', which refer to Paul III's election.[9] Another shows Christ driving the traders from the temple and is inscribed 'Domus mea, domus orationis'.[10] Over and above this Michelangelo's frescoes also have to be interpreted as personal documents of his old age, as symbols of faith rather than as historical episodes: it is not the events as such that interest him but their significance, and in these two works more than anywhere else personal confession takes precedence over objective statement.

One may note in passing that the juxtaposition of these two subjects is also found later in Caravaggio's canvases for the Cappella Cerasi in S. Maria del Popolo.

The written sources do not record which of the two frescoes in the Cappella Paolina is the earlier, but since *The Conversion of St Paul* bears

stylistic resemblances to the *Last Judgement*, it may well be the earlier, dateable to 1542–5, leaving *The Crucifixion of St Peter* for 1546–9.

The Conversion of St Paul has Paul lying on the ground, prostrated by his vision of Heaven. Contrary to the Bible story he is shown as an old man. While one of his attendants tries to support him, others, in attitudes of terror and self-protection, are lying on the ground, cowering or running away. In the centre of the picture Paul's horse is rearing, and a boy fights to keep it under control. Directly above Paul, in Heaven, is Christ, swooping down in a beam of light like a bird. His right arm is stretched out along this beam of light towards Paul, while his left points towards the city of Damascus, which rises in silhouette on the extreme right of the picture. Choirs of angels – wingless, youthful figures, as in the *Last Judgement* – surround Christ in adoration and supplication, almost as though defending themselves.

Paul's conversion is described in the Acts of the Apostles: 'And as he journeyed, he came near Damascus; and suddenly there shined round about him a light from heaven; And he fell to the earth, and heard a voice saying unto him, Saul, Saul, why persecutest thou me?' (9:3–4). From the twelfth century onwards Western painters had portrayed Paul as a horseman (although the Bible makes no mention of a horse), incorporating from Prudentius' *Psychomachia*[11] – a work illustrated again and again in the course of the Middle Ages – the theme of Superbia (Pride) on horseback attacking Humilitas (Humility) and other virtues and plunging down into the pit dug by Fraus (Deceit). In the same way Paul falls from his horse when he sees the heavenly vision of Damascus. On the one side this may simply be a matter of thematic influence; on the other side one may well be entitled to interpret Paul's fall as an example of *superbia*, the pride that leads to disaster.

This illustration to Prudentius' work does not, of course, mark the first appearance of the theme. Its origin lies in antiquity, and we meet it, for instance, in the famous mosaic in the Casa del Fauno at Pompeii, which is apparently a copy of a painting of Alexander in battle by Philoxenos of Eretria, mentioned in Pliny.[12] This particular mosaic was not rediscovered until 1831, but other works, such as the sarcophagus of Alexander from Sidon (now in the Museum of Antiquities in

Istanbul),[13] show that the subject was well known. It also recurs in the Amazon theme, as shown by the statue of the so-called Amazone Patrici, related to the Attalic amazons of the Acropolis in Athens.[14]

If one excepts for the moment the fact that Michelangelo too has this motif of Paul as a rider, there is no direct line from the theme of the fallen rider as such to Michelangelo, who portrays Paul already lying on the ground, not falling from his horse. The horse, held by a boy, is rearing. But then this last motif – one need only think of the Roman statues of Castor and Pollux on the Quirinal Hill – goes back to the very same classical source. In the mosaic of the Casa del Fauno it appears next to the motif of the stumbling horse and bears a striking resemblance to Michelangelo in its marked foreshortening. It is also found in the depiction of the Battle of the Amazons on the sarcophagus which stood in front of the church of SS. Cosmas e Damiano in Rome in the first half of the sixteenth century and was later moved to the Vatican Belevedere; this was Rubens's model for his *Battle of the Amazons*.[15]

Further research needs to be done on the question of when the motif of the horse-tamer became linked with the subject of St Paul's conversion.[16] But as far as Michelangelo is concerned we need only refer to Raphael's tapestry.[17] Here we find the separation of horse and rider, which has the great advantage, for the subject of Paul's conversion, of bringing the apostle into immediate contact with the descending figure of Christ.

A further work on this subject is Luca Signorelli's fresco in the Sagrestia della Cura in Loreto.[18] The companion figure holding a shield over his head; the rear view of the man watching the scene in terror; the figure in the centre turning towards Paul in fear; the position of Paul himself – these are specific points of contact. In addition there is the general economy of line, the bareness of the landscape and the mystery surrounding the scene. From the iconographical point of view Signorelli follows the Byzantine tradition, in which there is no horse.

Paul's recumbent posture recalls a classical motif that Michelangelo had used in *The Battle of Cascina*, but now in the form found in Raphael's *Chastisement of Heliodorus*. There is a remarkable resemblance between Heliodorus and Paul in the legs, in the position of the body and even in the raised arm, which in Michelangelo is a purely expressive gesture.

This is a further indication of the importance of Raphael for Michelangelo's composition.

Raphael depicts the conversion as a natural event set in time and space. The procession of horsemen and men on foot moves from right to left, with Paul, a young man, as in the Bible, out in front. Then, struck by the heavenly vision, he falls to the ground; his horse bolts, and he lies on his back and stares at the figure of Christ, his arms, legs and expression conveying a mixture of shock, fright, self-defence and a slowly dawning attraction to the figure before him.

The composition is as subtle as the scene itself is natural. Paul is in the very front of the picture and, together with his horse, which stands farther back, dominates the left side; his companions remain on the right. Christ, also on the right, gestures towards the left. The picture is held firmly within its frame on all four sides, the bottom forming a particularly emphatic cut-off point. Yet in spite of the balance between the left and right halves of the composition there is an urgent sense of movement which gives the action the vividness of historical reality.

Michelangelo took this naturalness for granted, but it has lost its importance for him. He moves beyond it, replacing a causal sequence of actions by gestures and attitudes which convey the inner meaning of the events. The world of the picture loses its objective autonomy and merges with the world of the beholder as it had done in the Middle Ages, but now in a new sense – that of the Renaissance. The viewer is addressed directly and is induced to identify himself with the prostrate apostle, who is no longer just the historical figure of Saul, as in Raphael, but the symbol of man's encounter with God.

Michelangelo's composition cannot be compared with Raphael's. The lower horizontal has lost all meaning: the two figures at the front, seen in rear view, stand there as though it did not exist. The movement of these two figures is taken up by the two men, also in rear view, on the left, who give the impression of moving into the distance and leading the world of time and space into the realm of strangeness and uncertainty; it is also taken up by the two old men on the right, who are making their way towards the front – but again, with no finite conclusion to their movement. These widely separated groups, together with the shield-bearer on the left and the man holding his hands over his

ears on the right, are linked in composition and design and also set in contrast to each other. A circular motion, starting with the figures in front, embraces the movements of the individual figures and even takes in the figure of Paul himself. This is no specific landscape, with trees and bushes and paths, but an abstract region, as the city is not a real city but a hieroglyph.

Yet Michelangelo's originality *vis-à-vis* Raphael and tradition goes further than these general observations. For Raphael the unity of space includes Heaven, but Michelangelo separates earth from sky: in the lower zone, contained within the features of the landscape, are groups of men in varying degrees of shock and terror; only the horse breaks out of this confinement, yet it too is dragged back, its strength tamed; in the upper half of the picture, like constellations round the sun, are the heavenly figures, freed from the earthly pull of gravity and obedient to other laws. Confusion reigns in the lower zone, order in the upper zone – albeit in agitated conditions of movement and counter-movement. Only when viewed in terms of this contrast does the action that links the two worlds acquire its real meaning. As the upper circle opens, the ray of heavenly light penetrates the darkness, and Christ, surrounded by the heavenly hosts, reaches down to man. Paul cannot see Him – even if the brightness had not dazzled him, he could not see Him – but he feels His presence as the shaft of light illumines his features, and since he is turned towards us, we can witness what is happening to him. Rarely has one been confronted with so spiritual a depiction of ecstasy, of the experience of waking from a dream, of an inner perception of heavenly light. It is as though time had stood still for Paul. The agitation and confusion of his companions do not affect him. His raised left hand seems to shield his face from the light and at the same time to brush away the vision of a dream that clouds his mind:

> Vorrei voler, Signior, quel ch' io non voglio;
> Tra 'l foco e l' cor di iaccia un vel s'asconde,
> Che 'l foco ammorza.

> (I wish, God, for some end I do not will.
> Between the fire and heart a veil of ice
> Puts out the fire.)[19]

A motif unknown in the traditional iconography is that of the companion who bends lovingly over Paul and tries to support him.[20] As in the *Last Judgement*, where the blessed help each other like guiding angels, we find here the simple motif of succour and support, a reflection of Michelangelo's profound humanity. Man needs succour as he gropes his way towards God, and to love one's neighbour is to serve God.

Paul is a likeness of the aged Michelangelo himself. In his youth he had portrayed his own features in the statue of St Paul for the Piccolomini altar in Siena Cathedral. Now, in the expression on the face of Paul at the moment of his conversion, he represents his own religious experience and conversion. This is the time when Vittoria Colonna wrote to Michelangelo of her 'constant devotion, held in the grip of Christian conviction',[21] and when he responded:

> . . . per cosa più perfetta
> Da voi rinascer poi, donna alta e degna.

> (. . . later would I
> Be made more perfect, born of one so high.)[22]

This experience now finds expression in his painting. The figure of Paul's companion, too, has biographical significance, for Michelangelo's religious development would be unthinkable without the support for which he clamours again and again in his poems.

The motif of the rearing horse is set against that of the stricken apostle. What was a subsidiary, contrasting motif in Raphael has here become a principal motif. Only Christ, the other main figure, is left with freedom of movement, for the angels that surround him do not encroach upon his independence.

As in the *Last Judgement*, so here also there is no one point from which the entire meaning of the scene, as an event in time and space, can be grasped. The size of the groups is determined not by optical principles but by conceptual considerations. Heaven is not depicted as some distant realm, or the earth as our 'natural' habitat, but again as in the *Last Judgement*, divine power, by definition intangible and inaccessible, acquires its earthly reality through its presence in human bodies and human actions.

The Crucifixion of St Peter is set in a similar barren landscape to that of *The Conversion of St Paul.* An engraving by Giovanni Battista de' Cavalieri[23] shows the scene in greater detail. Here there is a hill in the centre with rising steps to left and right,[24] but Michelangelo seems at the last minute to have abandoned so precise a definition of the scene in order to give the painting a further quality of universality and abstraction. Indeed, one could hardly imagine a more sketchily delineated locality.

On a mound in the centre of the picture seven men are erecting the heavy cross on which Peter has been nailed upside-down, while an eighth man is digging a hole at the front. Grouped around these figures are foot-soldiers, a prancing troop of cavalry, supporters of Peter, and men and women on the point of leaving the scene. Here too there is no question of causal connections. The movement is symbolic movement, and it is this that lifts the event out of the sphere of history.

In the so-called *Legenda aurea*, a compendium of earlier accounts, we read:

> When Peter . . . came to the cross, he said: 'As my Master descended to earth from Heaven, he was crucified upright. But I, who am rendered the honour to be summoned to Heaven from earth, must hang with my head to the ground and my feet to the sky. So as I am not worthy to be crucified like my Lord, turn the cross round and crucify me head downwards.' So they turned the cross round and nailed his feet to the top and his hands to the bottom.[25]

The oldest known representation (fourth century) of the martyrdom of St Peter was to be found at this time in the atrium of Old St Peter's and has been preserved in an early seventeenth-century drawing by Giacomo Grimaldi. The fresco was already in a very bad state. It shows Peter upside-down on the cross, surrounded by soldiers, men and women. In the background are the sepulchral pyramid of Cestius by the Porta S. Paolo and the Vatican pyramid – since destroyed – by St Angelo.[26] In St Peter's there are several portrayals of the subject: Giotto's Stephaneschi Altar for the Sagrestia del Capitolo dei Canonici; Filarete's bronze door in the main porch; and the high altar commissioned by Sixtus IV for Old St Peter's. The last-named anticipates Michelangelo

in the motifs of the captain of cavalry on the left, the youth behind the cross who is turning agitatedly towards him, and the old man with arms folded in the bottom right-hand corner.[27] Besides these there were representations of Peter's crucifixion itself: that by Giovanni del Ponte in the Uffizi, Masaccio's painting for the high altar of Pisa Cathedral, and Filippino Lippi's fresco in S. Maria del Carmine in Florence.[28]

In all these cases Peter is portrayed merely as a victim, and a study of the iconography of the scene leaves the impression that this was as far as artists of the time could go. According to the *Legenda aurea* Peter said, as he hung on the cross: 'Thou, O Lord, art noble, upright and sublime but we are the children of the first man, who buried his head in the ground, and whose fall has left its mark on the whole human race. It is as though we were scattered head-first over the face of the earth.'[29] But before Michelangelo this symbolic interpretation of St Peter's crucifixion is not found in the visual arts.

Michelangelo is the first to portray, not the crucified St Peter or the act of crucifixion, but the actual erection of the cross. The cross is not yet upright, and Peter lies on the sloping surface with his head towards the viewer. For the first time in the history of the subject Peter is shown, not as a mere victim but, even in the moment of his deepest humiliation, as a hero who, in turning towards us, becomes a man of spiritual action. The longer we look, the more we are gripped by his staring eyes and by his domination of the scene: surrounded by feverish activity, he yet exudes serenity, conviction and steadfastness, and while, with the single exception of the frightened woman in the right foreground, everyone is absorbed in his own part in the event or in his own thoughts, Peter regards the viewer. It is *we* with whom Peter is concerned – *we* who have to bear his gaze.

In the immediate vicinity of Peter there is a powerful circular movement in which his body is caught up. Of the two men who are bearing most of the weight of the cross, one is turning inwards, the other looks away; three other men surround them – the bearded figure on the left, making with his left arm a gesture which it is hard to interpret, the youth on the right who takes the weight of the cross on his shoulder and gazes anxiously, almost hysterically, at the apostle, and the figure in the centre pointing to Peter with his right hand.

185

Around this inner circle are various groups, some coming, some going, some looking on, all cut into by the edges of the picture. The figures in the left foreground, in rear view, are unconcerned; above them, led by the captain in command of the occasion, the cavalry are galloping up. On the right a group is ascending the hill from the back while another group, at the bottom of the picture, is leaving the scene. In the group at the back are an old man, standing as though petrified, and a woman hesitating to go further, who is being shown the way by the powerful young man leading the group; prominent in the group at the front is the magnificent figure of the old greybeard with arms folded, lost in meditation. Is this perhaps meant to be a self-portrait? Be this as it may, he is set alongside Peter in this prominent position as one who embodies the thoughts and sympathies of all present. Once again the world of the picture merges with the world of the beholder, who involuntarily identifies himself with this figure. His air of profound meditation is emphasized by the frightened expression on the face of the woman in the front of the picture and by the way in which the young man who bears the weight of the cross looks anxiously yet pitilessly at Peter. Among the apostle's companions in the centre our attention is particularly drawn to the figure of a young man who is agitatedly engaging the attention of the captain of cavalry, while motioning with his left hand towards Peter. Max Dvořak gave him the name of 'spokesman' (*Sprecher*)[30] – the counter-figure to the captain, a voice raised in protest yet without the power to change the course of events, while Peter submits to his torture with relentless determination.

In *The Conversion of St Paul* earth and heaven are set against each other; in *The Crucifixion of St Peter* the action is restricted to the world of earth and portrays humankind caught up in the maelstrom of events – a scene that would bring only suffering and dejection, were it not for the determination with which Peter accepts his fate. This sombre vision of suffering is Michelangelo's last utterance on the subject.

The stylistic principles of the two frescoes are the same: variations of scale, an overrunning at the bottom and the sides, a flouting of perspective and a surrounding air of abstract unreality in the scene as a whole. These features are more prominent in *The Crucifixion of St Peter*, where the group-formations are more pronounced – sometimes involving, as

in the figures against the left-hand edge, a strange disregard for natural features. The portrayal of independent characters, like the old man in the right foreground, is such that only the simplest of forms are valid. Yet what strength there is in these forms! Admittedly the top group on the left of the picture is poorly defined – it may well be the work of an assistant – but nothing could be falser than to speak, on the evidence of this fresco, of Michelangelo's declining powers.

In the intricacies and tensions of the central group one seems to sense a perhaps unconscious involvement with the sculpture known as the *Farnese Bull*, the 'grandissimo monte di marmo bianco', as Aldovrandi calls it.[31] We know that Michelangelo greatly admired this group,[32] and although his high estimation of it may seem almost impossible for us to understand today, his fresco of St Peter shows that what he chiefly admired, apart from the sculptural craftsmanship, was its free, sophisticated composition, with its richness of contrasts. Allowing for the different subject-matter, and converting natural forms into ornamental forms, one can also draw a comparison with the etching from Ferrucci's *Le Antichità Roma* (1585),[33] which shows the group through sixteenth-century eyes and comes remarkably close to Michelangelo. The *Farnese Bull* was discovered at the end of December 1545; Michelangelo started work on his fresco in March 1546.

It was long customary to complain of the poor state of preservation of these frescoes, which had also been damaged by fire, but when they were restored in 1934, the subsequent overpainting was removed and the frescoes were seen to be well preserved. Their colours, above all those of *The Crucifixion of St Peter*, recall those of the Sistine ceiling. The predominating colours of the figures are a brown-grey flesh tone, green, brown-red, golden yellow, blue, grey and a greyish violet, all in rich variation; the surrounding grey-blue sky and olive-coloured earth contribute towards the atmosphere of unreality. In *The Conversion of St Paul* the action is animated by the pale yellow ray of light in which Christ descends and which gives the figures in Heaven a warm glow. The greens and browns of the figures below, on the other hand, are overhung with a cold grey. Paul's violet robe intensifies his gesture of transfiguration, and his brown-red cloak brings a faint echo of the brown-red robe of Christ. In *The Crucifixion of St Peter* the olive-

coloured ground stretches higher, and above it are the bright blue of the distant mountains and the pale blue of the evening sky, with violet clouds. The colours are more highly contrasting than in *The Conversion of St Paul*: particularly striking is the brilliant blue surrounding the cross and merging with the blue mountains, which seems like a symbolic gesture from the world beyond.

Our knowledge of Michelangelo's *Christ and the Traders* derives from three drawings in the British Museum (Dussler Nos. 165–7)[34] and a copy by Marcello Venusti in the National Gallery, London.[35] Its intensity is even greater than that of the two frescoes, and, as there, so here also it is not the action as such that matters but its symbolic significance. In the centre stands a large figure of Christ – the manner is comparable to that of the *Last Judgement*. With His left hand He is overturning a table, and in His right He is swinging a whip; indeed, His whole movement is one single, self-contained expression of rage and punishment. The traders, in closely knit groups on either side, cower in confusion or take flight. The attitudes of the two men sitting in the front at Christ's side respond to His gesture of wrath. The background design – a double arch with a central pillar – only appears on one of the sketches, and then only indistinctly.[36] The design is obviously intended for a lunette. Venusti's copy retains hardly anything of Michelangelo's own style.

Like the frescoes, this subject is not to be seen merely as a response to a commission but as an act of personal confession, for the aged Michelangelo, friend of Vittoria Colonna and supporter of the Italian reform movement, was deeply committed to the purification and reformation of the Church.[37]

Chapter 14

Palazzo Farnese

The frescoes for the Cappella Paolina were Michelangelo's last paintings. He seems in the final years of his life to have made a few designs for pictures and sculptures on his own account, and also did a number of independent drawings like those for Tommaso Cavalieri and Vittoria Colonna, but his activity became increasingly centred on architecture.

At the same time, as we have already observed, architecture and graphic design were intimately linked for him. This not only emerges from his works but is made explicit in a letter, part of which has been preserved, probably written to Cardinal Rodolfo Pio at this time – his sole surviving statement on his theory of architecture. He writes:

> If a plan falls into a number of parts, those parts which are of one kind of quality and quantity must be decorated in like manner, likewise their corresponding portions. If, however, there is a fundamental change in the plan, then it is not only permissible but essential to change the decoration and the corresponding portions. Nevertheless, the central parts enjoy a certain independence, as the nose, which is in the middle of the face, is independent of both eyes; either hand, however, has to be like the other, and either eye like the other, in respect of nature and position. It is therefore certain that architectural members derive from human members, and no artist who is not a master of the human figure and of anatomy can understand this.[1]

Michelangelo as architect sees himself as identical with Michelangelo the artist of human forms, which entitles us to draw also on pictorial considerations when discussing his architecture.

In 1535 Michelangelo had been appointed chief architect of the papal palace. The following year, 'per amor di Dio e per la riverenza al principe degli Apostoli',[2] he assumed control of the construction of New St Peter's, and in 1550 he undertook to design the church of S. Giovanni dei Fiorentini in Rome. From a letter of Loyola's we learn that in 1554 he offered to direct the work on the new church of Il Gesù as an act of

piety and without remuneration.[3] In addition there was his work on the Palazzo Farnese, his designs for the Capitol and the Porta Pia in Rome, and finally, two years before his death, his conversion of the Thermae of Diocletian into the church of S. Maria degli Angeli. 'In almost any substantial architectural project in Rome at this time we find him making designs, giving advice or taking charge of the work himself.'[4]

That Michelangelo finally concentrated entirely on architecture is not solely to be explained in terms of commissions. It is also expressive of his development as an artist. More and more his artistic imagination was leading him towards the use of the abstract forms of architecture to express his visions. As far back as the Medici Chapel we find that natural, organic forms and structural forms have become interchangeable, while in his paintings from the *Last Judgement* onwards the figures become vehicles of supra-personal powers, and space becomes a force to which the figures are subject. His final architectural works continue in this mould. Whereas the vestibule of the Biblioteca Laurenziana had been designed in terms of its circumscribing limits, the nature of the circumscribed space itself now becomes the object of his attention. Even that final change of direction which was to take him to the very limits of what could be expressed in sculpture and drawing is foreshadowed in his architecture. Giovanni Bottari said of his plan for the Cappella Sforza: 'We do not seem to see something real but an abstract idea, a kind of vision or dream of a building.'[5]

Michelangelo made architecture, that most objective of arts, the instrument of his own subjectivity, and it is only in this light that one can understand the architectural works of his last period. Yet in Rome, as in Florence, one must not overlook the *genius loci*, and the Eternal City has left clear traces on the works he did there.

Cardinal Alessandro Farnese, later Pope Paul III, had Antonio da Sangallo the Younger design a grand palace for him in Rome, the so-called Palazzo Farnese. Building commenced in 1516;[6] by 1546 the masonry of the second storey of the façade was almost complete. Then the Pope pronounced himself dissatisfied with the design for the cornice, and according to Vasari[7] approached Perino del Vaga, Sebastiano del Piombo, Michelangelo, Jacopo Melighino and Vasari himself for fresh designs, leaving Sangallo to execute the best of them. In spite

of the opposition of Sangallo and his supporters, Michelangelo's design was the one accepted, and he quickly proceeded to turn his cornice design into a project for the entire building. In 1548 the Pope accepted this project, commemorating the occasion by striking a medal with Michelangelo's façade elevation on it.[8]

The Palazzo Farnese is the largest High Renaissance palace in the city of Rome[9] and distinguished as much by its situation as by its size. In Michelangelo's design[10] the open piazza gives a clear view of the massive façade; later two fountains, with basins made of granite from the Baths of Caracalla, were set in the piazza, with water spouting from the fleurs-de-lis, the emblem of the Farnese family.

Sangallo's project (Fig. k)[11] shows a rectangular structure consisting of four wings with a square courtyard in the centre. The front and rear wings are short and deep, the side wings longer and narrower. The longitudinal axis is accentuated by the vestibule, the passage-way and the garden loggia in the rear wing, but it is typical of Sangallo to offset this movement towards the rear by the stillness of the courtyard.

The façace elevation (Pl. 100) shows three storeys, with stone quoins (*rustica*) at the corners.[12] Sangallo's original intention had been to join the two upper storeys by giant pilasters at the corners but later he gave up the idea and carried the existing quoins of the lower storey through to the cornice.[13] The ground floor, set on a projecting socle, has rectangular windows crowned by a flat lintel, with pendant volutes at the sides; beneath each window is a pair of large volutes acting as consoles. The windows of the two upper storeys are framed by tabernacles with applied pilasters; those of the first storey have alternating triangular and segmental pediments, those of the second storey, solely triangular ones. Beneath the tabernacles are further consoles, which in the second storey take the form of slender double volutes and rest on the cornice of the storey below. The cornices that divide the storeys bear the fleur-de-lis motif of the Farnese. These members stand out in relief against the facing of the brick wall.[14] The tripartite structure of the vestibule is not apparent from the outside; the porch itself is picked out by stone blocks.

Sangallo's design for the court of the palace can only be reconstructed from sketches and from the present form of the building itself.[15] At

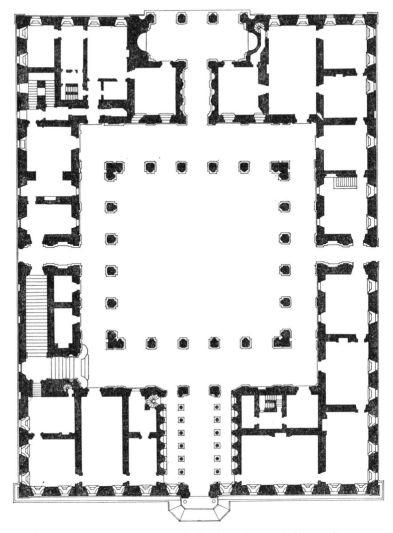

k Palazzo Farnese, Rome. Ground plan (after James Ackerman).

ground level there are five bays on each side of the court with Tuscan, Ionic and Corinthian columns, and originally open arcades were planned for all three storeys, in the manner of Roman theatres,[16] but Sangallo subsequently closed these arcades in the two upper storeys and replaced them with window-bays, as in the present palace. Also

part of Sangallo's design is the façade vestibule – the tripartite portico with broad cassetted barrel-vault in the centre and flat cassettes on either side. The rear wing, facing the garden, was also intended to have a façade-like design, but one can hardly reconstruct this on the basis of Sangallo's plan.

Michelangelo's changes in Sangallo's project concern the façade elevation, the great hall, the vaulting of the front corridor on the first floor, and the court.

In the façade elevation his work consists of the window above the portal (Pl. 101) and the crowning cornice. Sangallo's central window had probably been intended to be flanked by columns, and Michelangelo introduced the pattern of free-standing and applied columns that we see today, recessing the window into the wall and creating a single plastic unit, in the manner of the *ricetto* in the Biblioteca Laurenziana. Sangallo had crowned the window with an arch enclosing a tympanum which was to contain the Farnese insignia, but Michelangelo walled over the arch, replaced it with a flat lintel at the same height as the architrave of the windows on either side, and set a huge representation of the papal arms above it which rises over the level of the first-storey lintel.[17]

The cornice[18] that Michelangelo added to the third storey (Pl. 102), the height of which he also raised, dispenses with the architrave and starts immediately above the frieze, as in the Palazzo Medici and Palazzo Strozzi in Florence. Above egg and dart and dentils come powerful volutes supporting the cornice proper, which is decorated underneath with rosettes; above the volutes are lions' heads, and between them club-like motifs. This mass of ornamentation, which led Michelangelo's opponents to claim that the building could not stand the weight,[19] is both non-classical and non-High Renaissance; indeed, it is less a work of ornamentation or an independent member than a part of the structure as a whole.

For each of the two upper stories Sangallo had planned a large hall (Pl. 103), embracing five windows on the left of the façade and the first three windows of the left wing. By combining these two halls into one, Michelangelo produced what has been called 'the most impressive of all festive Roman halls of the Cinquecento'.[20] The upper windows of this

lofty hall have semicircular arches on the outside but rectangular frames on the inside, with sharply sloping soffits which, as in the Medici Chapel, cast the light diagonally downward. The great beamed ceiling is probably Michelangelo's design.[21] He also completed the gallery in front of the hall (Pl. 104), 'making the vaulting', as Vasari says, 'with a new and ingenious kind of arch in the form of a half-oval'.[22] We meet this form again later in the Cappella Sforza.

In the courtyard (Pls. 105 and 106) Michelangelo first continued Sangallo's design. He completed the arches and Ionic columns but altered the windows, the balustrades and the frieze of masks and garlands.[23] To meet the practical necessity of providing storage space and servants' quarters he provided a mezzanine between the vault of the second and the floor of the top storey.[24] From the outside this mezzanine is visible only by the row of small rectangular windows between the second and third storeys, which admitted diagonal light in the same way as the windows of the great hall. The insertion of this mezzanine meant a modification of the entire second storey. There are socles between the mezzanine windows, and on top of these, each with its own socle, are Corinthian pilasters, continuing Sangallo's plan. Behind each pilaster, in the characteristic manner first encountered in the façade elevation of S. Lorenzo, are pillars, so that once again we find that the individual architectural element has become part of the structure as a whole. A thin horizontal band along the parapet above each mezzanine window is continued round the socles. The arches of the two lower storeys are dispensed with.

The windows[25] show a bewildering variety of strange forms which are at odds with that respect for rules which characterizes the Renaissance. The sides project below the sill, and in the top corners there are lions' heads with rings, while at the sides one finds panel-like bands alongside the jambs and strange volute-like brackets above them. Above the windows but detached from them are segmented pediments in strong relief with deeply recessed tympana, in the centre of which are rams' heads with pendant garlands. Finally, above the pilasters is a frieze of masks and egg and dart, and at the top, resting on small consoles with regulas, the cornice proper.

It is in his design for this courtyard that Michelangelo departed most

radically from Sangallo's conception. Vasari's account enables us to understand the situation more clearly:

> That same year at the Baths of Antoninus [*i.e.* the Baths of Caracalla, which belonged to the Farnese family] was discovered a block of marble, measuring fourteen feet in every direction [i.e. the so-called *Farnese Bull*] in which there had been carved by the ancients a figure of Hercules standing on a mound and holding the bull by its horns, with another figure helping him, and with a surrounding group of shepherds, nymphs and animals: a work of truly exceptional beauty, which was believed to have been meant for a fountain. Michelangelo advised that it should be taken to the second courtyard of the Farnese Palace and there restored to spout water as it did originally. This was agreed, and the work is still being carried on today with great diligence, by order of the Farnese family. At the same time Michelangelo made designs for a bridge crossing the Tiber in a straight line with the palace, so that it would be possible to go direct to another palace and gardens that they owned in the Trastevere, and also from the principal door facing the Campo di Fiore to be able to see at a glance the courtyard, the fountain, the Strada Siuliana, the bridge, and the beauties of the other garden, all in a straight line as far as the other door opening on to the Strada di Trastavere. This was a marvellous undertaking which was worthy of that pontiff and of Michelangelo's talent, judgement and powers of design.[26]

Thus in Michelangelo's hands Sangallo's principle of a central axis became a grand conception for a vista that should extend from the piazza in front of the palace to the horizon. This is the first example, after Bramante's Belvedere, in a line of development which was to be followed time and again by the artists of the baroque.

To realize this plan would have necessitated opening up the courtyard and the rear wing. An etching of 1560 (Pl. 107) shows that Michelangelo intended to do away with the rooms in this wing and leave a mock façade: an open arcade, with a window on either side, would have led into the garden, while the first storey would have had a double loggia with five arcades facing the garden and three facing the court; the top

storey would have retained its self-contained character, here as in the other wings.

But this project for the rear wing, like the overall design that Vasari describes, was never realized, and the façade of the rear wing itself, as Sangallo had planned it, was only completed thirty years later by Giacomo della Porta (Pl. 106).[27] Above the garden loggia is the famous Carracci gallery, and in the top storey an empty lobby.

Chapter 15

Capitoline Hill – Cortile del Belvedere

Michelangelo's work on the Capitoline Hill[1] was his second non-religious commission in Rome and the biggest he ever received. In classical times there stood here the fortress and temple of Juno Moneta on the left and the temple of Jupiter Capitolinus on the right. In the centre, at the highest point, stood the *tabularium*, housing the archives of state; behind this was the *asylum*, the consecrated spot on which Romulus had granted asylum to the refugees from Latium, together with the cave of Romulus and Remus and the bronze statue of the Mother Wolf. All these faced the Forum Romanum, from which a processional path and a steep stairway led up to the hill. The Roman emperors made it the culminating point of their triumphal processions, and by the end of the Roman Empire it was reckoned among the Seven Wonders of the World.

In the early Middle Ages a sinister change came over the hill. The seat of gods became the seat of demons. In the fifth-century legend St Silvester, a contemporary of the Emperor Constantine, mounted the hill in order to bind the jaws of a terrible dragon whose poisonous breath killed six thousand men every day;[2] later the Vandals and other marauding bands utterly destroyed the former glory of the place.

The year 1144 marked the beginning of a new epoch in the history of the Capitol. At this time there was a revolt by the citizens against the authority of the Pope and the nobles, a revolt which ended with a senator taking up his official residence on the hill and establishing himself in the *tabularium*, which had formerly been used by the aristocratic family of the Corsini as a fortress. But instead of facing the forum, the senator's new palace looked out over the medieval settlement between the Capitol and the Tiber, towards the Campus Martius and the Vatican. This marks the beginning of the change of aspect of the Capitol Hill on which Michelangelo was to set the capstone. Later a small piazza was laid out in front of the senatorial palace, intended for communal purposes. Around the middle of the fourteenth century the guilds' court of

justice was installed on the south side of this piazza in a porticoed building with an enclosed first storey, and in the fifteenth century the Conservatori, who, in addition to acting on behalf of the Roman Senate, were charged with the maintenance of public buildings, took up residence there. The outer walls of this building are preserved in Michelangelo's Palazzo dei Conservatori – a name it already bore in the fifteenth century. In the middle of the fifteenth century and again around the year 1520 it was extensively restored. The oblique angle (80°) at which the Conservatori stands to the Palazzo del Senatore is thus not an innovation of Michelangelo's but part of the old construction.[3]

In 1471 Pope Sixtus IV had the large ancient bronzes – the Mother Wolf, the Spinario, the massive head of Constantine, the large bronze hand, known as the 'palla Sansonis', and a figure of Hercules – taken to the Capitol,[4] thereby restoring them, as the deed of gift states, to their rightful place. To these bronzes were added in 1515 and 1517 a number of works in marble – three reliefs of an arch of Marcus Aurelius and two large river-gods from the Quirinal Hill. In 1537, overriding the protests of the chapter of S. Giovanni in Laterano, Pope Paul III ordered the equestrian statue of Marcus Aurelius, 'optimus princeps', to be transferred from the Lateran Hill, where it had been taken for a statue of Constantine, to the piazza of the Capitol, and in January 1538 it was moved there.[5] The Conservatori had had the same idea in 1498 but had been prevented by the chapter of S. Giovanni from carrying it out.[6]

In 1539 Michelangelo, who had also originally been against moving the statue, was commissioned to do a base for it and to prepare a suitable site.[7] This is the moment from which the association of his name with the history of the piazza dates.

With the transfer of the statue 'ex humiliore loco in aream Capitolinam', as the inscription on the base puts it,[8] came a renewed desire to restore the classical *dignitas* of the Capitol in the spirit of Sixtus IV. This desire was to receive its triumphant expression in Michelangelo's new design for the piazza, which, as can be seen more clearly from Étienne Dupérac's engravings of 1567–9 than from the piazza in its present-day form, went far beyond the original plans[9] and was concerned more with the piazza as a whole than its separate parts. The erection of the statue in

the centre of the piazza seems to have given him the idea of rationalizing the relationships between the individual buildings. The only earlier piazza design that can be compared with Michelangelo's is that of Bernardo Rossellino for the cathedral square in Pienza (1456/8–64),[10] but this latter seeks a very different effect.[11] Each building in Michelangelo's piazza has to be seen within the context of the complete square, not as an item on its own.

Michelangelo's plan (Pl. 108) was formidably extensive. The equestrian statue was to stand in the middle of the piazza set in an oval field; the Palazzo del Senatore was to be restored with a double outer stairway, and the campanile moved to the centre axis of the palace; the Palazzo dei Conservatori was also to be restored, and a new building, the so-called Palazzo Nuovo, built at the same angle on the north side of the piazza to offset the Conservatori, thus making the piazza into a trapezium; a wall and balustrade were to be built at the front of the square, giving it a firm delineation on the side facing the city;[12] and finally a flight of steps (*cordonata*), like a bridge, was to lead up to the enclosed piazza from below, further accentuating the central axis. Both the authorities and Michelangelo himself also had plans to erect a number of further pieces of classical sculpture in the piazza.[13]

The execution of Michelangelo's project took many years.[14] During the pontificate of Paul IV (1555–9) work stopped altogether and was only resumed in 1561 under Pope Pius IV. It was finally completed after Michelangelo's death by Giacomo della Porta and Girolamo Rainaldi in baroque style. As Sedlmayer put it: 'The Capitol one sees today . . . is the work of della Porta; Michelangelo's Capitol has to be reconstructed.'[15]

At first the statue of Marcus Aurelius seems to have been placed on a provisional base and not in the centre of the piazza[16] (we do not know when it was moved to its present position). A sketch made by Francisco de Hollanda (*c.* 1539, now in the Escorial)[17] shows, however, that Michelangelo's design for the base must already have been made, although the work was not carried out until the end of the 1550s.[18] In 1561 the four *membretti* (angle-piers) were added,[19] and in 1564 the foundation was renewed; the same year the oval area was laid out.[20] The oval curvature at the ends of the base on which the statue is set picks up

the oval ground-pattern, which suggests that the two were designed at the same time.

Three steps descend to the rim of the oval, the surface of which is domed, with the statue at the highest point. This oval is a most unusual feature: it was virtually unknown in earlier architecture and was first used by Michelangelo in his initial design of 1505 for the interior of the tomb of Julius II. Before Michelangelo it is only found in church and villa sketches by Peruzzi, but it was to be widely used in baroque times.[21] The oval in the piazza fulfils the dual purpose of isolating the statue and accentuating the centre of the piazza together with the axis from the front stairway to the Palazzo del Senatore. The interplay of oval and trapezoid creates a tension of forms characteristic of Michelangelo, and in spite of the similar trapezoidal form of the cathedral square in Pienza, the contrast between the two squares could hardly be greater. Dupérac's engravings of the oval show three concave recessions at the rim, two facing the corners of the Senatore, one facing the *cordonata*.[22] The oval thus conceals a triangular motif with its points at these recessions and 'its two long sides emphasising the diverging axes of the sides of the piazza'.[23] We thus have an architectonic complex of oval, trapezium and triangle. The plan in Lafreri's *Speculum Romanae magnificentiae* of 1567 (Pl. 108)[24] and Dupérac's engravings (Pl. 109) show a stellate pattern inside the oval, the areas spreading out and increasing in size from the centre to the rim[25] and arranged in sequences of twelve, recalling the zodiac. Perhaps this is also meant to give the figure of the emperor a universal significance.[26]

In Michelangelo's project there is a high parapet facing the city, with a short, steep ascent to the piazza. Giacomo della Porta's *cordonata* of 1578, however, breaks up this conception of an enclosed area and gives open access to the piazza from below.[27]

We know from a letter written in 1538 to Pope Paul III by Giovanni Maria della Porta, the Duke of Urbino's ambassador to Rome,[28] that the Pope intended to move the famous statues of Castor and Pollux with their rearing horses from the Quirinal Hill to the Capitol. Michelangelo succeeded in dissuading the Pope from carrying out his intention, which considerations of size alone would have made virtually impracticable, but when in the late 1550s a smaller pair of statues of the two sons of

Jupiter was found,[29] he mounted the two figures on the front parapet. Dupérac[30] shows them facing each other on either side of the steps like heralds; in this position they add to the impression of a self-contained piazza. Later Giacomo della Porta turned them ninety degrees to face outwards, which makes them seem to invite the visitor to enter the piazza (Pl. 110).

The double stairway to the Palazzo del Senatore replaced the old flight of steps and two-storeyed loggia which had stood on the right side of the palace and been removed in 1547.[31] An engraving by Hieronymus Cock shows the new stairway under construction the same year,[32] and it was completed by 1552.[33] It consists of a double-storeyed central section with niche below and baldachin above, reaching to the level of the *piano nobile*, and flights of steps on either side, each flight broken by a projecting landing (part of the old palace). Single staircases of this kind, such as that of the Bargello in Florence, were common in civic buildings, but not double staircases. Michelangelo may have been influenced by the façade of the Villa in Poggio a Caiano by his old friend and probable mentor in the field of architecture, Giuliano da Sangallo.[34] At all events, the staircase cannot be seen solely in terms of the building to which it belongs but must be set in the context of the piazza as a whole. It both absorbs the central axis and links the two sides, adding a further motif to those embodied in the oval.

In Michelangelo's design the two massive figures of the river-gods Nile and Tigris, which had stood on the Quirinal Hill throughout the Middle Ages and been erected in front of the old Palazzo dei Conservatori at the beginning of the sixteenth century,[35] were now (1552) given a new setting in front of the two side staircases (Pl. 111). Tigris was rechristened Tiber, and the symbolic 'tiger' gave way to the Mother Wolf suckling Romulus and Remus.[36] We know from Vasari that Michelangelo intended a statue of Jupiter for the niche.[37] Was it perhaps his idea to call to mind the temple of Jupiter which had stood on the Capitol Hill in antiquity and which he knew from an ancient relief (now in the Louvre)?[38] Be this as it may, his intention was never fulfilled. In 1583 a statue of Minerva as *Roma armata* was erected in the niche; in 1593 this was replaced by another, but far too small, figure of Minerva as *Roma trionfante* (or *Roma vincitrice*, as it is called in guide-

books).[39] In 1589, at the behest of Pope Sixtus V, a large fountain was erected in front of the niche.[40]

The stairway gives direct access to the new portal that leads to the great hall in the *piano nobile*. The portal was completed in 1554, after the stairway.[41]

Michelangelo's façade elevation of the Palazzo del Senatore can only be reconstructed from Dupérac's engravings. He planned an almost complete reconstruction of the old palace. The bottom storey is treated as a kind of rough stone base; above this, at the height of the staircase, is a colossal pilaster order linking the two storeys, which, unlike those of the medieval palace, were now of equal height. At the top is a heavy entablature with balustrade and statues. The window aediculas have small balconies, with segmental and triangular pediments alternating in both the *piano nobile* and the upper storey; small volutes – a popular motif of Michelangelo's – were to hang from the pediments. The wall behind each window is recessed, and strips merge at the sides with the pilasters. Above the porch is the baldachin, which echoes the form of the campanile above; the campanile was to be moved from the left into the centre.

But the reconstruction by Giacomo della Porta could not be started until 1598. On Porta's death in 1602 Girolamo Rainaldi took over the supervision of the work, and the building was finally completed in 1612. The rusticated socle, the colossal pilaster order, the balustrade and the location of the campanile above the centre of the façade – these elements of Michelangelo's design were retained, but their character changed. His plan to raise the height of the second storey was abandoned; it was left at the same height as it had been in the Middle Ages, and square windows were added. The planned baldachin was replaced by a tablet of 1605 with the insignia of Pope Clement VIII, and cartouches were added on either side. The whole façade elevation, which in Michelangelo's conception had been full of plastic energy, now became, under Porta, an exercise in plane surfaces.

In August 1577 the campanile was struck by lightning. A new one was built between 1579 and 1583 in the central position assigned to it by Michelangelo, but Porta converted the single-storey structure into two open storeys framed by paired pilasters, without, however, any change of height.

Whereas we can only reconstruct Michelangelo's intentions for the Palazzo del Senatore from Dupérac's engravings, the Palazzo dei Conservatori is there for all to see (Pl. 112). In 1563, while Michelangelo was still alive, Pius IV asked for construction to begin,[42] and the following year, after Michelangelo's death, Porta was appointed architect in charge. Most of the work was finished by 1573.

Like the Senatore, the Conservatori was not a completely new building, for the walls of the old palace, which had last been restored in 1520, were still standing, together with the six guild-offices in the bottom storey and the three *saloni* of the Conservatori in the upper storey.[43] The open portico was a feature taken over by Michelangelo from the earlier building, though in execution it shows the remarkable flexity and originality of his imagination. Unlike the pattern usually found in the early Renaissance, such as in Brunelleschi's Foundling Hospital in Florence, the Procuratie in Venice and the old Palazzo dei Conservatori, which have arches and vaults, the portico has entablatures and a flat, coffer-like ceiling, as previously found in the upper storey of Bramante's cloister in S. Maria della Pace in Rome. The entablatures rest on columns set at the front of each bay, while matching half-columns stand against the back wall. Each pilaster forms a compound unit with the pier and column on either side of it, and the movement is continued from one end of the portico to the other. The same is true of the half-columns and pilasters on the inner wall, where the relationship between projecting wall and recessed pillars recalls the membering of the walls of the vestibule in the Laurentian Library.

The portico and the upper storey are joined by colossal pilasters set on socles which extend almost halfway up the columns. The wall-surfaces round the windows are set back, and strips frame each area, joining at the sides with the pilasters – the same features found in the top storey of the courtyard of the Palazzo Farnese and the sketch for the Palazzo del Senatore. The window aediculas have segmental pediments – again like those of the third storey in the Farnese courtyard – and small balconies, while above the entablature is a high balustrade.

With the Palazzo dei Conservatori it is particularly clear that the form of the portico, with its entablatures and colossal orders, is not to be interpreted in isolation but as part of the plan for the whole piazza.

203

Verticality and horizontality balance each other. Verticality gives the palace its air of self-containedness, especially through the colossal order, which one may compare with Bramante's design for the Palazzo dei Tribunali in Rome, and which later acquired supreme importance for Palladio; horizontality, present in the portico façade, the entablatures and the balustrade, emphasizes the longitudinal axis of the piazza. Moreover, the articulation of the façade is extended to the sides, which again serves to direct one's gaze to the back of the piazza. Under Pope Alexander VII (1655–67) these side bays were doubled.[44]

Giacomo della Porta's modifications to Michelangelo's design are confined to the erection of paired columns round the central entrance to the vestibule and the addition of a large central window in the upper storey. These features, however, not only modify but conflict with Michelangelo's conception by emphasizing the autonomy of the palace and thereby contradicting its original function as one of the wings of the piazza as a whole.

Pope Clement VIII laid the foundation stone of the Palazzo Nuovo, which was to stand opposite the Palazzo dei Conservatori, in 1603, and its execution was put in the hands of Girolamo Rainaldi, Porta's successor. Work was soon interrupted, however, and only resumed under Innocent X; the building was finished in 1654. It corresponds exactly, as Michelangelo had intended, to the Conservatori and includes Porta's modifications to the portico and the central window: it also completes the enclosed trapezoidal pattern that Michelangelo had planned for the piazza.

The Pope and the Conservatori of Rome sought to restore to the Capitol its former *dignitas*, and all these elements – the enclosed piazza with its three palaces, the raised statue of Marcus Aurelius in the middle, the oval with its stellate pattern, the stairway to the Palazzo del Senatore, reminiscent of the Temple of Jupiter, and the Dioscuri on the front parapet, whom Dante saw as the defenders of the people against tyrants[45] – combined to achieve this purpose. The ancient sculptures on the balustrades also symbolize the homage due to the city, helping to make the Capitol once again 'deorum et Jovis domicilium terrestre'.[46] Moreover this restitution of its classical grandeur in no way conflicted with the position of Rome as the centre of the Christian Church, for one

of the inscriptions of 1568 on the Conservatori commends the new Capitol to the care of Christ: 'S.P.Q.R. Capitolium praecipue Jovi olim commendatum nunc Deo vero cunctorum bonorum auctori Jesu Christo tuendum tradit'.[47]

In 1550–1, at the behest of Julius III, Michelangelo, as chief architect to the Vatican Palace, took over Bramante's plan for the Cortile del Belvedere.[48] Vasari writes:

> In the Belvedere he made the present new stairway in place of the original built earlier by Bramante. Bramante's stairway, for the principal niche in the centre of the Belvedere, consisted of two half circles with eight steps in each, a concave followed by a convex flight. Michelangelo designed and had erected the very beautiful quadrangular staircase with balusters of peperino-stone which stands there now.[49]

In 1512 Bramante, on the instructions of Pope Julius II, had started to build a pair of rectangular courts on ascending levels between the Vatican Palace and the Belvedere, the summer residence of Innocent VIII. The lower court was intended as an arena for jousts,[50] the upper court as a garden; a terrace was to separate the two, and steps and ramps led from one to the other. An exedra was planned for the northern end of the court, and the staircase described by Vasari formed part of this.[51]

The Cortile del Belvedere (Pl. 113), inspired by the magnificent Temple of Fortuna in Palestrina,[52] was the boldest architectural programme of the High Renaissance before Michelangelo. But only the earliest stages were carried out during Bramante's lifetime; many changes were later made in the plan, and when finally Domenico Fontana's library for Sixtus V and Raffaele Stern's Braccio Nuovo were added, its original intended effect was lost for ever.

Michelangelo's contribution consists only of the stairway before the Gran Nicchione. For Bramante's circular stairway he substituted one with double ramps and a balustrade, similar to that for the Palazzo del Senatore on the Capitoline Hill, to which the Belvedere stairway also bears a resemblance in that it is not just part of the building to which it is attached but also, without disturbing Bramante's overall conception,

serves as a focal point in the vertical axis. Drawings by Bartolomeo Ammanati and Giovanni Dosio from the 1550s give a clear picture of the original function of Michelangelo's stairway[53] and also show that he envisaged the exedra as having two storeys. The Nicchione itself was built by Pirro Ligorio between 1562 and 1565.

The antique pine-cone (*pigna*), from which the upper part of the Cortile takes its present name, was erected shortly before 1615 by Pope Paul V. Michelangelo's original balustrade was replaced by Clement XI (1700–21), who also added his family insignia and the spheres at the bottom of the steps.

Porta Pia

In 1561 Pope Pius IV commissioned Michelangelo to provide a design for the Porta Pia,[1] part of an extensive replanning of part of the city.[2] The Pope aimed to build a broad avenue from the Palazzo Venezia via the Quirinal Hill to the Via Nomentana – a plan which anticipated the large-scale programme of Sixtus V and Domenico Fontana, which is the *fons et origo* of baroque town-planning. Whether Michelangelo was involved in such plans, we do not know. In any case, the only parts of Pius IV's idea to be carried out were the present-day Via del Quirinale and Via Venti Settembre, which form a straight line from the Piazza del Quirinale to the Porta Pia and on to the old Via Nomentana.

The Porta Pia occupies the position of the ancient Porta Nomentana. But in contrast to the city-gates of antiquity, the Middle Ages and the Renaissance in general, it faces, not outwards like an entrance, but inwards, and instead of being an isolated piece of architecture, it is the focal point of the newly planned avenue from the Quirinal – a spatial concept which could not but fascinate Michelangelo. He set no store by the gateways of classical Rome – as it would have been reasonable to expect, since the new gate was to replace a classical one – but seems to have taken as his starting-point the conventions of stage scenery such as those described by Serlio after the Roman example of Vitruvius.[3]

In the gate as it now stands (Pl. 114), Michelangelo was responsible for the central portal, the two windows and rectangular cartouches above them, and the two medallions in the attic. The upper parts were only finished under Pope Pius IX in 1853, and then in a revised form. Of their original form we know nothing,[4] and Faleti's engravings of 1568, showing obelisks on both sides of the crenellated wall and small spheres on the pediment – neither of which features was executed – were hardly made from this original.[5]

The pediment of the portal reaches into the attic, and the fluted pilasters at the front overshoot the cornices of the pilasters at the sides – a further example of Michelangelo's predilection for incorporating the

individual members into the architecture as a whole, rather than setting them against each other. The pilasters have strange, eccentric capitals (furthermore the Doric pilasters have Ionic fluting), and in the middle of the tall entablature above them is a broken segmental pediment with a fantastic mask set in the centre above the capstone. Stretching up into the attic zone and projecting beyond the pilasters at the sides is the triangular pediment, in the centre of which is set an inscribed tablet; linking the volutes on either side of the tablet is a pendant garland which offsets the segmental gable below. Certain bizarre motifs recall the Laurentian Library – indeed, the portal as a whole reminds one of the portals of the reading-room, and the pilasters are similar to those of the ricetto.[6] The rustication he adopts for the immediate frame of the gate was customary in classical Roman gates, but the flattened arch is unusual and reminds one of the vaulting of the gallery before the great hall in the Palazzo Farnese, as well as anticipating the Cappella Sforza.

The pedimented windows, set on consoles, are in strong relief and similar in outline to the portal, though simpler; the lateral pilasters are not fluted but have a single channel in the middle, while the cartouches, the attic entablature and the medallions have a strictly linear form.

One may summarize the Porta Pia in Jacob Burckhardt's words from his *Cicerone*:

> A much-criticized structure, pure caprice. But the proportions, and the combined effect of what are quite arbitrary elements, reveal an inner law which the master made for himself . . . The work is a unity which one would attribute at one's first glance to a great, if distracted artist, and within the apparent arbitrariness there rules a sense of determination which amounts almost to a necessity.[7]

St Peter's

Michelangelo's greatest ecclesiastical task as an architect was the completion of New St Peter's in Rome (Pl. 115).[1]

The history of New St Peter's begins with the plan of Pope Nicholas V (1447–55), drawn up with the advice of Leon Battista Alberti.[2] A series of chapels was to be added to the nave and the side aisles were to be vaulted, but at the same time the obligation of all Popes to keep the core of the hallowed basilica intact had still to be respected. The old apse at the west end was to be replaced by a large vault embracing a cross with three arms of almost equal length, with a cupola over the crossing. This is what Günter Urban called 'the culminating point of the plan' and 'the historical watershed between Old and New St Peter's'.[3] The notion of a cupola above the grave of the apostle Peter remained constant from now on and even led Pope Julius II to propose a seemingly paradoxical plan according to which the venerable tradition of the basilica would have been completely abandoned and St Peter's turned into a single central-plan structure. This plan was not put into practice, and Carlo Maderna's nave finally reasserted the basilica principle, yet the result was a compromise, for the essence of the cathedral as it stands today still resides in the centrality of the apostle's grave. The only part of Nicholas V's project to be executed was the western arm (the so-called Rossellino choir), and even this was only completed by Bramante; it was razed during the execution of Michelangelo's plan in the 1580s.

On 18 April 1506 Pope Julius II laid the foundation stone of New St Peter's. According to Vasari's biography of Giuliano da Sangallo, Michelangelo's discussions on the burial tomb that Julius had commissioned in March 1505 led him to the idea of a complete reconstruction of the church in unitary form: 'Many architects submitted designs [for a funerary chapel] but eventually the conclusion was reached that instead of building a chapel, one should embark on an extensive reconstruction of St Peter's . . . and the task was finally given to Bramante.'[4]

Behind the plan to replace the old basilica with a centralized domed

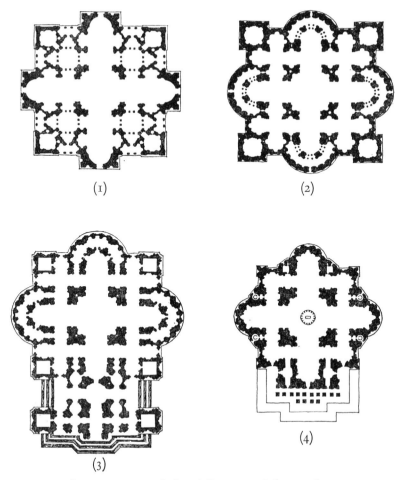

(1)

(2)

(3)

(4)

1 St Peter's, Rome. Ground plans (after James Ackerman).
(1) Bramante, 1506. (3) Antonio da Sangallo, 1539.
(2) Bramante–Raphael, 1515–20. (4) Michelangelo, 1546–64.

structure, which would have extended over most of the area of the old basilica, lay two considerations. One was the attraction for the Italian Renaissance of such a structure as the ideal form for a church, as first formulated by Alberti in Book Seven of his *De re aedificatoria*.[5] The other was the logical and reasonable desire to adopt for the tomb of St Peter the same form of church as that used in the East for housing the bones of martyrs. Bramante's well-known Tempietto for S. Pietro in Montorio,

erected in 1502 above the spot where, according to tradition, St Peter had been martyred, was to be followed by a monumental church built above his tomb.

Bramante's ideal plan[6] (U.A.I.; Fig. 1 (1)) envisaged a square penetrated by a Greek cross with a large cupola above the crossing, four lesser cupolas above smaller Greek crosses in the diagonal arms, and four square towers above circular areas at the ends of the diagonals. There were entrances on all four sides, and only the four apses projected beyond the sides of the square. Bramante's elevation is known from Caradosso's medal of 1506,[7] struck to commemorate the laying of the foundation-stone. The design is dominated by the central dome, 'to which the whole substructure appears to lead up'.[8]

This project was never carried out, for both the Pope and Bramante had to give way before the forces of tradition. Bramante's final idea seems to have been for a combination of nave and central-plan structure, i.e. a return to the form of the Latin cross,[9] but his original plan was to survive in Michelangelo's own work.

The piers and the coffered vaulting of the main dome were in place before Bramante's death in 1514, and work was started on the south arm of the cross and the first piers of the nave, evidently in accordance with a new overall plan. The Rossellino choir, now retained, was vaulted shortly after Bramante's death.[10]

In spite of all the subsequent modifications and alterations the diameter of the cupola and the size of the cross remained as Bramante had planned. The diameter is 41.55 metres, as against the 23 metres of Nicholas V's plan, and was intended to emulate that of the Pantheon, which is 42.70 metres.[11]

The combination of nave and cupola was preserved by Bramante's successors, Raphael, Giocondo, Peruzzi and Antonio Sangallo the Younger – the two latter pupils of Bramante's – but a return to the form of the Greek cross was also considered,[12] and Sangallo's design is essentially for a centralized structure. Building proceeded only slowly in difficult circumstances, chief among them the Sack of Rome in 1527 and the events leading up to it, and it was not until the mid-1530s, under the initiative of Paul III, that work was resumed in earnest. Between 1535 and 1538 Antonio da Sangallo, who had assumed control after Raphael's

death, erected a wall between the old basilica and the new which enabled Old St Peter's to be used once more as a church.[13] He also strengthened Bramante's piers and raised the floor level by almost four metres.[14] In 1535 a start was made on the vaulting of the southern arm of the cross.[15]

But Sangallo's principal contribution was an entirely new overall plan (Fig. 1 (3)), prepared between 1538 and 1541, which was to become Michelangelo's point of departure for his own work on the basilica. This plan is known from a complete wooden model (now in the Museo Petriano in Rome),[16] four engravings of this model made in 1549 by Antonio Labacco[17] – the first copper engravings of architectural projects – Sangallo's own *Memoriale* with criticisms of earlier plans,[18] and Michelangelo's later comments on Sangallo's work.

Sangallo sought a synthesis of basilica and centralized structure, taking his lead for the interior from an earlier plan – probably Peruzzi's[19] – and simplifying it here and there. He then added a new façade with a liturgically inspired loggia, flanked by two immense towers; this loggia was linked to the body of the church by a large porticoed vestibule crowned by a cupola. From outside the building had the traditonal form of the Latin cross, but the interior, from which neither the vestibule nor the porch was visible, retained the shape of the Greek cross.

The interior alterations were confined to those made necessary by his modifications of Bramante's plan,[20] but the exterior now had a completely different appearance. The apses received an elaborate multistorey superstructure that almost disguised the interior structure; in particular, this superstructure is continued round the sides so that the semicircular apses merge with the basic square – a considerable advance on Bramante. This pattern is based on classical Roman models such as the Colosseum and the Theatre of Marcellus, and is here applied for the first time in the Italian Renaissance to a circular structure. The large central arch of the portico forced Sangallo to introduce a high attic which separated the storeys and adversely affected the monumental unity, and Michelangelo made harsh criticisms of this feature, but Sangallo's imaginative amalgamation of the discrepant elements takes us a step beyond the heterogeneity of Bramante's design in the direction of Michelangelo, and signifies at the same time the achievement of something representatively Roman.

For the façade elevation of his arch[21] Sangallo, like Alberti in the churches of S. Maria Novella in Florence and S. Andrea in Mantua, called on the motif of the Roman triumphal arch, though by adding a further arch above it, he detracted somewhat from the effect of the main arch. The central cupola is completely different from Bramante's[22] and now has two arcade members separated by a cornice in place of Bramante's peristyle. The underlying thought was to relate the building to the dome by taking over the motif of the surface membering – a further anticipation of Michelangelo, as is the added steepness of the dome, made necessary by the addition of the large portico which partly blocked the view of the dome.

The state of New St Peter's on Michelangelo's appointment as *capomaestro* in 1546 can be seen from drawings by the Dutch painter Marten van Heemskerk,[23] a Flemish drawing from the year 1544,[24] and a fresco by Vasari in the Sala dei Cento Giorni in the Palazzo della Cancelleria,[25] which, though painted in the 1550s, goes back to a sketch made in 1546. These sources show that the construction of the arms was well advanced, that the old Rossellino–Bramante choir had an exterior colossal order and Doric entablature, and that the lower row of blind windows in the southern apse had just been started.[26]

Antonio da Sangallo died on 29 September 1546. Giulio Romano from Mantua was considered as his successor[27] but he died on 1 November, before he could leave for Rome, and the same year Michelangelo assumed control[28] – a late moment in his career, for he had been 'chief sculptor, painter and architect to the Vatican' since 1535, and his association with the plan for New St Peter's went back to his 1505 design for the tomb of Julius II. Vasari writes:

It happened that in 1546 Antonio da Sangallo died; and since there was now no one supervising the building of St Peter's, various suggestions were made by the superintendents to the Pope as to who should take over. At length (inspired, I feel, by God) His Holiness resolved to send for Michelangelo; but when he was asked to take Sangallo's place, Michelangelo refused, saying, to excuse himself, that architecture was not his vocation. In the end, entreaties being to no avail, the Pope commanded him to accept. So to his intense

dismay and completely against his will he was compelled to embark on this enterprise.[29]

As *capomaestro* of St Peter's under five different Popes, Michelangelo met with innumerable difficulties. Now that it was his design that was to be followed, the 'setta Sangallesca' ('Sangallo faction'), as Vasari sarcastically called his predecessor's supporters,[30] grew more and more antagonistic towards him and looked only to cause him trouble and annoyance. In 1554 Vasari wrote to him from Florence, to which Duke Cosimo de' Medici hoped to attract him back: 'Is it possible that you, who took St Peter's out of the hand of thieves and murderers and brought to completion what others had left incomplete, should be subjected to this? Return and lay your bones to rest in this city that gave you birth, and flee from that ungrateful Babylon!'[31] To which Michelangelo replied: 'Know that I would dearly lay my bones to rest beside those of my father, as you beseech me. But were I to leave Rome at this moment, it would be a disaster for St Peter's, a disgrace for myself and a grievous sin. Yet once the building is completed, so that nothing can be changed, I hope to do what you say.'[32] Michelangelo stayed in Rome till the end of his life. But he did not see the completion of his plan.

Michelangelo utterly rejected Sangallo's design for St Peter's: 'His model is good for dumb oxen and silly sheep who know nothing about art.' Vasari records:

> Afterwards Michelangelo used to say openly that Sangallo's model was deficient in light, that on the exterior Sangallo had made too many rows of columns one above the other, and that with all its projections, spires and subdivisions of members it derived more from the German manner than from either the sound method of the ancient world or the graceful and lovely style followed by modern artists. As well as this, he would add, fifty years of time and over three hundred thousand crowns of money could be saved on the building, which could be executed with more majesty, grandeur and facility, better-ordered design and greater beauty and convenience.[33]

Leaving Sangallo, Peruzzi and Raphael aside, Michelangelo went back to Bramante, whose original plan, ironically, had been the source

of Michelangelo's chimerical notion that Bramante was determined to ruin him.[34] Acknowledging Bramante's mastery, he now followed in his footsteps, abandoning any compromise or synthesis of basilica and centralized structure and returning to the principle of a pure central-plan scheme. He wrote to one Bartolomeo:

> One cannot deny that Bramante was as worthy an architect as any since ancient times. He laid down the first plan for St Peter's that was not full of confusion but clear and pure, full of light, and caused no detriment to any part of the palace. And it was regarded as a beautiful thing – as, indeed, it is obvious to all today that anyone who departs from Bramante's arrangement, as Sangallo has done, departs from the truth. Any dispassionate observer can see from Sangallo's model that this is so.[35]

However, despite the significance of Michelangelo's return to Bramante's design, his starting-point was necessarily Sangallo, and it is in the first instance by Sangallo's design that his own plan has to be judged. 'He diminished the size of St Peter's,' says Vasari, 'but increased its grandeur in a manner which pleases all those able to judge.'[36]

The Pope's *motu proprio* putting Michelangelo in charge of the building, according to Vasari's account, 'gave him full authority to do or undo whatever he chose, and to add, remove or vary anything just as he wished. The Pope also commanded that everybody employed there should take their orders from him.'[37] Before the end of 1546[38] he completed a preliminary clay model of the entire building – Vasari says it took him fourteen days[39] – but it has not survived. Between the end of 1546 and the autumn of 1547 he had a wooden model made, 'not only because he was dissatisfied with parts of the old model but also because the whole enterprise was so enormous that there would have been more point in hoping to witness the end of the world than the completion of St Peter's.'[40] This model too is lost; all we have is a painting of part of it by Domenico Passignani in the Casa Buonarroti,[41] which also shows the small cupolas added by Vignola. In 1557 Michelangelo made a clay model of the dome, from which in 1558 and 1561 the extant wooden model was made (Rome, Vatican, Museo Petriano; Pl. 125).

For the purpose of reconstructing and assessing Michelangelo's plan

we can draw on his own sketches, those of his circle, various copies and engravings, Vasari's detailed though not complete description of the model of the dome, and the model itself.[42] Especially valuable are the engravings of Étienne Dupérac (Pls. 120 and 121), which, however, were made only after Michelangelo's death and are based on a variety of sources.[43]

Yet various questions still remain unanswered. The most important concerns the basilica itself (Pls. 115 and 117). The whole of the western part follows Michelangelo's plan – though parts were not executed until after his death. He strengthened and modified Bramante's piers once more and, having razed the walls of Sangallo's apse, raised the southern arm almost to its full height and the northern arm to about half-height; except for later modifications, the attic and the drum are also his.[44] The dome, on the other hand, was raised only between 1588 and 1590, after his death; its modified form is the work of Giacomo della Porta, who also completed parts of Michelangelo's design for the Capitoline Hill, and Domenico Fontana. This western part of the cathedral, both the interior and the exterior, is basically as Michelangelo designed it, although it is difficult to judge this for oneself today, since it is not possible to walk right round the building. The most impressive view of the cathedral as a whole is from the Vatican gardens. The nave and façade elevation of Carlo Maderna, done between 1607 and 1614, are entirely in Michelangelo's vein.

Michelangelo's ground plan (Fig. 1 (4)),[45] rejecting Sangallo and moving back towards Bramante, is for a centralized structure with dome, which again makes us wonder whether, at the time of his work on the tomb of Julius II, he might not have had a hand in this unusual design for St Peter's. Sangallo's design is radically simplified. The ambulatories, basically a medieval feature that Bramante appears to have incorporated in his final design and bequeathed to his successors, are done away with. In the Bartolomeo letter mentioned above Michelangelo criticized the concept of the ambulatory: 'It deprives Bramante's design of all light', he wrote;

not only that, it contributes no light of its own and has a mass of niches and crannies and dark corners which encourage immorality:

criminals hide there, forgers lurk there, others rape nuns there and commit similar acts of villainy. When mass is over in the evenings, twenty-five men are needed to search the ambulatories to see whether anyone is hiding there, and even then one would be unlikely to find them all.[46]

Michelangelo was particularly concerned with the question of interior light, which he increased, at the same time further emphasizing the coherence of his design. He also eliminated the corner-towers and the chapels beneath the lesser domes, so that the inner and outer wall coincided. The ambulatories gave way to thick walls which bore the thrust of the vaulting; the piers at the entrances to the northern and southern hemicycles were strengthened and two spiral staircases formed within them.[47] He designed a new façade which did away with Sangallo's portico. Yet features of Sangallo's project remained, such as the emphasis – recalling the Basilica of Constantine – on the eastern end, as opposed to Bramante's plan, consistent with a centralized building, for entrances on all sides.

By greatly reducing the dimensions of the basilica as a whole, Michelangelo avoided the danger of encroaching on existing parts of the Vatican Palace. 'If one were to surround Bramante's composition on all sides', he observed, 'one would be compelled to demolish the Pauline Chapel, the Offices of the Piombo, the Ruota and various other buildings; probably not even the Sistine Chapel would survive intact'.[48]

As well as strengthening the four main piers bearing the dome, Michelangelo changed their form, replacing the original single niche with two niches, the upper larger than the lower.[49] He also replaced the small windows, with their numerous small panes, by fewer but larger windows. The colossal order of Bramante's plan is retained and given greater prominence through the unitary emphasis of Michelangelo's project. The overall grandeur of this project – which is what gives the building its present-day character – becomes even clearer when one considers his work on the drum and on the interior of the dome.

It is in the exterior (Pl. 116) that Michelangelo's design differs most strikingly from Sangallo's. By doing away with Sangallo's tripartite order which surrounded the interior like the wings of a stage and

disguised its structure, and by applying the interior colossal order to the exterior, he achieved a new unity. Bramante had already used this feature in a sketch for the choir,[50] but Michelangelo gave it a new intensity. It is as though a sculptor had treated the whole building like a single block of stone. Sangallo's structure had consisted of a harsh juxtaposition of cubic and spherical forms, and the repetition of identical members gives a cumulative effect to the order as a whole; Michelangelo introduced slanting walls between the cubes and spheres as a kind of transition, thereby unifying the whole and giving each part of this whole its own individual meaning. The applied pilasters at the corners project above the slanting and spherical members, producing, instead of a repetition of identical members, an alternating sequence of broad and narrow bays.

Besides linking the storeys, the colossal order with its ornate composite capitals points upward to the drum and the dome, so that, for all its classical Roman spirit, it holds the horizontal members of the building together in a vertical, 'Gothic' style which reminds us of the cathedral in his native Florence. In his usual manner the pilasters are linked to the wall by side-strips and virtually become part of the facing. Each broad bay has two large plastic aediculas – an upper pedimented window with balustrade and a lower pedimented niche, the pediments alternating between triangular and segmental, recalling the palaces of the Capitol and the courtyard of the Palazzo Farnese. In each of the narrow bays, compressed between the pilasters, are three delicately framed openings with round arches: the uppermost opening is a window, the lower two are niches, and above each, as in the vestibule of the Biblioteca Laurenziana, are delicate rectangular cartouches. Above the colossal order is a stepped lintel and above this the attic.

Sangallo's elevation provided for a tall attic between the main storeys,[51] with only a narrow lintel at the very top, and there is little relationship between the body of the building on one hand and drum and dome on the other. Michelangelo also has a tall attic. Structurally it acts as an abutment for the vault; aesthetically it both adds a horizontal dimension to the base and, by continuing the multiple vertical membering characteristic of Michelangelo, draws the eye upwards to the drum and the dome. The pilasters, in the cluster-form also characteristic of Michel-

angelo, are continued, likewise the sequence of broad and narrow bays, with rectangular windows in the broad bays, and niches with candelabra in the narrow.

There remains, however, a certain amount of doubt concerning the exact form of Michelangelo's attic.[52] In 1557 he himself constructed the attic of the south arm,[53] and an engraving made by Vincenzo Luchino in 1564 (Pl. 118) shows this state:[54] the pilaster-clusters are missing, and there are no broad and narrow bays; the only surface membering consists of unframed, round-arch windows with broken soffits and perspective coffering. Did he intend to leave it thus or to face it (it remained bare till the end of his life)? Is it an engraving of an earlier project that Michelangelo replaced by the attic as it exists today? Or is its present form a later modification by Pirro Ligorio (who was relieved of his post as Michelangelo's successor at the end of 1566 or the beginning of 1567) or Vignola? The researches of Millon and Smyth suggest that Luchino's engraving represents Michelangelo's final design,[55] yet is it not equally possible that the present form, at least to the extent of the continuation of the membering, corresponds to his overall conception?[56] He must at least have decided the scale of the attic himself.

The construction of the façade was not started before his death.[57] The eastern arm, as far as the beginning of the apse, was complete by the time Sangallo died,[58] but the old nave still existed, as did Sangallo's wall between Old St Peter's and the new basilica. It is even doubtful whether Michelangelo got beyond preliminary plans for the façade. To judge from Passignani's painting in the Casa Buonarroti,[59] the wooden model of 1547 had no façade, so that we are entirely dependent on later sources, of variable reliability, for our knowledge of the original design.[60]

The most important of such sources are the engravings and drawings of Dupérac, together with a drawing erroneously attributed to him and inscribed 'This building is to be constructed in this manner in accordance with Buonarroti's design' (Pl. 119),[61] and the well-known series of authenic engravings of 1569 (Pls. 120 and 121) (though of these latter only that of the plan is reliable).[62] The drawing shows a portico, with six free-standing columns and a triangular pediment, of the same dimensions as the apse-walls of the other three arms – this represents Michelangelo's first answer to the problem. The arrangement of these

columns derives from the five entrance-doors that were planned, but the doors were incompatible with this design, and it had to be abandoned. The centre is left free.

Dupérac's engraving corrects this drawing by realizing the necessity to move the entrances from the centre – where Sangallo had had them – to the axes of the dome-piers and corner chapels. The vestibule is turned into a 'double façade of columns'[63] with a total of ten columns, matched by paired pilasters against the rear wall with four columns in front.[64] But this is so much at odds with Michelangelo's principle of a coherent central-plan structure that one may doubt whether it reflects his intentions at all.[65] The earlier drawing is probably more authentic but it can hardly convey Michelangelo's ultimate conception.

Sangallo's model shows a façade with a large Roman triumphal arch. Michelangelo, on the other hand, seems to have had the Pantheon façade in mind, and this is the first time that we find this monument to imperial Rome – which was never destroyed – as the inspiration for a modern work. At the same time Dupérac's engraving shows once again how Michelangelo returned to the design of Bramante,[66] one of whose later sketches, based on the Porticus Octaviae in Rome, shows a nave whose eastern end forms just such a portico.[67] This makes it all the more unlikely that Dupérac's engraving reflects Michelangelo's intention.

Whether the minor domes were already in Michelangelo's mind, we cannot definitely say. They are present in the above-mentioned drawing and engravings – in the latter presumably in Vignola's design[68] – but their execution in the form we see today is the work of Giacomo della Porta.[69]

The central dome of St Peter's (Pl. 122)[70] is one of the greatest works in the whole of Western art. Classical and Byzantine domes had always been designed from the interior, and the exterior aspect had had no independent significance. This is still true of the Baptistery in Florence. The dome of the Duomo, on the other hand, is the first building to have an independent architectural exterior – and this in the design of 1368,[71] not merely in its finished form by Brunelleschi.[72] It is the greatest predecessor of the dome of St Peter's and was highly praised by Vasari, for one. In its train come the domes of the Santuario della Sante Casa in Loreto, of S. Biagio in Montepulciano and of the cathedral in Foligno.

As a son of Florence, Michelangelo always had the example of the Duomo before him, and there are also precise points of reference. As early as 1516, for example, long before his connection with St Peter's, he expressed indignation at the lack of correspondence between Baccio d'Agnolo's gallery round the frieze of the Duomo and the spirit of the dome itself, and designed a new model;[73] we also have his drawings of the dome (Pls. 123 and 124).[74] But his real starting-points were the sketches of Bramante and, above all, of Sangallo.

Since the dome of St Peter's was only completed between 1588 and 1590, some twenty-five years after Michelangelo's death, his intentions have to be reconstructed from the surviving records of the construction itself,[75] the various sketches, the wooden model and Vasari's detailed description of this model.[76] The early models of the basilica as a whole would presumably also have enabled us to see Michelangelo's conception of the dome, but they have been lost.[77]

There are references to the construction of the great ring at the foot of the drum between 1547 and 1549;[78] the drum itself was raised between 1554 and 1557.[79] On 3 July 1557 a clay model of the dome was completed and fired.[80] In Vasari's words:

In St Peter's Michelangelo had carried forward a great part of the frieze, with its interior windows and paired columns on the outside following the huge round cornice on which the cupola has to be placed. But now little was being done. So bearing in mind his state of health, Michelangelo's closest friends urged him in view of the delay in raising the cupola at least to make a model for it. These were men such as the Cardinal of Carpi, Donato Giannotti, Francesco Bandini, Tommaso Cavalieri and Lottino. Michelangelo let several months go by without making up his mind, but at length he started work and little by little constructed a small model in clay, from which, along with his plans and sections, it would later be possible to make a larger model in wood. He then began to work on the wooden model, which he had constructed in little more than a year by Giovanni Francese, who put into it great effort and enthusiasm; and he made it so that its small proportions, measured by the old Roman span [about nine inches], corresponded perfectly and exactly to those of the cupola

221

itself. The model was diligently built with columns, plinths, capitals, doors, windows, cornices, projections and every minor detail, as was called for in work of this kind; and certainly in Christian countries, or rather throughout the whole world, there is no grander or more richly ornamented edifice to be found.[81]

The wooden model of the dome was made between 19 November 1558 and 14 November 1561 (Pl. 125).[82] As a preface to his detailed description of it Vasari wrote:

If it should ever happen (which God forbid) that this work were impeded, now that Michelangelo is dead, by the envy and ill-will of presumptuous men (as it has been hitherto), these pages of mine, such as they are, may be able to benefit those faithful men who will execute the wishes of this rare artist, and also restrain the ambition of those evil men who might wish to change them.[83]

It is generally accepted that the model of the drum and dome now preserved in the Sala dell' Immaculata of the Vatican Museum is a faithful replica,[84] although the outer shell of the dome was later modified by Giacomo della Porta in accordance with his own elevation.[85]

Bramante's dome, which we know from a woodcut of Serlio's,[86] had paid the same regard to the exterior elevation as did Michelangelo's: a peristyle surrounded the drum (cf. the Tempietto at S. Pietro in Montorio), and the hemispherical cupola was topped by a lantern with pilasters, gallery and volutes. The dome is completely independent of the body of the basilica and reveals a perfect harmony of load and support; the peristyle round the drum enhances this independence and conveys an atmosphere of order and serenity which is also transmitted by the cupola itself.

Sangallo's dome, which we know from his wooden model of St Peter's,[87] has an arcaded peristyle round the drum, in the style of the Colosseum, in place of Bramante's columns, and a second, recessed row of arcades above it, round the foot of the dome – the kind of small-scale membering which Michelangelo sharply criticized in Sangallo's design. But in contrast to Bramante, Sangallo establishes a relationship between dome and building, and this brings him a step nearer to Michelangelo.

A further important point is that Sangallo's dome elevation, probably as a result of the massive façade which now restricted the view of the dome, is steeper and acquires an ovoid form, in place of Bramante's hemisphere. Sangallo, like Michelangelo, was a native of Florence and may have recalled the dome of the Duomo there. Instead of a single massive shell we have an outer shell with thirty-two ribs, arranged according to the arcade membering of the drum and the base of the dome, and an inner shell with a classical coffered ceiling. All these features anticipate Michelangelo's design. Sangallo retains Bramante's peristyle round the lantern, which is now so big that the dome itself loses an unreasonably large part of its impressiveness, especially with the additions to the membering of the drum.

In order to increase the height of the dome and to raise it above the basilica below, Michelangelo inserted a large ring between the drum and the cornice of the pendentive zone: Vasari describes it as 'in uso di pozzo' ('like a well').[88] The drum reverts to Bramante's pattern of columns, but instead of a regular sequence of columns round the whole circumference Michelangelo, in a characteristic variation, erects pilasters at regular intervals with paired columns in front of each pilaster, each cluster projecting from the wall in a manner that recalls the lantern of the Medici Chapel in S. Lorenzo; in the intervening spaces are rectangular windows with alternating triangular and segmental pediments,[89] so that the wall-surface of the drum is made clearly visible at these points, not totally obscured behind the columns, as in Bramante's design. Furthermore by making the paired columns correspond to the paired pilasters of the lower elevation and the alternation of columns and window aediculas correspond to that of the broad and narrow bays, Michelangelo relates the membering of the dome to the system of the basilica below, as Sangallo had done before him.

The attic, with pilasters that continue the columns of the drum and with garland motifs in the intervening bays, both crowns the drum and provides a base for the dome, for the ribs of the dome rest directly on the attic pilasters.

Like Sangallo, Michelangelo – from his first designs onwards – adopted a rib-structure,[90] but he reduced Sangallo's thirty-two ribs to sixteen, making them continue the upward movement of drum columns

and attic pilasters. Windows, with pediments matching those of the windows in the drum, are let into the cupola, and the whole structure, basilica and dome together, becomes a single coherent concept.

Such is the form of the dome that came to be built. But what was its original form? It appears that here, as with the attic and façade of the basilica, Michelangelo had no single, unchanging plan but modified his ideas right down to the end, leaving us, as often in his sculptures too, with a work that is not just the culmination of a fixed intention but the chronicle of a creative process.

In a letter of 30 July 1547,[91] before the wooden model of St Peter's had been completed, Michelangelo wrote to his nephew Lionardo in Florence asking him to send him the measurements of the lantern of the Duomo: he was particularly concerned to know the relationship between the height of the lantern and the height of the dome as a whole. This letter is probably connected with the sketches of dome and lantern which are preserved in the Teyler Museum in Haarlem (Dussler No. 148; Pl. 123).[92] These show the outer shell of the dome – apparently with eight ribs – as elliptical, the inner shell as spherical; mounted on this is a small lantern on a circular cornice, and between the two shells, indistinctly drawn, is a kind of interior lantern. A more precise sketch in the top left-hand corner of the same sheet shows a taller octagonal lantern that reminds one of that of the Duomo in Florence;[93] this seems to be Michelangelo's first real sketch for an interior lantern which was visible from below and would have admitted indirect light between the two shells of the dome.

The Haarlem sketches suggest that Michelangelo's first conception was of an elevated outer shell, which would have been the natural expression of his vision of a building soaring to its culmination in the dome.[94] Sangallo too had designed a double shell with an elliptical profile and a ribbed structure. It is from the basis of this form as shown in the Haarlem sketches that one must assess the subsequent correction of the design in the form of a lowering of the profile, though Michelangelo also appears to have experimented at this time with a less elevated dome and a taller lantern. One thing is certain: dome profile and lantern belong together in all the designs. An elliptical dome will have a lower lantern, a hemispherical dome a taller one.

A study in the Musée des Beaux-Arts in Lille (Dussler No. 301; Pl. 124),[95] related to, and contemporary with, the Haarlem sketches, also shows Michelangelo's uncertainty. There are various differing profiles of the dome, all of which, however, are offset by a consistently hemispherical inner shell. There are apparently no ribs[96] (like Bramante's): the lantern, as in the Haarlem sketches, has eight members and the drum has sixteen faces, with roundels that again recall the Duomo in Florence.[97]

Passignani's painting in the Casa Buonarroti[98] of Michelangelo presenting his model of St Peter's to a Pope also shows an ovoid dome, which indicates that the wooden model of 1546–7 must have had such a profile.[99] The British Museum drawing attributed to Dupérac (Pl. 119)[100] brings the first indication of a lowering of the profile, but not until the wooden model of the dome (1557–61) does Michelangelo appear to have resolved on a flattening of the profile. A rough sketch in the Ashmolean Museum in Oxford (Dussler No. 207),[101] dateable to 1556–7 by the fragment of a letter on the left-hand side of the sheet, still shows a certain indecision, but there is a clear tendency towards a hemispherical form; above the dome, resting on a substantial circular canopy that crowns the interior lantern, is a tall, hastily sketched outer lantern.

The semicircular form, with sixteen ribs and a tall lantern, is finally reached with Dupérac's engravings (Pls. 120 and 121),[102] which also show the tapering of the ribs towards the top mentioned in Vasari's description of the wooden model of the basilica.[103] The purpose of this new feature, which only appears after the elliptical profile has been abandoned, is to replace the effect of the raised profile by the illusion of perspective.[104] Between the ribs there is a sequence of three dormers above each other, which illuminate the hollow between the inner and outer shells.

It must once again be emphasized that Michelangelo's decision in favour of a hemispherical dome was by no means inevitable, for in the context of the building as a whole an elliptical form would have been more logical. His return to Bramante's proposal for a hemispherical dome, but without sacrificing the principle of an all-embracing upward movement, represents a stylistic development of his old age which also manifests itself in his designs for the church of S. Giovanni dei Fiorenti

in Rome. And while being the integral culmination of the whole structure of St Peter's, the dome also retains an independent impressiveness, gathering into itself, as it were, the forces below it and fusing them into a structure of controlled power – that same controlled power that characterizes his last sculptures.

As for the outer shell, so also for the interior of the dome (Pl. 117) Michelangelo does not appear to have had a definite plan from the beginning. The early sketches – those in Haarlem and the Ashmolean Museum – show him considering both a closed inner shell and the insertion of an interior lantern. This lantern can be clearly seen on Dupérac's engraving (Pl. 121). It has sixteen apertures which are not visible from the outside[105] and could therefore only have admitted a diffuse light from the top row of dormers in the dome; the remarkable effect of mystery thus created is a moment of expression characteristic of Michelangelo.

The order of slim paired pilasters between the apertures picks up the membering of the interior of the drum.[106] The interior dome has sixteen ribs;[107] at the bottom, starting above a balustrade, they are the same width as the paired pilasters of the drum but they taper towards the thick semicircular base of the lantern at the top. The areas between the ribs have an alternating sequence of tondi and squares.

As we have seen, the size of the lantern depended on the profile of the dome. Michelangelo seems to have found no definitive solution to the problem of its form,[108] but Dupérac's engravings probably give a fair idea. They show a shorter, squatter form than that of the drawing in the Ashmolean Museum.[109] The pattern of paired columns with intervening windows, as used for the drum, is here adopted in compressed form, and above the columns are volutes; the result recalls the lantern of the Medici Chapel.[110] Dupérac shows the windows as rectangular but in the lantern itself they are round-arched. The lantern as a whole stands on a stepped podium. Vasari calls the whole design a *tempio*.[111]

Giacomo della Porta, who was appointed chief architect of St Peter's in 1573 or 1574, increased the height of the outer dome[112] both of the wooden model and in the construction of 1588–90.[113] Grimaldi writes: 'The architect Giacomo della Porta, a pupil of Buonarroti's, increased the height of the dome because he thought it would make it stronger

and more beautiful.'[114] There was justification enough for Porta's action in the history of Michelangelo's own designs, and when Maderno's nave came to be built in 1614, the view from the east added a further vindication.

The attic pilasters and the ribs are narrower in the model of the basilica and on the actual dome than they are in Dupérac's engraving; also the candelabra have been added to the lantern and the gallery corrected. Inside the dome Porta altered the illumination by opening the hollow between the outer and inner shell and admitting light directly into the building. The mosaic decoration is also Porta's work. These and other alterations would not have been possible without Michelangelo's own dome, but Porta's dome has its own value and significance, and is from the stylistic point of view a step towards baroque.

S. Giovanni dei Fiorentini[1]

In 1518 Pope Leo X de' Medici gave permission to the Florentine community in Rome to erect a new church between the Tiber and the Via Giulia, near the Florentine banks, to take the place of the small oratory of the Compagnia della Pietà that they had hitherto been using. The commission was awarded to Jacopo Sansovino against competition from Raphael, Antonio da Sangallo the Younger and Baldassare Peruzzi. 'The church', according to Vasari in his *Vita* of Sansovino, 'was to have a total length of twenty-two ells. But as there was not this much space available, and as the façade was intended to face the houses on the Strada Giulia, it was necessary to build out into the river for a distance of at least fifteen ells . . . More than 40,000 scudi was spent on this work, a sum that would have covered half the cost of the whole church.'[2] For reasons we cannot explain, Sansovino was discharged in 1520 and replaced by Sangallo the following year.[3] Some ten plans of Sangallo's are preserved, showing a development from a centralized circular scheme to a broad basilical plan for a five-bay nave, with aisles and chapels on either side, and a large choir with massive piers at the crossing, surmounted by a cupola.[4]

When Leo X died in 1521 the scale of this costly enterprise had to be cut back; it was decided to complete the building temporarily and to defer the construction of the dome. But even the nave showed little progress, and the Sack of Rome in 1527 brought everything to a halt. When work was resumed in 1582, Giacomo della Porta was put in charge, and the construction of the nave, following Sangallo's plan, is basically his. After Porta's death in 1602 Maderna completed the east end of the church – choir, transept and dome; the façade, however, was only raised between 1732 and 1735 by Alessandro Galilei, architect of the façade of S. Giovanni in Laterano.

In 1550 it was suggested that the family graves of Pope Julius III be moved to the church, and Michelangelo was approached for his advice and co-operation, but the idea came to naught.[5] In the middle of 1559

it was proposed to resume the construction under the patronage of Duke Cosimo de' Medici, and Michelangelo was again approached. From Vasari's account and from a letter of Michelangelo's to Duke Cosimo[6] we learn that he submitted five different designs; three of these – for a central-plan building – have survived (Casa Buonarroti) but none of them was the one executed. These designs are, however, of great importance for our knowledge, not only of Michelangelo himself but of sixteenth-century Italian architecture as a whole.

Rejecting Sangallo's smaller-scale project,[7] he took up Sangallo's first design[8] for a central-plan building and proceeded to develop his own more elaborate, more concentrated project through a succession of stages. Once again we see that Michelangelo's relationship to Sangallo was far from a purely negative one. Sangallo's completely circular plan provided for a central dome, with minor domes crowning a series of chapels set round the central circle. On the opposite side to the altar chapel is a prominent curved façade. The form of the circle is thus everywhere dominant.

Michelangelo's first design (Dussler No. 143; Pl. 126)[9] shows a Greek cross set in a circle, and the circle set in a square, the sides of which are overlapped by small segments of the circle. At the front there is a rectangular portico with apses left and right, at the rear a corresponding annexe with enclosed oval bays left and right. There are two side entrances, and an inner colonnade round the circumference which recalls the church of S. Stefano Rotondo in Rome.[10] Four chapels are formed by the four segments of the circle, while the diagonal openings from each of these chapels lead into the four spaces between circle and outer square which were to be used as sacristies, and from which staircases led down to the crypt. In the centre is an octagonal altar-platform.[11]

This combination of circle, Greek cross and square goes far beyond Sangallo. The circle is not, as in Sangallo and in the Renaissance ideal, a self-contained entity but forces its way outwards, only to be pressed back again by the sides of the square – Michelangelo's familiar creation of stress and dynamic tension. The cross motif reasserts itself in the axes between the two side entrances and between portico and choir chapel.

In his second, more involved plan (Dussler No. 142; Pl. 127)[12] Michelangelo goes beyond both Sangallo and his own first plan and

adopts a form in which octagon and St Andrew's cross are prominent, together with a slight weighting of the longitudinal axis. This is a far remove from the geometrical principles of the Renaissance, but Michelangelo seems to have had Guiliano da Sangallo's sacristy in S. Spirito in Florence in mind. At the four apexes of the diagonals there are chapels or sacristies with hemicyclical apses. There is a detached portico at the front. In place of ambulatory in the first plan we now have paired pilasters on either side of each chapel or sacristy, and in front of these pilasters groups of three piers supporting the dome. These piers, like the free areas all round the periphery, look inward towards the open centre of the church; even the high altar has been taken from the centre and set in the choir chapel.

The third plan (Dussler No. 145; Pl. 128)[13], anticipated to some extent by sketches on the *verso* of the second,[14] is a synthesis of its two predecessors. Circle (the piers grouped round the centre), cross (in the Greek and St Andrew's forms) and squares are combined. The diagonal apses, unlike the second plan, are absorbed into the interior; at three of the apexes of the Greek cross are entrance foyers with apses, at the fourth is a chapel. The central circular motif of the first plan reappears and the high altar is again in the middle, but instead of single, symmetrically placed columns there are paired columns on large single bases which, as in the second plan, bear a relationship to the diagonal chapels and renew the octagonal form of this plan.

The richness of the interior contrasts with the simplicity of the exterior. The walls have been strengthened and the profile made more compact. As well as developing the earlier plans, Michelangelo appears to have thought through once again, with a stronger sense of compression and unity, his ideas for St Peter's – but this time without reference to Bramante.

This plan of 1560 was the one accepted. As Vasari put it: 'After the choice had been made, Michelangelo told them that if they put the design into execution they would produce a work superior to anything done by either the Greeks or the Romans.' To which Vasari added: 'Words unlike any other ever used by him, before or after, for he was a very modest man.'[15]

A fair copy of this plan, with a few modifications, was made by

Michelangelo's pupil Tiberio Calcagni and is now in the Uffizi.[16]
The inner circle of columns was again dispensed with, and the motif of
the circle survived only in the paired columns in front of the curved
interior walls and in the high altar. In a letter to Duke Cosimo de'
Medici on 1 November 1559 Michelangelo wrote: 'I shall have a copy
of this plan made which will be far clearer than I, in my old age, could
make.'[17] On 5 March 1560 he again promised the Duke to attend to the
construction, 'even though, as a result of my age and my poor state of
health, I cannot do so as I would like.'[18] 'It causes me great suffering to
be so old and so near to death that I cannot do everything to my
satisfaction.'[19]

Drawings and engravings[20] enable us to picture the lost model that
Vasari describes,[21] a perspective interior view of which is found in a
sketchbook by Giovanni Antonio Dosio in the Biblioteca Estense in
Modena (Pl. 129).[22] The drawing is inscribed: 'ritratto dal modello di S.
Giovanni de fiorentini in Roma inventione di Michelagniolo buonaroti
B.M.ia', and follows Calcagni's copy. A particularly noticeable feature
is that the chapel arches extend into the drum, depriving it of its inde-
pendence. A second order of columns is mounted above that at ground
level and bears the mitred cornice from which the ribs of the dome,
following the lines of the two sets of columns below, proceed upwards
to the open summit. Verticals predominate over horizontals. Between
each lower pair of columns is a round-arch niche with a rectangular
cartouche above it; between each upper pair of columns is a window with
a triangular pediment. In the dome above the chapel entrances are tondi
which echo the circular plan and contrast with the vertical membering.
There is no lantern, and the cupola has an open oculus at its crown, like
that on the Pantheon (the *Ritratto di Roma moderna* of 1634 refers to the
model as a 'somiglianza della Ritonda'[23]). The elevation of the dome is
hemispherical; whether it had exterior ribs cannot be seen from Dosio's
drawing. The one entrance that is clearly shown, contrary to the
surviving plans, is an arched portico with columns.

An engraving made by Le Mercier in 1607 (Pl. 130)[24] shows a number
of changes in the interior of the dome, such as the addition of ovals and
rectangles to the tondi. Its greatest value, however, lies in its clear
presentation of the exterior elevation, which seems to correspond to

that of the final model.[25] The surrounding chapels are membered with
single and paired pilasters which carry the attic, above which the barrel
vaults of the chapels, of varying heights, are visible. The drum, inde-
pendent of its exterior elevation, has rectangular windows; the ribless
hemispherical dome rests on a stepped base – also a feature of the
Pantheon – and is crowned by a lantern. In contrast to the interior,
the outer elevation is dominated by horizontals, a feature matched by
the self-containedness of the dome elevation and the absence of ribs.

The small windows of the lantern admit a diffused light into the dome,
while direct light shines in through the shaft-like windows in the drum
(these windows are of a kind first used by Michelangelo in the Medici
Chapel). The chapels are illuminated by their own windows.

A similar engraving to that of Le Mercier is one done by Valérien
Régnard in 1684.[26]

These copies of Michelangelo's model reveal that there was hardly
any correspondence between the interior and the exterior. The interior
is governed by vertical forces stretching from the base to the dome, and
the only counterbalance lies in the interchange of circular, oval and
rectangular cartouches on the interior of the dome (not found in Dosio's
drawing); the drum has virtually no independent significance. Extern-
ally, on the other hand, horizontal dimensions predominate; the drum
is sharply distinguished from the dome, and there is an almost ascetic
restraint in the use of ornamentation.

The designs for S. Giovanni dei Fiorentini were made a few years
after the model of the dome of St Peter's, but whereas Michelangelo
eventually adopted a hemispherical dome for St Peter's only after long
hesitation, for S. Giovanni he seems to have decided on it from the
beginning. At the same time, unlike his dome for St Peter's – but in
common with Bramante's – he has done away with the external ribs.
Again we encounter the feature of Michelangelo's late style which lies
in his urge to contain the soaring forces of the interior within the con-
fines of a firm profile. Only in the pilaster membering of the chapels does
the vertical principle assert itself. Unlike St Peter's, where he was
restricted by earlier plans, Michelangelo here holds the balance between
the forces of restraint and the forces of freedom in a spirit, not of tension
but of reconciliation.

Chapter 19

S. Maria degli Angeli[1]

In 1541 a Sicilian priest called Antonio del Duca, rector of the church of S. Angelo in Palermo, was inspired by a vision to go to Rome and spread the cult of the worship of the angels which was widespread in Sicily. His plea to Pope Paul III that the Baths of Diocletian be made available for this purpose was refused,[2] but in the Holy Year of 1550 Pope Julius III gave his consent. Fourteen altars were installed, seven to the angels, seven to the principal martyrs; the great frigidarium became the nave, with the chapels to the angels on the north and those to the martyrs on the south. The vaulted areas at the sides were also incorporated. The entrance was at the west end, the main altar at the east. In this initial form, however, it was more a makeshift adaptation of a classical building for Christian purposes than an architect-designed structure, and in 1551 the altars were dismantled.

Ten years later Duca's plea met with the approval of Pope Pius IV, who was making plans for a street to run from the Palazzo Venezia to the Via Nomentana, on which the Porta Pia was to stand. Having called on Michelangelo to submit plans, the Pope issued a bull on 27 July 1561 assigning the Baths to the Carthusian Order for the construction of a church and a monastery. On 5 August 1561, in the presence of nineteen cardinals and almost all the magistrates of the city, he laid the foundation stone under the altar. Michelangelo, now eighty-eight years old, embarked on the construction; in 1565 it was made a titular church and in 1566, two years after Michelangelo's death, the first mass was read there.

Michelangelo's task was to convert a pagan building into a Christian church, yet to preserve as much as possible of the original fabric. The tradition of such conversions in Rome includes the Pantheon (remodelled as S. Maria Rotonda), the Tomb of Constantia (S. Costanza) and the Temple of Antoninus and Faustina (SS. Cosmas and Damian). The marble inscription in the apse of the new church reads: 'Quod fuit idolum nunc templum est Virginis. Auctor est Pius ipse pater. Daemones

aufugite.'[3] But it was not until the sixteenth century that an under-standing of classical architecture developed which showed itself in an urge to preservation. The papal Act of Concession to the Carthusians expressly stipulated that the new building should not only serve the needs of the Christian religion but also preserve the memory of the Baths and be an adornment to the city of Rome.[4]

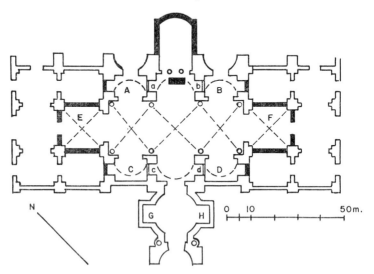

m S. Maria degli Angeli, Rome. Ground plan (after Herbert Siebenhüner).

A drawing of the south wall of the frigidarium made by Dosio in about 1565 (now in the Uffizi)[5] shows the building before Michel-angelo's reconstruction: a large hall, with vaults rising from colossal columns, opening into barrel-vaulted side-chambers. The idea of con-verting this hall into a church seems to have already been mooted in the 1520s, as we can see from drawings of the north wall by Giuliano da Sangallo and Baldassare Peruzzi,[6] which seem to be concerned to reduce the gigantic scale of the Baths to human proportions. The side-chambers are now enclosed. 'As in the Baptistery in Florence, we find the motif, taken from the Pantheon, of columns standing immediately in front of a wall and joined by an uninterrupted cornice.'[7] A chancel, its altar set round with tabernacles, occupies the central one of these side-chambers, and there are side-entrances at the east and west ends. The rectangularity

234

of the Roman hall remains: Sangallo worked from the exterior walls inwards, not vice versa.

Michelangelo, on the other hand, sought to incorporate the huge classical hall into his own spatial conception (Pl. 131). He dispenses with Sangallo's wall-membering and retains the classical proportions and undecorated vaulting; he also retains the monolithic columns of Egyptian granite with their capitals and buttresses, and the transverse walls lead into the large side-chambers, as in classical buildings.

But the new Christian purpose of the building also compelled Michelangelo to make alterations. He walled in the vestibules at the east and west ends and placed portals at their entrances. The southern entrance rotunda – the old tepidarium – served as the principle vestibule: Vasari calls it 'una entrata fuor della opinione di tutti gli architetti' ('an entrance beyond the judgment of all architects').[8] Duca had envisaged a longitudinal nave with entrance in the west and high altar in the east,[9] but Michelangelo retained the original cross-axis form,[10] turning the old chamber on the north side leading from the great hall to the natatio into a *cappella maggiore*, with the altar at the front. Since the Carthusians required a private choir, he built in the area of the Roman natatio a new semicircular chancel behind this *cappella*, isolated from it by two columns preserved from the ancient Baths. This columnar screen provided the privacy required, but the choir was opened to view after S. Maria degli Angeli was declared a titular church in 1565.

Diocletian's great frigidarium (Fig. m) had been the centre of a symmetrical architectural scheme; its accesses to the side-chambers were open to the sky, and it was evenly lit by the large three-bay windows and through the passages to the chambers. Michelangelo sets the hall apart, does away with the open-plan conception and creates a closed precinct for the celebration of the Christian rite; the even lighting from the sides is replaced by the illumination of the vaults through the high-placed windows, which gives the building its specifically religious character.

S. Maria degli Angeli was yet one more of Michelangelo's projects to remain unfinished. Under Pius V (1566–72) work slowed down and finally stopped altogether; under Gregory XIII (1572–85) symmetrically placed chapels were added on the north-south axis.

The present-day church owes its form basically to the alterations

made in the eighteenth century (Pl. 132). In 1700 the west vestibule was closed and made into the Chapel of S. Bruno; in 1746 the east vestibule was turned into the chapel of S. Algardi.[11] The four chambers on the north and south sides of the main hall, whose round arches Michelangelo had incorporated with the central nave, were completely blocked off, and large altar paintings from St Peter's set on the walls. In 1749 Luigi Vanvitelli embarked on a major programme of renovation: to the classical granite columns he added six brown-and-white mottled pilasters and an ornamental classicistic cornice extending the entablature throughout the church, replaced the rotunda lantern and possibly also the main altar, and covered all parts of the church except the vaults of the main hall with highly decorated stucco-work. The volutes embracing the outer bays of the portal were added some time before 1703; the classical triple windows had already been reduced in size in the seventeenth century. Windows with low segmental pediments, as in the aisles designed by Maderna for St Peter's, were added in the passages leading to the choir, the chapels of St Bruno and St Algardi, and the vestibule. Between 1763 and 1794 Michelangelo's chancel was extended and renovated, and a polygonal apse added, following Vanvitelli's earlier plan. The church as it now stands was virtually complete by the end of the eighteenth century.

Cappella Sforza[1]

Among Michelangelo's late architectural projects in Rome is his design for the funerary chapel of Cardinal Guido Ascanio Sforza in the left aisle of the early Christian basilica of S. Maria Maggiore, to the left of Flaminio Ponzio's large Cappella Borghese of 1611. It is a kind of late variation on the theme of the Cappella Medicea. Vasari writes: 'Michelangelo also procured for Tiberio [Calcagni] the commission to finish under his direction a chapel for Cardinal Santa Fiore in Santa Maria Maggiore; but this remained unfinished because of the unhappy death of Tiberio himself, as well as of the cardinal and Michelangelo.'[2]

Tiberio Calcagni, who had also helped Michelangelo in preparing the two designs for S. Giovanni dei Fiorentini, became the master's assistant in 1556 but died in 1565, so the Cappella Sforza must have been started during this period; it was finally completed by Giacomo della Porta, whose style is apparent in the altar and the tombs. The façade was removed in 1748 but the exterior elevation can be seen in a seventeenth-century drawing by Lieven Cruyl.[3]

As with S. Giovanni dei Fiorentini, the final form of the chapel (Pl. 133) is the product of extended planning. Many sketches have survived which show us how frequently Michelangelo concerned himself in his late years with the problems of central-plan structures, and from these we can see how, starting with simple forms, he developed ever more complicated solutions.[4]

Of the various drawings connected with the Cappella Sforza only those on one particular sheet, in the Casa Buonarroti (Dussler No. 132),[5] seem definitely to represent an early stage in the design. One of these studies shows the basic idea of the chapel: there is an outer rectangle with a projecting apse for the altar chapel and two exedras at the sides; in this rectangle the four points of a square crossing are each marked by a column in front of a pier, and entrance vestibule, tomb-chapels at the sides and altar-chapel opposite the entrance are built outwards from these points. A *pentimento* on the left shows that from the beginning

Michelangelo considered having sloping walls and linking the crossing and the apses by means of a second column. Whether the outer rectangle was meant to enclose some larger complex we cannot say.

The final design (Fig. n)[6] allows the thought behind the *pentimento* to penetrate all the basic forms present – square, circle and Greek cross. Apses are developed from the segments overlapping the sides of the central crossing, and the diagonal setting of the piers and columns adds the motif of the St Andrew's cross. A second column is set in each of the lateral apses, and opposite the entrance is the rectangular choir, approached by two rising steps and with the altar against the rear wall.

The dominant feature of the interior is the diagonally set column-plus-pier clusters (Pl. 134) that support the balloon vault. A socle zone, between five and six foot high and profiled at the top and the bottom, runs right round the walls, columns and piers, and the pilasters stand on

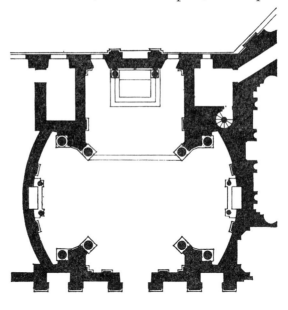

n Cappella Sforza in S. Maria Maggiore, Rome.
Ground plan (after James Ackerman).

this socle – one on either side of the entrance door, abutting applied pilasters in the corners (in the manner first found in the vestibule of the Biblioteca Laurenziana and later in the exterior of St Peter's), one on either side of the tombs in the side chapels – as though drawing the various sources of energy towards the centre – and one on either of the longitudinal sides of the altar-chapel. The Corinthian capitals (Pl. 135) rest on a narrow moulding, and above them runs a broad, mitred cornice that matches that of the socle. The various parts of the building combine to form a unified whole.

The pilasters in the tomb-chapels (Pl. 136) are continued into the vault by tapering ribs that meet at a point invisible from the centre of the chapel; thus a movement towards the summit is added to the above-noted movement towards the middle. There are rectangular blind windows flanking the tombs and a central splayed window with pediment in the centre of the vault (cf. the Medici Chapel); rectangular windows – later walled up – above the doors in the altar-chapel (Pl. 137) correspond in height to those in the side-chapels.[7] Two windows, one above the other, appear to have been added at each side of the altar in the course of the seventeenth century but not opened until the eighteenth century; in the vault of the altar-chapel is a broad splayed tabernacle window, matched by a similar window in the entrance wall.

Originally the lighting came from the windows on all four sides, emphasizing the centre, but when buildings rose on the outside of the chapel, the light from the side-chapels was cut off, and today most of the illumination comes from the altar-chapel, which gives greater prominence to the longitudinal axis than Michelangelo's plan had envisaged.

The cardinals' tombs are placed in the centre of the two side-chapels: on the right is that of Guido Ascanio Sforza, founder of the chapel, who died on 7 October 1564, and on the left, erected some time before his death in 1582, that of his brother Alessandro. Neither design is related to Michelangelo's.

It is not certain whether, as in the Medici Chapel and S. Giovanni dei Fiorentini, a dome was to have crowned the crossing, though the above-mentioned sketch in the Casa Buonarroti makes it seem likely. If so, the altar-chapel, with its wide tabernacle window and its accentuation

of the longitudinal axis, could only have been planned after the idea of a dome had been abandoned. What we now have is Michelangelo's highly unusual solution in the form of a balloon vault, without drum, similar to that used by Brunelleschi for the Foundling Hospital in Florence. The arches rise from the cornice but are then flattened and meet along the lines of the crossing below, thus accentuating again the basic square, despite the pull towards the diagonals. The form of the vault also recalls the arches of the Sala Grande in the Palazzo Farnese and those of the Ponte Trinità in Florence,[8] for which latter Michelangelo made sketches in 1560. The altar-chapel has a barrel vault, with a transverse arch above the pilasters of the side-walls.

For all the subtleties and complications of the Cappella Sforza, it is the central square that dominates the plan. The jutting pilasters and columns, the walls of the side-chapels that seem to retreat behind the columns, the contrast between diagonal and orthogonal axes – these features, however, give the chapel a sense of tension which no reproduction or photograph can convey. In addition there is the contrast between the pilasters and Corinthian orders on the one hand and the linearity of socle, cornice, ribs and windows on the other. The grey walls and white ceiling and columns add to the religious atmosphere, and the whole chapel is an outstanding example of that subjectivity that characterizes the whole of Michelangelo's architecture. It is but a short step to his final works – the *Rondanini Pietà* and the last drawings – and the influence of the Cappella Sforza on baroque art, in particular on Borromini's designs for S. Carlo alle Quattro Fontane and S. Agnese in the Piazza Navona, is patent. In 1748 Giovanni Bottari, who tried to prevent the destruction of the façade of the chapel, wrote in a letter: 'No vi sembra di vedere una cosa vera, ma un' idea astratta o figurata col pensiero o veduta in sogno di un edificio il più singolare e magnifico, e che sorpassi le forze del pensiero umano.'[9] ('You seem to see, not something real, but an abstract idea, either elaborated in the mind or seen in a dream, of a most remarkable and splendid building that would surpass the power of human thought.')

When Michelangelo died, none of his buildings in Rome, religious or secular, was yet finished. Bruno Zevi called Rome *un non-finito michelangiolesco*.[10] Yet Rome today is as it is largely because of Michelangelo.

Chapter 21

Pietà in Florence – *Rondanini Pietà* – last drawings

A medal minted by Leone Leoni in 1560-1 has on the obverse a likeness of Michelangelo and on the reverse a blind wanderer with the features of the old master leaning on a stick and groping his way forwards, guided by his dog. The inscription (Psalm 51:13) reads 'Docebo iniquos ut et impii at te convertantur' ('Then will I teach transgressors thy ways; and sinners shall be converted unto thee').[1] Both the motif – which appears to derive from a lost drawing of Michelangelo's – and the inscription may be seen in autobiographical terms. The loneliness of these last years in his shabby quarters by the Macello dei Corvi, opposite S. Maria di Loreto, is expressed in a bizarre, bitter poem:

> I' sto rinchiuso come la midolla
> De la suo scorza, qua pover' e solo,
> Come spirto legat' in un' ampolla:
>
> E la mia scura tomba è picciol volo;
> Dov' è Aracn' e mill' opre e la lavoranti,
> E fan di lor filando fusaiulo.
>
> (I feel constrained and blocked as in the marrow
> Into its bone, right here, so poor and lonely,
> And as some spirit in a vial narrow.
>
> And this grave-dungeon is so small that only
> Arachne dwells with webs and all her clients,
> Each hardly finding room to spin so cunningly.)[2]

Halfway up the staircase of his house was a painting of Death as a skeleton with a coffin on its back. Underneath were the lines:

> Io dico a voi, ch' al mondo avete dato
> L'anima e 'l corpo e lo spirito 'nsieme:
> In questa cassa oscura è 'l vostro lato.

(I say to you, who to the world have given
Body and soul and heart and everything:
In this dark coffin lies the rest of you.)[3]

Virtually the sole subject of Michelangelo's last sculptures is the Passion, portrayed, not as an historical event but as the vision of a man to whom it appears as a revelation in which he seeks an assurance of divine grace.

Scarco d' un' importuna e grave salma,
 Signor mio caro, e dal mondo disciolto,
 Qual fragil legno, a te stanco mi volto
 Dall' orribil procella in dolce calma.

Le spine, e' chiodi, e l' un e l' altra palma
 Col tuo benigno umil pietoso volto
 Prometton grazia di pentirsi molto,
 E speme di salute alla tris' alma.

Non mirin con giustizia i tuoi santi occhi
 Il mio passato, e 'l gastigato orechhio
 Non tenda a quello il tuo braccio severo.

Tuo sangue sol mie colpe lavi e tocchi,
 E più abbondi, quant' io son più vecchio,
 Di pront' aita e di perdon' intero.

(Unburdened by the body's fierce demands,
 And now at last released from my frail boat,
 Dear God, I put myself into your hands;
 Smooth the rough waves on which my ship must float.

The thorns, the nails, the wounds in both your palms,
 The gentleness, the pity on your face –
 For great repentance, these have promised grace.
 My soul will find salvation in your arms.

And let not justice only fill your eyes,
 But mercy too. Oh temper your severe
 Judgement with tenderness, relieve my burden.

Let your own blood remove my faults and clear
My guilt, and let your grace so strongly rise
That I am granted an entire pardon.)[4]

Thoughts of reconciliation, of gentleness, of stillness now prevail. A dualism had sustained the whole of Michelangelo's art – the dualism of reality and ideality, of the temporal and the eternal; his figures had first struggled against invisible forces, then succumbed to them. Now he seems to sense his conquest of this dualism, as though he were standing before the gate that leads from this earthly prison to the region of divine freedom and peace beyond.

These last sculptures and drawings are expressions of the moments of illumination in which he feels the presence of God's grace. His poems, on the other hand, reflect right to the end the agonies of fear and struggle:

Vivo al peccato, a me morendo vivo:
vita già mia non son, ma del peccato:
mie ben dal ciel, mie mal da me me' è dato,
dal mie sciolto voler, di ch' io son privo.
Serva mie libertà, mortal mie divo
a me s' è fatto. O infelice stato!
a che miseria, a che viver son nato!

(Alive to sin, I live to death alone;
Being of sin, my life I cannot claim.
All good from heaven comes, from me all blame;
Swept by my will, no will at all I own.
Freedom a slave, mortality has grown
Into a god in me. O woe! O shame!
Into what wretched life, through birth, I came.)[5]

Once Vasari was sent by Julius III at the first hour of the night to Michelangelo's house to fetch a design, and he found Michelangelo working on the marble *Pietà* that he subsequently broke. Recognizing who it was by the knock, Michelangelo left his work and met him with a lamp in his hand. After Vasari had explained what he was after, he sent Urbino upstairs for the drawing and they started to

discuss other things. Then Vasari's eyes fell on the leg of the Christ on which Michelangelo was working and making some alterations, and he started to look closer. But to stop Vasari seeing it, Michelangelo let the lamp fall from his hand, and they were left in darkness. Then he called Urbino to fetch a light, and meanwhile, coming from the enclosure where he had been working, he said: 'I am so old that death often tugs my cloak for me to go with him. One day my body will fall just like that lamp, and my light will be put out.'[6]

The work referred to in this story is the *Pietà* now standing in the Duomo in Florence (Pl. 138).[7] Michelangelo began work on it in the late 1540s and it was still in progress in 1553. In 1555 he abandoned the whole idea and broke up the figure because, it seems, of faults in the marble and because Christ's left leg had broken off. Francesco Bandini acquired the group in 1561 and had Tiberio Calcagni restore it after Michelangelo's model, but with the death of Bandini, Michelangelo and Tiberio, according to Vasari, the work was left uncompleted. For many years it stood in Pier Antonio Bandini's vineyard on the Quirinal Hill, after Vasari had tried in vain to have it transferred to Michelangelo's tomb in S. Croce in Florence. In the seventeenth century it was finally taken to Florence; originally it was intended for the Medici Chapel but it was first erected in S. Lorenzo, then, in 1722, in the Duomo, where it stood behind the high altar. Since 1933 it has stood in a chapel in the north transept. In his *Life of Bandinelli*[8] Vasari says that it was Michelangelo's wish to be buried in S. Maria Maggiore at the foot of this group, and in a letter of 18 March 1564[9] to Michelangelo's nephew Lionardo, Vasari explicitly states that the figure of the aged Nicodemus was a self-portrait.

Calcagni's restoration took in Christ's left and right forearms, except for the hands, part of Christ's breast and the fingers of Mary's left hand. The kneeling figure of Mary Magdalene has been completely reworked but the figures of Nicodemus and the Virgin, and much of the Christ, have not been touched and remain unfinished. The chisel-work of the late Michelangelo is particularly striking: 'Extensive gradine scoring and pointed chisel-work are found side by side. The small-scale chiselling is perhaps not as precise as before but the master's power of

representation is as strong as ever.'[10] The expressiveness of the unfinished figures of Nicodemus and Mary overshadows that of the completed Magdalene.

The missing left leg of Christ remains a mystery. We know only that it existed and that it lay across the Virgin's thigh.[11] Perhaps it is in some way connected with Michelangelo's abandonment of the project.

Condivi writes:

> In a beautiful movement the Virgin holds the body between her arms, her knees and her breast, while Nicodemus, a firm, upright figure, assists her by gripping Christ under the arms. The Magdalene, for all her sorrow, is lost in an act of worship in which the Virgin, overcome by grief, cannot join. The lifeless figure of Christ hangs limply in His Mother's arms but in a very different position from that of the *Pietà* drawing for Vittoria Colonna and that of the marble *Pietà* in St Peter's. The beauty and the emotions conveyed by the suffering, sorrowful figures, above all by the Virgin, are beyond description.[12]

As in the drawing for Vittoria Colonna, the concept of the Man of Sorrows is at the centre of the Florentine *Pietà*, a concept, traceable in Italian art back to the thirteenth century, which combines with those of the descent from the cross and the lamentation of the Virgin.

The arrangement and the rhythm of the figures have a remarkable richness. Mary sits at one side while the Magdalene kneels at the other; the exhausted Christ, His body twisted, His countenance wracked in pain, has collapsed. Behind them, leaning slightly forward, is Nicodemus, who brings the double motif of supporting and embracing. The figures themselves, on the other hand, show the increasingly abstract quality of Michelangelo's final works. The sagging figure of Christ, held within the arc of His right side, with this arc accentuated by the parallelism of right arm and right leg and by the twisted left arm (cf. Michelangelo's early *Madonna of the Stairs*), is the central and dominant motif, and Mary is so close to Him that their heads, even their bodies, can hardly be separated. Nicodemus' left arm also holds them together, as does his pitying gaze.

The right arm of the Magdalene, on the other hand, contradicts this

outward movement, and her figure, framed between the right arm and leg of Christ, scarcely retains an independent plastic quality. The tall form of Nicodemus turns his body in parallel with Christ and stands at the apex of the group. As an exercise in the accommodation of spatial tensions within an absolutely strict profile, the Florentine *Pietà* goes far beyond the drawing for Vittoria Colonna.

The expression aims at simplicity and humanity. The dominant motifs are those of collapse, embrace, support, loving devotion and sorrowful compassion.

In the self-portrait of Nicodemus we may wonder whether Michelangelo had in mind the Nicodemus who was the legendary sculptor of the famous Volto Santo in Lucca, or the Nicodemus, 'a ruler of the Jews', as St John calls him, who came to Jesus by night in search of the truth.[13]

The subsidiary figure of Mary Magdalene draws the beholder into the scene and evokes his compassion. But the action of the group itself belongs to a sphere to which the beholder has no access.

The wealth of movement and expression in the group is such that it can be viewed from different angles, but only the frontal aspect, as indicated by the line of the base, allows its sharp profile and linear subtlety to fully manifest themselves. To view the group from the right, for instance, looking straight at Nicodemus, is to lose essential elements of the figure of Christ – though the Virgin's face gains in this aspect, which is also the only point from which the left supporting arm of Nicodemus becomes clear.

The fusion of the motif of the Man of Sorrows with those of the Virgin's lamentation and the descent from the cross is found in Italian art before Michelangelo: earlier examples include panel paintings by Giovanni da Milano (Florence, Accademia), Fra Angelico (Munich, Alte Pinakothek), Cosimo Rosselli and Jacopo del Sellaio (Berlin, Staatliche Museen), and a drawing by Andrea del Castagno (Uffizi).[14] But Michelangelo's group is distinguished from these earlier works above all by the intensity with which the reality of Christ's death is expressed. The sagging figure also seems to have been influenced by late medieval northern representations which first appear in France in the second half of the fourteenth century. Particularly close to Michel-

angelo, for instance, is a painting of the Holy Trinity by Robert Campin, now in the Städel Institute in Frankfurt.[15]

This change of direction in Michelangelo's late works from the values of classicism to the values of the Middle Ages is not fortuitous. Moreover it is shared by the anti-classical movement of Mannerism, which, as the Florentine *Pietà* shows, both influenced and was influenced by Michelangelo. A striking example is *The Descent from the Cross*, painted in the early 1540s – i.e. before Michelangelo's group – as an altar-piece for the church of S. Giovanni Decollato in Rome by the Florentine artist Jacopino del Conte, a pupil of Andrea del Sarto, which reveals the influence of the early Florentine Mannerism of Pontormo and Rosso. One need only observe the line of Christ's right side and the weightlessness of His body to realize the connection between the two works.[16]

At the same time there is a profundity in Michelangelo's work which shows the enormous gulf that separates him from Jacopino del Conte and the whole of Mannerism. He has none of the weary, dispirited, pathological, formalistic qualities of Mannerism – nor has he any of its elegance. His art remains heavy, powerful, with a tragic intensity, an art of supreme intellectual vigour and health.

In spite of the gulf that seems to lie between Michelangelo's late works and the works of antiquity, classical motifs of form and the power of classical plastic values retain their hold on him to the end. The Christ of the Florentine *Pietà* reminds one again of the figure of Patroclus in the Menelaus group: the body twisted to one side, the sharp angle of the right leg, the drooping head, the left arm twisted from the shoulder – these are features which have a plasticity alien to the Middle Ages but proper to antiquity. One may also recall the group known as the *Farnese Bull*, which had been rediscovered in 1545 and already played a part in the composition of Michelangelo's fresco *The Crucifixion of St Peter*. Could this have stimulated him to carve the subject of the *pietà* out of one monumental marble block? The two works have a remarkable similarity in profile and in their wealth of contrasting rhythms. This would also provide a *terminus post quem* of 1545 for the beginning of Michelangelo's work on the Florentine *Pietà*.[17]

Michelangelo's last sculpture is the unfinished so-called *Rondanini Pietà* (Milan, Castello Sforzesco; Pl. 139), a smaller group. Mary is

standing on a stone, supporting the lifeless but upright figure of Christ. Her left hand grips His left shoulder, and her right, barely visible, seems meant to have rested on His head. His left arm hangs limply against her left thigh; His right arm probably lay above her right knee. The whole of the back of the group is only roughly done. The polishing of Christ's legs and His missing right forearm belong to an earlier version of the work which Michelangelo must have destroyed, as does also the polishing of Mary's left thigh. Similarly the forehead and hair-line of another figure of Christ – above and to the right of the present figure – together with the forehead, nose and eyes of another Mary – also above and to the right – apparently belong to the first stage of an unfinished second version, also rejected and mutilated. Christ's face has been broken off and there was hardly enough stone left from which to carve another; the body has also had too much stone cut away. As Dagobert Frey puts it: 'In this condition the *Pietà* was an utterly ruined block. Yet Michelangelo, in a wild, despairing effort, tries again to make it express his ultimate artistic vision; with a few blows of hammer and chisel he strikes once more at the hollowed-out marble before him, giving life to nose and eyes and mouth.'[18]

Having described Michelangelo's Florentine *Pietà* and its history, Vasari writes: 'It was now necessary for him to find another block of marble, so that he could continue using his chisel every day; so he found a far smaller block containing a *Pietà* already roughed out and of a very different arrangement.'[19] This makes it clear that the first version of the *Rondanini Pietà* precedes the Florentine *Pietà*, though when Michelangelo destroyed it, we cannot tell. As is also apparent from Vasari, he only resumed work on it after abandoning the Florentine *Pietà* and was still occupied on it a few days before his death. 'I forget whether I also mentioned', wrote Daniele da Volterra to Michelangelo's nephew Lionardo, 'that he stood and worked on the body of Christ for this *Pietà* throughout the whole of the Saturday before Carnival Sunday [12 February 1564.]'[20] Five days later he died.

Like that of the Florentine *Pietà*, the spiritual history of the *Rondanini Pietà* begins with the *Pietà* drawing for Vittoria Colonna, or even with the 1516 design for the tomb of Pope Julius. A *pietà* in vertical format first appears in a badly mutilated drawing in the Teyler Museum in

Haarlem (Dussler No. 300).[21] Christ is lying against the shoulder of a youthful Mary, her left arm encircling His breast, her right arm holding Christ's right arm. The setting of the two figures one behind the other shows the connection with the Vittoria Colonna drawing, but the Haarlem sketch shows for the first time the motif of the standing figure of Mary supporting the body of her son, as well as the motif of the sideways drooping head of the dead Christ. But the individuality of the figures remains.

Of particular interest for the history of Michelangelo's works on the theme of the *pietà* is a set of chalk sketches in the Ashmolean Museum in Oxford (Dussler No. 201; Pl. 140).[22] Two of the five studies are of the entombment, the other three of the *pietà*. The former are variants of the Vittoria Colonna composition; the latter, by linking the Colonna composition with the motif of the Haarlem sketch, introduce a new principle.

The most important of these sketches is the right-hand one of the two groups on the left of the sheet. The dominant motif is that of the mother embracing her Son. In Christ there is a counterpoint between the movement of His legs, which are bent to the right, and His torso, which is inclined to the left, and this counterpoint is a feature of Michelangelo's earlier style, but the sketches on the extreme left and right of the sheet have given up this counterpoint. It is only a step from these sketches to the first version of the *Rondanini Pietà* as reconstructed – albeit not in every precise detail – by Arno Breker.[23] Here we can see how little Michelangelo is now concerned with the causality of the events he portrays. The heads, altered in the sculpture many times, as also in the Oxford sketches, retain a dramatic quality, but the two figures are bound together in a symbolic relationship that exists beyond the boundaries of time and space.

This residual dramatic element disappears altogether in the final stage of the second version. The parallel movement of the two bodies is almost complete: the bodies merge, the heads turn the same way, the eyes are cast down. There is now only one composite theme, and we are witnesses of how Michelangelo struggles to give visible expression to this theme, sacrificing what he had already finished yet never achieving the complete fulfilment of his vision.

The second version shows a striking change in its proportions. Christ is thin, with narrow shoulders, almost a phantom figure. Nothing remains of the ideal quality that is still present in the Florentine *Pietà*. We are at the limits of what can be expressed in sculpture, and the individuality of nature, which used to have an absolute validity for Michelangelo, now counts for nothing. Form has become pure spirit, and the concept of completion has become unreal. Even that closeness to the marble block which used to be so characteristic of him has now become irrelevant, and if one takes away Christ's right arm remaining from the first version, which still shows its derivation from the block, what is left is little more than an ideogram.

The proper aspect of the group is probably that which, like the sketch on the extreme left of the Oxford sheet, allows Mary's left leg to be seen. This is the only firm point in the group; the rest seems weightless and unstable.

Like the Florentine *Pietà* this last sculpture of Michelangelo's bears witness to his return to the Middle Ages, and one may assume a link between the first version and Robert Campin's *Holy Trinity* – itself a copy of a sculpture – or some comparable work from northern Europe. One need only refer to the right arm and the legs of Christ, and note the diagonal aspect of the group as a whole, to see the similarity. The changes made for the second version – the adoption of a more erect form for the head and torso of Christ, and the twist of the body from the front to the side – lead away from these early models and restore the emphasis on the old concept of the embrace of Mary and the Man of Sorrows.

Antiquity now seems a long way off. The restricted dimensions, the avoidance of any semblance of plastic display, the weightlessness, the abstract, symbolic quality – all this is foreign to the classical world. Yet in this, his last sculpture, Michelangelo comes face to face with Phidias, the greatest sculptor of antiquity. There is a mysterious kinship between the *Rondanini Pietà* and the group of the sisters with their dying brother from Phidias' Niobe sculptures.[24]

In the last period of his life Michelangelo also did a series of seven independent drawings on the subject of the Crucifixion (Pls. 141–5). They are attempts to see Christ's act of redemption through the eyes of

the spirit, so to speak – expressions of an urge to find grace through the depiction of the contemporary significance of the theme, and the mass of copies made from these drawings shows that they had not only an aesthetic but also a devotional influence.

The dating of these sketches, like their internal chronology, is uncertain,[25] but one should probably put them as late as possible, and certainly later than *The Crucifixion of St Peter*. Christ's Crucifixion is depicted as a mystery, with Mary and John as representatives of mankind, for whose sake the sacrifice was made, and we are meant to identify ourselves with these two figures. Both are completely untraditional, and as the various drawings differ considerably among themselves, we find ourselves witnessing Michelangelo's struggles to find the appropriate form of expression for the feelings of mankind – guilt, repentance, mourning, and ultimately a childlike sense of security and protection – in the face of the sacrifice of the Son of God.

First we may examine the charcoal sketch in the Louvre (Dussler No. 211; Pl. 141),[26] probably made after 1550. Christ, His arms raised high above His head, is nailed to the cross. The *pentimenti* show that the upright arms are the result of several different attempts to give expressive meaning to this particular motif, and Christ's head was originally somewhat higher. The frontal figure of the Virgin turns her head towards the cross, holding her cloak in her left hand, while her right arm hangs down in a gesture of grief. John approaches from the back, his head bent forward. Stylistically the drawing is related to the frescoes in the Cappella Paolina, especially *The Crucifixion of St Peter*.

Closely akin to this drawing, as evidenced particularly by the *pentimenti*, is a charcoal sketch in the British Museum (Dussler No. 174; Pl. 142).[27] Yet here we see Michelangelo looking for new moments of expression. Instead of a right-angled cross he now uses a forked cross of Duecento type – similar to that in the *Pietà* for Vittoria Colonna – in order to bring Christ's arms and the arms of the cross closer together. Mary and John have turned to face the cross; Mary's arms are folded in the manner first encountered in the interceding figure of the Virgin in the *Last Judgement*, while John gazes sorrowfully into the distance.

A pencil drawing in Windsor Castle (Dussler No. 243; Pl. 143)[28] shows a return to the right-angled cross. The *pentimenti* show how

Michelangelo tried three different ways in the figure of Christ to give the most powerful expression possible to the motif of the crucified Redeemer. Mary and John stand trembling. Mary's arms are folded, as in the British Museum drawing, and she rests her head pensively against her right arm in fear and sorrow; John raises his head to Christ and, in a new motif, lifts up his arms in terror yet also in surrender. In both these figures Michelangelo seems to be seeking to express man's consciousness of his guilt.[29]

The same form of the cross is adopted in a charcoal sketch preserved in the Ashmolean Museum in Oxford (Dussler No. 204; Pl. 144).[30] Here Christ slumps forward from the hips. The positions of Mary and John below the cross are reversed; Mary – if it really is Mary – holds her head in her hands in agony and despair, as though to ward off the pain of a tragedy she cannot understand; John – if it really is John – wears the expression of what Tolnay has called 'a murderer tormented by his conscience'.[31] All this is a remarkable departure from traditional concepts. It is a personal expression of Michelangelo's feelings of guilt in the face of the crucified Lord. Stylistically it again recalls *The Crucifixion of St Peter*.

Probably the last of these drawings, and certainly the freest treatment of the theme of the Crucifixion, is a chalk sketch in the British Museum (Dussler No. 175; Pl. 145).[32] Christ turns His head in a movement of love, and Mary and John clasp the cross below. The theme is no longer guilt, repentence or pain but childlike trust, consciousness of grace and the heavenly protection afforded by the Redeemer's outstretched arms. Dussler points to the vesper hymn for Passion Sunday, 'Vexilla regis', and the words 'O crux, ave, spes unica'.[33] Michelangelo has found peace at the end:

> Nè pinger nè scolpir fia più che quieti
> L' anima volta a quell' Amor divino
> Ch' aperse, a prender noi, in croce le braccia.

> (Painting and sculpture cannot any more
> Quieten the soul that turns to God again,
> To God who, on the cross, for us was set.)[34]

A sketch in the Casa Buonarroti[35] suggests that Michelangelo considered a sculpture on the subject of the Crucifixion during his last years.

In addition to the theme of the Crucifixion Michelangelo was exercised in his final years by the themes of the Annunciation and the Mount of Olives. The earliest of his drawings on the Annunciation, dating from the period of his friendship with Vittoria Colonna and perhaps inspired by one of her sonnets, is a composition known from a copy by Marcello Venusti in the Old Sacristy of S. Giovanni in Laterano,[36] and from an engraving by Nicholas Beatrizet. These reveal a dramatic presentation of the event in the style of the *Last Judgement* yet within the framework of tradition: the angel has burst into the room, and Mary, standing by her prayer-desk, seems to shrink back yet also to eagerly receive the divine message.

Subsequently Michelangelo turned towards a spiritual presentation of Mary's realization of the meaning of the event. The most fully developed, and probably the latest, of the drawings in this mould is a chalk drawing in the Ashmolean Museum in Oxford (Dussler No. 205; Pl. 146),[37] made, as we know from an accompanying note by Michelangelo, after 1556. The angel, an imposing youthful figure, approaches from the right; Michelangelo first depicted him walking, then hovering above the Virgin. There is a free, relaxed air about the sketch: the forms are hinted at rather than made explicit, and the range of degrees of reality stretches from the comparatively firm lines of the Virgin to the light, ethereal features of the angel. She turns to face the angel as though she has been awaiting him; her left arm, resting on the prayer-desk, is stretched out as in welcome and almost touches the angel's right hand, while her right arm, half raised, follows the movement of her head.

The subject of the Mount of Olives also first appears in connection with Vittoria Colonna[38] and was perhaps suggested by her sonnet 'Quando 'l Signor nell' orto al Padre volto'.[39]

In the 1550s Michelangelo returned to the subject, and a number of sketches and copies have survived,[40] an oil painting by Venusti in the Galleria Doria in Rome being the best.[41] Christ is on the left, His eyes cast down, His hands raised in prayer; contrary to the tradition there is no angel and no cup. In a manner unusual for the sixteenth century

Michelangelo has drawn a second image of Christ on the right, facing the two disciples who are crouching on the ground – 'in gran sonno', as Vittoria Colonna's sonnet puts it; the third disciple rises as in a daze and leans towards Christ.

Various earlier pictures appear to have guided Michelangelo towards this composition. Thus the themes of prayer and the awakening of the disciples combined in a single scene occur in a related form in a mosaic in St Mark's in Venice[42] and in an even more closely related form in a Florentine panel in the Vatican Gallery.[43] Here too the disciples are shown in a closely knit group, but what in earlier works had been a mere agglomeration of elements becomes with Michelangelo a unified composition meant to be read from left to right. Christ, firm in profile, is frontally portrayed, serene and deep in prayer; a pychologically motivated gap separates Him from the events on the right of the scene. The real subject is not, it seems, the historical moment of Christ's call: 'Why sleep ye? Rise and pray, lest ye enter into temptation' (Luke 22:46), but the awakening of mankind – represented by the apostles – to faith, as conceived by the Italian reform movement.

Probably Michelangelo's last graphic work is his sketch in black chalk of a mother and child, preserved in the British Museum (Dussler No. 161; Pl. 147).[44] Is it Mary and the Christ-child? Or is it just a mother with her baby? A transparent veil covers her body, but it is not a question of representing the human form; rather it is as though the artist had had a vision of the primeval state before nature had received her shape. The form itself is firm, yet the drawing embraces an area of mystery within which form is subsumed. The mother stands with slightly bent knees and tenderly embraces the child, who clings to her. The standing position and the act of embracing have a basic quality shared by all creatures, but this quality is transfigured by the transparency of the figure and the delicacy of expression, which raise the composition to the realm of the ideal. Once again we find ourselves at the limits of the expressible. Michelangelo's last steps seem to lead into a dream land in which his suffering finds ultimate rest. It is the land of the new heaven and the new earth of which St John writes: 'And God shall wipe away all tears from their eyes; and there shall be no more death, neither sorrow, nor crying, neither shall there be any more pain; for the former

things are passed away.' (Revelation 21:4.) These last drawings show the artist of tragic mysteries as the herald of eternal bliss.

Michelangelo died in Rome on the evening of 18 February 1564 in his ninetieth year. Daniele da Volterra, Tommaso Cavalieri and Diomede Leoni of Florence were with him.[45] 'With perfect consciousness he made his will in three sentences, leaving his soul to God, his body to the earth, and his material possessions to his nearest relations. Then he told his friends that, as he died, they should recall to him the sufferings of Jesus Christ. And so . . . he breathed his last and went to a better life.'[46] He was buried in the church of S. Croce in Florence.

Conclusion

The Incomplete and the Uncompletable[1]

We have seen that Michelangelo's works of architecture are by no means the direct realization of preconceived ideas but are themselves part of a continuous creative process. The completion of the task was made the more difficult by external circumstances which brought frequent interruptions and forced him to make repeated fresh starts. The same is true of his sculptures. And when we are confronted by incomplete works we find ourselves asking certain questions. Did the block of marble prove unsuitable? Did a new commission prevent him from carrying out the old one? Did he change his ideas about the subject in the course of the work but find it too late to turn back? Is it just a matter of adding the missing parts in order to make complete what was left incomplete? Or is the incompleteness an integral part of the work – in other words, is it uncompletable rather than incomplete, and is to think in terms of completion to misunderstand the inner nature and value of the work? In this case are we therefore entitled to talk of artistic purpose, or have we to accept that Michelangelo is the victim of an ineluctable fate? Such are the questions left for us to consider.

In the case of *St Matthew* there are obvious external circumstances to explain why it was not finished and why none of the other eleven apostles was even started. He was working on too many projects at the time; then he was summoned to Rome, then came his journey to Bologna, followed by a further summons to Rome – indeed, it is remarkable that work even on this one figure progressed as far as it did.

Similarly it was mainly for known circumstantial reasons that work on the tomb for Pope Julius and the Medici Chapel dragged on over the years and was finally abandoned altogether. We know that this state of affairs caused Michelangelo considerable distress, and his own reference to the 'tragedia del sepolcro' makes it doubly clear.

In other cases we do not know the specific reasons why works were not completed, but this is not to say that there were none. The Floren-

256

Conclusion: The Incomplete and the Uncompletable

tine *Pietà* appears to have had flaws in the marble, and the left leg of the figure of Christ had broken off; the incompleteness in the figures of Christ, Mary and Nicodemus thus had external causes. In the case of the *Rondanini Pietà* he had put the work on one side but then gone back to it in the very last days of his life, only for death to intervene. Even if one concedes that the works of his final period are characterized by allusion and symbol rather than by direct statement, one cannot possibly accept the sketch-like group in its present condition as Michelangelo's last word. The faces of the two Marys and Christ's right forearm left from the first version are by themselves sufficient to prove this.

Yet however far such circumstantial considerations may take us, in Michelangelo we are facing one of the most powerful artistic minds the world has known, a mind that takes us into a realm where the thought of completeness is a restriction and an irrelevance, like the temporal in the face of the eternal. The incomplete is sometimes the uncompletable. Would the agonized self-probing of *St Matthew*, the brooding melancholy of *Evening* and the dawning power of *Day* in the Medici Chapel, the silent meditation of Nicodemus in the Florentine *Pietà*, the other-worldliness in the expression of the Virgin in the *Rondanini Pietà* be one whit better if Michelangelo had made one more stroke of the chisel? Is there not a sense in which these works are in fact not incomplete at all, so that any addition to the explicit sculptural forms would detract from the significance of the work of art as a manifestation of spiritual values? Would we therefore have wanted Michelangelo to 'finish' them? True, these works as they have come down to us are like the characters of some other-worldly language, but even if we admit that art has here reached the limits of the artistically expressible, dare we attribute this to Michelangelo's deliberate intention? Is it not rather the force of fate that compels and drives him, a fate he does not seek but to which he is forced to bow?

And of course alongside uncompleted works there are also finished ones – *Night* and *Morning* in the Medici Chapel, *Rachel* and *Leah* on the tomb of Pope Julius. Will anyone venture to claim that these are lesser works for being finished?

As we know from written sources and from the way his works were received, this question of works left unfinished already raised problems

Conclusion: The Incomplete and the Uncompletable

during his lifetime. The tondo for Bartolomeo Pitti, for example, was accepted in spite of not being finished, and the marble *Apollo* for Baccio Valori was also delivered in its incomplete state. The respective patrons appear to have accepted the situation without demur. The architect Buontalenti took the *Boboli Captives* as they were and erected them in a grotto, where their incomplete state, far from being a disadvantage, was held to give them a special attraction. This, of course, was completely opposed to Michelangelo's own intentions and attitudes, but it was customary at the time to assess a work of art in the first place by its decorative value and only then to look for its intrinsic qualities, witness the displays of classical statuary in formal gardens.

More significant in this regard is the evidence in the works of Condivi and Vasari. The former writes: 'He [Michelangelo] has immense powers of imagination, and this is the prime reason why he has always been dissatisfied with his works and perpetually disparaged them, for he could see that his hand had not realized the conception he had had in his mind.'[2] In another passage Condivi writes that a state of incompleteness 'need not impair the finished beauty of a work'.[3] That is to say, a work may be complete in conception without being complete in execution – which does not mean that Michelangelo deliberately intended to leave his works as *non-finiti*. The notion of completion is transferred from the physical to the spiritual sphere.

Vasari expresses himself at greater length on the subject, suggesting that Michelangelo's judgement

> was so severe that he was never content with anything he did. That this was the case can be proved by the fact that there are few finished statues to be seen of all that he made in the prime of his manhood, and that those he did finish completely were executed when he was young, such as the *Bacchus*, the *Pietà* in St Peter's, the giant *David* at Florence, and the *Christ* in the Minerva. It would be impossible to add to these or take away a single grain without ruining them. The others, with the exception of *Duke Giuliano* and *Duke Lorenzo*, the *Night*, the *Dawn*, the *Moses*, with the other two, which altogether do not amount to eleven – the others, I say, and there were many of them, were all left unfinished. For Michelangelo used to say that if he

had had to be satisfied with what he did, then he would have sent out very few statues, or rather none at all. This was because he had so developed his art and judgement that when, on revealing one of his figures, he saw the slightest error, he would abandon it and run to start working on another block, trusting that it would not happen again. He would often say that this was why he had finished so few statues or pictures.[4]

> This reveals clearly the duality of concept and execution.

Following Condivi's train of thought, Vasari writes elsewhere:

His imagination was so powerful and perfect that he often discarded work in which his hands found it impossible to express his tremendous and awesome ideas; indeed, he has often destroyed his work, and I know for a fact that shortly before he died he burned a large number of his own drawings, sketches and cartoons so that no one should see the labours he endured and the ways he tested his genius, and lest he should appear less than perfect.[5]

In his description of the *Medici Madonna* Vasari also expresses the thought of perfection residing in the concept, not in its material expression: 'Although this statue [the *Medici Madonna*] remained unfinished, having been roughed out and left showing the marks of the chisel, in the imperfect block one can recognize the perfections of the completed work.'[6]

Both Condivi and Vasari base their accounts on Michelangelo's own remarks, and the recurrence of these attitudes in his poems only serves to confirm their authenticity:

> For one can only find
> Beauty when it is late, and one is dying.[7]

Here the possibility of success is still open; incompleteness is artistic failure. There is nothing of an intention to leave works unfinished in order to achieve particular effects, but a confession, made on many other occasions also, that his hand cannot achieve the realization of his visions. Michelangelo's unfinished works remained unfinished because he despaired of ever completing them.

Conclusion: The Incomplete and the Uncompletable

Dissatisfaction with his own achievements is a trait deeply rooted in Michelangelo's self-torturing nature. At the same time it reflects a philosophy of art which had a special significance for him. As expressed by Plotinus in a passage which greatly exercised Goethe in his old age, the concept in the mind of the artist has absolute priority over its manifestation in a particular subject-matter, and any realization of an artistic impulse is tainted *a priori* with imperfection.[8]

This philosophy of art, which goes back to Plato, retained an influence long after classical times. In Dante's *De Monarchia*, for example, three degrees in the work of art are distinguished – the concept in the artist's mind, the application of technique and the raw material of nature; material reality offers stubborn resistance, while the highest ideal lies beyond the earthly realm, in Heaven.[9] In his *Trionfo d'Amore* Petrarch talks of the gap between the work of art and the artist's intentions or desires;[10] Vasari recalls these lines when discussing the unfinished works of Leonardo da Vinci.[11]

It is easy to see the attraction of these Neoplatonic ideas for the Middle Ages, but they retained their influence beyond this, and in fact from the time of the Renaissance, which marks the change from medieval attitudes to the modern concept of art as the imitation of nature, we have numerous examples to prove this. The new relationship to the classical heritage not only brought a rediscovery of the aesthetic values of antiquity – this used to be often maintained – but also revived the Neoplatonic theory of art, and far from limiting art to the imitation of nature or to subjects derived from natural experience, it encouraged a new spirituality in art.

Vasari tells of a conversation between Leonardo and the Regent of Milan concerning a complaint by the Prior of S. Maria delle Grazie that work on the *Last Supper* was progressing so slowly. 'Leonardo', writes Vasari, 'talked a great deal about art and explained to the Regent that a superior artist sometimes achieved the most when he seemed to be the least active, because his mind was at work evolving those perfect thoughts and concepts to which it was the task of the hand to give form and expression.'[12]

As a frequent guest in the Palazzo Medici, where he met men such as Angelo Poliziano, Marsilio Ficino, Pico della Mirandola and Cristoforo

Conclusion: The Incomplete and the Uncompletable

Landini, Michelangelo was still a young man when he first came into contact with Neoplatonism, and his views on the potentialities and the limitations of art owe a good deal to Plotinus, without sharing, however, Plotinus' extreme dualism. But Plotinus' notion of art as 'the realization of an inner concept',[13] an activity which is the nobler, the more it succeeds in imposing inner, spiritual form on the subject-matter, could not but appeal to him, and his proclivity to stretch his powers to the utmost, to give visible expression in this earthly prison ('carcer terreno') to the concept of eternal truth ('l'immortal forma'), yet also to give utterance to his dissatisfaction with his fulfilment of these tasks – all this found sustenance in Neoplatonic idealism.

How can we explain, however, that these Neoplatonist traits of dissatisfaction with one's own achievement and of seeking to convert concepts into visual forms first appear in Michelangelo and not in the Middle Ages, when the dualism of form and idea was so deep-rooted?

As long as art took its lead – as it did in the Middle Ages – not from nature herself but from traditional images and notions, the artist by-passed reality and produced a kind of hieroglyph of the idea itself. To be sure, alongside his study of a lion in his remarkable book of studies and sketches Villard de Honnecourt has added the words: 'Know that this is taken from real life', but his drawing is an imaginative construct, not a study from nature.[14]

In the Renaissance, however, art modelled itself on nature, though without sacrificing the conceptual aims of medieval art, and with this came the moment of artistic subjectivity, where previously objective values alone had prevailed. A tension developed between art as imitation of nature and art as a language of concepts, and the scene of this tension was the mind of the artist himself. How were the demands of the real and the demands of the ideal to be reconciled? This was not a problem known to Villard de Honnecourt, or, for that matter, to Dante or Petrarch. But from the time of the Renaissance it became a central question both for life and for art. Dürer, of course, like all artists, fought to find the right expression; in his own words: 'However good we make a work, it can still be made better.'[15] But he left no work which was not fully and utterly complete.

Leonardo da Vinci, Michelangelo's great rival, left many works

unfinished, and is the only artist who can be compared with Michelangelo in this respect. 'The fact is . . .', says Vasari in explanation, 'that because he undertook too much, his noble and far-sighted mind found itself restricted; and because he always strove after fullness and perfection, many works were never finished.'[16] But it also appears that Leonardo, for whom art was only one of many intellectual activities, was not unduly concerned about finishing his works, whereas Michelangelo left works uncompleted, not out of indifference but because he despaired of finishing them. All his feverish efforts went into this struggle – a tragic personal struggle in which the establishment, at this moment in time, of the autonomy of art through its foundation in nature played an important part.

However well one may understand the spiritual reasons for his leaving works incomplete, there remains the question of the degree of uncompleteness. At what stage did he break off? Are his *non-finiti* unified pieces in spite of their incompleteness? How can we distinguish them from mere fragments? This leads back to the thought advanced by Condivi and Vasari that the notion of completion in art is proper, not to the execution but to the concept.

The world of objects and ideas in which Michelangelo the artist lived was a categorically objective world. He did not invent his subjects but portrayed what mythology and the Christian faith offered, and would never have embarked on a work that did not have its basis in these.

In the execution of his works he proceeded from traditional attitudes and forms, departing only rarely from objective, 'recognizable' reality. 'Free' subjects like *The Walker* or *The Thinker* [17] – the latter particularly significant in modern art – are not found, nor is the separation of artistic form from natural form that characterizes, for instance, Rodin's *Méditation*, in which the woman is portrayed without arms as a means of emphasizing her absorption in her thoughts. Every single work of Michelangelo's has a concrete, objective meaning and respects the demands of nature – without, of course, being entirely bound by them – and aims at an objective and formal unity. Seen objectively, his torsoes are fragments, unlike the controlled and carefully completed works in this genre which we find from Rodin onwards. How, then, can we

explain that despite their incompleteness they convey so strange an impression of perfection?

In the first place it is only individual parts that are incomplete, not the work as a whole, the execution of the plan, not the plan itself, the appearance of the figure, not its essence. The unfinished, sometimes barely recognizable parts are absorbed in the all-embracing concept whose dominance is already felt and whose completeness precedes that of its individual objective parts. Only at such a stage does Michelangelo put his work on one side.

We thus find ourselves distinguishing between an internal and an external completeness. The former is achieved in the moment when the subject breaks through from formlessness to visible form; the latter is reached with the final execution of the handiwork, an integral part of any work of art, but one which Michelangelo often found himself unable to carrry out.

Vasari gives a metaphorical account of Michelangelo's technique:

One must take a figure of wax or some other firm material and lay it horizontally in a vessel of water; then, as the water is, of course, flat and level, when the figure is raised little by little above the surface the more salient parts are revealed first, while the lower parts (on the underside of the figure) remain submerged, until eventually it all comes to view. In the same way figures must be carved out of marble by the chisel: the parts in highest relief must be revealed first and then little by little the lower parts.[18]

Once again we have the notion of the pre-existence of the complete work as a concept.

The image of the liberation of the statue from the block[19] – a Neoplatonist image common to the Middle Ages (Thomas Aquinas) and the early Renaissance (Leon Battista Alberti) – also occurs in Michelangelo's poetry:

> Non ha l'ottimo artista alcun concetto,
> Ch' un marmo solo in sè non circonscriva
> Col suo soverchio; e solo a quello arriva
> La man che ubbidisce all' intelletto.

Conclusion: The Incomplete and the Uncompletable

> (The marble not yet carved can hold the form
> Of every thought the greatest artist has,
> And no conception can yet come to pass
> Unless the hand obeys the intellect.)[20]

Michelangelo the sculptor no less than Michelangelo the poet shows himself the disciple of Plotinus.

Yet we are still confronted by the question of why he so often held back from completing his works – and here we find ourselves in areas of the spirit where we can deal only in allusions and suggestions, not in explanations.

To bring a work of art to a conclusion is to give it independence – but also to cut it off from the world that gave it birth. A shell both conceals and protects. Might Michelangelo have feared that the process of individuation would lead too far into the sphere of reality and forfeit its ideal origin? Could the holding back that we have so often observed be the expression of a metaphysical fear?

That it may be so is suggested by the fact that in his sculptures – as we observed in his *St Matthew* – he works from the plane surfaces of the marble block, not from an organic conception of the human figure. Layer by layer he works his way through the block which determines and codifies the figure's gestures and movements. In the words of Friedrich Kriegbaum: 'With each fresh layer the elements of the prismatic block repeat themselves. The block determines the forms of the individual figures, and the completed work reveals the block as the governing principle.'[21]

At first sight it seems difficult to reconcile this observation with one's experience of the dynamic quality of Michelangelo's statues. How can we resolve the paradox of an overwhelming power – far greater than anything seen in sculpture before – in the creation of organic, living figures, and the almost supernatural domination of the lifeless stone?

For Michelangelo the block is not only a mass that resists his attempts to give it form, not only the shell that hides the form, but a law that controls it. The figure is not free but subject to this law. Whether the figure resists this law or submits to it, its lack of freedom remains. It lacks the autonomy of antiquity. Here we can see the Christian character

264

of Michelangelo's art and its derivation from the Middle Ages. Man's lack of freedom means for him subservience to God. Indeed he must have been in a state of perpetual fear that, as he worked, getting ever further away from the block the closer his imitation of nature became, the moment when the power of the ideal was at its height would pass by unnoticed and unexploited. Here perhaps lies the profoundest reason why Michelangelo so often laid his chisel aside. Yet to do so, and thereby to defer once more the moment of completion, could not but cause him great suffering.

In his struggle to reconcile his extraordinary wealth of imagination with his urge towards the metaphysical, and to preserve the eternal in the temporal, the supernatural in the natural, Michelangelo must have realized early in life how limited were the powers of art – even of an art so rich in expressiveness as his own. By the end of his life this realization even seems to have driven him to turn his back on art itself. The incomplete and uncompletable in Michelangelo's works is not an artistic principle but an agonizing inner necessity.

Bibliography

(Works on points of detail are quoted in the notes to the individual chapters.)

I BIBLIOGRAPHICAL WORKS

STEINMANN, Ernst, and WITTKOWER, Rudolf. *Michelangelo-Bibliographie 1510–1926*. With an appendix of documents by Rogert Freyhan. Leipzig, 1927. New edition by Luitpold Dussler in preparation.

STEINMANN, Ernst. *Michelangelo im Spiegel seiner Zeit*. Leipzig, 1930. Bibliography 1927–30.

—— *Michelangiolo Buonarroti nel IV Centenario del Giudizio Universale*. Florence, 1942. Bibliography 1931–42.

VASARI, Giorgio. *La Vita di Michelangelo nelle redazioni del 1550 e del 1568, curata e commentata da Paola Barocchi*. Vol. I. Milan and Naples, 1962. Bibliography 1942–61. Supplemented in review by H. von Einem in *Zeitschrift für Kunstgeschichte*, XXVIII (1965), 362 ff.

MELLER, Peter. 'Aggiornamenti bibliografici', in *Michelangelo artista, pensatore, scrittore*. Novara, 1965. Bibliography 1961–5.

ISERMEYER, Christian Adolf. 'Das Michelangelo-Jahr 1964 und die Forschungen zu Michelangelo als Maler und Bildhauer 1959–1965', *Zeitschrift für Kunstgeschichte*, XXVIII (1965).

RAMSDEN, E. H. 'Recent Michelangelo Literature', *The Burlington Magazine*, CVIII (1966), 202 ff.

TOLNAY, Charles de. 'Alcune recenti scoperte e risultati negli studi Michelangioleschi', *Accademia Nazionale dei Lincei* (Rome, 1971), 3 ff.

2 DOCUMENTS AND SOURCES

MAURENBRECHER, Wolf. *Die Aufzeichnungen des Michelangelo Buonarroti im Britischen Museum in London und im Vermächtnis Ernst Steinmann in Rom*. Leipzig, 1938.

MILANESI, Gaetano. *Le Lettere di Michelangelo Buonarroti edite ed inedite coi Ricordi ed e Contratti artistici*. Florence, 1875.

—— *Les Correspondants de Michelange*. Vol. I: *Sebastiano del Piombo*. Paris, 1890.

GAYE, Giovanni. *Carteggio inedito d'artisti dei secoli XIV, XV, XVI*. Vol. II. Florence, 1840.

FREY, Karl. *Die Briefe des Michelangelo Buonarroti*. Berlin, 1907. 3rd ed. by H. W. Frey, Berlin, 1961. (Review: L. Dussler in *Pantheon* (1963).)

—— *Sammlung ausgewählter Briefe an Michelangelo Buonarroti nach den Originalen des Archivio Buonarroti*. Berlin, 1899.

CONDIVI, Ascanio. *Vita di Michelangiolo Buonarroti*. Rome, 1553.

VASARI, Giorgio. *Le Vite de' più eccellenti pittori, scultori, architettori*. Rome, 1550 and 1568. New edition in 9 vols by Gaetano Milanesi, Florence, 1878–85.

—— *La Vita di Michelangelo nelle redazioni del 1550 e del 1568, curata e commentata da Paola Barocchi*. Vols I–V. Documenti di Filologia V. Milan and Naples, 1962. (Reviews: Creighton Gilbert in *Art Bulletin* (1964); Michael Hirst in *The Burlington Magazine* (1964); Herbert von Einem in *Zeitschrift für Kunstgeschichte* (1965).)

The Letters of Michelangelo. Translated from the original Tuscan, edited and annotated by E. H. Ramsden. Stanford, 1963. Vol. I: 1496–1534. Vol. II: 1534–1564. (Review: Creighton Gilbert in *Art Bulletin* (1964).)

BARDESCHI, L., and BAROCCHI, G. and P. (eds.). *I Ricordi di Michelangelo*. Florence, 1970.

BAROCCHI, P. (ed.). *Il Carteggio di Michelangelo*. 6 vols. So far publ. Vol. I: *Lettere di Michelangelo e suoi correspondenti 1496–1518*, 1965. Vol. II: *Lettere di Michelangelo e suoi correspondenti 1518–1523*, 1967.

3 POETRY

GUASTI, Cesare. *Le Rime di Michelangelo Buonarroti*. Florence, 1863.

FREY, Karl. *Die Dichtungen des Michelangelo Buonarroti*. Berlin, 1897. New ed. by H. W. Frey, Berlin, 1964.

GIRARDI, Enzio Noe. *Le Rime di Michelangelo Buonarroti*. Bari, 1960. *Complete Poems and Selected Letters of Michelangelo*. Trans. C. Gilbert. Ed. Robert N. Linscott. New York, 1963.

Bibliography

FRIEDRICH, Hugo. *Epochen der italienischen Lyrik*. Chapter 7. Frankfurt, 1964.

CLEMENTS, Robert I. *The Poetry of Michelangelo*. London, 1966.

MARIANI, Valerio. *Poesia di Michelangelo*. Rome, 1940.

4 WORKS

(a) Drawings

FREY, Karl. *Die Handzeichnungen des Michelangiolo Buonarroti*. 3 vols. Berlin, 1909–11. Appendix by Fritz Knapp, Part I, Berlin, 1925.

BERENSON, Bernard. *The Drawings of the Florentine Painters*. Vol. 3. Chicago, 1938.

GOLDSCHEIDER, Ludwig. *Michelangelo: Drawings*. London, 1951. New ed. 1966.

WILDE, Johannes. *Italian Drawings in the British Museum: Michelangelo and his Studio*. London, 1953.

DUSSLER, Luitpold. *Die Zeichnungen des Michelangelo*. Berlin, 1959. (Reviews: Robert Oertel in *Kunstchronik* (1962); Kurt Gerstenberg in *Pantheon* (1962); Alexander Perrig in *Zeitschrift für Kunstgeschichte* (1965).)

BAROCCHI, Paola. *Michelangelo e la sua scuola: I disegni dell'Archivio Buonarroti*. Florence, 1964. (Review: H. von Einem in *Zeitschrift für Kunstgeschichte* (1965).)

—— *Michelangelo e la sua scuola: I disegni di Casa Buonarroti e degli Uffizi*. 2 vols. Florence, 1962. (Review: H. von Einem in *Zeitschrift für Kunstgeschichte* (1965).)

(b) Architecture

SCHIAVO, Armando. *Michelangelo architetto*. Rome, 1949.

ACKERMAN, James S. *The Architecture of Michelangelo*. 2 vols. London, 1961. 2nd rev. ed. 1964.

PORTOGHESI, Paolo, and ZEVI, Bruno. *Michelangelo architetto*. Turin, 1964.

PUPPI, L., and BARBIERI, B. *Tutta l'architettura di Michelangelo*. Milan, 1964.

(c) *Sculptures and paintings*

KRIEGBAUM, Friedrich. *Michelangelo Buonarroti: Die Bildwerke*. Berlin, 1940.

RUSSOLI, Franco. *Tutta la scultura di Michelangelo*. Milan, 1953.

CARLI, Enzo. *Tutta la pittura di Michelangelo*. Milan, n.d.

GOLDSCHEIDER, Ludwig. *The Paintings of Michelangelo*. London, 1940. 2nd ed. 1948.

MARIANI, Valerio. *Michelangelo pittore*. Milan, 1964.

WEINBERGER, Martin. *Michelangelo the Sculptor*. 2 vols. London, 1967. (Review: Michael Hirst in *The Burlington Magazine* (1969).)

CLARK, Kenneth. 'Michelangelo pittore', *Apollo* (1964). *L'Opera completa di Michelangelo pittore*. Milan, 1966.

5 BIOGRAPHIES AND STUDIES

GRIMM, Herman. *Leben Michelangelos*. 2 vols. Hanover, 1860–3. New ed. by L. Goldscheider, Vienna, 1933, and by K. Laux, Leipzig, 1940.

GOTTI, Aurelio. *Vita di Michelangelo Buonarroti*. 2 vols. Florence, 1875.

SPRINGER, Anton. *Raffael und Michelangelo*. 2 vols. Leipzig, 1887.

SYMONDS, John Addington. *The Life of Michelangelo Buonarroti, Based on Studies in the Archives of the Buonarroti Family at Florence*. 2 vols. London, 1893.

JUSTI, Carl. *Michelangelo: Beiträge zur Erklärung der Werke und des Menschen*. Leipzig, 1900.

THODE, Henry. *Michelangelo und das Ende der Renaissance*. 3 vols. Berlin, 1902–12.

—— *Michelangelo: Kritische Untersuchungen über seine Werke*. 3 vols. Berlin, 1908–13.

FREY, Karl. *Michelangiolo Buonarroti: Sein Leben und seine Werke*. Vol. I. Berlin, 1907.

MACKOWSKY, Hans. *Michelangelo*. Berlin, 1908. 6th ed. Stuttgart, 1939.

JUSTI, Carl. *Michelangelo: Neue Beiträge zur Erklärung seiner Werke*. Berlin, 1909.

TOLNAY, Charles de. *Michelangelo*. Princeton, 1943–60.

Vol. I: *The Youth*. 2nd ed. 1947.

Vol. II: *The Sistine Ceiling*. 2nd ed. 1949.

Bibliography

Vol. III: *The Medici Chapel.* 1948.

Vol. IV: *The Tomb of Julius II.* 1954.

Vol. V: *The Final Period.* 1960.

(Reviews: Weinberger in *Art Bulletin* (1945); Kurz in *The Burlington Magazine* (1945 and 1951); Hartt in *Art Bulletin* (1950): Dussler in *Kunstchronik* (1950); Stechow in *Art Bulletin* (1953); Luporini in *Critica d'Arte* (1960); Pittaluga in *Commentari* (1960); Bazin in *Gazette des Beaux-arts* (1961); von Einem in *Zeitschrift für Kungstgeschichte* (1962).)

—— *Werk und Weltbild des Michelangelo.* Zürich, 1949.

—— *Michelangiolo.* Florence, 1951.

—— *The Art and Thought of Michelangelo.* New York, 1964.

—— *Michel-Ange.* Paris, 1970.

PAPINI, Giovanni. *Vita di Michelangiolo nella vita di suo tempo.* Milan, 1949. 7th ed. 1952.

EINEM, Herbert von. *Michelangelo.* Stuttgart, 1959.

MORGAN, Charles H. *The Life of Michelangelo.* London, 1960.

CLEMENTS, Robert I. *Michelangelo's Theory of Art.* New York, 1961. (Review: C. Gilbert in *Art Bulletin* (1962).)

GOLDSCHEIDER, Ludwig. *Michelangelo.* 5th ed. London, 1967.

—— *Werk und Persönlichkeit.* Vol. I: *Michelangelo Buonarroti.* Würzburg, 1964.

HARTT, Frederick. *Michelangelo.* 3 vols. London, 1965.

KELLER, Harald. *Michelangelo.* Königstein, 1966.

BERTI, Luciano. *Michelangelo.* Florence, 1968.

—— *Michelangelo artista, pensatore, scrittore.* 2 vols. Novara, 1965.

RAMSDEN, E. H. *Michelangelo.* London, 1971.

MARIANI, Valerio. *Michelangelo.* Naples, 1964.

—— *Michelangelo e Leonardo.* Naples 1965.

Notes

INTRODUCTION

1 Cf. A. E. Brinckmann, *Michelangelo. Vom Ruhme seines Genius in fünf Jahrhunderten*, (Hamburg, 1944); E. Steinmann, *Michelangelo im Spiegel seiner Zeit* (Leipzig, 1930); E. Heye, *Michelangelo im Urteil französischer Kunst des 17. und 18. Jahrhunderts* (Strasbourg, 1932); E. Dörken, *Geschichte des französischen Michelangelobildes von der Renaissance bis zu Rodin* (Bochum, 1936); J. Gantner, *Michelangelos Ruhm, Discordia concors* (Basle, 1968).

2 Michelangelo to the commandant of Cortona, May 1518; Milanesi, *Lettere* No. CCCLIV, p. 391.

3 Canto XXXIII, ed. of 1534. Cf. A. Monti, *L'Ariosto e Michelangelo, Il Buonarroti* II (Rome, 1867).

4 Vasari–Milanesi IV, 13.

5 Vasari–Milanesi VIII, 193.

6 Thode, *Kritische Untersuchungen* II, 64; cf. also H. Tietze, 'Michelangelos Jüngstes Gericht und die Nachwelt' in *Festschrift für Paul Clemen* (Bonn, 1926), 429 ff., and E. Tietze-Conrat, 'Neglected contemporary sources relating to Michelangelo and Titian', *Art Bulletin* XXXV (1943), 154 ff.

7 Vasari–Milanesi VII, 65 and 240.

8 G. Gaye, *Carteggio* II, 500, also Tolnay I, 148 f., and E. Steinmann, *Michelangelo im Spiegel seiner Zeit* (Leipzig, 1930), 48.

9 *Quellenschriften für Kunstgeschichte* II (Vienna, 1871), esp. p. 82.

10 H. v. Einem, *Michelangelo und die Antike. Stil und Überlieferung* (Düsseldorf, 1970), 148.

11 *Discourses Delivered at the Royal Academy*, ed. R. Frey (London, 1905), final discourse.

12 Part III; Propyläenverlag (Berlin, n.d.), 2nd ed., 137.

13 E. C. Mason, *The Mind of Henry Fuseli* (London, 1951), 248. The remark was probably made in 1788 (second lecture). Cf. G. Schiff, 'Johann Heinrich Füssli und Michelangelo', *Jahresbericht des Schweizerischen Institutes für Kunstwissenschaft* (1964), 123 ff.

14 *Italienische Reise*, 22 November 1786 (Hamburger Ausgabe XI, 140).

15 Ibid. 2 December 1786 (Hamburger Ausgabe XI, 145).

16 Cf. v. Einem, *Goethe-Studien* (Munich, 1970).

17 Gesamtausgabe IV (Stuttgart, 1933), 74.

18 Ibid. IV, 82.

19 Ibid. III, xxiv f.

20 Eugène Delacroix, *Sur le jugement dernier* (1837), *Œuvres littéraires* (Paris, n.d.).

21 *Entretiens réunis par Paul Gsell* (Paris, 1911), 283.

22 *Gesammelte Schriften* VII (Leipzig and Berlin, 1927), 248.

23 Cf. v. Einem, 'Michelangelo und die Antike', *Antike und Abendland I* (1945), and *Stil und Überlieferung* (Düsseldorf, 1970); G. Kleiner, *Die Begegnungen Michelangelos mit der Antike* (Berlin, 1950).

24 Cf. v. Einem, *Stil und Überlieferung.*

CHAPTER I

1 The exact date is not known. On Urbino see G. Papini, *Vita de Michelangiolo nella vita di suo tempo* (Milan, 1952), Ch. IX.

2 *Quellenschriften für Kunstgeschichte* VI, 105.

3 Michelangelo's apprenticeship with Ghirlandaio is beyond dispute. Condivi tries (perhaps at Michelangelo's behest) to minimize Ghirlandaio's role and to give greater importance to Francesco Granacci, but Vasari quotes a letter from Michelangelo's father which makes it clear that Michelangelo was apprenticed to Ghirlandaio for three years on 1 April 1488 (Vasari–Milanesi VII, 138). G. Fiocco attempted to support Condivi ('La data di nascità di Francesco Granacci e un' ipotesi michelangiolesca' in *Rivista d'Arte*, 1930 and 1931), and proved that Granacci was born, not, as had hitherto been believed, in 1477 but in 1469, i.e. six years before Michelangelo, but there is little to support his view that Michelangelo produced a number of paintings in his youth under Granacci's influence. Cf. also G. Fiocco, 'Un' altra pittura giovanile di Michelangelo', *La Critica d'Arte* (1937); R. Longhi, 'A proposito dell' inizio pittorico di Michelangelo', *Le Arti* (1941); A. Chastel, 'Vasari et la légende médicéenne', *Studi Vasariani* (1952), 165, note 2. In opposition—fully justified—to this view see Tolnay I, 242. G. Marchini (*The Burlington Magazine*, 1953) seeks to prove that some of the heads in Ghirlandaio's frescoes for S. Maria Novella were done by Michelangelo. On Michelangelo's early paintings see also R. Longhi, *Paragone* (1958) (a fragment of a painting of St John in a private Swiss collection); C. Gould, 'The Sixteenth-century Italian Schools' (National Gallery Catalogue, London, 1962); C. v. Holst, 'Michelangelo in der Werkstatt Botticellis?', *Pantheon* (1967).

4 H. Egger, *Codex Escurialensis. Ein Skizzenbuch aus der Werkstatt Domenico Ghirlandaios* (Vienna, 1906). Cf. also I. Mesnil, 'L'Éducation des peintres florentins au XVème siècle', *Revue des idées* (1910), and M. Wackernagel, *Der Lebensraum des Künstlers in der florentinischen Renaissance* (Leipzig, 1938), 306 ff.

5 Vasari–Milanesi VII, 142.

6 Cf. Tolnay I, 51, note 56.

7 Condivi, ed. Frey, 20.

8 Ibid. 114.

9 Vasari–Milanesi VII, 141 f.

10 On Bertoldo see W. v. Bode, *Bertoldo und Lorenzo dei Medici* (Freiburg, 1925), and M. L. Gengaro, 'Maestro e scolare, Bertoldo di Giovanni e Michelangelo', *Commentari*, Vol. 12 (1961), 52 ff.

11 Vasari–Milanesi IV, 256.

12 Cf. Chastel, op. cit., and *Art et humanisme à Florence* (Paris, 1959), 19 ff.

13 Cf. H. Reymond, *Sculpture florentine*, Vol. II (Florence, 1894), 137; L. Dussler, *Benedetto da Maiano* (Munich, 1924), 37 and 60; and above all M. Lisner, 'Zu Benedetto Maiano und Michelangelo', *Zeitschrift für Kunstwissenschaft* (1958). Margrit Lisner's attempt to make the right putto on the top of Maiano's altar retable in S. Anna dei Lombardi in Naples into a work done by Michelangelo in 1489 in Maiano's workshop is not convincing. That this putto is superior to the one on the left does not prove that it could not have been the work of the mature Maiano or that it must have been the work of the then only fourteen-year-old Michelangelo, particularly as his *Madonna of the Stairs* still exhibits a remarkable degree of incompleteness. The kinship between this putto and the figure of Jesus in the *Bruges Madonna* may show a connection between Michelangelo and Maiano but it certainly does not prove Michelangelo's authorship of the putto. One may also note that the significant motif in the Christ-child of the arm pointing across the body occurs, not in the right putto of the Naples group but the left. Nor are the links with later works of Michelangelo's, such as *David* and the *Pitti Tondo*, so close that his authorship of the putto must be assumed.

14 E. Panofsky, *The Neoplatonic Movement and Michelangelo: Studies in Iconology* (New York, 1939). Cf. also P. Monier, *Le Quattrocento* II, 4th ed. (Paris, 1924); A. Chastel, *Marsile Ficine et l'art* (Geneva and Lille, 1954); H. Schommodau, 'Michelangelo und der Neuplatonismus', *Jahrbuch für Aesthetik und allgemeine Kunstwissenschaft* VII (1962), 28 ff.

15 Cf. J. Schnitzer, *Savonarola* (Munich, 1924); G. Poggi, *Michelangelo e il Savonarola: Michelangiolo Buonarroti nel IV Centenario del 'Giudizio Universale'* (Florence, 1942), 113 ff. Also Condivi, ed. cit. 204.

16 The attempts by R. Longhi (*Paragone*, 1958) and J. Pope-Hennessy (*Italian High Renaissance and Baroque Sculpture*, London, 1963) to assign a later date to the *Madonna of the Stairs* are not convincing, nor is the rejection of its authenticity by Colin Eisler (*Akten des 21. Internationalen Kongresses für Kunstgeschichte*, Bonn, 1964, Vol. 2 (Berlin, 1967)). On its relationship to classical antiquity see v. Einem, *Stil und Überlieferung* (Düsseldorf, 1970). On the theme of *Maria lactans* see V. Lasareff, 'Studies in the Iconography of the Virgin', *Art Bulletin* (1938).

17 H. W. Janson, *The Sculpture of Donatello* (Princeton, 1957), Vol. I, Plates 123–4 and Vol. II, 86 f.

18 Condivi, ed. cit. 28.

19 F. Wickhoff, 'Die Antike im Bildungsgang Michelangelos', *Mitteilungen des Institutes für Oesterreichische Geschichtsforschung* II (1882), 408 ff. Cf. also Tolnay I, 134.

20 On the statue of Hercules, which had passed from the hands of the Strozzi family to King Francis I of France and was erected by King Henry IV in the Jardin de l'Estang in Fontainebleau, see Tolnay, 'L'Hercule de Michelangelo à Fontainebleau', *Gazette des Beaux-Arts*, CVI (1964). On the crucifix in S. Spirito see M. Lisner, 'Michelangelos Kruzifixus aus S. Spirito in Florenz', *Münchener Jahrbuch*

der bildenden Kunst, 3. Folge, XV (1964); U. Procacci-Umberto Baldini, 'Il restauro del Crocifisso di S. Spirito', ibid.; and M. Lisner, 'Der Gekreuzigte des Michelangelo in S. Spirito in Florenz', in *Holzkruzifixe in Florenz und in der Toscana* (Munich, 1970), Pt IV.

21 Condivi, ed. cit. 30. On Prior Nicolaus de Florentina of S. Spirito see K. Frey, *Quellen und Forschungen* I (Berlin, 1907), 107 ff.

22 Cf. K. Frey, *Michelangelo* I, 35 f.; Mesnil, op. cit. 9; S. Esche, *Leonardo da Vinci. Das anatomische Werk* (Basle, 1954).

23 Cf. M. Lisner, 'Das Quattrocento und Michelangelo', *Akten des 21. Internationalen Kongresses für Kunstgeschichte, Bonn, 1964*, Vol. 2 (Berlin, 1967), 78 ff.

24 Condivi, ed. cit. 36.

25 Vasari–Milanesi VII, 147.

26 On this figure of St John see C. A. Isermeyer in *Zeitschrift für Kunstgeschichte* XXVIII (1965), 315 ff. Isermeyer's rejection of the ideas of Longhi (*Paragone*, 1958), Parronchi (*Studi Urbinati*, 1960) and F. de' Maffei (*Michelangelo's Lost St John*, London, 1964) seems justified; cf. also Tolnay, *Michel-Ange* (Paris, 1970), 258 f. On the Cupid see Isermeyer, op. cit. 318 ff.; Isermeyer confirms the identification of this figure by Konrad Lange in 1883 with a statue in the Archaeological Museum in Turin. Cf. also A. Parronchi, 'Il Cupido dormiente di Michelangelo', *Akten des 21. Internationalen Kongresses für Kunstgeschichte, Bonn 1964*, Vol. 2 (Berlin, 1967), 121 ff.

27 Condivi, ed. cit. 38.

CHAPTER 2

1 Jacob Burckhardt, *Die Kultur der Renaissance, Gesamtausgabe* (Stuttgart, 1930), V, 133.

2 G. Dehio, 'Die Bauprojekte Nikolaus' V. und L. B. Albertis', in *Kunsthistorische Aufsätze* (Munich, 1914). J. Ackerman, *The Cortile del Belvedere* (Rome, 1954). T. Magnuson, 'The Projects of Nicolas V for Rebuilding the Borgo Leonino in Rome', *Art Bulletin* (1954); *Studies in Roman Quattrocento Architecture* (Rome and Upsala, 1957). G. Urban, 'Die römische Kirchenbaukunst des Quattrocento', *Römisches Jahrbuch für Kunstgeschichte* IX (1959); 'Zum Neubauprojekt von St Peter unter Papst Nikolaus V.', *Festschrift für Harald Keller* (Darmstadt 1963).

3 Cf. Ch. I, note 4.

4 Preserved in two parts, *Codex Vaticanus* and *Codex Senensis*, ed. Farbriczy (Stuttgart, 1902). Cf. also C. Hülsen, *Il Libro di Giuliano da Sangallo* (Leipzig, 1910); R. Falb, *Il taccuino senese di Giuliano da Sangallo* (Siena, 1902).

5 Burckhardt, op. cit. 133. Cf. A. v. Salis, *Antike und Renaissance* (Erlenbach and Zürich, 1947), 13.

6 Vasari–Milanesi IV, 10. On the ancient works mentioned by Vasari cf. H. H. Brummer, *The Statue Court in the Vatican Belvedere* (Stockholm, 1970).

7 I. D. Passavant, *Raffael von Urbino* I (Leipzig, 1839), 308 ff.; A. v. Salis, op. cit. 31.

8 H. Siebenhüner, *Das Kapitol in Rom, Idee und Gestalt* (Munich, 1954), 37; W. S.

Heckscher, *Sixtus IV. Aeneas insignes statuas romano populo restituendas censuit* (The Hague, 1955).

9 K. Frey, *Michelangelo* I, 270; Hübner, *Le statue di Roma* (Leipzig, 1912); J. S. Ackermann, op. cit. 35 ff. (reconstruction of Julius II's collection of statues).

10 K. Frey, op. cit. I, 285 ff.

11 Condivi, ed. cit. 40.

12 The date is known from Michelangelo's letter to his father on 19 August 1497. Milanesi, *Lettere* No. II, p. 4. J. Wilde, 'Eine Studie Michelangelos nach der Antike', *Mitteilungen des kunsthistorischen Instituts in Florenz* (1932), 54: Wilde expresses the view that the *Bacchus* is the statue which Michelangelo made for Cardinal Riario but which the Cardinal did not accept. In this case it would have been started in 1496 not 1497. The dimensions given by Michelangelo in a letter to Lorenzo di Pier Francesco de' Medici on 2 July 1496 (Milanesi, *Lettere* No. CCCXLII, p. 375 f.) are not those of the *Bacchus*.

13 *Codex Berolinensis*, fol. 72a. Hülsen and Egger, *Die römischen Skizzenbücher von Marten van Heemskerck im Kgl. Kupferstichkabinett zu Berlin* (Berlin, 1913), I, Plate 74; Tolnay I, Ill. 169.

14 Francisco de Hollanda, *Tractato de pintura antigua* (1538), in *Quellenschriften für Kunstgeschichte, Neue Folge* (Vienna, 1899), 194.

15 Carl Justi, *Michelangelo, Neue Beiträge* (Berlin, 1909), 77.

16 Ibid. 74.

17 *Die Jugendwerke des Michelangelo* (Munich, 1891), 29.

18 Tolnay, 'Michelangelostudien', *Jahrbuch der Preussischen Kunstsammlungen* (1933), 107.

19 Tolnay I, Ill. 22.

20 F. Sapori, *Jacopo Tatti, detto il Sansovino* (Rome, 1928), Plate 25.

21 Letter from the Cardinal to the elders of Lucca, 18 November 1497 (Milanesi, *Lettere*, p. 613, note 1). Cf. Poggi in *Michelangelo Buonarroti nel IV Centenario del 'Giudizio Universale'* (1942), 120; A. Schiavo, 'Giovanni de Villiers de la Groslaye e la Pietà di Michelangelo', *Studi Romani* VI (1958).

22 Poggi, op. cit. 120.

23 Milanesi, *Lettere*, p. 613, *Contratti* No. I.

24 Milanesi, *Lettere*, p. 614, *Contratti* No. I.

25 D. Redig de Campos, *Raffaello e Michelangelo* (Rome, 1946), 108 ff., which also describes the subsequent arrangement and corrects Tolnay I, 147, in this respect.

26 Vasari–Milanesi VII, 151.

27 Canto XXXIII, 1 ff.

28 Jeremiah 1:12. In 1736 four fingers on Mary's left hand were completed, possibly inaccurately. Cf. R. Wittkower, 'A Note on Michelangelo's Pietà in St Peter's', *Journal of the Warburg Institute* (1938); Tolnay I, 45 f.

29 Cf. the group (8th-century B.C.) from Urzulei, Cagliari, Museo, (W. Körte 'Deutsche Vesperbilder in Italien', *Kunstgeschichtliches Jahrbuch der Biblioteca*

Hertziana I (1937), Ill. 10) and from Secci (7th–8th-century B.C.; Hamburg, Museum für Kunst und Gewerbe: see catalogue 'Frühe Plastik aus Sardinien').

30 Cf. H. Swarzenski, 'Quellen zum deutschen Andachtsbild', *Zeitschrift für Kunstgeschichte* (1935), 141.

31 Ibid. Ill. 8. Cf. also E. Panofsky, 'Reintegration of a Book of Hours executed in the Workshop of the "Maître des Grandes Heures de Rohan"', *Medieval Studies for A. Kingsley Porter* II (Cambridge, 1939), fig. 16.

32 Cf. J. Ford and S. Vickers, 'The Relation of Nuno Concalves to the Pietà from Avignon', *Art Bulletin* (1939), 5 ff.

33 Körte, op. cit. 81.

34 Examples in Körte, op. cit., and Tolnay I, 181 and 182. Particularly close to Michelangelo is a drawing by Filippino Lippi in the Louvre (see A. Scharff, *Filippino Lippi* (Vienna, 1935), Fig. 172); cf. also M. Weinberger, *Michelangelo the Sculptor* I (London, 1967), 73.

35 Cf. the drawing by Philippe Colombe (1416) of the grave of Marshall Pierre Brosse in the Collegiate Church of St Martin d'Huriel in Burgundy; see P. Bradel, *Michel Colombe* (Paris, 1953), Plate 1 (I owe this information to Georg Kauffmann).

36 There is no connection between Michelangelo and the fresco of the so-called *Pietà di Marcialla* signed B. M.; cf. R. Weiss, *Michelangelo nel IV Centenario del 'Giudizio Universale'* (1942), 258 ff., Plate 1.

37 There may be a connection with Cavallini's *Pietà* of the angel in S. Paolo fuorile Mura in Rome, cf. the drawing in the *Codex Barberini*, Lat. 4406, fol. 123; S. Waetzoldt, *Die Kopien des 17. Jahrhunderts nach Mosaiken und Wandmalereien in Rom* (Vienna and Munich, 1964), Cat. 583, Ill. 322.

38 H. v. Einem, 'Das Abendmahl des Leonardo da Vinci', *Arbeitsgemeinschaft für Forschung des Landes Nordrhein-Westfalen. Geisteswissenschaften*, Heft 99 (Cologne and Opladen, 1961).

39 C. Kennedy and E. W.-P. Bacci, *The Unfinished Monument by A. del Verrocchio to the Cardinal Nicolò Forteguerri at Pistoia* (Northampton, 1932).

40 G. Nicco, *Jacopo della Quercia* (Florence, 1934), Plate XXVII.

41 *Die klassische Kunst*, 7th. ed. (Munich, 1924), 46.

CHAPTER 3

1 Vasari–Milanesi IV, 38. This was the cartoon of the painting in the Louvre, which Leonardo appears to have completed only between 1506 and 1513, after leaving Florence for the second time. The cartoon now in London was probably made in Milan.

2 Cf. F. Kriegbaum, 'Le statue di Michelangiolo nell' altare dei Piccolomini a Siena', *Michelangiolo Buonarroti nel IV Centenario del 'Giudizio Universale'*, (1942) and *Jahrbuch der preussischen Kunstsammlungen*, (1942); W. R. Valentiner, 'Michelangelo's Statuettes of the Piccolomini Altar at Siena', *Art Quarterly* (1942) and

Studies of Italian Renaissance Sculpture (London, 1950), 193 ff.; E. Carli, *Michelangelo e Siena* (Rome, 1964); Milanesi, *Lettere*, p. 267, *Contratti* No. VII.

3 W. R. Valentiner, *Studies . . .* 213 ff.; a different opinion in L. Dussler, *Kunstchronik* (1963), 309. Today the central niche contains an older statue of Mary and Child ascribed by Carli (*Critica d'Arte* (1949), 17 ff.) to the young Jacopo della Quercia. Michelangelo's group could well have been conceived in 1501, the year in which the Piccolomini altar was commissioned; it was probably completed after the second contract of 11 October 1504. Cf. V. Mariani, 'Sulla Madonna di Bruges di Michelangelo', *Bollettino d'Arte* (1954); Mancusi-Ungaro, *Michelangelo, The Bruges Madonna and the Piccolomini Altar* (New Haven, 1971).

4 L. Dussler, *Benedetto da Majano* (Munich, 1924), Ill. 39; Gengaro, 'Rapporti tra la scultura e pittura nella seconda metà del Quattrocento', *Bollettino d'Arte* (1937), 460 ff.

5 G. Nicco, *Jacopo della Quercia* (Florence, 1934), Plate XLV.

6 H. W. Janson, *The Sculpture of Donatello* (Princeton, 1957), I, Plates 290 ff.

7 Cf. Signorelli's tondo in the Uffizi (van Marle, *The Development of the Italian Schools of Painting*, Vol. XVI (1937), Fig. 16). The motif of the child also suggests classical influence, cf. a drawing by Pisanello in the Ambrosiana, Milan (Degenhardt, *Antonio Pisanello* (Vienna, 1940), Ill. 31, and Tolnay I, Ill. 203b). Margrit Lisner (*Zeitschrift für Kunstwissenschaft* (1958), 142) wrongly traces the motif to Maiano.

8 The documents in G. Poggi, *Il Duomo di Firenze* (Berlin, 1909), Nos 437, 441, 444, 446, 448, 449. Cf. also Tolnay I, 151; C. Seymour, 'Homo magnus et albus', *Akten des 21. Internationalen Kongresses für Kunstgeschichte, Bonn, 1964*, Vol. 2 (Berlin, 1967), 96 ff.; *Michelangelo's David: A Search of Identity* (Pittsburgh, 1967) (review: J. Paoletti, *Art Bulletin* (1969) and H. von Einem, *Zeitschrift für Kunstgeschichte* (1972)); H. W. Janson, 'Giovanni Chellini, Libro and Donatello', *Festschrift für L. H. Heydenreich* (Munich, 1964).

9 G. Swarzenski, *Nicola Pisano* (Frankfurt, 1926), Plate 16.

10 *Il pavimento della Cattedrale di Siena* (Siene n. d.), Plate 47; cf. also Castagno's leather shield in the Washington National Gallery (G. M. Richter, *Andrea del Castagno* (Chicago, 1943), Plates 16–17).

11 In the Louvre (Tolnay I, Ill. 93). W. Boeck (*Mitteilungen des Kunsthistorischen Instituts in Florenz* VIII (1959), 131 ff.) has convincingly shown that the bronze statuette acquired by K. von Pulszky in Florence and now in the Louvre (Tolnay 1970, Ill. 261) is a cast of Michelangelo's damaged original. There is little to support the suggestion of A. Parronchi (*Arte antica e moderna* V (1962), 170 ff.) that this original is the statuette in Naples ascribed to Pollaiuolo; cf. Isermeyer in *Zeitschrift für Kunstgeschichte* (1965), 324. On the inscription see Papini, Ch. XXXIX, 120, and D. Frey, *Michelangelo* (Cologne, 1942), 17.

12 Gaye II, 455; C. Neumann, 'Die Wahl des Platzes für Michelangelos David in Florenz im Jahre 1504', *Repertorium für Kunstwissenschaft* (1916); E. Panofsky, 'Die Michelangeloliteratur seit 1914', *Wiener Jahrbuch für Kunstgeschichte* (1922), 27 f.;

H. Käutner, 'Uber die Entstehung und die Formen des Standbildes im Cinque-cento', *Münchener Jahrbuch für bildende Kunst* (1956), 141.

13 Vasari–Milanesi VII, 154.

14 Milanesi, *Lettere* 625 f., *Contratti* No. VI; cf. also K. Frey in *Jahrbuch der Preussischen Kunstsammlungen* (1909), Beiheft, 109 ff.

15 18 December 1505; Gaye II, 477; Thode I, 92.

16 J. Wilde, 'The Hall of the Great Council of Florence', *Journal of the Warburg and Courtauld Institutes* (1944); 'Michelangelo and Leonardo', *The Burlington Magazine* (1953).

17 Thode assumes (I, 95), with good reason, that the cartoon was completed between the time of Michelangelo's flight from Rome (17 April 1506) and the following November, when he went to Bologna. Tolnay (I, 210), apparently misled by the omission of the date 1506, maintained that Michelangelo started work on the wall between the end of April and the end of May 1505, but at this moment Michel-angelo was on his way to Carrara to choose the marble for the tomb of Julius II; Giovanni Balducci's letter of 9 May 1506 (Gotti II, 52) is here taken to refer to the fresco but on p. 36 to the *St Matthew*.

18 On the reconstruction of Leonardo's work see Neufeld, 'Leonardo's Battle of Anghiari: a genetic reconstruction', *Art Bulletin* (1949), and J. Wilde, op. cit. 53.

19 Vasari–Milanesi VI, 433 f. Cf. W. Köhler, 'Michelangelos Schlachtkarton', *Kunst-geschichtliches Jahrbuch der k. u. k. Zentralkommission* (Vienna, 1907), and J. Wilde, op. cit. Wilde's reconstruction is supported by H. W. Grohn, 'Die Schule der Welt; Zu Michelangelos Karton der Schlacht bei Cascina', *Il Vasari: Rivista di Studi manieristici* XXIV (1963), but rejected by C. A. Isermeyer, 'Die Arbeiten Leonardos und Michelangelos für den grossen Ratssaal in Florenz', *Festschrift für L. H. Heydenreich* (1964) and *Zeitschrift für Kunstgeschichte* (1965), 330 f. I cannot accept Isermeyer's views. Cf. also R. Salvini, 'La Battaglia di Cascina: Saggio di Storia di Critica delle Varianti', *Studi di Storia dell' Arte in Onore di Valerio Mariani* (Naples, 1971), 131 ff.

20 Vasari–Milanesi VII, 160. Cf. also the following passage: 'There were also many groups of figures drawn in different ways: some outlined in charcoal, others sketched with a few strokes, some shaded gradually and heightened with lead-white.' A. Foratti in *Rassegna d'Arte* (1920), 240 ff.

21 *Cronaca* XI, Ch. 97 (*Cronisti del Trecento*, ed. R. Palmarocchi (Milan, 1935), 549 ff.). Cf. Tolnay I, 218 f.

22 *Lebensbeschreibung des Benvenuto Cellini*, Weimarer Ausgabe I, Bd. 44, 308.

23 C. Justi II, 172.

24 M. Easton, 'The Taddei Tondo: A frightened Jesus?', *Journal of the Warburg and Courtauld Institutes* 32 (1969), 311 ff.

25 G. Poggi, 'Michelangelos Madonna Doni in den Uffizien', *Jahresberichte des Kunst-historischen Instituts in Florenz* (1906–7); H. W. Lightbown, 'Michelangelo's great tondo: its origin and setting', *Apollo* 89 (1969), 22 ff.; L. d'Ancona, 'The Doni

Madonna by Michelangelo: an iconographic study', *Art Bulletin* 50 (1968), 43 ff.);
C. Eisler, 'The Athlete of Virtue' *The Iconography of Asceticism. Essays in Honor of Erwin Panofsky*, Vol I (New York, 1961).

26 M. Lisner, 'Zum Rahmen von Michelangelos Madonna Doni', *Festschrift für Theodor Müller* (Munich, 1965).

27 Vasari–Milanesi VII, 158.

28 Jacob Burckhardt, *Der Cicerone, Gesamtausgabe IV* (1933), 259.

29 C. Justi II, 178.

30 Cf. D. Thompson, *Materials of Medieval Painting* (London, 1936); Dörner, *Malmaterial* (Stuttgart, 1938), 272.

CHAPTER 4

1 Vasari–Milanesi IV, 282.

2 J. Klaczko, *Jules II* (Paris, 1898), 13. Cf. L. v. Pastor, *Geschichte der Päpste* III (Freiburg, 1895); E. Steinmann, *Die Sixtinische Kapelle* II (Munich, 1905), 3 ff.; F. Hartt, 'Lignum Vitae', *Art Bulletin* (1950), 116 f.

3 Letter from Michelangelo to Giovanfrancesco Fattucci in January 1524 (Milanesi, *Lettere* CCCLXXXIV, p. 429).

4 Cf. the sub-contracts of 12 November and 10 December 1505 (Milanesi, *Lettere*, pp. 630 and 631, Contratti Nos VIII and IX).

5 Condivi, ed. cit. 64.

6 Letter of Michelangelo to Giuliano da Sangallo, 2 May 1506 (Milanesi, *Lettere* CCCXLIII, p. 377).

7 Condivi, ed. cit. 116.

8 Cf. H. v. Einem, 'Michelangelos Juliusgrab im Entwurf von 1505 und die Frage seiner ursprünglichen Bestimmung', *Festschrift für H. Jantzen* (Berlin, 1951), 152 ff.; cf. also Tolnay 1954 and 1970 and G. C. Argan in Portoghesi–Zevi 65. This thesis of a connection between the Tomb of Pope Julius and St Peter's was rejected by Isermeyer (*Zeitschrift für Kunstgeschichte* (1965), 330 f.), M. Weinberger (*Michelangelo the Sculptor* I (1967), 135 ff.) and G. Werdahl ('Michelangelos erster Entwurf des Juliusgrabmales', *Konsthistorisk Tidskrift* 32 (1963), 65 ff.). In 'Le premier projet pour S. Pierre de Rome: Bramante et Michelange', *The Renaissance and Mannerism. Studies in Western Art. Twentieth Congress of the History of Art* (New York, 1961), Vol. 2 (1963), 70 ff., F. W. Metternich proposes the south-west chapel of Bramante's ideal project U.I.A. as the chosen spot for the tomb, but this proposal is not convincing; cf. Isermeyer, op. cit. 328, who returns to the suggestion of the Rosselino Chapel – which contradicts Vasari's account. Cf. also J. Pope-Hennessy, 'Michelangelo, The Tomb of Pope Julius II', in *Italian High Renaissance and Baroque Sculpture* (London, 1963), 25 ff.

9 E. Panofsky, 'The first two projects of Michelangelo's Tomb of Julius II', *Art Bulletin* (1937), 561; Tolnay IV, 9 ff. The dimensions from Condivi (ed. cit. 66) and Vasari (Vasari–Milanesi VII, 164).

10 The dimensions of the lower storey are taken from the third contract of 8 July 1516 (Milanesi, *Lettere, Contratti* No. XVI, p. 646). Cf. J. Wilde in *Jahrbuch der kunsthistorischen Sammlungen* (Vienna, 1928), 213 f. It is not possible to give precise measurements for the remainder of the tomb.

11 The sources do not make it clear whether two side-niches were intended or three, although I incline to the latter view (cf. Panofsky in *Art Bulletin* (1937), 571).

12 Cf. Tolnay IV, 9 ff. and 137 ff., Ill. 95–7.

13 Cf. ibid. 11 f. and 93. In *Michelangelo's Entombment of Christ* (National Gallery, 1972) Michel Levey suggests that an unfinished painting of this subject in the National Gallery is by Michelangelo and was originally part of the 1505 design for the tomb; with the abandonment of this design the painting was left unfinished; later (1515) it was to have been hung in Pier Francesco Borgherini's chapel in S. Pietro in Montorio in Rome but nothing came of this plan either. Whether the painting is by Michelangelo or by one of his school (Antonio Mini, Silvio Falconi, Pietro Urbano, Tiberio Calcagni) is open to dispute, as is also the date. The bearer on the left seems to show the influence of the *Laocoon* (discovered on 14 January 1506), which would give a *terminus post quem* (cf. A. Smart, 'Michelangelo, the Taddeo Taddei Madonna and the National Gallery Entombment', in *Journal of the Royal Society of Arts* (October 1967), 850 ff., and C. Gould, op. cit.). It also recalls the *St Matthew*. The head of Christ, on the other hand, recalls the crucifix for S. Spirito, also in that the figure is naked. As Wölfflin (*Die Jugendwerke Michelangelos* (1891), 82) pointed out, however, the Mannerist style of the work suggests a date in the 1520s. I find it hard to accept the ascription to Michelangelo, let alone that the picture formed part of the 1505 design for the tomb of Julius.

14 Ed. Frey 70.

15 Condivi, ed. cit. 66.

16 Cf. L. D. Ettlinger, 'Pollaiuolo's Tomb of Pope Sixtus IV', *Journal of the Warburg and Courtauld Institutes* (1953).

17 Condivi, ed. cit. 68.

18 Vasari–Milanesi VII, 164.

19 Cf. above, p. 79.

20 E. Panofsky, *Tomb Sculpture* (New York, 1964); M. Weinberger, op. cit. 136 f.

21 A. Gotti, *Vita di Michelangelo Buonarroti* 2 (Florence, 1876), 150, and letter by Daniele da Volterra to Vasari on 27 March 1564 (Gotti 1, 358). J. Hess ('Michelangelo and Cordier', *The Burlington Magazine* XXXII (1943), 55 ff.) has proved from Totti's *Ritratto di Roma* (1638) and Baglione's *Vite* (1642) that the unfinished block for a statue of St Gregory was completed in 1602 by Nicolas Cordier for the Oratorio di S. Barbara, next to S. Gregorio Magno in Rome.

22 Ed. Frey, 63.

23 Condivi, ed. cit. 62; cf. W. Körte, 'Deinokrates und die barocke Phantasie', *Die Antike* (1937).

24 Cf. H. v. Einem, op. cit., 161 f.

25 On the relationship to the Gothic papal tombs in Avignon and Villeneuve see H. v. Einem, op. cit. 162, and Tolnay IV, 26. Julius II was Archbishop of Avignon.

26 Cf. H. v. Einem, op. cit. 163, and Tolnay IV, 26.

27 Tolnay IV, Ill. 232.

28 Panofsky, op. cit., Fig. 2.

29 F. Kriegbaum, in *Michelangelo Buonarroti, Die Bildwerke* (Berlin, 1940), 10, refers to Hadrian's tomb, but against this see R. Pierce, 'The Mausoleum of Hadrian and the Pons Aelius', *The Journal of Roman Studies* (1925) and G. Lugli, *Monumenti antichi a Roma e suburbio* III (Rome, 1938), 707 ff.

30 Cf. H. v. Einem, op. cit. 154 f. and Tolnay IV, 19 f.

31 Letter to Aliotti, October 1542 (Milanesi, *Lettere* No. CDXXXV, p. 494).

32 Letter of 10 May 1506; Gotti I, 46.

33 Condivi, ed. cit. 74.

34 Letter to Fattucci, January 1524 (Milanesi, *Lettere* No. CCCLXXXIII, p. 427).

35 Cf. Tolnay I, 169.

36 J. Wilde, *Italian Drawings: Michelangelo and his Studio* (London, 1953), No. 3.

37 Vasari-Milanesi VII, 273. Benvenuto Cellini, *Trattato della Scultura* (Florence, 1568), Ch. 6.

38 Kriegbaum, op. cit. 29.

39 Ibid. 43.

40 Justi II, 204.

41 Salis, *Antike und Renaissance* (Erlenbach and Zürich, 1947), 136 ff.

42 Cf. Tolnay I, Ill. 242.

43 Janson, *Donatello*, Plate 43a.

44 Cf. Tolnay I, 219 ff.

45 Tolnay I, Ill. 247.

CHAPTER 5

1 Condivi, ed. cit. 82.

2 Justi I, 15 f.

3 Cf. E. Steinmann, *Die Sixtinische Kapelle*, 2 vols (Munich, 1901, 1905); Tolnay II, 11 ff.; J. S. Ackermann, *The Cortile del Belvedere* (Rome, 1954); E. Battisti, *Il significato simbolico della Cappella Sistina, Commentari* VIII (1957); J. White and J. Shearman, 'Raphael's Tapestries and their cartoons', *Art Bulletin* (1958); R. Salvini, *La Cappella Sistina in Vaticano* (Milan, 1965); D. R. de Campos, 'L'architetto e il costruttore della Cappella Sistina', *Palatino* IX (1965), 90 ff. and *I Palazzi Vaticani* (Bologna, 1967), 64 ff.

4 Tolnay II, Ill. 253.

5 Cf. F. X. Kraus, *Geschichte der christlichen Kunst* II, 2 (by J. Sauer) (Freiburg, 1908), 344 ff.; L. D. Ettlinger, *The Sistine Chapel before Michelangelo* (Oxford, 1965). The 15th-century frescoes have been in the process of restoration since 1965, and the

original titles were discovered in the course of this work, cf. D. R. de Campos, 'I
tituli degli affreschi del Quattrocento nella Cappella Sistina', *Studi di Storia dell'
Arte in Onore di Valerio Mariani* (Naples, 1972).

6 Cf. C. Justi I, 88.

7 Cf. Tolnay II, 15 ff.; B. Biagetti, 'La Volta della Cappella Sistina', *Rendiconti della
Pontificia Accademia Romana di Archeologia* XII (1936), 199 ff.; 'Indagini sul pro-
cedimento disegnativo di Michelangelo', *Michelangelo Buonarroti nel IV Centenario
del 'Giudizio Universale'* (1942), 184 ff.

8 Cf. Tolnay II, 113 ff.

9 *Opera*, ed. Fea, II, 207, and letter to Azara, 4 May 1774, Azara–Fea, No. 27.

10 The sources give no precise date but I accept the interpretation given by Thode I,
236 ff., against the views of Tolnay II, 110 ff., and 1970, 240. Tolnay dates the last
four historical pictures, eight of the ignudi, five of the prophets and sibyls to
January–August 1511 (cf. also F. Hartt in *Art Bulletin* (1950), 240 ff., and J. Schulz's
review of Friedberg, *Painting of the High Renaissance in Rome and Florence* (Cam-
bridge, 1961) in *Art Bulletin* (1963), 162). The separation of lunettes and penden-
tives by Tolnay II, 111 f. seems to me correct.

11 Milanesi, *Lettere* No. CCCLXXXIII, p. 426 ff.

12 Milanesi, *Lettere* No. CCCLXXXIV, p. 429 f.

13 Tolnay II, No. 36, Ill. 230.

14 'Ein Entwurf Michelangelos zur Sixtinischen Decke', *Jahrbuch der Preussischen
Kunstsammlungen* (1892), 178 ff.

15 Gotti I, 46.

16 A. v. Salis, *Antike und Renaissance* (Erlenbach and Zürich, 1947), 37 ff.; J. Schulz,
'Pinturicchio and the Revival of Antiquity', *Journal of the Warburg and Courtauld
Institutes* XXV (1962); N. Dacos, 'La découverte de la Domus aurea et la for-
mation des grotesques à la Renaissance', *Journal of the Warburg and Courtauld
Institutes* XXI (1969).

17 Steinmann, op. cit. II, 64. Dacos (see note 16) makes an unconvincing case for a
relationship between the first two designs and the stuccoed ceilings of the thermae
in Hadrian's villa near Tivoli.

18 Vasari–Milanesi VII, 178.

19 E. Wind, 'Sante Pagnini and Michelangelo', *Gazette des beaux-arts* (1944 and 1947);
Tolnay II, 254 f.; F. Hartt, 'Pagnini, Vigerio and the Sistine Ceiling', *Art Bulletin*
(1951), 262 ff.

20 F. Hartt, 'Lignum Vitae', *Art Bulletin* (1950).

21 Cf. also F. Hartt's review of Tolnay II in *Art Bulletin* (1950), 246 ff.

22 Tolnay II, No. 37, Ill. 231; Frey and Thode regard this as the first design. It was
first correctly interpreted by J. Gantner, 'Zum Schema der Sixtinischen Decke',
Monatshefte für Kunstwissenschaft (1921). Berenson regarded it as inauthentic; its
authenticity is accepted by J. Wilde, *Italian Drawings in the Department of Prints
and Drawings in the British Museum: Michelangelo and his Studio* (London, 1953),

18, and by Dussler, No. 5. Cf. also Panofsky in *Wiener Jahrbuch für Kunstgeschichte* (1922), 35.

23 Gantner took this sketch to be of historical pictures rather than of the prophets and sibyls, but without drawing the consequences for the commissioning of the work. Wind and Hartt take no account of the drawing. A third sketch in the British Museum (Dussler No. 325) seems closely related. Cf. Wilde, op. cit., No. 10 and Tolnay II, No. 38, Ill. 232.

24 23 August 1787 (Hamburger Ausgabe XI, 386).

25 Cf. E. Panofsky, *Die Sixtinische Decke* (Leipzig, 1921), 5 f.

26 There is also a strip of blue sky visible above the thrones of Jonas and Zechariah.

27 Justi I, 22.

28 F. Kriegbaum, 'Michelangelo und die Antike', *Münchener Jahrbuch der bildenden Kunst* 3–4 (1952–3), 30 f.

29 Cf. E. Wind, 'Maccabean Histories in the Sistine Ceiling', *Italian Renaissance Studies: A Tribute to the late Cecilia M. Ady* (London, 1960).

30 The Gospel for The Birth of the Virgin Mary, 8 September.

31 Cf. Justi I, 88.

32 Cf. Wind, op. cit. 224, and Hartt, *Art Bulletin* (1950), 139 ff.; R. Bauerreis, *Arbor Vitae* (Munich, 1938); E. Wind, *Michelangelo's Prophets and Sibyls* (London, 1960).

33 Hartt, *Art Bulletin* (1950), 181.

34 Steinmann, op. cit. II, 349.

35 Ibid, 351.

36 Ibid. 406; G. Jachmann, *Die vierte Ekloge Vergils* (Cologne and Opladen), 1953.

37 Hartt, *Art Bulletin* (1950), 189.

38 Cf. L. Freund, *Studien zur Bildgeschichte der Sibyllen* (Hamburg, 1936); W. Vöge, *Jörg Syrlin der Ältere* II (Berlin, 1950).

39 'Judicii signum tellus sudore madescet. E caelo rex adveniet per saecla futurus: Scilicet in carne praesens ut judicet orbem'; cf. L. Freund, op. cit. 2; Steinmann, op. cit. II, 383; W. Vöge, op. cit. 15.

40 Book III, 441 ff., and Book VI, 10 ff.

41 Tolnay II, 20.

42 Cf. Hartt, *Art Bulletin* (1950), 181 and 197 f.

43 Cf. H. Keller, *Giovanni Pisano* (Vienna, 1942), Plate 49 ff. and 87 ff.

44 Cf. L. Dussler, *Signorelli* (Stuttgart, 1927), Plate 7 ff.

45 Janson, *Donatello* I, Ill. 38 ff.

46 Dussler, op. cit. Plate 119.

47 Steinmann, op. cit. II, 371. Bottom left are the letters A L E F of the Hebrew alphabet, one of which was set at the beginning of each strophe.

48 *Die klassische Kunst*, 68.

49 Justi I, 94.

50 Jonah I–IV.

51 Nicco, *Jacopo della Quercia*, Plate XV; cf. Thode I, 342 f.

52 Dussler, Plate 28; cf. also E. Panofsky in *Wiener Jahrbuch* (1922), 34 f.

53 *Aeneid*, Book VI, 10.

54 *Il Pavimento della Cattedrale di Siena*, Plate 8.

55 This is the view of Tolnay II, 157.

56 Vasari–Milanesi VII, 184.

57 *Die klassische Kunst* 67.

58 Cf. Panofsky, op. cit. 7.

59 Pastor, *Geschichte der Päpste* III, 576 f.; Steinmann, op. cit. II, 17 f.

60 Cf. Tolnay II, 65.

61 *Die klassische Kunst* 70; cf. A. Foratti, 'Gli Ignudi della Volta Sistina', *L'Arte* XXI (1918), 109 ff.; E. Panofsky in *Wiener Jahrbuch* (1922), 38 ff.

62 Cf. J. Garber, *Wirkungen der frühchristlichen Gemäldezyklen der alten Peters- und Paulsbasiliken in Rom* (Berlin and Vienna, 1918).

63 Nicco, op. cit., Plates XXV ff.

64 L. Planiscig, *Lorenzo Ghiberti* (Vienna, 1940), Plates 47 ff.

65 v. Marle X, Figs. 145 ff.

66 Tolnay's attempt (*Bollettino d'Arte* XXIX (1936), 389 ff.; II, 22 and 129) to see in this central group of pictures, not the biblical themes of Creation and Fall but the Neoplatonic motif of the elevation of the soul, is not convincing.

67 Justi I, 28.

68 Cf. Wölfflin in *Jahrbuch der Preussischen Kunstsammlungen* (1892); Gantner, op. cit. 4. Panofsky (*Wiener Jahrbuch* (1922), 41) also refers to the tripartite arrangement of an original overall plan for the whole ceiling.

69 Cf. Quercia's figure of the delving Adam in S. Petronio in Bologna; Nicco, op. cit., Plate XXXV.

70 The symbolic allusions adduced by H. B. Gutman ('Religiöser Symbolismus in Michelangelos Sintflutfresko', in *Zeitschrift für Kunstgeschichte* (1955), 74 ff.) are not convincing. On the other hand one may recall that on 21 September 1494 Savonarola gave a sermon in the cathedral in Florence on the text: 'And behold, I, even I, do bring a flood of waters upon the earth' (Genesis 6:17). This sermon had a great impact, and Michelangelo may well have been among the congregation. Cf. J. Schnitzer, *Quellen und Foreschungen zur Geschichte Savonarolas* III, 12. Cf. also E. Wind, 'The Ark of Noah. A Study in the Symbolism of Michelangelo', *Measure* I (1950).

71 Nicco, op. cit., Plate XXXV.

72 Cf. E. Gombrich, 'A Classical Quotation in Michelangelo's "The Sacrifice of Noah"', *Journal of the Warburg Institute* I (1937), 69 ff.

73 S. Maria del Carmine, Brancacci Chapel; Tolnay II, Ill. 302.

74 S. Petronio, Bologna; Nicco, op. cit., Plate XXXIV.

75 Wölfflin, *Die klassische Kunst* 62.

76 Nicco, op. cit., Plate XXXII.

77 Thode I, 312, and Tolnay II, 35. Perhaps it is also meant to portray the goddess Sophia; cf. U. Wilckens, *Weisheit und Torheit* (Tübingen, 1959), 182 f.

78 Panofsky, op. cit. 32, Ill. 3; cf. also H. v. Einem, 'Michelangelo und die Antike', *Antike und Abendland* I (1945), 65 f.

79 Condivi, ed. cit. 100

80 Vasari–Milanesi VII, 180.

81 Cf. Thode I, 303 ff.; K. Lange, 'Michelangelos zweiter Schöpfungstag', *Repertorium für Kunstwissenschaft* (1919); E. Panofsky, op. cit. 41 ff. Tolnay II, 37 and 138, follows Vasari's interpretation and refers to Italian Bible illustrations.

82 Garber, op. cit., Ill. 2.

83 Cf. E. Panofsky, *Idea* (Leipzig, 1924), 18.

84 Cf. Panofsky, *Die Sixtinische Decke*, 8.

85 Justi I, 33.

86 Cf. E. Wind, 'The Crucifixion of Haman', *Journal of the Warburg Institute* II (1938).

87 Tolnay II, 105 ff.

88 Vasari–Milanesi VII, 185.

89 Thode I, 381 and 388.

90 Panofsky, *Die Sixtinische Decke*, 10.

91 *The Complete Poems of Michelangelo*, trans. J. Tusiani (New York, 1960), 24.

92 Cf. Tolnay II, 99 ff. and Hartt, op. cit. 239.

CHAPTER 6

1 Milanesi, *Lettere* No. XV, p. 23 (wrongly dated 1509). Shortly after he writes to his father: 'I am not yet working but waiting for the Pope to tell me what I am to do' (no date; *Lettere* No. XXXVI, 46).

2 Cf. the diary of Paris de Grassis, J. J. I. v. Döllinger, *Beiträge zur politischen, kirchlichen und Kulturgeschichte der sechs letzten Jahrhunderte* III (Regensburg, 1863), 363 ff., 4 Februaty 1513: 'Addiditque velle . . . in capella Sixtina se locarem sic ibi permanendum quod sepulcrum suum, quod, iam inchoari mandaverat, perficeretur' (429); 21 February: 'Portavimus super tapete ad altare capellae Sixtinae . . . circa horam noctis tertiam posuimus in capsa et sepulcro subterraneo sub tribuna dictae capellae inter altare ed parietem tribunae' (432 f.).

3 During the Sack of Rome in 1527 Julius's tomb was plundered. See M. Cerrati, 'Tiberii Alpherani de Basilicae Vaticanae antiquissima et nova structura', in *Studi e Testi* 26 (Rome, 1914), 79 f. In 1550 or 1557 a new location seems to have been found for the grave (cf. Cerrati 81). A barely decipherable inscription on a stone in the Vatican dungeons records that Julius lay 'sub hoc elegantissimo aereo monumento', i.e. Pollaiuolo's tomb of Sixtus IV.

4 However, Paris de Grassis's reference to a 'sepulcrum . . . quod iam inchoari mandaverat' makes it seem likely. An authentic will of the Pope's has not survived; cf. Pastor, *Geschichte der Päpste* III, 683 f.

5 Milanesi, *Lettere*, p. 635 ff., *Contratti* No. XL; cf. also Maurenbrecher, 296.

The original contract has since been found; cf. S. Prete, *The Original Contract with Michelangelo for the Tomb of Pope Julius II* (New York, 1963).

6 Milanesi, *Lettere*, p. 640, *Contratti* No. XIII.

7 30 July 1513. Milanesi, *Lettere* No. XCII, p. 109.

8 Letter of May 1518; Milanesi, *Lettere* No. CCCLIV, 391.

9 Letter of 9 June (?); Milanesi, *Lettere* No. XCVII, p. 115. On 11 August he wrote again: 'Since returning [from Florence] I have done no work at all. I have only concerned myself with models and preparatory work, so that when the time comes, I can embark on the final task with all the strength at my command. That is what I have pledged myself to do.' (*Lettere* No. CIII, 121.)

10 Cf. Justi I, 297.

11 On 21 April 1516 the Cardinal asked Michelangelo whether the Duchess of Urbino could view the work on the tomb (G. Daelli, *Carte michelangiolesche* (Milan, 1865), No. 11).

12 Milanesi, *Lettere*, p. 636, *Contratti* No. XI; Maurenbrecher 296.

13 Milanesi, *Lettere*, p. 640, *Contratti* No. XIII.

14 C. A. Isermeyer, 'Zur Rekonstruktion des Juliusgrabes von Michelangelo', *Kunstchronik* (1954), 268, erroneously proposed that the tomb was meant for Sixtus IV's choir chapel but in 1965 retracted the suggestion. His proposal that it was intended for the Sistine Chapel is equally improbable, as is W. Metternich's notion ('Zur Aufstellung des Juliusgrabes nach dem Entwurf von 1513', in *Festschrift für Heinrich Lützeler* (Bonn, 1962)) that it was to be erected against one of the piers of the transepts in Bramante's working design for St Peter's.

15 Cf. Tolnay II, 129. Isermeyer, op. cit. 268, explains the discrepancy in terms of the difference between the Roman and the Florentine *palmo*.

16 Condivi, ed. cit. 116.

17 Vasari–Milanesi VII, 187.

18 Letter to Fattucci in December 1523 (Milanesi, *Lettere* No. CCCLXXXIII, p. 428) and letter to Aliotti in October 1542 (Milanesi, *Lettere* No. CDXXXV, p. 489 ff.).

19 Cf. the drawing in the British Museum (Dussler No. 152; Tolnay IV, Ill. 104), which shows a view of the completed lower storey without the frieze. On the date see Dussler 97. Two niches are now intended for each side (Milanesi, 637).

20 Milanesi, *Lettere*, p. 637, *Contratti* No. XI.

21 Milanesi, *Lettere*, p. 637.

22 This uncertainty has led to widely varying reconstructions. Panofsky (*Art Bulletin*, 1937) imagined the *cappelletta* as a projecting structure (although the record speaks of it being 'above that face of the tomb which adjoins the wall') which stretched the whole width of the base (contrary to the evidence of the Berlin sketch); he puts two of the statues at the ends and extends the niches for the two statues at the side of the Madonna up to the architrave; the Madonna he takes to be a standing figure. Tolnay's reconstruction (Ill. 204), which keeps closer to the text of the record and to the Berlin sketch, seems the more likely.

23 This is Tolnay's view (IV, 33 f.).

24 Cf. H. W. Janson, *Apes and Ape Lore in the Middle Ages and the Renaissance* (London, 1952). Panofsky maintains (*Grabplastik*, 1964) that there is the head of an ape behind the Captive's left knee.

25 On this motif see H. v. Einem, 'Das Grabmal der Königin Margarete von Giovanni Pisano', *Festschrift für Hans Rudolf Hahnloser* (Berne, 1959).

26 Cf. L. Ettlinger in *Journal of the Warburg and Courtauld Institutes* (1953), 269 ff.

27 Cf. H. v. Einem, 'Raffaels Sixtinische Madonna', *Konsthistorisk Tidskrift* 37 (1968).

28 Justi I, 222.

29 An opposing opinion in Kriegbaum 36.

30 Cf. O. Ollendorf, 'Der Laokoon und Michelangelos gefesselter Sklave', *Repertorium für Kunstwissenschaft* (1898), 112 ff.

31 Cf. A. v. Salis, *Antike und Renaissance*, 147.

32 Cf. J. Hess, 'Zum Stil Guido Renis', *Zeitschrift für Kunstgeschichte* (1956), 190, Ill. 15 and 17.

33 Justi I, 224.

34 L. Planiscig, *Bernardo und Antonio Rossellino* (Vienna, 1942), Plate 66 ff.

35 L. Dussler, *Benedetto da Maiano* (Munich, 1924), Ill. 41.

36 A. Grünwald, 'Über einige Werke Michelangelos in ihrem Verhältnis zur Antike', *Jahrbuch der Kunsthistorischen Sammlungen Wien* (1907-9), 139.

37 A precise dating of the *Moses* is not possible on the basis of the sources. K. A. Laux's proposal of a late date (*Michelangelos Juliusmonument* (Berlin, 1943), 149 ff.) is made untenable by his reference to a drawing of this figure by Leonardo, which could only have been made during Leonardo's stay in Rome between 1513 and 1516; cf. W. R. Valentiner, 'A late drawing by Leonardo', *The Burlington Magazine* (1949), 343. Equally untenable is the attempt by W. Messerer to date it as 1506 (*Kunstchronik*, 1962). E. Rosenthal, in an important work ('Moses dal di sotto in su' in *Art Bulletin* XLVI (1964)), proves that the statue was carved from a horizontal block.

38 Condivi, ed. cit. 154.

39 v. Marle III, Fig. 249.

40 Janson, op. cit., Plates 11 ff.

41 H. Grimm I, 359.

42 Cf. H. v. Einem, 'Michelangelos Juliusgrab im Entwurf von 1505', *Festschrift für Hans Jantzen* (Berlin, 1951), 155; P. Murray, 'Bramante and Michelangelo', *Akten des 21. Internationalen Kongresses für Kunstgeschichte in Bonn, 1964*, II, 54 ff.

43 Letter to Giovanfrancesco Fattucci, January 1524 (Milanesi, *Lettere* No. CCCLXXXI).

44 Condivi, ed. cit. 196.

45 Justi II, 256.

46 Cf. G. Marchini, *Giuliano da Sangallo* (Florence, 1942), 69 ff. and 100 f.; J. S. Ackermann, *The Architecture of Michelangelo* (London, 1966), I, 11 and II, 3 ff.;

R. Pommer, *The Drawing for the façade of S. Lorenzo by Giuliano da Sangallo* (New York University, 1957).

47 Vasari–Milanesi VII, 188.

48 Cf. Tolnay, 'Michelange et la façade de S. Lorenzo', *Gazette des beaux-arts* (1934), 24 ff.; W. Körte in *Zeitschrift für Kunstgeschichte* 3 (1934), 300; W. and E. Paatz, *Die Kirchen von Florenz* II (Frankfurt, 1955), 467 and 526 ff.; Ackermann II, 3 ff.; E. Hubala, 'Michelangelo und die florentiner Baukunst', *Michelangelo Buonarroti* (1963), 157 ff. Charles de Tolnay, *I progetti di Michelangelo per la facciata di S. Lorenzo a Firenze*, Commentari XXIII (1972).

49 Milanesi, *Lettere* No. CDXXXV, p. 489.

50 Condivi, ed. cit. 118.

51 Cf. the letters from the Controller of the Papal Exchequer, Domenico Buoninsegni, who conducted the negotiations with Michelangelo for Pope Leo X and Cardinal Giuliano de' Medici; cf. K. Frey, *Sammlung ausgewählter Briefe an Michelangelo Buonarroti* (Berlin, 1899), 40 ff.; Tolnay 1934, 24 ff.

52 To Buoninsegni, July–August 1517; Milanesi, *Lettere* No. CCCXLVIII, p. 383.

53 To Berto da Filicaia, August 1518; Milanesi, *Lettere* No. CCCLVI, p. 394.

54 20 March 1517; Milanesi, *Lettere* No. CCCXLVI, p. 381.

55 Milanesi, *Lettere*, pp. 671 f., *Contratti* No. XXXIII; the original is in the possession of the Historical Society of Pennsylvania (cf. Tolnay in *Art Bulletin* XXII (1940), 129 f.).

56 Milanesi, *Lettere* No. CCCLXXIV, p. 403.

57 Ackerman I, Ill. 3a; Marchini, op. cit., Plate XXIVb.

58 Ibid. Ill. 3d; Dussler No. 86, Ill. 57. The drawing also contains studies for the 1516 design of the tomb of Pope Julius: cf. Barocchi No. 43, Plate LXXIX.

59 Ackerman I, Ill. 3c; Dussler No. 123; Barocchi No. 42, Plate LXXVIII.

60 Ibid. Ill. 4a; Dussler No. 89; Barocchi No. 44, Plate LXXXI.

61 Ibid. Ill. 5a; Dussler No. 85; Barocchi No. 45, Plate LXXXII. On the reverse is a sketch of the body of Julius for the 1516 project. (Barocchi Plate LXXXVIII)

62 Marchini, op. cit. XXIIIb.

63 Tolnay 1934, 38.

64 Ackerman I, Ill. 5b; see also Ackerman II, 15.

65 Milanesi, *Contratti* 671 ff.

66 Tolnay 1934, 41.

67 H. Thode, *Michelangelo: Kritische Untersuchungen* 2 (Berlin, 1908), 98.

68 Text in Milanesi, *Lettere* 644, *Contratti* No. XVI.

69 Tolnay's reconstruction (IV, Ill. 205) is not exact. Individual statues should be set in the niches, and the upper storey has applied half-columns, not pilasters; also the summit of the monument, with neither pediment nor lunette-like crown, seems problematical. J. Wilde ('Michelangelo's Victory', in *Charlton Lectures on Art* (1954), 7 ff., Fig. 1) offers a different solution.

70 Cf. Wilde above, note 69.

71 A drawing of January 1517 in the Casa Buonarotti (Dussler No. 105; Tolnay IV, Ill. 100) shows that the upper storey was to have been one-eighth higher than provided for in the contract.

72 Tolnay 1934, 25 ff.; Paatz II, 528.

73 Cf. Dussler No. 279, Ill. 159 (drawing in the Casa Buonarroti). The contract reads: 'la figura del morto, ciò è di Papa Julio, con dua altre figure che l' mettono in mezzo' (Milanesi 650). The connection between the 1516 design and the designs for S. Lorenzo is shown by the fact that on the verso of this sheet (Dussler No. 85) is a sketch for the S. Lorenzo façade.

74 Cf. a letter from Cardinal Agen to Michelangelo on 23 October 1518 and from Leonardo Sellaio to Michelangelo in October 1518; see Frey, *Sammlung ausgewählter Briefe an Michelangelo*, 122 and 123.

75 Cf. letter of Sellaio to Michelangelo on 13 February 1519 (ibid. 133).

CHAPTER 7

1 A. E. Popp, *Die Medicikapelle Michelangelos* (Munich, 1922), 101.

2 Cf. D. Frey, *Michelangelostudien* (Vienna, 1920), 142.

3 Cf. L. v. Pastor, *Geschichte der Päpste* IV, I, 193; Justi II, 232; S. F. Young, *The Medici* (London, 1913), Ch. 12.

4 Popp, op. cit. 167 ff.; Tolnay III, 76 ff.

5 Cf. J. Wilde, 'Michelangelo's Designs for the Medici Tombs', *Journal of the Warburg and Courtauld Institutes* (1955); A Bertini, 'Nuovi Studi su la Cappella Medicea', *Critici d'Arte* (1954); L. Goldscheider, *Michelangelo's Bozzettis for Statues in the Medici Chapel* (London, 1957); W. Goez, 'Annotationes zu Michelangelos Medicäergräbern', *Festschrift für Harald Keller* (1963); G. Corti, 'Una ricordanza di Giovan Battista Figiovanni', *Paragone, Arte* (1964); A. Parronchi, 'Michelangelo al tempo dei lavori di S. Lorenzo in una ricordanza del Figiovanni', *Paragone, Arte* (1964); C. A. Isermeyer in *Zeitschrift für Kunstgeschichte* (1965); C. L. Frommel, 'S. Eligio und die Kuppel der Cappella Medici', *Akten des 21. Internationalen Kongresses für Kunstgeschichte in Bonn 1964*, 2 (Berlin, 1967).

6 Cf. Isermeyer, op. cit. 334.

7 Cf. Paatz, *Die Kirchen von Florenz* II, 465.

8 R. Falb, *Il taccuino senese di Giuliano da Sangallo* (Siena, 1899), fol. 21v; Luporini, *Brunelleschi* (1964), fig. 346; Ackerman II, 23 (who dates Sangallo's design earlier than 1516; against this Isermeyer, op. cit. 335).

9 Cf. letter from Cardinal Giuliano to Michelangelo on 28 November 1520 (Frey, *Ausgewählte Briefe*, 161): 'Ad una vostra di 23 respondemo brevemente, che havemo el disegno o schizo della cappella'. This clearly refers to a sketch of the chapel, not of the tombs. There is only one known ground plan for the chapel (Dussler No. 10; Barocchi No. 313v); cf. E. Hubala in *Kunstchronik* 18 (1965) and Isermeyer, op. cit. 333 f. The date (summer 1519 or the end of 1520) is not certain.

10 Cf. Wilde, op. cit. 57.

11 Cf. Michelangelo's letter to Clement VII, probably written in January 1524 (Milanesi, *Lettere* No. CCCLXXXI, p. 424); cf. Thode I, 432.

12 G. Thode I, 342; Maurenbrecher 73 ff.

13 Tolnay III, 29 ff., demonstrates that the *pietra serena* work was done at the same time as the pilasters and cornices and is not the result of a change in the design.

14 Marchini, *Giuliano da Sangallo*, Plate IX.

15 Cf. Frommel, op. cit. 52.

16 Cf. Wilde, op. cit. 63.

17 Cf. Frommel, op. cit. 52.

18 Cf. letter referred to in note 9 and three letters by Buoninsegni to Michelangelo, particularly that of 28 December 1520 (Tolnay III, 226 f.). Cf. Gotti I, 150 f. and Tolnay III, 33 ff. and 127 ff.; cf. also the following drawings of Michelangelo: Casa Buonarroti No. 49A (Dussler No. 91; Barocchi No. 59); Casa Buonarroti No. 88A (Barocchi No. 57) and 71A (Barocchi No. 58); British Museum (Dussler No. 155; Wilde No. 25).

19 Cf. British Museum drawings (Dussler No. 150, Ill. 55 and 153, Ill. 60 and 61; Wilde Nos 26 and 28).

20 British Museum (Dussler No. 151, Ill. 56; Wilde No. 27).

21 On the later history of the chapel see Thode I, 437; Popp, 118 ff.; Paatz, op. cit. 578. On Alessandro as the son of Pope Clement VII, not of Duke Lorenzo, see G. F. Young, *The Medici* I (London, 1913), 439.

22 When the statue of Lorenzo was erected, the niche was found to be 15 cm too small (Isermeyer, op. cit. 337) and had to be hollowed out a further 10 cm. On the other hand the base of the statue of Giuliano projects 2 cm further beyond the floor of the niche than the statue of Lorenzo. However, no conclusions as to the dating follow from this.

23 Vasari–Milanesi VII, 193.

24 D. Frey, op. cit. 141.

25 According to Justi (II, 226), the appellation goes back to Milton. Vasari refers to 'il pensoso duca' (Vasari–Milanesi VII, 196).

26 Bocchi–Cinelli, *Le Bellezze della Città di Firenze* (Florence, 1677), 528.

27 Milanese, *Lettere* No. CDII, p. 453. Cf. H. W. Frey, 'Zur Entstehungsgeschichte des Statuenschmuckes der Medicikapelle in Florenz', *Zeitschrift für Kunstgeschichte* (1951), 40 ff. M. Ferbach's contention (*Das Chaos der Michelangelo-forschung* (Vienna, 1957)) that the letter is a forgery is untenable.

28 This is also the view of Justi II, 229.

29 On the date cf. Goez, op. cit., and Isermeyer, op. cit. I still incline to a late date for the figure of Giuliano and the figures on his sarcophagus, on stylistic grounds. An earlier date for the figure of Lorenzo, on the other hand, is indicated by a sketch in the Archivio Buonarroti (Dussler No. 401; Barocchi No. 316) on the verso of a letter of 3 March 1521 (not 1525, as Tolnay and Dussler have it). Cf. also Tolnay III, 58, and Weinberger, op. cit. 321.

30 H. Grimm II, 120.

31 Vasari–Milanesi VII, 196.

32 Cf. Tolnay III, 133, Ill. 243.

33 Planiscig, *Lorenzo Ghiberti*, Ill. 84 and 85.

34 Vasari–Milanesi VII, 197; Tusiani, *Complete Poems*, 96.

35 Justi II, 252.

36 *Faust* II, 6220–4.

37 Cf. H. v. Einem, 'Michelangelo und die Antike', *Antike und Abendland* I (1945), 70, and Tolnay III, 137, Ill. 281.

38 Vasari–Milanesi VII, 196.

39 Kriegbaum, 39.

40 Tolnay III, 58. Kriegbaum puts *Day* and *Night* as pre-1526, *Morning* and *Evening* as 1531. His date for *Morning* does not tally with the sources: the *Trionfo di Fortuna di Sigismondo Fanti Ferrarese* (Venice, 1526) portrays Michelangelo at work on this figure (illustration in *Zeitschrift für Kunstgeschichte* (1951), 45). The *Morning* and *Night* are mentioned in a letter from Giovanni Battista Mini to Baccio Valori on 29 September 1531: 'After we had talked a long while about art, he permitted me to see the two figures the next day. They are indeed remarkable works – I know that you have already seen the one that depicts Night, but the second surpasses this in every respect and is a glorious work.' (Cf. E. Steinmann, *Das Geheimnis der Medicigräber Michelangelos* (Leipzig, 1907), 31). But this gives no precise information about dates. On the date of *Day*, cf. Wilde, *Michelangelo, The Group of Victory* (Oxford, 1954), 15 f.; cf. also Isermeyer, op. cit. 338, and G. Neufeld, 'Michelangelo's Times of Day: A study of their Genesis', *Art Bulletin* 48, (1966).

41 Kriegbaum, 37 ff., contested by Tolnay III, 131, Dussler in *Kunstchronik* (1951), 247, and H. W. Frey, op. cit. 1951, but reasserted by W. Gramberg, 'Zur Aufstellung des Skulpturenschmuckes in der Neuen Sakristei von S. Lorenzo', *Mitteilungen des Kunsthistorischen Instituts in Florenz* VII (1955), 151.

42 Tolnay III, 131; H. Kauffmann, 'Bewegungsformen an Michelangelostatuen', *Festschrift für H. Jantzen* (Berlin, 1951), 149).

43 Vasari–Milanesi VII 195.

44 A receipt of 23 April 1521 reads: 'Et spetialmente fare delli dicti marmi una figura di Nostra Donna a sedere secondo è disegnata.' (Milanesi, *Lettere*, p. 696, *Contratti* No. XLIX.) Pope-Hennessy's view (*Italian High Renaissance*, 25, 35 f.) that the *Medici Madonna* was made for the tomb of Julius in 1521–3 is not convincing.

45 Letter from Giovanni Battista Mini to Baccio Valori, 29 September 1531 (Gaye II, 228): 'He could very well work in the adjoining room and complete there his magnificent Madonna . . .'

46 Cf. sketches in Popp, op. cit., Plate 28 and Dussler No. 360; the sketch in the Uffizi (Dussler No. 488; Barocchi No. 1) with the motif of *Maria lactans* was probably made around 1515.

47 Kriegbaum 40. Kriegbaum's analysis does not give a fair account of the figure.

48 Cf. the Goddess of Ostia in the Vatican Museum; Herbig in *Archäologisches Jahrbuch* 59–60 (1944), 144, and E. Langlotz in *Festschrift für Arnold v. Salis* (1951), 163.

49 Wölfflin, *Die klassische Kunst* 193.

50 Tolnay III, 152 f., Ill. 57 ff.

51 Ibid., 146 ff., Ill. 61 ff.

52 Bocchi–Cinelli 539 f.

53 Ibid.; D. Moreni, *Delle tre sontuose Cappelle Medicee* (Florence, 1813), 152 ff. Cf. also H. Brockhaus, *Michelangelo und die Medicikapelle* (Leipzig, 1909), 63.

54 *Volksmessbuch* (Einsiedeln, 1936), 1682; Brockhaus, op. cit. 89 ff.

55 Cf. Thode I, 500 ff., and Tolnay III, 61 ff.; also F. Hartt, 'The Meaning of Michelangelo's Medici Chapel', *Beiträge für Georg Swarzenski* (Berlin, 1951), 145 ff.; Creighton Gilbert, 'Texts and Contexts of the Medici Chapel', *Art Quarterly* (1971).

56 Description of the altar and the candelabra in Thode II, 111 ff. The left candelabrum was renovated by Ticciati in the eighteenth century (Tolnay III, Ill. 206–7).

57 Cf. L. Bruhns, 'Das Motiv der ewigen Anbetung in der römischen Grabplastik des 16., 17. und 18. Jahrhunderts', *Römisches Jahrbuch für Kunstgeschichte* IV (1940), 253 ff. W. Goez's remarks (op. cit. 240) on the nature and direction of the dukes' gaze are rightly rejected by Isermeyer, op. cit. 338.

58 Cf. Justi II, 234, 260; Tolnay III, 125.

59 Tolnay III, Ill. 65. On Cosmas and Damian cf. Vasari–Milanesi VI, 634: 'Diede a fare Michelagnolo a Raffaello Montelupo il S. Damiano ed al frate (Montorsoli) S. Cosimo'.

60 Popp, op. cit. 162; Tolnay III, 49.

61 Cf. E. Panofsky, *Studies in Iconology* (New York, 1939), 203; Tolnay III, 48 and Ill. 150; F. Hartt, op. cit. 53. Tolnay and Hartt see in the lunette above Lorenzo the attack by the snakes, and in that above Giuliano the liberation from the snakes; Popp (op. cit. 158 ff.) reverses the interpretation.

62 Tolnay III, 39, 209, No. 58, Ill. 90.

63 Ibid. 73, 209, No. 72, Ill. 104; cf. also Thode I, 501.

64 Vasari–Milanesi VI, 65.

65 Brockhaus, op. cit. 90. E. Tietze–Conrat (*Art Bulletin* XXXVI (1954) has convincingly drawn attention to Clement I's second epistle, which quotes the four times of day as an argument for the truth of the Resurrection). Clement VII may also have referred to this epistle. There is little to commend Goez's allusion to *Semper*, the Medici motto.

66 Tusiani, *Complete Poems*, 50. Cf. Dante, *Inferno* VII, 78 ff.

67 The title of Ernst Steinmann's book, which interprets the four seasons as the four temperaments, and the two dukes as basic human types which combine these temperaments.

68 They are already found in Varchi, *Due Lezioni* (1546–8); Thode I, 503 f.

69 Cf. H. v. Einem, 'Bemerkungen zur Cathedra Petri des Lorenzo Bernini', *Nachrichten der Akademie der Wissenschaften in Göttingen* (1955), 111 ff. The empty throne is also found in the Chapel of the Cardinal of Portugal in S. Miniato—an important forerunner of the Medici Chapel. Cf. F. Hartt, G. Corti, C. Kennedy, *The Chapel of the Cardinal of Portugal* (Philadelphia, 1964); Tolnay, 'Nuove osservazioni sulla Cappella Medicea', *Accademia Nazionale dei Lincei* (1969), No. 130.

70 Frey, op. cit. 136; cf. Thode I, 507.

71 Cf. Thode I, 503, and Brockhaus, op. cit. 53 f.

72 Vasari–Milanesi VII, 195 f.

73 Kriegbaum, 16.

74 Cf. K. Borinski, *Die Rätsel Michelangelos* (Munich, 1908); Tolnay, 'Studi sulla Cappella Medicea', *L'Arte* (1934); Tolnay III; Panofsky, *Studies in Iconology* (New York, 1939); J. Arthos, 'Neoplatonism and the New Sacristy', *Art Journal* 28, (1969).

75 Panofsky, op. cit. 204.

76 Tolnay III, 68.

77 Ibid. 71 ff.

78 L'Orange and v. Gerkan, *Der spätantike Bildschmuck des Konstantinsbogens* (Berlin, 1939), Plate 38. Cf. also Steinmann, *Geheimnis* . . . 64 ff.

79 See note 68.

80 Borinski after Marsilio Ficino, op. cit. 133.

81 Cf. Panofsky, op. cit. 208 ff.

82 Cf. Borinski after Pico della Mirandola, op. cit. 130; Tolnay III, 63 ff.

83 Hartt in *Art Bulletin* (1951), 248.

CHAPTER 8

1 Thode II, 113 ff.; W. and E. Paatz, *Die Kirchen von Florenz* II, 451 ff.; R. Wittkower, 'Michelangelo's Biblioteca Laurenziana', *Art Bulletin* XVI (1934), 123 ff.; Ackerman I, 33 ff.; II, 33 ff.; P. Portoghesi, 'La Biblioteca Laurenziana e la critica michelangiolesca alla tradizione classica', *Akten des 21. Internationalen Kongresses für Kunstgeschichte in Bonn, 1964,* 2 (Berlin, 1967), 3 ff.; Portoghesi – Zevi, 209 ff.

2 Cf. Ackerman II, 33 ff.

3 Milanesi, *Lettere* No. CCCLXXXV, p. 431. Stefano di Tommaso di Giovanni Lunetto was Michelangelo's deputy from 1521 to 1524 during the construction of the New Sacristy.

4 The most important are discussed below.

5 Frey, *Ausgewählte Briefe*, 204 ff.; Thode II, 113 f.; Ackerman II, 33 ff.

6 Cf. letter of Fattucci to Michelangelo, 30 January 1524; Frey, op. cit. 209; cf. the drawing in the Casa Buonarroti (Dussler No. 58; Barocchi No. 61, Plate CIII).

7 Cf. letter of Fattucci to Michelangelo, 9 February 1524; Frey, op. cit. 211; cf. the

drawing (No. 9A) in the Casa Buonarroti (Dussler No. 57; Barocchi No. 62, Plate CIV).

8 Cf. letter of Fattucci to Michelangelo, 3 April 1524; Frey, op. cit. 221.

9 Cf. letter of Fattucci to Michelangelo, 2 January 1524; Frey, op. cit. 204.

10 Cf. letter of Fattucci to Michelangelo, 12 April 1525; Frey, op. cit. 250.

11 Cf. drawings No. 42A (Dussler No. 84; Barocchi No. 78, Plate CCXXIII) and No. 89A (Dussler No. 121; Barocchi No. 80, Plates CXII and CXXVI) in the Casa Buonarroti and drawing A33 (Dussler No. 298, Ill. 65) in Haarlem. Cf. also Wittkower, op. cit. 167.

12 Cf. letter of Fattucci to Michelangelo, 29 April 1524; Frey, op. cit. 226.

13 Cf. drawing (Dussler No. 173; Wilde No. 36, Ill. LX) in the British Museum.

14 Wittkower, op. cit. 167.

15 Their appearance both before and after their completion in Wittkower, op. cit. Figs 2–4.

16 Cf. Portoghesi–Zevi, Ill. 295.

17 Cf. E. Panofsky, 'Die Treppe der Libreria von S. Lorenzo', *Monatshefte für Kunstwissenschaft* 33 (1922), 599; Wittkower, op. cit. 155.

18 Cf. Buontalenti's staircase for S. Trinità, now in S. Stefano in Florence; Wittkower, op. cit., Fig. 42.

19 Cf. letters from Michelangelo to his nephew Lionardo (16 December 1558) and Bartolomeo Ammanati (14 January 1559): Milanesi, *Lettere* Nos CCCXIII, p. 344 and CDLXXXVI, p. 550.

20 Paatz, op. cit. 492.

21 Cf. letter of Michelangelo to Vasari (28 September 1558): Milanesi, *Lettere* No. CDLXXXV, p. 548.

22 p. 312.

23 Ackerman I, 40 f., Fig. 6.

24 Cf. W. Hager, 'Zur Raumstruktur des Manierismus', *Festschrift für Martin Wackernagel* (Cologne, 1958), 123.

25 H. Keller, *Michelangelo* (Königstein, 1966), 18. Cf. also G. Kauffmann, *Florenz* (Stuttgart, 1962), 139; Tolnay 1970, 188.

26 Milanesi, *Lettere* No. CDLXXXV, p. 548.

27 Burckhardt, *Cicerone*, 312.

28 Milanesi, *Lettere*, p. 701, *Contratti* No. LIV.

29 Ed. Frey, 128.

30 Vasari–Milanesi VII, 201.

31 *Cod. Magliabecchiano* No. 622, Class. XXV c 5–6; Gotti I, 183; Thode II, 147.

32 Dussler Nos 59–73, 75, 77; Barocchi Nos 102–118; Tolnay 1951, 64 ff.; Ackerman I, 45 ff.; II, 43 ff.; Portoghesi–Zevi 379 ff.

33 Milanesi, *Lettere*, p. 701.

34 Thode II, 147.

CHAPTER 9

1 Cf. letter of Michelangelo to Fattucci (mid-April 1523): Milanesi, *Lettere* No. CCCLXXIX, p. 421 f.; cf. also Maurenbrecher 63 f.

2 Justi I, 299.

3 To Giovanni Spina, 19 April 1525: Milanesi, *Lettere* No. CCCXCIV, p. 442.

4 To Fattucci, 1 November 1526: Milanesi, *Lettere* No. CDIII, p. 454.

5 Cf. Michelangelo's letters to Fattucci on 4 September and 24 October 1525 (Milanesi, *Lettere* Nos CCCXCVIII and CD, pp. 447 and 450). The latter says: 'I approve of the idea of making a tomb such as that of Pope Pius in St Peter's as you have described it to me.' Fattucci's letter of 14 October 1525, however, makes no mention of the tomb (Frey, *Ausgewählte Briefe* No. CCXLV, pp. 260 f.). Tolnay (IV, 51) is of the opinion that the 'disegno di Julio' mentioned by Fattucci in a letter to Michelangelo of 16 October 1526 (Frey, op. cit. No. CCLXV, p. 289) is a sketch for the tomb of Julius reduced to the proportions of a wall-tomb, but this is very questionable, cf. Fattucci's words 'il quale mi ha dato grandissimo piacere'. Cf. Tolnay (III, 77, and IV, 51 ff.), who has revealed the reflection of the wall-tomb design of 1525 in drawings formerly regarded as studies for the Medici tombs. Cf. also Tolnay III, Ill. 121–2 and p. 108.

6 Cf. A. E. Popp, 'Two Torsi by Michelangelo', *The Burlington Magazine* LXIX (1936), 200 ff.; Tolnay IV, 51.

7 Cf. Justi I, 296 ff.

8 29 April 1532: Milanesi, *Lettere, Contratti* No. LV, pp. 702 f.

9 30 April 1532; Gotti II, 78 f.; Tolnay IV, 36.

10 Letter from Sebastiano del Piombo, 16 June 1531; Milanesi, *Correspondants*, 54.

11 Tolnay IV, Ill. 98.

12 Milanesi, *Lettere* No. CDXXXIII, pp. 485 f.

13 Condivi, ed. cit. Ch. 152.

14 Cf. Tolnay IV, 43.

15 Cf. Kriegbaum, 34.

16 Letter to Duke Cosimo, 29 December 1564: Vasari–Milanesi VIII, 388.

17 Cf. Thode I, 144, 213 f. and 215 f.

18 Tolnay IV, Ill. 197 and 198, p. 157. On the wax figure in the Victoria and Albert Museum see Tolnay IV, Ill. 264, p. 157, and Pope-Hennessy, *Catalogue of Italian Sculptures in the Victoria and Albert Museum* (1964), No. 44; the former considers it a copy, the latter, the original.

19 Cf. A. v. Hildebrand, *Gesammelte Schriften zur Kunst* (Cologne and Opladen, 1969), 419.

20 Kriegbaum, 37. Tolnay (*Commentari* XVI, 1965) has published an unfinished fifth 'Captive' from the Casa Buonarroti. Cf. also Tolnay 1970, No. 38, rightly rejected by Isermeyer, in *Zeitschrift für Kunstgeschichte* (1965), 330.

21 Cf. J. Wilde, *Michelangelo: The Group of Victory* (Oxford, 1945), 21 f., Fig. 2. Wilde's reconstruction differs from Tolnay's by adopting different plinths and

recessed rectangular panels behind the groups, instead of the round-arch niches found in Michelangelo's final façade elevation of S. Lorenzo; he also takes the *Boboli Captives* as atlantes and omits the herms. Wilde's date for this new form is the 1520s.

22 J. Wilde, *Italian Drawings in the Department of Prints and Drawings in the British Museum* (London, 1953), No. 23; Tolnay IV, 139, No. 127; Isermeyer in *Kunstchronik* (1954), 269, and *Zeitschrift für Kunstgeschichte* (1965), 326.

23 Cf. letter of Leonardo Sellaio to Michelangelo, 13 February 1519; Frey, op. cit. 135.

24 Milanesi, *Lettere* No. CDXXXV, pp. 489 ff.

25 Cf. letter of Sebastiano del Piombo to Michelangelo, 21 November 1531; Milanesi, *Correspondants* 70, and Wilde, *The Group of Victory*, 12.

26 Cf. Popp in *The Burlington Magazine* LXIX (1936); Tolnay IV, 51.

27 Tolnay IV, 60 ff.; reconstruction Ill. 206. Tolnay (1951) takes Vasari's reference to four slave-statues in Michelangelo's studio in Rome to refer to the *Boboli Captives*, but this is unlikely, since the *Captives* seem never to have been in Rome; Vasari also calls the figures 'perfiniti', which is certainly not true of the *Boboli Captives*. Cf. also Tolnay IV, 114.

28 Cf. Piombo's letter (note 25) and Michelangelo's letter to Piombo, 26 June 1531, in which he suggests that 'the blocks already started here' be sent to Rome (Milanesi, *Lettere* No. CDVII, p. 458).

29 Cf. J. Wilde, *Michelangelo: The Group of Victory* (Oxford, 1954).

30 Cf. Sangallo's platter for the Sassetti tomb in S. Trinità in Florence (1485–91); F. Burger, *Geschichte des florentinischen Grabmals von den ältesten Zeiten bis Michelangelo* (Strasbourg, 1904), 106.

31 Vasari–Milanesi VII, 166.

32 Wilde, *Victory*, 14, puts it between 1527 and 1530; Tolnay (IV, 111), who connects both the *Victory* and the *Boboli Captives* with the project of 1532 (left niche) puts it at 1532–4.

33 Wilde, *Victory*, 21, sets it in the right niche at the front, keeping the left niche for the statue (clay model in the Casa Buonarroti; Tolnay III, Ill. 274b) that he interprets as a Hercules (cf. *Jahrbuch der Kunsthistorischen Sammlungen* (Vienna, 1928), 206 ff.). I cannot accept this view. Cf. also Panofsky, *Studies in Iconology* (New York, 1939), 231 f.; Tolnay III, 98 ff., partic. 102.

34 Aldovrandi, *Antichità* (1556), 245.

35 Milanesi, *Lettere, Contratti* No. XIV, 14 June 1514, p. 641. Cf. W. Lotz, 'Zu Michelangelos Christus in S. Maria sopra Minerva', *Festschrift für H. v. Einem* (1965); Tolnay, *Il tabernacolo per il Cristo della Minerva, Commentari* (1967); G. Weber, 'Bemerkungen zu Michelangelos Christus in S. Maria sopra Minerva', *Wiener Jahrbuch für Kunstgeschichte* 22 (1969).

36 Michelangelo gave the statue in 1522 to Metello Vari, who erected it in a *corticella* in his house. Cf. Aldovrandi, *Antichità* (1556), 247: 'non fornito per rispetto d'una

vena che si scoperse nel marmo della faccia'. Cf. Thode II, 267, and Tolnay III, 177.

37 Cf. Isermeyer, op. cit. (1965), 332 f. An illustration of Bramante's sepia in *Jahrbuch der Kunsthistorischen Sammlungen* (Vienna, 1905), Plate IV. An illustration of Vecchietta's painting in Pope-Hennessy, *Italian Renaissance Sculpture* (London, 1958), Plate 95. Cf. also R. Berliner, 'Bemerkungen zu einigen Darstellungen des Erlösers als Schmerzensmann', *Das Münster* IX (1956), and Colin Eisler, 'The Golden Christ of Cortona and the Man of Sorrow in Italy', *Art Bulletin* LI (1969), 107 ff.

38 Letter to Michelangelo, 6 September 1521; Milanesi, *Correspondants* 30.

39 Cf. Berliner, op. cit.

40 *Prediche e Scritti*, ed. M. Ferrara (Milan, 1930). Cf. also Tolnay, *Werk und Weltbild des Michelangelo*, 67 and III, 91.

41 Sonnet IV.

42 H. L. Heydenreich, *Leonardo* (Berlin, 1943), 88. Tolnay I, 198 ff., has traced this motif back to antiquity.

43 Vasari–Milanesi VII, 201.

44 Cf. Thode II, 285.

45 Tolnay (III, 96) believes that Michelangelo converted a David into an Apollo, but I prefer a continuity of conception.

46 Cf. also Marcantonio Raimondi B.334; Apollokamee, *Choix des pierres gravées du Cabinet Impérial*, Plate XVII.

47 Raimondi, op. cit. B.332.

48 Tolnay III, Ill. 272.

49 Cf. E. Steinmann, *Die Sixtinische Kapelle* II (Munich, 1905), 461 ff.

50 *Due Lezioni* (Florence, 1549), 53; cf. Justi II, 381.

51 December 1532; Milanesi, *Lettere* No. CDXI, p. 462.

52 To Bartolommeo Angiolini in Rome: Milanesi, *Lettere* No. CDXVIII, p. 469.

53 Sonnet XXX.

54 Vasari–Milanesi VII, 271 f.

55 Aldovrandi, *Antichità* (1556), 225 ff.; cf. Steinmann–Pogatscher in *Repertorium für Kunstwissenschaft* (1906), 502 f.

56 Steinmann, *Sixtinische Kapelle* II, 467; Thode II, 310.

57 Cf. Panofsky, *Iconology*, 212 ff.

58 *De rerum natura* III, 982 ff.; cf. Panofsky, op. cit. 217.

59 *Opere del Cardinale Bembo* I (1808), 85; cf. Panofsky, op. cit. 217.

60 *Leges* I, 636; cf. Panofsky, op. cit. 214. Cf. also H. Sichtermann, *Ganymed: Mythos und Gestalt in der antiken Kunst* (Berlin diss., 1953); P. C. Mayer, *The Myth of Ganymed in Art* (New York diss., 1967; cf. Marsgas, 1967); Philips, 'A Ganymed Mosaic from Sicily', *Art Bulletin* (1960).

61 *Symposium* VIII; cf. Panofsky, op. cit. 214.

62 Cf. E. Beer, *Die Rose der Kathedrale von Lausanne* (Berne, 1952), Ill. 34.

63 Cf. Panofsky, op. cit. 213.

64 Transl. H. F. Cary (1844).

65 Cf. Panofsky, op. cit. 214 f.

66 *Metamorphoses* II, 304–80.

67 Cf. H. J. Herrmann, 'Miniaturhandschriften aus der Bibliothek des Herzogs Andrea Matteo III', *Acquaviva: Jahrbuch der Kunsthistorischen Sammlungen* (Vienna, 1898), 160, Plate VII.

68 (Lyons, 1551); cf. Panofsky, op. cit. Plate LXXXX, No. 170; H. Sedlmayr in *Hefte des Kunsthistorischen Seminars München* II, 27.

69 *Hell* XVII, 107, trans. H. F. Cary (1844).

70 Panofsky, op. cit. 219.

71 December 1532; Milanesi, *Lettere* No. CDXI, p. 462.

72 Cf. B. Degenhardt in *Münchener Jahrbuch für bildende Kunst* (1952).

73 Tolnay III, Ill. 155.

74 Ibid. Ill. 154.

75 Ibid. Ill. 151.

76 Ibid. Ill. 294.

77 H. Egger, *Codex Escurialensis* (Vienna 1906), Plate 40.

78 Tolnay III, Ill. 152; cf. A. Perrig, 'Michelangelo und Tommaso de Cavalieri', *Akten des 21. Internationalen Kongresses für Kunstgeschichte in Bonn, 1964*, 2 (Berlin, 1967), 164 ff.: Perrig takes the Venice sketch to be the work of Cavalieri.

79 Tolnay III, Ill. 153.

80 Cf. H. v. Einem, 'Michelangelo und die Antike', *Antike und Abendland* I (1945), 72.

81 Tolnay III, Ill. 156.

82 Cf. Panofsky, op. cit. 221; Grünwald, 'Zur Arbeitsweise einiger hervorragender Meister der Renaissance', *Münchener Jahrbuch für bildende Kunst* (1912), 16 ff.; cf. also the engraving by Georg Pencz (1529) in *Reallexikon zur deutschen Kunstgeschichte* I, Col. 1327–8.

83 E. Wind, 'Charity', *Journal of the Warburg and Courtauld Institutes* (1937–8), 621.

84 Lost inscription on the base; cf. H. Kauffmann, *Donatello* (Berlin, 1935), 170, and H. W. Janson, *The Sculpture of Donatello* II (Princeton, 1957), 198.

CHAPTER 10

1 Cf. documents in Steinmann, *Die Sixtinische Kapelle* II (Munich, 1905), 742 ff., and R. de Campos–Biagetti, *Il Giudizio Universale di Michelangelo* (Rome, n.d.); cf. also Tolnay V and 'Morte e Resurrezione in Michelangelo', *Commentari* XV (1964); M. Gosebruch, 'Zum "Disegno" des Michelangelo', *Michelangelo Buonarotti* I (Würzburg, 1964); D. R. de Campos, *Il Giudizio Universale di Michelangelo* (Milan, 1964).

2 Condivi, ed. cit. 150.

3 Vasari–Milanesi VII, 206.

4 Milanesi, *Lettere, Contratti* No. LVII, 708.

5 Text in Milanesi, *Lettere*, p. 708, and L. Dorez, *La Cour du Pape Paul III d'après les régistres de la Trésorerie Secrète* (Paris, 1932), Ch. 4, 143 ff.

6 Cf. Thode II, 3 ff.

7 Vasari–Milanesi VII, 209; cf. R. Feldhusen, *Ikonologische Studien zu Michelangelos zu Jüngstem Gericht* (Hamburg diss., 1953), 126.

8 Condivi, ed. cit. 150.

9 Justi II, 309. Tolnay (V, 19 ff.) is of the opinion that the commission was originally for a Resurrection above the altar. Against this view see H. v. Einem in *Zeitschrift für Kunstgeschichte* (1962), 82; cf. also Isermeyer in *Zeitschrift für Kunstgeschichte* (1965), 340 f., who makes the counter-proposal that the Resurrection was intended for the altar itself, in place of Perugino's Assumption – but this seems unlikely in view of the dedication of the chapel.

10 Cf. Justi II, 309.

11 Cf. J. White and I. Shermann, 'Raphael's Tapestries and their Cartoons', *Art Bulletin* (1958).

12 Cf. Feldhusen, op. cit. 29 ff., and H. Hager, *Die Anfänge des Altarbildes* (Munich, 1962), 40 ff.

13 Feldhusen, op. cit. 48.

14 L. v. Ranke, *Geschichte der Päpste*, 6th ed. (1872), 82.

15 Cf. ibid. 82 and de Campos in *Römische Quartalschrift* 59 (1964).

16 De Campos, op. cit., Plate CXVII; according to Tolnay V, 99, some 45 cm are missing.

17 Steinmann II, 517.

18 J. Wilde, 'Der ursprüngliche Plan Michelangelos zum Jüngsten Gericht', *Graphische Künste, Neue Folge*, I (1936), 11; M. Hurst, 'Two Unknown Studies by Michelangelo for the Last Judgement', *The Burlington Magazine* III (1966), 27 f.

19 Dussler No. 246, Ill. 89.

20 Dussler No. 55, Ill. 94. On the date see H. v. Einem, 'Michelangelos Jüngstes Gericht und die Bildtradition', *Kunstchronik* (1955), 89 ff.; Dussler puts it at the end of February 1534 at the latest.

21 G. Rodenwald, *Kunst um Augustus* (Berlin, 1945), Ill. 33.

22 Condivi, ed. cit. 162.

23 Ibid. 166.

24 Ibid. 160.

25 Vasari–Milanesi VII, 212.

26 Romans 5: 14.

27 Feldhusen, op. cit. 79.

28 Tolnay, 'Le Jugement Dernier de Michelange', *Art Quarterly* III (1940), 134.

29 Cf. G. Kleiner, *Die Begegnungen Michelangelos mit der Antike* (Berlin, 1950), 44 f.

30 Thode II, 56 f.

31 Vasari–Milanesi VII, 213.

32 Ibid. 211.

33 Steinmann II, 511.

34 Vasari–Milanesi VII, 214.

35 Ibid.

36 Condivi, ed. cit. 192; cf. J. v. Schlosser, 'Aus der Bildnerwerkstatt der Renaissance', *Jahrbuch der Kunsthistorischen Sammlungen* (Vienna, 1913).

37 Vasari–Milanesi VII, 215.

38 *Lebensbeschreibung des Benvenuto Cellini* (Weimarer Ausgabe I, 44).

39 Cf. B. Brenk, *Tradition und Neuerung in der christlichen Kunst des ersten Jahrtausends* (Vienna, 1966) (review: E. Dinkler-v. Schubert in *Byzantinische Zeitschrift* 62 (1969)); W. Paeseler, 'Die römische Weltgerichtstafel im Vatikan', *Kunstgeschichtliches Jahrbuch der Biblioteca Hertziana* II (1938); D. R. de Campos, *Raffaello e Michelangelo* (Rome, 1946), Ch. 9.

40 Cf. H. v. Einem in *Kunstchronik* (1955), 89 ff. There is a remarkable resemblance with the standing Christ in Dello Delli's *Last Judgement* in the Old Cathedral in Salamanca, cf. G. Fiocco, *L'Arte di Andrea Mantegna* (Bologna, 1927), 50. Further examples of Christ in a standing position in H. Schrade, *Deutsche Vierteljahrsschrift für Literaturwissenschaft und Geistesgeschichte* VII, 356.

41 Cf. v. Einem, op. cit. 89 ff.

42 Marcanton Michiel ('Notizie d'opere del disegno', in T. Frimmel, *Quellenschriften zur Kunstgeschichte, Neue Folge* I (Vienna, 1888), 102) reports seeing a picture of Hell by Bosch at Cardinal Grimani's in Venice in 1521.

43 Cf. Tolnay in *Art Quarterly* III (1940). The dalmatic is reproduced in Schüller-Piroli, *Zweitausend Jahre St. Peter* (Olten, 1950), 176. Cf. G. Millet, *La Dalmatique du Vatican* (Paris, 1945). On the reconstruction of Cavallini's fresco see Paeseler, *Jahrbuch der Biblioteca Hertziana* II (1938).

44 Thode II, 24 ff.

45 De Campos, op. cit., has attempted to do this; cf. also de Campos, 'Drei Bedeutungen des Jüngsten Gerichtes Michelangelos', *Römische Quartalschrift* 59 (1964), 230 ff.

46 Vasari–Milanesi VII, 213.

47 Cf. W. Kallab, 'Die Deutung von Michelangelos Jüngstem Gericht', *Beiträge zur Kunstgeschichte, Franz Wickhoff gewidmet* (Vienna, 1903), and K. Borinski, *Die Rätsel Michelangelos* (Munich, 1908).

48 Cf. Tolnay, *Werk und Weltbild des Michelangelo* Ch. III; Tolnay V; F. Lemmi, *La riforma in Italia* (Milan, 1939); de Campos, *Raffaello e Michelangelo*, 131 ff. (with bibl.); H. Jedin, *Geschichte des Konzils von Trient* I (Freiburg, 1951), Book I, Ch. 7; *Kardinal Contarini als Kontroverstheologe* (1949); 'Il Cardinale Pole e Vittoria Colonna', *L'Italia Francescana* XXII (1947); 'Contarini und Camaldoli', *Archivio Italiano per la Storia della Pietà* II (1953).

CHAPTER 11

1 H. Grimm II, 253.

2 I. Wyss, *Vittoria Colonna* (Frauenfeld, 1916) (with bibl.); Tolnay V, Ch. III; E. M. Jung, 'Vittoria Colonna between Reformation and Counterreformation', *Review*

of *Religion* XV (1951); Pedicini, 'Vittoria Colonna', *Studi in memoria di Carmelo Sgroi* (Turin, 1965).

3 Condivi, ed. cit. 200.

4 *Tractato de pintura antigua* (1538); cf. H. Grimm II, 254 ff., and V. Mariani in *Argomenti d'Arte* (1961), 55 ff.

5 Sonnet XIV, first version.

6 Sonnett XXVIII.

7 Sonnet XVII.

8 1545 or 1546; Frey, *Ausgewählte Briefe*, 308.

9 To Vasari; Sonnet LXV.

10 To Vasari; Sonnet LXVI.

11 Condivi, ed. cit. 202, and Vasari–Milanesi VII, 275. Neither Michelangelo's original drawing of *Christ and the Woman of Samaria* nor any sketches of it are preserved, but the composition can be reconstructed from engravings and copies of paintings, cf. Tolnay V, 64 f., Ill. 334–6.

12 Cf. Tolnay, 'Michelangelo's Compositions for Vittoria Colonna', *Records of the Princeton University Library* XII (1953). Tolnay's reasons for considering the Boston sketch (Dussler No. 378) to be by Michelangelo are convincingly refuted by Dussler.

13 Condivi, ed. cit. 202.

14 *Paradiso* XXIX, 91; in Dante these words refer to the Bible.

15 R. Pallucchini, *Sebastiano Viniziano* (Milan, 1944), Plate 82; cf. E. Panofsky, 'Die Pietà von Ubeda', *Festschrift für Julius v. Schlosser* (Vienna, 1927).

16 Pallucchini, op. cit., Plate 38.

17 Vasari–Milanesi V, 568.

18 Cf. Thode II, 489.

19 F. Knapp, *Andrea del Sarto* (Bielefeld and Leipzig, 1907), 31.

20 W. Mersmann, *Der Schmerzensmann* (Düsseldorf, 1952), Plate 7.

21 P. Schubring, *Donatello* (Stuttgart and Berlin, 1922), Plate 45; cf. H. Kauffmann, *Donatello* (Berlin, 1935), 233 f.

22 A. Heimann, 'Der Meister der Grandes Heures de Rohan und seine Werkstatt', *Städeljahrbuch* VII–VIII (1932), 50, Ill. 32; note 156 refers to the *Pietà* for Vittoria Colonna.

23 Heimann, op. cit. 53.

24 Cf. D. R. de Campos, 'Das Kruzifix Michelangelos für Vittoria Colonna', *Akten des 22. Internationalen Kongresses für Kunstgeschichte in Bonn, 1964,* 2 (Berlin, 1967); Dussler No. 329; G. Cimino, *Il Crocifisso di Michelangelo per Vittoria Colonna* (Rome, 1967) (not convincing). R. Haussherr, *Michelangelos Kruzifix für Vittoria Colonna. Bemerkungen zur Ikonographie und theologischen Deutung* (Opladen, 1971).

25 Condivi, ed. cit. 147.

26 Ibid. 202.

27 Tusiani, *Complete Poems*, 129–30.

28 Tolnay IV, 131. Cf. also D. I. Gordon, 'Gianotti, Michelangelo and the Cult of Brutus', *Fritz Saxl, 1890–1948: A Volume of Memorial Essays from his Friends in England* (Edinburgh, 1957); R. Steinmann, *Michelangelo im Spiegel seiner Zeit* (Leipzig, 1930), 22 f.

29 A. Grünwald, *Florentiner Studien* (Prague, 1914), 11 ff.

30 D. Gianotti, *Gespräche mit Michelangelo* (see German transl. by Joke Frommel (Amsterdam, 1968), 98).

31 Vasari–Milanesi VII, 262.

32 Tolnay IV, Ill. 94.

CHAPTER 12

1 Pogatscher in E. Steinmann, *Die Sixtinische Kapelle* II, Appendix of Documents, 748, No. 4.

2 7 September 1539. Gotti I, 264; cf. Justi I, 319 f.

3 Cf. letter from Cardinal Ascanio Parisani to the Duke of Urbino, 23 November 1541. Gaye II, 290.

4 Cf. Duke of Urbino to Michelangelo, March 1542; Gaye II, 289. Cf. also Michelangelo's request to Paul III of 20 July 1542; Milanesi, *Lettere* No. CDXXXIII, pp. 485 ff.; Frey, *Ausgewählte Briefe*, 152 ff.

5 Frey, op. cit. 154 ff.

6 Milanesi, *Lettere*, 715 f., *Contratti* No. LXIII.

7 Milanesi, *Lettere* No. CDXXXIV, p. 488.

8 Letter of October 1542 to Luigi del Riccio: Milanesi, *Lettere* No. CDXXXVII, p. 496.

9 Cf. letter of Michelangelo to Luigi del Riccio: Milanesi, *Lettere* No. CDXXVI, p. 477.

10 Cf. Tolnay IV, 68; cf. P. Fehl, 'The Final Version of Michelangelo's Tomb of Julius II', *Renaissance Papers* (1968–9).

11 The moulding round the pilaster stops beneath the right herm and continues to the right as a simple strip; the cornice of the lower storey is cut off diagonally at both ends. The herms are usually ascribed to Jacopo del Duca (Justi I, 336, and Tolnay IV, 68 and 127), but the contract of 5 October 1542 (Maurenbrecher, 166), on which this ascription is based, refers to the 'Quattro teste di termini' of the upper storey. On the herms see Vasari–Milanesi VII, 284.

12 Cf. Contract No. LXI of 1 June 1542 (Milanesi, *Lettere* p. 712) and Subcontract No. LXIV of 21 August 1542 (Milanesi, *Lettere* p. 717).

13 Cf. Contract No. LXV of 6 February 1543 (Milanesi, *Lettere*, p. 719).

14 This view is taken by Tolnay IV, 68, who regards the drawing Cod. Vat. 3211 (Tolnay, Ill. 106) as a sketch for the candelabra of the final project.

15 Letter of Michelangelo to Silvestro da Montauto, 3 February 1545 (Milanesi, *Lettere* No. CDXLV, p. 505).

16 Cf. Tolnay IV, 102, Ill. 107.

17 Cf. Ibid. 124 ff. and Maurenbrecher, 157.

18 Milanesi, *Lettere*, p. 706, *Contratti* No. LVI.

19 Maurenbrecher, 161.

20 Milanesi, *Lettere*, p. 646, *Contratti* No. XVI.

21 Maurenbrecher, 169.

22 Cf. Tolnay IV, 126.

23 Contract No. LXIV: Milanesi, *Lettere*, p. 718.

24 Cf. engraving of Salamanca in Tolnay IV, Ill. 207.

25 Cf. Tolnay IV, 69.

26 Cf. ibid. Ill. 3.

27 H. Grimm I, 358 f.

28 Thode I, 221.

29 Tolnay IV, 123, states that the bronze copy by Gregorio Rossi in S. Andrea della Valle in Rome (Ill. 276) contains an oil lamp; Thode (I, 224) calls it an ointment jar.

30 Condivi, ed. cit. 56.

31 Cf. Thode I, 225.

32 Cf. Tolnay, *Werk und Weltbild des Michelangelo*, 74.

33 Burckhardt, *Cicerone*, 634.

CHAPTER 13

1 Cf. H. v. Einem, 'Michelangelos Fresken in der Cappella Paolina', *Festschrift für Kurt Bauch* (Munich, 1957), 193 ff. with bibl.); Tolnay V, 70 ff.; C. L. Frommel, 'Antonio da Sangallos Cappella Paolina', *Zeitschrift für Kunstgeschichte* (1964).

2 The sanctuary must have been removed by Maderna at the time the new nave of St Peter's was built; when rebuilt, it was twice as long, slightly wider and illuminated by its own lantern.

3 Vasari–Milanesi VII, 216.

4 Cf. Tolnay V, 77 ff.

5 Cf. Baumgart–Biagetti, *Die Fresken des Michelangelo, L. Sabatini und F. Zuccari in der Cappella Paolina im Vatikan* (1934), 87.

6 Cf. Thode II, 77.

7 Vasari–Milanesi VII, 215 f.

8 Cf. Frommel, op. cit. 42.

9 Bonanni, *Numismata Pontificum Romanorum* . . . (Rome, 1706), No. XXXVII.

10 Ibid. No. XX.

11 Cf. R. Stettiner, *Die illustrierten Prudentiushandschriften* (Berlin, 1895); A. Katzenellenbogen, *Die Psychomachie in der Kunst des Mittelalters* (Hamburg, diss., 1933).

12 A. v. Salis, *Antike und Renaissance* (Zürich, 1947), 89 ff.

13 Ibid. Plate 19.

14 Cf. H. v. Einem, op. cit. note 11.

15 Cf. Robert, *Die antiken Sarkophagreliefs* II, 96; W. Pinder, 'Kampfmotive in neuerer Kunst', *Gesammelte Aufsätze* (1938), 121 ff.

16 Cf. H. v. Einem, op. cit. note 13. On the iconography of *The Conversion of St Paul* see Huggler, 'Bekehrung Pauli von Manuel Deutsch', *Jahresbericht der Gottfried-Keller-Stiftung* (Zürich, 1958–9), and S. Hohenstein, *Die Ikonographie der Bekehrung Pauli* (Frankfurt diss., 1956).

17 H. v. Einem, op. cit. Ill. 3.

18 Ibid. Ill. 4.

19 Sonnet LXXV.

20 The similarity in motif with Bassano's *Martyrdom of St Mark* in Hampton Court (*Catalogo della Mostra Jacopo Bassano* (Venice, 1957), No. 15) needs further research. Cf. also two drawings of Jacob Jordaens in Cleveland (D'Hulst, *De tekeningen van Jacob Jordaens* (Brussels, 1956), Nos 165–6).

21 20 July 1542 or 1543; Frey, *Ausgewählte Briefe*, 307.

22 Sonnet XIV, first version.

23 Baumgart–Biagetti, op. cit. Plate XXIV.

24 Cf. also the fragment of the cartoon in Naples (Baumgart–Biagetti, op. cit. Plate LIII). According to P. Fehl ('Michelangelo's Crucifixion of St Peter: Notes on the Identification of the Locale of the Action' in *Art Bulletin* (September 1971)) the setting is the Montorio hill in Rome, traditional site of Peter's crucifixion, on which the martyry of Bramante's Tempietto stands. One must however emphasize that Michelangelo is not concerned to depict a specific locality.

25 Cf. German ed. by E. Jaffé (Berlin, 1912), 120.

26 S. Waetzoldt, *Die Kopien des 17. Jahrhunderts nach Mosaiken und Wandmalereien in Rom* (Vienna and Munich, 1964), 67, No. 863, Ill. 466.

27 Ill. in Schüller–Piroli, *Zweitausend Jahre St. Peter* (Olten, 1950), 245–6; 35;365.

28 v. Marle, *The Development of Italian Schools of Painting* IX, Fig. 47; X, Fig. 170; XII, Fig. 190; cf. W. Friedländer in *Journal of the Warburg Institute* (1945).

29 *Legenda Aurea* 121 (see note 25).

30 M. Dvořák, *Geschichte der italienischen Kunst* II (Munich, 1928), 134.

31 Aldovrandi, *Le Statue di Roma* (1550), 158 f.

32 Cf. H. Siebenhüner, 'Der Palazzo Farnese in Rom', *Wallraf-Richartz-Jahrbuch* XIV (1952), 151.

33 H. v. Einem, op. cit. Ill. 202.

34 Dussler Nos 165–7; Tolnay V, 230–5.

35 Tolnay V, Ill. 317.

36 Dussler No. 166; Tolnay V, Ill. 242.

37 Cf. Thode III, 137, and Dussler, 106.

CHAPTER 14

1 Milanesi, *Lettere* No. CDXD, p. 554; cf. Ackerman I, 1, and David Summers, 'Michelangelo on Architecture', *Art Bulletin* LIV (1972), 146 ff.

2 Brevet of Pope Paul III, 1 January 1547. Cf. Bonani, *Historia Templi Vaticani* (Rome, 1696), 77; Vasari–Milanesi VII, 220.

3 Cf. Tolnay, *The Art and Thought of Michelangelo*, 74.

4 D. Frey, *Michelangelostudien* (Vienna, 1920), 139 and 143.

5 Cf. Fanfani, *Spigolatura Michelangiolesca* (Pistoia, 1876), 90; Tolnay, *Michelangiolo*, 198, and 'Un dessin inédit représentant le façade de Michelange de la Chapelle Sforza', *Études écrites et publiées a l'honneur de Pierre Lavedan* (Paris, 1954), 361 f.

6 The date 1516 has now been established by C. L. Frommel, whose work *Der römische Palastbau der Hochrenaissance* is to be published in 1973 in three volumes of *Römische Forschungen der Biblioteca Hertziana*; Volume II will contain catalogue and documentation. Among earlier works see Ackerman I, 75 ff., and II, 67 ff.; Tolnay, 'Zu den späten architektonischen Projekten Michelangelos', *Jahrbuch der Preussischen Kunstsammlungen* 51 (1930); Tolnay, *Michelangiolo*, 203 ff.; H. Siebenhüner, 'Der Palazzo Farnese in Rom', *Wallraf-Richartz-Jahrbuch* XIV (1952), 144 ff.; G. Giovannoni, *Antonio da Sangallo il Giovane* (Rome, 1959), 150 ff.

7 Vasari–Milanesi V, 469 f.; cf. Ackerman II, 71.

8 Siebenhüner, op. cit. Ill. 136.

9 Ackerman I, Plate 39; Portoghesi–Zevi, Ill. 266.

10 Cf. the Beatrizet engraving of 1549 (Ackerman I, Plate 41) and Ackerman I, 87 f.

11 Siebenhüner, op. cit. Ill. 127; Portghesi–Zevi, Ill. 694 and 698.

12 Cf. Letarouilly's engraving in Siebenhüner, op. cit. Ill. 131.

13 Siebenhüner pointed out this important fact.

14 Cf. Siebenhüner, op. cit. 155.

15 Cf. Ackerman II, 69 f.

16 Cf. the drawing by Sangallo in the Uffizi, Dis. 627a (Siebenhüner, op. cit. Ill. 129).

17 The insignia at the sides are of later date.

18 Ackerman I, Plate 40; cf. S. Meller, 'Zur Entstehung des Kranzgesimses am Palazzo Farnese in Rom', *Jahrbuch der Preussischen Kunstsammlungen* XXX (1909), 1 ff.

19 Cf. Siebenhüner, op. cit. 154.

20 Ibid. 160.

21 Portoghesi–Zevi, Ill. 707–708.

22 Ibid. Ill. 705. Vasari–Milanesi VII, 224.

23 Ackerman I, 84.

24 Cf. engraving by Lafreri (1560); Portoghesi–Zevi, Ill. 697.

25 Ibid. Ill. 691.

26 Vasari–Milanesi VII, 224 f.

27 Cf. G. Gronau, 'Über zwei Skizzenbücher des Guglielmo della Porta in der Düsseldorfer Kunstakademie', *Jahrbuch der preussischen Kunstsammlungen* (1918), 199 ff.

CHAPTER 15

1 Cf. H. Siebenhüner, *Das Kapitol in Rom, Idee und Gestalt* (Munich, 1954) (reviews: H. Keller in *Kunstchronik* (1954); L. Ettlinger in *Burlington Magazine* (1956);

Ackermann in *Art Bulletin* (1956); P. Künzle in *Mitteilungen des Instituts für Oesterreichischische Geschichtsforschung* (1956); Ackerman I, 54 f., and II, 49 ff.; F. Saxl, 'The Capitol during the Renaissance: A Symbol of the Imperial Idea', *Lectures* (London, 1957); A. Schiavo, 'Il Campidolgio di Michelangelo e dei continuatori', *Capitolium* 39 (1964); G. de Angelis d'Ossat and C. Pietrangeli, *Il Campidoglio di Michelangelo* (Milan, 1965).

2 Siebenhüner, op. cit. 19.

3 Cf. drawing by Martin van Heemskerck, fol. 72r, *c.* 1535–6; Siebenhüner, op. cit. Ill. 8; Ackerman I, Plate 30a.

4 Rome, Palazzo dei Conservatori. Cf. W. Heckscher, *Sixtus IV Aeneas insignes statuas Romano populo restituendas censuit* (The Hague, 1955); Siebenhüner, op. cit. Ill. 11–17.

5 Ackerman II, 50.

6 Siebenhüner, op. cit. 54.

7 Cf. P. Künzle, 'Die Aufstellung des Reiters vom Lateran durch Michelangelo', *Miscellanea Bibliotecae Hertzianae* (1961).

8 The full inscription in T. Buddensieg, 'Zum Statuenprogramm im Kapitolsplatz Pauls III', *Zeitschrift für Kunstgeschichte* (1969), 209, note 27.

9 Ackerman II, 49.

10 Cf. L. H. Heydenreich, 'Pius II. als Bauherr von Pienza', *Zeitschrift für Kunstgeschichte* (1937), 105 ff.

11 Ackerman I, Plate 34a.

12 Cf. H. Sedlmayr, 'Das Kapitol des della Porta', *Epochen und Werke* 2 (Vienna and Munich, 1960), 46.

13 Cf. Buddensieg, op. cit. 177 ff.

14 On the date see the above (note 1) reviews by Ackerman and Künzle of Siebenhüner, *Das Kapitol in Rom.*

15 Sedlmayr, op. cit. 45.

16 Cf. an anonymous drawing in Brunswick (Ackerman I, Plate 31a, dated 1554–60 by Ackerman, II, 62) and the engraving by Hieronymus Cock from *Operum antiquorum Romanorum . . . reliquiae* (Antwerp, 1562; Ackerman I, Plate 30b), showing the square in 1547. A drawing by Heemskerck in the Franz Hals Museum in Haarlem shows Marcus Aurelius riding towards the Palazzo dei Conservatori.

17 Ackerman I, Plate 32.

18 A drawing in the Louvre (1558–60; Ackerman I, Plate 31b) by the same artist as that of the Brunswick drawing shows the new base but not the *membretti*; the same state appears in an engraving (*c.* 1560) from Lafreri, *Speculum Romanae magnificentiae* (Siebenhüner, op. cit. Ill. 36).

19 Künzle, op. cit. 262 f. They do not appear on Francisco d'Ollanda's drawing (Ackerman I, Plate 32) or on Beatrizet's engraving, 1548 (Siebenhüner, op. cit. Ill. 42).

20 Cf. Ackerman II, 54; Portoghesi–Zevi, 428.

21 Cf. W. Lotz, 'Die ovalen Kirchenräume des Cinquecento', *Römisches Jahrbuch für Kunstgeschichte* VII (1955), 7 ff.; Ackerman i, 61.

22 Cf. the plan of 1567 (Ackerman I, Plate 36b) and the views of 1568 (Siebenhüner, op. cit. Ill. 47) and 1569 (Siebenhüner, op. cit. Ill. 48; Ackerman I, 37).

23 H. Sedlmayr, 'Die Area Capitolina des Michelangelo', *Epochen und Werke* I (Vienna and Munich, 1959), 271. Two recessions were later also added to the front, cf. Portoghesi–Zevi, Ill. 425.

24 Ackerman I, Plate 36b.

25 The appearance since 1940 is most clearly seen from Portoghesi–Zevi, Ill. 425.

26 Cf. Ackerman I, 73.

27 Cf. Ibid. II, 57.

28 Cf. G. Gronau, 'Die Kunstbestrebungen der Herzöge von Urbino, II: Michelangelo', *Jahrbuch der Preussischen Kunstsammlungen* 27 (1906), *Beiheft* 9f., No. XXI). On the date of this letter (after 28 November 1537 and before 18 January 1538) see Künzle, op. cit. 260.

29 Siebenhüner, op. cit. Ill. 48; see also Buddensieg, op. cit. 205.

30 Ackerman I, Plate 36b.

31 Cf. Heemskerck's drawings in Siebenhüner, op. cit. Ill. 8, 9 and 24.

32 Ibid. Ill. 89; Ackerman I, Plate 30b. The engraving shows the old stairway on the right and Michelangelo's new staircase on the left.

33 Ackermann II, 51.

34 G. Marchini, *Giuliano da Sangallo* (Florence, 1942), Plate III; the plan in Plate 4a.

35 Siebenhüner, op. cit. Ill. 22 and 23; cf. also Heemskerck's drawing (Ill. 24).

36 Ackerman I, 68.

37 Vasari–Milanesi VII, 222.

38 Cf. Siebenhüner, op. cit. 73, and Ackerman I, 69; also H. v. Einem, 'Michelangelo und die Antike', *Stil und Überlieferung* (Düsseldorf, 1970), 160.

39 Siebenhüner, op. cit. 107 ff.

40 Ibid. 108.

41 Ibid. 69.

42 Ibid. 93.

43 Cf. ibid. Ill. 36.

44 Cf. ibid. 96.

45 Cf. I. Olschki, *Dante* (Florence, 1953), 48 ff.; Buddensieg, op. cit. 206, note 87.

46 Cf. Bartolomeo Marliano, *Topografia veteris Romae* (Basle, 1538); quote from Buddensieg, op. cit. 214.

47 Buddensieg, op. cit. 228. Buddensieg's stimulating essay proceeds from the correct assumption that a project of the size of the Capitoline Hill must be considered in the first instance from the point of view, not of the artist but of the patron. Buddensieg therefore proposes a programme designed above all as a self-glorification of Pope Paul III. This, however, seems to go too far. The Senate and the

Conservatori were also involved in the plan, not only the Pope, and to regard the erection of the statue of Marcus Aurelius, the statue in the Palazzo del Senatore, the Dioscuri from the Quirinal Hill and the figure of Jupiter ('an allegorical glorification of Paul III himself') all as parts of a plan to immortalize the Farnese papacy is untenable. The decision of 1537 to replan the area must also be seen in the context of earlier plans. Moreover it is quite possible that there were differences of opinion between the Pope on the one hand and the Senate and the Conservatori on the other.

48 Cf. J. Ackerman, *The Cortile del Belvedere* (Rome, 1954); Ackerman II, 115 f.; D. E. de Campos, *I Palazzi Vaticani* (Bologna, 1967), 90 ff.; D. Frey, *Michelangelostudien* (Vienna, 1920), 17 ff.; C. Hülsen, 'Bramante und Palestrina', *Festschrift für Hermann Egger* (Graz, 1933), 57 ff.; Portoghesi–Zevi, 939 ff.; Tolnay 1970, 214 ff.

49 Vasari–Milanesi VII, 228.

50 Cf. the 1565 engraving by Master H. C. B. (Ackerman I, Plate 53b).

51 Cf. a woodcut by Serlio (D. Frey, *Michelangelostudien*, Fig. 4).

52 Cf. C. Hülsen, op. cit.

53 Ackerman, *The Cortile del Belvedere*, Plates 25–6. Tolnay (1951 and 1970) sees in the drawing (probably by Dupérac) in Dyson Perrins's collection an echo of Michelangelo's overall plan but one must not forget that this drawing belongs to the 1570s (see Wittkower, *Disegni de le ruine di Roma* (Milan, 1963); Thoenes in *Kunstchronik* (1965), 18).

CHAPTER 16

1 Cf. Ackerman I, 114 ff., Plates 74–5, and II, 125 ff.; E. MacDougall, 'Michelangelo and the Porta Pia', *Journal of the Society of Architectural Historians* XIX (1960), 97 ff.

2 Cf. Ackerman I, 115 ff.

3 Cf. Serlio, *Libro secondo di prospetti* (Venice, 1584), fols 48–51; Ackerman I, Plate 80c; R. Krautheimer, 'The Tragic and Comic Scene of the Renaissance', *Gazette des beaux-arts* XXXIII (1948), 327 ff.; Ackerman I, 115.

4 The medal of 1561 (Ackerman I, Plate 76b) depicts a rejected design (cf. Ackerman II, 127).

5 Ackerman I, 120 and Plate 75.

6 Cf. Ackerman I, 120.

7 Burckhardt, *Cicerone* (Leipzig, 1925), 313.

CHAPTER 17

1 H. v. Geymüller, *Die ursprünglichen Entwürfe für St. Peter* (Paris and Vienna, 1875); K. Frey, 'Zur Baugeschichte des St Peter', *Jahrbuch der Preussischen Kunstsammlungen*, Beihefte to Vol. XXX (1909), Vol. XXXI (1910), Vol. XXXIII (1913) and XXXVII (1916); T. Hofmann, *Entstehungsgeschichte des St Peter in Rom* (Zittau, 1928); F. Wolff-Metternich, 'Gedanken zur Baugeschichte der Peterskirche im 15.

and 16. Jahrhundert', *Festschrift für Otto Hahn* (Göttingen, 1955); Ackerman I, 89 ff., and II, 83 ff.

2 G. Dehio, 'Die Bauprojekte Nikolaus' V. und Leon Battista Alberti', *Repertorium für Kunstwissenschaft* III (1880), 241 ff.; T. Magnuson, *Studies in Roman Quattrocento Architecture* (Stockholm and Rome, 1959); G. Urban, 'Zum Neubau von St. Peter unter Papst Nikolaus V.', *Festschrift für Harad Keller* (Darmstadt, 1963).

3 Urban, op. cit. 144.

4 Vasari–Milanesi IV, 282; cf. also H. v. Einem, 'Michelangelos Juliusgrab im Entwurf von 1505 und die Frage seiner ursprünglichen Bestimmung', *Festschrift für Hans Jantzen* (Berlin, 1951), 152; further information in chapter 4 of the present work.

5 Cf. M. Theuer, *Leon Battista Albertis Zehn Bücher über die Baukunst* (Vienna, 1912); C. Grayson, 'Die Entstehung von Albertis Decem Libri de re aedificatoria', *Kunstchronik* XIII (1960), 359 ff.; in *Münchener Jahrbuch der bildenden Kunst* XI (1960); R. Wittkower, *Architectural Principles in the Age of Humanism*, 3rd ed. (London, 1962).

6 In the Uffizi; found in Vasari's posthumous papers. On the verso, in the writing of Antonio da Sangallo: 'Pianta di S. Pietro di mano di Bramante che non ebbe effetto'; Wittkower, op. cit. Ill. 26.

7 Ackerman I, Plate 51a.

8 Wittkower, op. cit. 27.

9 Ibid.

10 Cf. Heemskerck's drawings (D. Frey, *Architettura della Rinascenza da Brunelleschi a Michelangelo* (Rome, 1924), Plates CXII and CXIII).

11 H. Rose, *Bearbeitung und Kommentar zu Heinrich Wölfflin, Renaissance und Barock* (Munich, 1926), 254.

12 Cf. Ackerman I, 90, Fig. 11. Important modifications of Bramante's plans consist in the strengthening of the dome-piers, the reduction of the arms of the cross to a single bay framed by broad ribs, and the motif of the ambulatories.

13 Cf. G. Giovannoni, *Antonio da Sangallo il Giovane* I (Rome, 1959), 115 ff.

14 K. Frey in *Jahrbuch der Preussischen Kunstsammlungen*, Beiheft to Vol. XXXIII (1913), 82; O. Pollak, in ibid., Beiheft to Vol. XXXVI (1915), 86.

15 K. Frey, op. cit. 29; Ackerman II, 85.

16 Giovannoni, op. cit. Fig. 90 (façade); Rose, op. cit. 154 (south apse).

17 Giovannoni, op. cit. Figs 88–9.

18 Vasari–Milanesi V, 476 f.; dated by K. Frey 1534–5; cf. also Giovannoni, op. cit. 132 f.

19 Cf. Metternich, op. cit. 8.

20 Cf. engraving by Labacco; Giovannoni, op. cit. Fig. 89; Ackerman I, Plate 51c.

21 Cf. engraving by Labacco; Giovannoni, op. cit. Fig. 90.

22 Ackerman I, Plate 51a; Wittkower, op. cit. Ill. 25.

23 Giovannoni, op. cit. Fig. 82.

24 Ackerman I, Plate 52a.

25 Ackerman I, Plate 52b and II, 87.

26 Precise details in Ackerman II, 86 f.

27 Cf. Dollmayer, 'Giulio Romano', *Jahrbuch des Allerhöchsten Kaiserhauses*, XVI (Vienna).

28 Cf. Ackerman II, 88.

29 Vasari–Milanesi VII, 218; Ackerman II, 88 f.

30 Vasari–Milanesi VII, 219.

31 Letter of 20 August 1554 (Vasari–Milanesi VIII, 318).

32 Letter of 19 September 1554 (Milanese, *Lettere* No. CDLXXIII, p. 534).

33 Vasari–Milanesi VII, 218.

34 Cf. letter to Aliotti, October 1542 (Milanesi, *Lettere* No. CDXXXV, p. 494); H. v. Einem in *Festschrift für H. Jantzen*, 152; also chapter 4 above.

35 Milanesi, *Lettere* No. CDLXXIV, p. 535. Milanesi's suggestion that the letter was addressed to Amanati has been shown to be incorrect; Frey (No. 112) has suggested it was meant for Bartolomeo Ferratini.

36 Vasari–Milanesi VII, 220 f.

37 Ibid. 220.

38 Pollak, op. cit. 52; Ackerman II, 88.

39 Vasari–Milanesi VII, 219.

40 Condivi, ed. cit. 198; Ackerman II, 89 f.

41 Ackerman I, Plate 58a, and II, 57 f.; J. Coolidge, 'Vignola and the little domes of St Peter's', *Marsyas* II (1942), 63 ff.

42 Vasari–Milanesi VII, 218 ff. and 248 ff. The most important sources for the reconstruction given in Ackerman II, 98f.; cf. E. Panofsky, 'Bemerkungen zur Neuherausgabe der Haarlemer Michelangelozeichnungen', *Repertorium für Kunstwissenschaft* 48 (1927), 25 ff.

43 On Dupérac see W. Körte, 'Zur Peterskuppel des Michelangelo', *Jahrbuch der Preussischen Kunstsammlungen* 53 (1932), 106 ff.; R. Wittkower, 'Zur Peterskuppel Michelangelos', *Zeitschrift für Kunstgeschichte* 2 (1933), 354 ff.; J. Coolidge, op. cit. excursus; Tolnay 1970, 194.

44 Details in Ackerman II, 95; cf. Lafreri's plan of Rome, 1577 (Portoghesi–Zevi, Ill. 581): the minor domes are not yet shown; the north arm of the cross has reached the vaulting.

45 Ackerman I, Fig. 11.

46 Milanesi, *Lettere* No. CDLXXIV, p. 535.

47 Ackerman II, 92–3.

48 See note 46.

49 Cf. Sangallo's plan in Labacco's engraving (Ackerman I, Plate 51c) and Dupérac's engraving from Michelangelo's design (Ackerman I, Plate 61); cf. also D. Frey, *Bramantes St-Peterentwurf und seine Apokryphen* (Vienna, 1915), plate to p. 28, where the perspective plan formerly ascribed to Peruzzi is discussed.

50 Cf. F. Wolff-Metternich, 'Eine Vorstufe zu Michelangelos St-Peter-Fassade', *Festschrift für Herbert von Einem* (Berlin, 1965), Plate 30, 2.

51 Cf. Giovannoni, Fig. 88.

52 Cf. J. Coolidge, op. cit. 63 ff.; H. A. Millon and C. H. Smyth, 'Michelangelo and St Peter's – I: Notes on a plan of the attic as originally built on the south hemicycle', *Burlington Magazine* CXI (1969), 484 ff.

53 At the end of 1557, to Michelangelo's great concern, part of the vault over the Cappella del Re in the south apse had to be dismantled because it had developed a crack. Cf. Michelangelo's letter to Duke Cosimo in Florence (Milanesi, *Lettere* No. CDLXXXI, 543 f.) and letter to Vasari (No. CDLXXXIII, p. 546).

54 Ackerman I, Plate 59a; Portoghesi–Zevi, Ill. 573. Cf. also the sketch in the Städel Institute in Frankfurt (Millon–Smyth, op. cit. Ill. 16), the painting by Passignani (Ackerman I, Plate 58a), the engraving by Alessandro Specchi (Portoghesi–Zevi, Ill. 580) and Lafreri's plan of 1577 (Portoghesi–Zevi, 581). An engraving (Portoghesi–Zevi, Ill. 579) of a joust in the court of the Belvedere (1565) shows in the uncompleted attic of the north apse the continuation of the membering of the lower parts, i.e. it already anticipates the final form of the attic. Since Pius V had ordered that Michelangelo's plans were to be strictly carried out, Vignola, who built the attic, must have kept to Michelangelo's intentions.

55 Millon–Smyth, op. cit. 484 ff. Books on the subject by these two authors, as well as by Franz Graf Wolff-Metternich, are in preparation.

56 In the London drawing attributed to Dupérac (Ackerman I, Plate 62a) both north and south apses have the same membering with arches, but the façade has a continuation of the membering of the lower part. In Nogara's fresco in the Vatican Library (Ackerman I, Plate 58b) the attic also has a balustrade, but this will hardly have been Michelangelo's intention. Ackerman (II, 102) points to the analogy of the balustrade of the Palazzo dei Conservatori, but there it is not above the attic.

57 V. Mariani, *Michelangelo e la facciata di S. Pietro* (Rome, 1943); Ackerman II, 105 ff.; C. Thoenes, 'Zur Petersfassade Michelangelos', *Festschrift für Hans Kauffmann* (Berlin, 1968), 331 ff.

58 Cf. Metternich in *Festschrift für Otto Hahn*, 8, and *Festschrift für H. v. Einem*, 170, note 22.

59 Ackerman I, Plate 58a.

60 The only original drawing of Michelangelo's for the façade elevation is *Codex Vaticanus* 3211, fol. 92 (Dussler No. 228), which is found underneath a sonnet dated by Frey *c.* 1550; cf. Ackerman II, 102 f.; Thoenes, 133 f.

61 *Disegni de le ruine di Roma* . . . 2 vols, ed. R. Wittkower (Milan, 1963); cf. C. Thoenes in *Kunstchronik* (1965), 10 ff. Ackerman I, Plate 62a. On the dating see Thoenes, op. cit. 18: it may well have been made in 1564–5 and certainly precedes Dupérac's engraving of 1569.

62 Ackerman I, Plate 59b.

63 Thoenes in *Festschrift für Hans Kauffmann*, 337.

64 Metternich in *Festschrift für H. v. Einem*, 169.

65 Thoenes (loc. cit.) gives good reasons for ascribing the façade elevation to Vignola.

66 Cf. Sangallo's plan (Uffizi), which is based on Bramante's, and the plan in the *Libro di Giuliano da Sangallo* (*Codex Barberinus* lat. 4424, 64v); cf. also Metternich, op. cit. 162 ff.

67 Metternich, op. cit. 169.

68 Cf. J. Coolidge, op. cit. 63 ff.

69 Cf. Ackerman I, 101.

70 D. Frey, *Michelangelostudien* (Vienna, 1920), 91 ff.; W. Körte, 'Zur Peterskuppel des Michelangelo', *Jahrbuch der Preussischen Kunstsammlungen* 53 (1932), 90 ff.; R. Wittkower, 'Zur Peterskuppel', *Zeitschrift für Kunstgeschichte* 2 (1933), 348 ff.; *La cupola di S. Pietro di Michelangelo* (Florence, 1964); A. Schiavo, 'La cupola di S. Pietro', *Bollettino del Centro; Studi di Storia dell' Architettura* 6 (1952); D. Gioseffi, *La cupola Vaticana* (Trient, 1960); H. R. Alker, *Michelangelo und seine Kuppel von St Peter in Rom* (Karlsruhe, 1968); C. Brandi, 'Michelangelo e la curva della cupola di S. Pietro', *Momenti del Marmo* (1969), 65 ff.

71 Cf. Andrea di Firenze's fresco in the Spanish Chapel of S. Maria Novella in Florence (see E. Borsook, *The Mural Painters of Tuscany* (London, 1960), Plate 36); cf. also R. Salvini, 'Arnolfo e la cupola di S. Maria del Fiore', *Atti del Congresso Nazionale* XVI (1938), 25 ff.

72 To some extent the domes of the cathedrals in Pisa and Siena can be seen as predecessors; cf. D. Frey, *Michelangelostudien*, 131.

73 Vasari–Milanesi V, 353 f.

74 Casa Buonarroti; cf. Dussler Nos 92 and 102; Barocchi No. 38, Plates LXXIV–LXXV.

75 K. Frey in *Jahrbuch der Preussischen Kunstsammlungen*, Beihefte to Vols 30 and 37.

76 Vasari–Milanesi VII, 250 ff.; cf. E. Panofsky in *Repertorium* (1927); D. Frey, op. cit. 110 ff.; R. Wittkower in *Zeitschrift für Kunstgeschichte* (1933), 349 ff.

77 Ackerman I, 97, considers it improbable that the model of 1546–7 had a dome.

78 Ackerman II, 92.

79 Ackerman II, 93 f.

80 Ackerman II, 95.

81 Vasari–Milanesi VII, 248 f.

82 Ackerman II, 95.

83 Vasari–Milanesi VII, 249 f.

84 Portoghesi–Zevi, Ill. 588–94.

85 At the spring of each exterior rib of the dome stands the heraldic emblem of the three hills, insignia of Pope Sixtus V, during whose pontificate the dome was raised.

86 *Terzo libro d'architettura* (Venice, 1540), ed. 1551; XL; ed. 1600, fol. 66v. Cf. R. Wittkower, *Architectural Principles in the Age of Humanism*, Ill. 25 and 27.

87 Giovannoni, Fig. 90; cf. also Labacco's engravings of 1549 (Giovannoni, Figs 88 and 89).
88 Vasari–Milanesi VII, 250.
89 The wooden model has only triangular pediments.
90 Ackerman I, 98 f., draws attention to the ribs of the dome of the Torre Borgia, Bramante's last work (cf. drawing by Peruzzi, Ackerman I, Plate 51b), but Sangallo seems a more likely model.
91 Milanesi, *Lettere* No. CLXXXV, p. 211.
92 Ackerman I, Plate 54, and II, 108 ff.; Dussler No. 148, 93.
93 R. Wittkower in *Zeitschrift für Kunstgeschichte* (1933), 357, who dates the sketch between 29 September 1546 and 27 November 1547.
94 Cf. Wittkower, op. cit. 364.
95 Ackerman I, Plate 55a, and II, 109; Wittkower, op. cit. 357.
96 Wittkower, op. cit. 358.
97 Cf. also the scale drawing of the drum in the Casa Buonarroti (Dussler No. 457; Barocchi No. 152, Plate CCLII) with Michelangelo's own words 'Questa parte che resta bianca e la faccia dove anno . . . gli occhi'; Wittkower, op. cit. 357.
98 Ackerman I, Plate 58a.
99 Wittkower, op. cit. 364, does not deal with this painting.
100 Ackerman I, Plate 62a, and II, 99.
101 Wittkower, op. cit. 358; Ackerman II, 110; Dussler No. 207. The letter is addressed to Messer Francesco [Bandini], one of those friends named by Vasari (Vasari–Milanesi VII, 249) as having been concerned that work on the dome should proceed more quickly. Hence the probable dating 1556–7.
102 Ackerman I, Plates 60–1.
103 Vasari–Milanesi VII, 255.
104 Cf. Ackerman I, 99.
105 Cf. W. Körte in *Jahrbuch der Preussischen Kunstsammlungen* (1932), 94; Wittkower, op. cit. 361; Ackerman II, 110.
106 'Un' ordine minore di pilastri doppi e finestre, simile a quelle che sono fatto di dentro' (Vasari–Milanesi VII, 255).
107 Vasari erroneously gives the number as eighteen.
108 Cf. Wittkower, op. cit. 360.
109 Wittkower (op. cit. 366) even talks of a 'massive weight that threatens the dome'.
110 Cf. the drawing in the Casa Buonarroti (Dussler No. 140; Barocchi No. 156v; Wittkower op. cit. 359), which also recalls the lantern of the Medici Chapel.
111 Vasari–Milanesi VII, 256.
112 I. A. F. Orbaan, 'Zur Baugeschichte der Peterskuppel', *Jahrbuch der Preussischen Kunstsammlungen* XXXVIII (1917), Beiheft 189 ff.
113 Both this construction and the model bear the insignia of Pope Sixtus V.
114 Bibl. Vat. Barberini lat. 27333; cf. D. Frey, op. cit. 122, and Ackerman II, 105.

CHAPTER 18

1 Cf. D. Frey, *Michelangelostudien* (Vienna, 1920), 57 ff.; A. Nava, 'Sui disegni archi-tettonici per S. Giovanni dei Fiorentini', *Critica d'Arte* I (1935); 'La storia della chiesa di S. Giovanni dei Fiorentini in Roma', *Deputatione romana della storia patria* LIX (1936); H. Siebenhüner, 'S. Giovanni dei Fiorentini in Rom', *Kunstgeschicht-liche Studien für Hans Kauffmann* (Berlin, 1956), 172 ff.; E. Ruffin, *S. Giovanni dei Fiorentini* (Rome, 1957); E. Battisti, 'Disegni cinquecenteschi su Giovanni dei Fiorentini', *Quaderni dell' Istituto di Storia dell' Architettura in Roma* (1961), 185 ff.; Ackerman I, Ch. 9; II, 117 ff.; Portoghesi–Zevi, 651 ff.; H. Gottschalk, *Michel-angelos Entwürfe für die Kirche S. Giovanni dei Fiorentini in Rom* (The Hague, 1968).

2 Vasari–Milanesi VII, 497 ff.

3 Cf. Vasari–Milanesi, V, 454 f.

4 Cf. Ackerman II, 117; Siebenhüner, op. cit. Ill. 3–8, esp. Uff. Dis. A 861.

5 Vasari–Milanesi VII, 229; Ackerman II, 118.

6 Vasari–Milanesi VII, 263; cf. also Michelangelo's letter to Duke Cosimo, 1 Nov-ember 1559 (Milanesi, *Lettere* No. CDLXXXVII, p. 551).

7 Ackerman I, Plate 66a.

8 Uffizi A 199; Giovannoni, *Antonio da Sangallo il Giovane* I (Rome, 1959), 214 ff., Fig. 167; Ackerman I, plate 66a.

9 Dussler No. 143; Barocchi No. 158, Plate CCLVIII; Ackerman I, Plate 66b.

10 Tolnay 1951, 192.

11 Cf. Ackerman II, 119.

12 Dussler No. 142; Barocchi No. 159, Plate CCLX; Ackerman I, Plate 67.

13 Dussler No. 145; Barocchi No. 160, Plate CCLXII; Ackerman I, Plate 68.

14 Barocchi No. 159v, Plate CCLXL.

15 Vasari–Milanesi VII, 263.

16 Ackerman I, Plates 69a and b.

17 Milanesi, *Lettere* No. CDLXXXVII, p. 551.

18 Milanesi, *Lettere* No. CDLXXXVIII, p. 552.

19 Milanesi, *Lettere* No. CDLXXXIX, p. 553.

20 Cf. D. Frey, op. cit. 81 ff.; Ackerman I, 103 ff.

21 Vasari–Milanesi VII, 263.

22 MS. 1775 fol. 140v; Ackerman I, Plate 70b, and II, 120.

23 p. 244; cf. D. Frey, op. cit. 81.

24 Ackerman I, Plate 71a.

25 Ackerman II, 120 f.

26 *Insignium Romae templorum prospectus* (1684); Ackerman I, Plate 71b.

CHAPTER 19

1 Cf. A. Pasquinelle, *Le vicende e delizie di S. Maria degli Angeli* III (Rome, 1925); A. Schiavo, *S. Maria degli Angeli alle Terme* (Rome, 1954); H. Siebenhüner, 'S. Maria degli Angeli', *Münchener Jahrbuch der bildenden Kunst*, 3. Folge VI (1955),

179 ff.; Ackerman I, 123 ff.; II, 132 ff.; Portoghesi–Zevi, 761 ff. On the Roman Baths see H. Sedlmayr, *Epochen und Werke* I (Vienna and Munich, 1959), 18 ff.

2 Plan of the Baths in Siebenhüner, op. cit. Ill. 1.

3 Cf. Ackerman I, 127.

4 Cf. Siebenhüner, op. cit. 191.

5 Ibid. Ill. 11; cf. also Dosio's engraving in Portoghesi–Zevi, Ill. 828. The triple windows are missing in both these sources, but this feature, as emerges from Portoghesi–Zevi and from reconstructions of Roman baths (Sedlmayr, Ill. 4 and 5), must be classical in origin.

6 Siebenhüner, op. cit. Ill. 117; cf. Ackerman I, 126, and II, 132; Portoghesi–Zevi, 766.

7 Siebenhüner, op. cit. 191.

8 Vasari–Milanesi VII, 261.

9 Siebenhüner, op. cit. Ill. 16.

10 Ibid. Ill. 19. Siebenhüner's theory (205) that, compared with the floor of the baths, the new floor-level is 1,15 m higher, has not been borne out by recent excavations. Cf. Schiavo, 19 f., and Ackerman II, 135.

11 Cf. Ackerman II, 137.

CHAPTER 20

1 Cf. V. Fasolo, 'La Cappella Sforza di Michelangelo', *Architettura e Arti decorative* III (1923–4), 433 ff.; Tolnay, 'Un dessin inédit représentant la façade de Michelange de la Chapelle Sforza à Ste Marie Majeure', *Urbanisme et architecture: Études écrites et publiées en l'honneur de Pierre Lavedan* (Paris, 1954); Ackerman I, 109 ff., and II, 122 ff.; Portoghesi–Zevi, 683 ff.

2 Vasari–Milanesi VII, 264.

3 Portoghesi–Zevi, Ill. 764.

4 Cf. Ackerman II, 123.

5 Casa Buonarroti No. 104 (Dussler No. 132; Barocchi No. 162, Plate CCLXV); Ackerman I, 720. The sketch in the British Museum (Dussler No. 181; Wilde, *Italian Drawings*, Plate CXXIX) does not seem to be of the Cappella Sforza. Cf. also Ackerman II, 123.

6 Ackerman I, Fig. 13; Portoghesi–Zevi, Ill. 729–63.

7 Cf. the engraving in G. G. de' Rossi, *Disegni di varii altari . . .* (Rome, 1665); Ackerman I, Plate 72b.

8 Cf. F. Kriegbaum, 'Michelangelo e il Ponte à S. Trinità', *Rivista d'Arte* XXIII (1941).

9 Portoghesi–Zevi, 683.

10 Ibid. 772.

CHAPTER 21

1 Vasari–Milanesi VII, 257; cf. Tolnay V, 12, Ill. 376.

2 Tusiani, *Complete Poems*, 74.

3 Ibid. 148.

4 Sonnet LXXIII.

5 Tusiani, op. cit. 30. Cf. L. Dussler, *Michelangelo Buonarroti* (1964), 115 ff.

6 Vasari–Milanesi VII, 281.

7 Cf. H. v. Einem, 'Bemerkungen zur Florentiner Pietà Michelangelos', *Jahrbuch der Preussischen Kunstsammlungen* (1940; with bibl.); P. Pavlinov, 'La sistemazione della Pietà di S. Maria del Fiore e il metodo creativo di Michelangelo', *Studi in onore di Giusta Nicco Fasola: Arte Lombarda* 10 (1965).

8 Vasari–Milanesi VI, 189; cf. also Condivi, ed. cit. 176.

9 Vasari–Milanesi VIII, 378.

10 Kriegbaum, 42.

11 Cf. Sabbatini's copy in St Peter's in Rome (Venturi IX, 6, Fig. 258); cf. also L. Steinberg, 'Michelangelo's Florentine Pietà: The Missing Leg', *Art Bulletin* (1968).

12 Condivi, ed. cit. 174.

13 Cf. W. Stechow, 'Joseph of Arimathia or Nicodemus?', *Festschrift für Ludwig Heydenreich* (1963), 289 ff.

14 Cf. H. v. Einem, op. cit. 90 f.; further examples in Stechow, op. cit. Ill. 47.

15 Cf. v. Einem, op. cit. 92.

16 Cf. ibid. Ill. 8.

17 The quality of the *Pietà*, made out of a classical capital from the Barberini chapel in S. Rosalia in Palestrina (now in the Accademia, Florence, but not authenticated by any drawings or documents relating to Michelangelo), does not suggest that it is the master's work. Goldscheider's theory (*Michelangelo*, 1953) that the group was begun by Michelangelo and continued by others has little to commend it. The group follows the sketches in the Oxford MS (partic. Dussler's group c) and the Florentine *Pietà*. Cf. J. Pope-Hennessy, 'The Palestrina Pietà', *Akten des 21. Internationalen Kongresses für Kunstgeschichte in Bonn 1964*, 2 (Berlin, 1967), 105 ff.; E. Sestieri, 'La Pietà in Palestrina e la sua attribuzione', *Commentari* (1969); Tolnay V, 152; Tolnay 1970, 255. Pope-Hennessy considers the work definitely inauthentic and attributes it to a seventeenth-century artist called Niccolò Menghini; Tolnay (1970), on the other hand, reasserts Michelangelo's authorship.

18 D. Frey, 'Die Pietà Rondanini und Rembrandts Drei Kreuze', *Kunstgeschichtliche Studien für Hans Kauffmann* (Berlin, 1956), 212; cf. Isermeyer in *Zeitschrift für Kunstgeschichte* (1965), 347.

19 Vasari–Milanesi VII, 244 f.

20 Cf. Thode II, 279.

21 Dussler No. 300, Ill. 107.

22 Dussler No. 201, Ill. 105. The date is uncertain, cf. Dussler 201 and Isermeyer, op. cit. 348. I would accept 1545, since the last sketches on the sheet (Dussler d and e) are earlier than the first version of the *Rondanini Pietà*, which according to Vasari was begun before the Florentine *Pietà*, which was started *c.* 1547.

23 Ill. in F. Baumgart, 'Die Pietà Rondanini', *Jahrbuch der Preussischen Kunstsamm-*

lungen (1935), and v. Einem, op. cit. Ill. 5. Cf. D. Frey in *Kunstgeschichtliche Studien für Hans Kauffmann* 209, note 2; A. Perrig, *Michelangelo Buonarrotis letzte Pietà* (Basle, 1960); Henry Moore, 'L'Ultima Pietà di Michelangelo', *Arte Figurativa* 14 (1966), 81 ff.; A. d'Auria, 'Sulla Pietà Rondanini', *Arte Figurativa* 14 (1966), 81 ff.

24 Cf. E. Langlotz, 'Niobidenreliefs des 5. Jahrhunderts', *Die Antike* (1928), 31 ff.

25 Cf. Wittkower, 'A Newly-discovered Drawing by Michelangelo', *Burlington Magazine* (1941), 159 ff., and Wilde, *Italian Drawings*, 120.

26 Dussler No. 211, Ill. 140; Tolnay V, No. 249, Ill. 224.

27 Dussler No. 174; Tolnay V, No. 251, Ill. 225.

28 Dussler No. 243, Ill. 139; Tolnay V, No. 250, Ill. 226.

29 Cf. H. v. Einem in *Zeitschrift für Kunstgeschichte* (1962), 84.

30 Dussler No. 204, Ill. 141; Tolnay V, No. 254, Ill. 229.

31 *Werk und Weltbild des Michelangelo*, 82: in the English edition (*The Art and Thought of Michelangelo* (1964), 77) Tolnay denotes the figures as 'Probably centurions'.

32 Dussler No. 175, Ill. 138; Tolnay V, 256, Ill. 231.

33 Dussler, 112.

34 Sonnet LXV.

35 Tolnay, 'Un bozzetto di legno di Michelangelo', *Commentari* XVI (1965), 93 ff.

36 Cf. Tolnay 1951, 155, Plate 389. Venusti's copy in H. Voss, *Die Malerei der Spätrenaissance in Rom und Florenz* I (Berlin, 1920), Ill. 25; cf. Wilde, *Catalogue*, 111; A. Perrig, 'Michelangelo und Marcello Venusti', *Wallraf-Richartz-Jahrbuch* 24 (1962), 261 ff.

37 Dussler No. 205, Ill. 144; Tolnay V, No. 264, Ill. 288.

38 Vasari–Milanesi VII, 272.

39 No. CXXIII; cf. Thode II, 463.

40 Dussler No. 202, 222–3, 322.

41 Tolnay 1951, Plate 392; V, Ill. 323. Cf. A. Perrig, op. cit. 261 ff. (the copy in the Galleria Nazionale Antica in Ill. 161). The suggestion that the painting was for Michelangelo's servant Urbino and was done in 1549–50 has little to support it.

42 Tolnay V, Ill. 320.

43 van Marle, op. cit. IX, Fig. 228.

44 Dussler No. 161, Ill. 27–8; Tolnay V, No. 266, Ill. 103.

45 H. Grimm II, 396.

46 Vasari–Milanesi VII, 268; cf. *The Divine Michelangelo: The Florentine Academy's Homage on his Death in 1564*, ed. R. and M. Wittkower (London, 1964). (Review: Levey in *Burlington Magazine* (1964), 429.)

CONCLUSION

1 Cf. H. v. Einem in *Jahresbericht der Gesellschaft von Freunden und Förderern der Universität Bonn* (1951) and in *Das Unvollendete als künstlerische Form: Ein Symposion*, ed. I. A. Schmoll Eisenwerth (Berne and Munich, 1959); A. Bertini, 'Il

problema del non-finito nell' arte di Michelangelo', *L'Arte* (1930); W. Körte, 'Das Problem des Nonfinito', *Römisches Jahrbuch für Kunstgeschichte* VII (1955); J. Gantner, *Michelangelo und Rodin* (Vienna, 1953); P. Barocchi, 'Finito e non-finito nella critica Vasariana', *Arte Antica e Moderna* (1958); P. Sanpaolesi, 'Il Nonfinito', *Marcatrè* 12–13 (1965); T. Brunius, 'Michelangelo's Nonfinito', *Contributions to the History and Theory of Art* (Uppsala, 1967); Acta Universitatis Upsaliensi, No. 5, VI.

2 Condivi, ed. cit. 210.

3 Ibid. 134.

4 Vasari–Milanesi VII, 243.

5 Ibid. 270.

6 Ibid. 195.

7 Tusiani, *Complete Poems*, 109.

8 Plotinus, *Enneades* V, Book 8. On Goethe see H. v. Einem, *Beiträge zu Goethes Kunstauffassung* (Hamburg, 1956), 144 f.; *Goethestudien* (Munich, 1971), 110 f.

9 II, 2; cf. also *Paradiso* I, 127–9. E. Panofsky, *Idea* (Leipzig and Berlin, 1924), 22.

10 III, 7 ff.

11 Vasari–Milanesi IV, 34.

12 Ibid. 30 f.

13 Cf. Panofsky, op. cit. 68.

14 Cf. H. R. Hahnloser, *Villard de Honnecourt* (Vienna, 1935), Plate 48, 147 ff.; Panofsky, op. cit. 21.

15 *Dürers schriftlicher Nachlass*, ed. Lange–Fuhse (Halle, 1893), 229.

16 Vasari–Milanesi IV, 34.

17 Cf. H. v. Einem, 'Der Torso als Thema der bildenden Kunst', *Zeitschrift für Aesthetik und allgemeine Kunstwissenschaft* (1935).

18 Vasari–Milanesi VII, 273. Vasari is talking metaphorically, not, as H. Kauffmann maintains (*Festschrift für Hans Jantzen* (1951), 145), about a specific procedure of Michelangelo's. Cf. also Justi I, 383; Panofsky, *Studies in Iconology*, 178; P. Barocchi, *Giorgio Vasari, La vita di Michelangelo* II, 231.

19 Cf. K. Borinski, *Die Rätsel Michelangelos* (Munich, 1908), 93 f.; Panofsky, *Idea*, 79. note 59.

20 Sonnet XV.

21 Kriegbaum, 24.

Index

Agostino di Duccio, *Hercules*, 27

Alberti, Leon Battista, 16, 44, 263; façade for S. Maria Novella, 86, 213; S. Sebastiano, S. Andrea, 87; and New St Peter's, 209; *De re aedificatoria*, 210

Alciati, Andrea, and Phaeton myth (*Emblemata*), 134

Aldovrandi, Ulisse, *Antichità*, 127, 132; on *Farnese Bull*, 187

Alexander VI, Pope, 18

Alexander VII, Pope, 204

Ammanati, Bartolomeo, Library staircase, 114, 205–6

Andrea di Firenze, *St Thomas*, 82

Andrea del Sarto, 84; *pietà* theme, 165

Angelico, Fra, 246; altarpiece, 156; Cappella del Sacramento frescoes, 176

Antonio da Pontassieve, and tomb of Julius II, 75–6, 125, 171

Apollo (unfinished), 127, 129, 130, 258; called 'David', 129–30; influence of Leonardo, 130

Apollo Belvedere, 10, 18

Aretino, Pietro, criticism of M., 2

Ariosto, Lodovico, on M., 1 (*Orlando Furioso*)

Aristotile da Sangallo, 121

Aristotle, and hubris, 134

Averardo, Giovanni d', 93

Bacchus, 18, 63, 129, 258; date of composition, 18, 275 n. 12; classical style, 18–19, 23, 28, 47; Gothic elements, 20

Baccio d' Agnoli, 84, 85, 221

Baccio da Montelupo, 35

Baldovinetti, Alessio, 17

Bandinelli, Baccio, 48

Bandini, Francesco, 221, 244

Bandini, Pier Antonio, 244

baroque, 5, 86, 106, 195, 199, 207, 227, 240

Bartolomeo della Porta, Fra, 31, 215, 216–17, 310 n. 35; S. Maria Nuova fresco, 146, 155; *Virgin and Child with St Anne*, 31

battles: Anghiari, 32; Cascina, 32–3

Battle of Cascina, 13, 30, 32, 66, 153–4, 180; contest with Leonardo, 31; reconstruction, 32–4; renewed work on, 46

Battle of the Centaurs, 12, 13, 33, 153–4

Beatrizet, Nicholas, 253

Bellini, Giovanni, 17

Bellori, Giovanni Pietro, 2

Bembo, Pietro, Cardinal, 168; and myth of Tityus (*Asolani*), 132

Benedetto da Maiano: possible teacher of M., 11, 14; altar retable, Naples, 273 n. 13; *Madonna*, 26; St Sebastian, 81

Bernini, Gian Lorenzo, 3

Bertoldo di Giovanni: 'school for sculptors', 10–11; M.'s debt to, 12, 13; *Battle of the Horsemen*, 13

Biagio da Cesena, and *Last Judgement*, 152

Biblioteca Laurenziana, 83, 92, 98, 190; planning and siting, 11–12; opening, 112; free-standing stairway, 114–15, 116; *ricetto*, 115–16, 193; reading-room, 116–17; *pavimento*, 117; façade, 117

Bilhères de Lagraulas, Cardinal Jean, and M.'s *Pietà*, 18, 20, 23

Boboli Gardens, *Captives*, 123–7, 258, 296 n. 27; *Atlas*, 123; *Awakening Giant*, 123; *Bearded Giant*, 123, 127; *Young Giant*, 123, 127

Bologna, 12, 46, 278 n. 17; S. Domenico, 14; S. Petronio, 15, 23, 66, 68, 284 n. 69; bronze effigy of Julius II, 48, 80, 99

Borghini, Vincenzo, 177, 178

Borromini, Francesco, S. Carlo and S. Agnese, 240

Bosch, Hieronymus, ascent of the blessed theme, 156

Boscolo, Maso di, 171

Bottari, Giovanni, on Cappella Sforza, 190, 240

Botticelli, Sandro, 17

Index

Bouts, Dierick, ascent of the blessed theme, 156

Bramante, Donato, 203; competition with M., 49, 55, 215, 216–17, 220, 221; Belvedere, 195, 205; and New St Peter's, 44, 45, 84, 209, 210, 211–13, 222, 223, 309 n. 12; Palazzo dei Tribunali, 204; Tempietto for S. Pietro in Montorio, 210–11, 304 n. 24

Bramantino, Bartolomeo, Man of Sorrows, 127

Bregno, Andrea, Siena Cathedral altar, 25–6

Bruges *Madonna and Child*, 26, 27, 63, 104, 129, 273 n. 13, 277 n. 3

Brunelleschi, Filippo: Duomo, 96, 220; Foundling Hospital, 203, 240; Old Sacristy, 93, 94, 98; Pazzi Chapel, 94; new S. Lorenzo, 84

Brutus (unfinished), political inspiration, 167–8

Buggiano, Piccarda da, 93

Buonarroti, Lodovico, father of M., 9

Buoninsegni, Domenico, 88, 288 n. 51

Buontalenti, Bernardo, 123, 258

Burckhardt, Jacob: and M.'s *terribilità*, 4, 6; on Pope Nicholas V, 16; on a preserved body of a young woman, 16–17; on Laurentian Library, 115, 116; on Porta Pia, 208; *Cicerone*, 4, 35, 115, 175; *Civilization of the Renaissance in Italy*, 16; *Weltgeschichtliche Betrachtungen*, 4

Calcagni, Tiberio, 168, 231, 237; restoration of *Pietà*, 244

Campin, Robert, *Holy Trinity*, 247, 250

Capitoline Hill, 197, 207 n. 47; palaces, 86, 197–8; Roman buildings and statues, 197, 201; restoration of ancient bronzes, 198; M. and the piazza, 198 ff.; sons of Jupiter statues, 200–1; Marcus Aurelius, 198–200, 204; Minerva, 201–2; Palazzo dei Conservatori, 198, 199, 201–5; Palazzo Nuovo, 199, 204; Palazzo del Senatore, 198, 199, 200–3; river gods (Nile and Tigris), 201

Cappella Paolina, frescoes, 135, 169, 177–88; *Christ and the Traders*, 177, 188; *Conversion of St Paul*, 177, 178–9, 180–3, 186–8; *Crucifixion of St Peter*, 177, 178–9, 184–8, 247, 251, 252

Cappella Sforza (unfinished), 190, 194, 208; M.'s designs for, 237–40

Caprese, M.'s birthplace, 9

Caradosso, medal of St Peter's, 211

Caravaggio, Michelangelo Merisi da, 135; Cappella Cerasi canvases, 178

Caroto, Antonio, 117

Carracci, Lodovico, 80

Carrara, marble quarries, 20, 39, 48, 85, 94, 278 n. 17

Castagno, Andrea del, 17, 246

Cavalieri, Giovanni Battista de', 184

Cavalieri, Tommaso, 221, 255; M.'s 'amatore divinissimo', 130–2; his drawings and writings for, 131–7, 189; *Bacchanal*, 134, 136–7; *Ganymede*, 134, 135; *Phaeton*, 134, 135–6; *Tityus*, 134

Cavallini, Pietro, fresco for S. Cecilia in Trastevere, 143–4, 154, 155, 157

Celano, Thomas a, *Dies irae*, 157

Cellini, Benvenuto, 46

Cencio, Bernardo, 127

Charles V, Emperor, 117, 118

Charles VII, King of France, 11

Christian art, 61, 65; *pietà* motif, 21–2, 164, 165, 245; and *arma Christi*, 23; symbolism of David, 28; depiction of the Creation, 70, 71; Adoration of the Virgin, 106; Man of Sorrows theme, 127–8, 164, 165, 246; Last Judgement, 154–5; Paul as a rider, 179–83; Pride attacking Humility, 179–80; crucifixion of St Peter, 184–5

Clement VII, Pope, 93, 120, 292 n. 65; and Laurentian collection, 111; imprisonment, 117, 120; restores M. to his offices, 118, 121, 141; premature death, 141, 142, 144; and *Last Judgement*, 142, 144

Clement VIII, Pope, 202, 204

Clement XI, Pope, 206

Cock, Hieronymus, 201

Colombe, Philippe, grave of Marshal Brosse, 276 n. 35

Colonna, Vittoria, 14, 158, 174; relations with M., 158, 160, 162–3, 183, 253; M.'s drawings for her, 164–6, 189, 253; 'Christ and the Woman of Samaria', 164, 301 n. 11; Crucifixion, 164, 166; Pietà, 164–5, 245, 248, 249

Condivi, Ascanio, 15, 118; biography of M., 10, 14, 122; on Bacchus, 18; and 'papal tomb', 39, 40, 41–2, 43, 44, 76, 141; and Sistine Chapel, 49, 51, 70; and M. as architect, 84, 85; and Medici tombs, 108; and Last Judgement, 142, 148–9; and M.'s love for Vittoria Colonna, 160, 164, 166; and Rachel, 174; and Florence Pietà; and his unfinished works, 258, 259

Contarini, Cardinal, 158

Cortile del Belvedere, 205–6

crucifix in wood, 13–14, 23, 280 n. 13

Crucifixion drawings, 250–3

Cruyl, Lieven, 237

Cupid recumbent (lost statue), 15

Dante: M. and, 11, 63, 107, 155, 156, 157, 164, 168, 204, 261; prayer of St Bernard, 21; Ganymede, 133; Phaeton, 134; Charon and Minos, 151–2; Rachel and Leah, 174; De Monarchia, 260

David (lost bronze), 29, 277 n. 11

David, 13, 27, 258; composition, 28–9, 46, 47, 175; free-standing, 47

Delacroix, Eugène, on M., 4, 5

della Porta, Giovanmaria, papal emissary, 121, 200

della Porta, Giacomo: and Capitoline Hill, 199, 200, 201, 202, 204, 216; and Cappella Sforza, 237; and New St Peter's, 216, 220, 222, 226–7; and S. Giovanni, 228

Delli, Dello, Last Judgement, 300 n. 40

Desiderio da Settignano, 12

Dilthey, Wilhelm, concept of personality, 5

Dolce, Lodovico, accusations against M., 2

Dolfini, Prior, 93

Domenico di Niccolò, David, 28

Donatello, 10, 11, 22; influence on M., 12, 26, 48, 61, 165; David, 27, 29; John the Baptist, 82; Joshua (lost), 27; Judith, 136; Madonna (Padua), 26; Madonna in the Clouds, 12; The Sacrifice of Isaac, 48; St Mark, 46; statues of the prophets, 61

Donati, Manno, 32–3

Donato Benti da Urbino, 171

Doni Tondo, 35–6, 62, 65, 68

Dosio, Giovanni Antonio, 206, 231, 232, 234

Duca, Antonio del, angel-worship cult, 233, 235

Duca, Jacopo del, 302 n. 11

Dupérac, Étienne, engravings of M.'s works, 198, 200, 201, 202, 203, 216, 219, 225, 226, 311 n. 56

Dürer, Albrecht, 26; Throne of Grace theme, 165

Dying Captive, 79, 80–1, 100, 123, 287 n. 24

Engelberg cross, 133, 135

Eugene IV, Pope, 176

Europe: pietà motif, 22; and papal authority, 144

Farnese, Cardinal Alessandro (Paul III), 144, 190

Farnese Bull, 187, 247

Fattucci, Giovanfrancisco, papal secretary, 53, 100, 111

Federighi, Antonio, Siena Cathedral font, 42

Félibien, André, 2

Ferrucci, Le Antichità di Roma, 187

Ficino, Marsilio, 11, 260

Filarete (Antonio Averlino), 184

Florence: Medicis and, 11, 25, 30, 111, 117; ruled by Grand Council, 25, 29; Weavers' Guild, 29, 46; struggle against Pisa, 32; plague and invasion,

Index

Florence—*contd.*
92; M.'s fortifications, 117–19; *fuoru-sciti*, 167–8; Accademia, 28, 46, 123; Baptistery, 66, 101, 143, 220; Cappella Medicea, 11; Cappella Ruccelai, 44; Duomo Operai, 27, 96, 220–1, 224–5; New Sacristy, 83; Oratoria della Misericordia, 11, 26, 81; Or San Michele, 46; Palazzo Vecchio, 27, 29–31, 46; Ponte Trinità, 240; S. Croce, 164, (M.'s tomb) 244, 255; S. Marco, 11, 31, 111, 116; S. Maria del Carmine, 69, 74, 185, 284 n. 73; S. Maria Novella, 9, 66, 67, 82, 85, 155; S. Maria Nuova, 146, 155; S. Miniato, 85, 118, 293 n. 69; S. Onofrio, 14; S. Spirito, 2, 13, 14, 95, 166, 230, 280 n. 13

Florence, Cosimo, second duke of, 92

Foligno, Cathedral, 221

Fontana, Domenico, 207; library for Sixtus V, 205; and New St Peter's, 216

Formis, S. Angelo fresco, 154

France: *Bible moralisée*, 22; and the *pietà*, 22, 23; *Grandes Heures de Rohan*, 165–6

Francesco da Urbino, 171

Francese, Giovanni, 221

Francisco de Hollanda, 160, 199; and *Bacchus*, 18

Fréart de Chambray, Roland, 2

Frey, Dagobert, on *Rondanini Pietà*, 248

Fuseli, Johann, 3, 32

Galilei, Alessandro, 228

Gemma augustea, 148

Genoa, tomb of Queen Margareta, 79

Ghiberti, Lorenzo, 22; Flood, 67; *Porta del Paradiso*, 66, 101

Ghirlandaio, Domenico del, 17; M.'s apprenticeship, 9–10, 16, 74, 272 n. 3; frescoes for S. Maria Novella, 9; *Codex Escurialensis*, 135

Gianotti, Donato, 167, 168, 221

Giocondo, Fra Giovanni, 211

Giotto, 9; Arena Chapel fresco, 154, 155; Stephaneschi Altar, 184

Giovanni da Milano, 246

Giovanni dal Ponte, 185

Giuliano delle Rovere, Cardinal, classical statuary, 17–18

Goethe, J. W. von, 132, 154, 260; on Sistine Chapel, 3–4, 56; and Raphael, 4; on 'bathing motif', 33; *Faust*, 102

Gothic art, 4–5, 20, 47, 101

Granacci, Francesco, 9, 10, 272 n. 3

Gregory XIII, Pope, 177, 235

Grimaldi, Giacomo, martyrdom of St Peter, 184

Grimm, Herman, on *Moses*, 173

Guariento, *Paradise*, 31

Hadrian VI, Pope, 120

Hartt, Frederick, and Sistine Chapel design, 56

Heemskerck, Maerten van, 213; and *Bacchus*, 18

Heinse, Johann, on M., 3

Hercules, 28; reconstruction, 13–14; history, 273 n. 20

High Renaissance, 5, 62, 72, 82, 83, 84, 85, 92, 99, 126, 191, 205

Holkham Hall, Norfolk, grisaille by M., 32, 33

Honnecourt, Villard de, 261

Innocent VIII, Pope, Belvedere, 205

Jacopo Galli, and *Bacchus*, 18; Piccolomini statuettes, 26; *Pietà*, 20

Jacopo della Quercia, 15, 277 n. 3; Madonna, 26

Jacopo del Sellaio, 246

Jacopino del Conte, *Descent from the Cross*, 247

Jerusalem, Christ's tomb, 44

Jesuits, Il Gesù church, 189–90

Julius II, Pope, 44, 55, 79; classical statuary, 17–18; and Apollo Belvedere, 18; summons M. to Rome, 25, 39; marble tomb, *see* Tomb of Julius II; and Sistine ceiling, 45, 55; bronze effigy (destroyed), 48, 49, 99; triumphal entry into Rome, 65; death and inter-

ment, 75; and New St Peter's, 209, 211

Julius III, Pope, 228, 233, 243; and Cortile del Belvedere, 205

Justi, Carl, 35–6; and *Bacchus*, 19; and Pope Julius's tomb, 120; and *Last Judgement*, 142; on change of style, 66; *Dying Captive*, 81; *Jonah*, 64; Sistine Chapel, 49–50

Körte, W., on the *pietà*, 22

Kriegbaum, Friedrich, on *St Matthew*, 47, 264

Labacco, Antonio, 212

Lafreri, *Speculum Romanae magnificentiae*, 171, 200

Landini, Cristoforo, 11, 260–1; on Ganymede, 133, Phaeton, 134

Laocoon, 48, 80, 81, 166, 280 n. 13

last drawings: Annunciation, 253; Crucifixion, 250–3; mother and child, 254; Mount of Olives, 253–4

Last Judgement, 2, 13, 31, 51, 92, 129, 135, 183; and *Fall of Phaeton*, 135–6, 154; commission and completion, 141–3, 144, 169, 299 n. 9; design and composition, 144–5, 152–4, 155; sketches, 145–7, 150; forerunners, 153–4; pictorial influences, 155–7; identification with reform movement, 158–9; Adam, 150, 155; Angels of Apocalypse, 149–50; Avarice and Lust, 151; Charon and Minos, 151–2, 157; Christ, 145, 146, 147, 148, 155; Ezechiel, 149–50, 156, 167; lunettes (angels), 147–8; St Bartholomew, 151; St Blasius, 151; St Catherine, 151; St Lawrence, 151; St Michael, 147; St Peter, 150; St Sebastian, 151; St Simeon, 151; Seven Deadly Sins, 147; Virgin Mary, 148–9

Leda and the Swan, 102

Legenda aurea, and crucifixion of St Peter, 184, 185

Le Mercier, Jacques, 231

Leo X, Pope, 11, 76; raises the Medicis to the aristocracy, 93; death, 120; permits a new church in Rome, 228; and tomb of Julius II, 84; and San Lorenzo, 85; and Laurentian collection, 111

Leonardo da Vinci, 14, 31; influence on M., 25, 26, 34, 63, 129, 130; contests with him, 30, 32, 34, 36; unfinished works, 261–2; *Christ*, 130; *Last Supper*, 23, 34, 260; *Leda*, 129; *St John*, 129; *Battle of the Standard*, 31, 32, 34; *Virgin and Child with St Anne*, 25, 34, 36, 276 n. 1

Leoni, Diomede, 255

Leoni, Leone, medal of M., 241

Ligorio, Pirro, 206, 219

Lippi, Filippino, 30, 276 n. 34; fresco in S. Maria del Carmine, 185

Lisner, Margrit, 14

Loreto Cathedral, Sagrestia della Cura, 61, 180; Santuario della Sante Casa, 220

Luchino, Vincenzo, 219

Lucretius, allegory of Tityus, 132

Lunetto, Stefano di Tommaso di Giovanni, 111, 293 n. 3

Maderna, Carlo, nave of St Peter's 209, 216, 227, 303 n. 2; and S. Giovanni, 228

Madonna of the Stairs, 12, 26, 65, 100, 104, 245; motif, 12–13

Malatesta, Galeotto, 32–3

Mannerism, 5–6, 72, 104, 247, 280 n. 13; M. and, 83, 88, 92, 126, 130

Mantegna, Andrea, 17

Mantua: S. Andrea, 86, 87; S. Sebastiano, 87

Marco del Tasso, 117

Masaccio, 9; Brancacci Chapel frescoes, 69, 74, 284 n. 73; Pisa Cathedral altar, 185

Matteo d'Amelio, Pier, 51

Medici, Duke Alessandro de', 97, 167

Medici, Duke Cosimo I de', 97, 129–30, 214, 229

Medici, Cosimo de', il vecchio, 111

Medici, Giuliano de', 93

Medici, Giuliano de', Duke of Nemours, 11, 92, 93

Index

Medici, Giulio de' (Clement VII), 93, 94, 96

Medici, Duke Lorenzino de', *Bruto Nuovo*, 167

Medici, Lorenzo de', Duke of Urbino, 93, 94, 120

Medici, Lorenzo de', il Magnifico, 10, 11, 84, 93

Medici, Piero de', 11

Medici Chapel of S. Lorenzo, façade, 83–8, 90; Cosmas and Damian, 88, 97; John the Baptist, 88; Peter and Paul, 88; St Laurence, 88

Medici Chapel of S. Lorenzo, 67, 190; New Sacristy, 93–4; design, 94–5, 98–9; interpretation, 105–10; dedication to the Resurrection, 105, 106, 109; *Crouching Boy*, 105; *Dawn* and *Evening*, 100–10 *passim*, 257, 258, 291 n. 40; *Day* and *Night*, 100–10 *passim*; Dukes Giuliano and Lorenzo, 96–7, 99–100, 104, 106, 258, 290 n. 22; *Heaven* and *Earth*, 107; *il Pensieroso*, 63, 99–100, 106, 109–10; *Madonna*, 12, 13, 103–6, 259; *River-gods*, 105, 106, 109; *la Vigilanza*, 100, 106, 109–10

Melighino, Jacopo, 190

Mengs, Anton Raffael, 52

Michelangelo Buonarroti: dichotomy of his appeal (*divinità* and *terribilità*), 1, 4, 83, 153; classicist disapproval, 2–3; fresh evaluation, 3–5; in historical perspective, 5–6; birth and family background, 9; school and apprenticeship, 9–10; training as a sculptor, 10–11; house guest in Medici palace, 11; impulsive nature, 12; and his own works, 13, 24, 29, 73, 106–7, 170, 259, 260; anatomical studies, 14, 28; movements in and out of Rome, 15, 16–18, 31, 39, 45, 55, 278 n. 17; treatment of the nude, 19, 28, 35, 65, 67, 80–1; contrast between restraint and freedom, 20, 28, 47, 232; an acknowledged master, 25; conception of human beauty, 28; relationship with Julius II, 39, 45, 53, 75, 285 n. 1; hatred of Bramante, 45;

mode of working, 46–7; objectives in sculpture, 47–8; new experience of antiquity, 62; melancholy disposition, 73, 137; as an architect, 83–4, 87, 92, 99, 126; female nude, 101, 102; Apollonic ideal of bodily beauty, 128; and Ganymede myth, 133; chief artist to Holy See, 141; religious change in later years, 143, 158, 160, 167, 174, 178, 183, 188; self-portrayal, 183; final works, 189–90; lonely last years, 241; last sculptures on the Passion, 242, 243, 245, 249, 251; dualism in his art, 243; change to values of Middle Ages, 247; death, 255; why were some works unfinished?, 256 ff.; self-tormenting nature, 260; portrayal of objective world, 262; Christian character of his work, 264–5

works, *see under individual items*

writings, 11, 109, 133; poems, 9, 73, 101, 128–9, 131, 182, 241–3, 252, 259, 263–4, 285 n. 91; sonnets to Vittoria Colonna, 160–3, 183

Michelozzo Michelozzi, 22, 111, 116

Middle Ages, 5, 47, 92, 128, 175, 179, 247, 250, 260, 261, 265

Milan, 31; S. Maria delle Grazie, 260

Milizia, Francesco, *Dell'arte di vedere*, 3

Mino da Fiesole, 12, 22

Montepulciano, S. Biagio, 221

Montorio, S. Pietro in Tempietto, 222

Montorsoli, Giovanni, 97

Nanni de Banco, Isaiah, 27

Naples, S. Anna dei Lombardi, 273 n. 13

Nardo di Cione, Cappella Strozzi frescoes, 155

Nelli, Giovanni Battista, 88

Neoplatonism, 133, 284 n. 66; influence on M., 11, 109–10, 130, 261; and Ganymede, 133; theory of art, 260, 263

Nero, Emperor, *Domus aurea* ceiling, 55

Nicholas V, Pope, 16, 44, 45, 176; and New St Peter's, 209, 211

Niobe: (Florence) 81, 151; (Phidias) 250
'Oratorio deli' Amore divino', reform movement, 158
Orvieto, 63; Cathedral, 155
Ovid: Phaeton myth, 133–4; *Metamorphosis*, 135
Ovid moralisé, Ganymede myth, 133

Padua, 26; Arena Chapel, 154, 155
Palazzo Farnese: Sangallo's project, 190–3; M. and, 191, 193–6; *Farnese Bull*, 195; Sala Grande, 240
Pallavicini, Francesco, Bishop of Aleria, 125
papacy: exile from Rome, 16; claim to Regency of the Almighty, 144; revolt against its authority, 197
Pasquino, 48
Passignani, Domenico, 215, 225, 311 n. 54
Paul III, Pope, 121, 141, 158, 233; and Sistine Chapel, 141; and *Last Judgement*, 152, 159; and Cappella Paolina, 169; and Tomb of Julius II, 169–70; and Vatican Palace, 176, 177, 178; and Capitoline Hill, 198, 200, 307 n. 47; and New St Peter's, 211, 215
Paul IV, Pope, 2, 159
Paul V, Pope, 206
Perugino, Sistine Chapel fresco, 51; painted over, 141–2, 147, 299 n. 9
Peruzzi, Baldassare, 211, 212, 214, 228, 234
Petrarch, 261; *Trionfo d'Amore*, 260
Philoxenos of Eretria, 179
Piccolomini, Cardinal Francesco (Pius III): altar, 26, 95, 183; statuettes, 25–6, 27, 277 n. 3
Pico della Mirandola, 11, 260
Piero della Francesca, 17
Pietà (Florence), 243–4, 248, 250, 256, 257; Man of Sorrows concept, 245; Christ, 244–5, 257; Mary Magdalene, 244, 245–6; Nicodemus, 244, 245, 246, 247; Virgin Mary, 244, 245, 246, 257
Pietà (St Peter's), 39, 69, 164–5, 245, 258; marble copy, 2; commission and com-

position, 18, 20–1, 23, 24, 27, 100; motif, 91
Piles, Roger de, 2
Pisa, 32–3; Baptistery, 28; Masaccio's high altar, 185; pulpits, 61; Traini's fresco, 155
Pisano, Giovanni 79, 165; Pisa and Pistoia pulpits, 61
Pisano, Nichola, 13; Pisa *Hercules*, 28
Pistoia: Forteguerri tomb, 23; Pisano's pulpits, 61
Pitti Tondo (unfinished), 36, 257, 273 n. 3
Pius III, Pope, 26
Pius IV, Pope, 199; and Porta Pia, 207, 233; and S. Maria degli Angeli, 233
Pius V, Pope, 235; and New St Peter's, 311 n. 54
Pius IX, Pope, 207
Plato, 109; Ganymede, 133; philosophy of art, 260; *Phaedo*, 109
Platonism, influence on M., 11, 109, 130
Pliny, 17
Plotinus, philosophy of art, 260, 261, 264
Poliziano, Angelo, 11, 13, 260
Pollaiuolo, Andrea, crucifixes, 14
Pollaiuolo, Antonio, 14; tomb of Sixtus IV, 41, 43, 75
Pompeii, Casa de Fauno mosaic, 179, 180
Pontormo, Jacopo, 247
Ponzio, Flaminio, Cappella Borghese, 237
Porta Pia, 190, 207–8
Prudentius, Marcus Aurelius, *Psychomachia*, 179
Pucci, Lorenzo, and tomb of Julius II, 75

Quattrocento, 19, 69–70, 120
Quercia, Jacopo della: Adam delving, 284 n. 69; church portal (Bologna), 66; Madonna, 23; O.T. reliefs, 48, 69; *Sapienza*, 64

Raffaello da Montelupo, 97; and tomb of Julius II, 169, 170, 171
Rainaldi, Girolamo, and Capitoline Hill, 199, 202, 204
Raphael, 2, 4, 45, 84, 165, 228; on divine

Index

Raphael—*contd.*
spirit of antiquity, 17; rivalry with M., 49; and New St Peter's, 211, 214; Sistine Chapel tapestries, 51, 143, 180; frescoes for Vatican Stanze, 145; *Chastisement of Heliodorus*, 180–2; Sala di Costantino, 31; *School of Athens*, 129, 130; Sistine Madonna, 79

Régnard, Valérien, 232

Reichenau island, St Georg, Oberzell, 155

Rembrandt van Ryn, *Blinding of Samson*, 135

Renaissance, 5, 22, 28, 80, 83, 115, 128

Reni, Guido, 80

Reynolds, Sir Joshua, admiration for M., 3

Riario, Cardinal, 15, 275 n. 12; classical statuary, 17–18

Ridolfi, Cardinal Niccolò, 167

Risen Christ, 127–9, 167, 258

Rodin, Auguste, and M., 4, 5; *Méditation*, 262

Rohan, Marshall Gié Pierre de, 29

Romano, Giulio, 213

Rome, 16, 17; Sack of (1527), 117, 120, 142, 211, 285 n. 3; spirit of classical antiquity, 83, 109; secularization, 128; replanning (1561), 207; site of St Peter's crucifixion, 304 n. 24; Ara Coeli church, 135; Baths of Caracalla, 191, 195; of Diocletian, 190, 233, 234; of Titus, 48; Cancelleria, 18; Compagnia della Pietà, 228; Quirinal Hill, 180, 198, 200, 201; S. Andrea della Valle, 120; SS Apostoli, 18; S. Cecilia in Trastevere, 143–4, 155; S. Costanza, 233; SS. Cosmas e Damiano, 180; S. Giovanni in Laterano, 198, 228, 253; S. Gregorio Magno, 43, 280 n. 21; S. Luigi dei Francesi, 135; S. Maria Maggiore, 237; S. Maria sopra Minerva, 127, 130, 156, 164; S. Maria della Pace, 203; S. Maria del Popolo, 44, 55, 84, 135, 171, 178; S. Maria Rotonda, 233; St Paul's basilica, 66, 70; S. Pietro in Montorio, 210–11, 280 n. 13; S. Pietro in Vincoli, 18, 40, 42, (tomb of Julius II) 75, 79,

90, 121, 170–1; S. Sabina, 18; S. Silvestro al Quirinale, 160; S. Stefani ad beatum Paulum, 143; S. Stefano Rotondo, 229; Trajan's Forum, 75; *see also* Sistine Chapel, Vatican Palace

Rondanini Pietà (unfinished), 128, 240, 248, 257, 316 n. 22; spiritual history, 248–50

Rosselli, Cosimo, 17, 246

Rosselli, Pietro, 45

Rossellino, Antonio, 27; St Sebastian, 81

Rossellino, Bernardo, 12; Pienza Cathedral square, 199

Rosso Fiorentino, Giovanni, 247

Rovere, Francesco Maria della, 93, 120, 121

Rovere, Leonardo Grosso della, and tomb of Julius II, 75, 84, 85, 286 n. 11

Rubens, Sir Peter Paul, 13–14, 146; *Battle of the Amazons*, 180; *Death of Argus*, 135

Sabbatini, Lorenzo, *Baptism of Paul by Ananias, Fall of Simon Magus, Martyrdom of St Stephen*, 177

St Augustine, and Erythraean sibyl, 60

St Dominic's shrine, statuettes of St Petronius and St Proculus, 14–15

S. Giovanni dei Fiorentini, 189, 225–6, 228; M.'s designs, 229–31; dome, 231–2

St Gregory (unfinished), 43, 280 n. 21

St John (lost statue), 15

S. Katharina in Viterbo nunnery, 158

S. Maria degli Angeli, 190, 233–4; M.'s unfinished reconstruction, 234–5; eighteenth-century alterations, 235–6

St Matthew (unfinished), 256, 257, 264, 278 n. 17, 280 n. 13; composition, 46–7; new spirit of freedom, 47, 71, 128; influence of *Laocoon*, 48, 80

St Paul, 179; influence on M., 157

St Peter's, Rome, 21, 18, 84, 86; New Church, 16, 39, 44–5, 164, 209; M. and, 16, 189, 209, 210, 211, 213–27; opposition to, 214; Sangallo and, 210–13; wooden model, 212, 215, 221–2, 224; drawings and engravings, 219–20;

attic, 218–19, 311 n. 54; basilica, 66,
209, 212, 216–17; Cappella del Re di
Francia, 20; Chapels of S. Petronilla
and of the Crucifix, 20; 'Dalmatic of
Charlemagne', 157; dome, 220–7, 232;
lantern, 96, 224, 225, 226; mausolea,
43–4; Rossellini Chapel, 44, 209, 211,
213; Sagrestia del Capitolo dei
Canonici, 184; tomb of Sixtus IV, 41,
43; of St Peter, 44–5, 209, 211

St Sebastian, 80, 81

S. Stefani monastery (tondo), 157

Sangallo, Aristotile da, 121

Sangallo, Bastiano da, 32

Sangallo, Giuliano da, 16, 39, 44, 80;
crucifixes, 14; Poggio a Caiano Villa,
201; and S. Lorenzo, 84, 87, 90, 94; S.
Maria degli Angeli, 234–5; S. Spirito
sacristy, 95, 230

Sangallo the Elder, Antonio da, 29, 84, 86

Sangallo the Younger, Antonio da, and
Vatican Palace, 176; and Palazzo
Farnese, 190–3, 196; and New St
Peter's, 210, 211–12; death, 213; M.
and his model, 214–18 passim, 221;
dome, 222–3, 224; and S. Giovanni dei
Fiorentini, 228, 229; Memoriale, 212

Santiquattro, Cardinal, 85

Sansovino, Andrea, 31, 84, 171; Ascanio
Sforza wall-tomb, 44; papal tombs,
84, 90; Sforza tombs, 171

Sansovino, Jacopo, 84; and S. Giovanni,
228; Bacchus, 20

Sant' Angelo, 184

Santi Priglioni, 117

Savonarola, Girolamo, M. and, 11, 158;
Grand Council, 25; burnt at the stake,
25; Prior of S. Marco, 111; and secular-
ization of Rome, 128; sermon on the
flood, 284 n. 70

Scapucci, Maestro Maria, 127

Scherano da Settignano, 171

Sebastiano del Piombo, 128, 190; Ubeda
and Viterbo Pietàs, 165

Sforza, Alessandro, 239

Sforza, Cardinal Guido Ascanio, funerary

chapel, 237, 239

Sforza, Lodovico, 25

Siena: Cathedral, statuettes, 25–6, 27;
Federighi's font, 42; Fonte Gaia, 64;
library ceiling, 55; pavimento, 28, 64;
Piccolomini altar, 95, 183; S. Maria
della Scala, 127

Signorelli, Filippo, 17

Signorelli, Luca, 1, 17; influence on M.,
35, 155–6; Cappella Brizio frescoes,
155–6; Dante's portrait, 63; Loreto
Cathedral figures, 61; Sagrestia della
Cura fresco, 180; Uffizi tondo, 35

Simone del Pollaiuolo, 29

Sistine Chapel, 3–4; dedication, 50, 51,
59; wall paintings, 50–1; tapestries, 51,
143; M.'s preliminary work, 51–2;
conjectures on his commission, 53–6;
medallions, 58–9, 65, 73; Christ's
ancestors, 59, 72; putti, 65; spandrels,
71–3; lunettes, 72–3; colour scheme,
73–4; completion, 75; Birth of Christ,
51; Discovery of Moses, 51; Fall of
Lucifer (projected), 141, 143, 156;
papal portraits, 51, 59, 72–3, 143;
sketches, 54–7, 283 n. 23; Stem of Jesse,
56, 59, 72; Tree of Life, 56

Sistine Chapel ceiling, 9, 15, 31, 34, 35;
Julius II and, 45, 49, 121; M. and, 49–
50; early decoration, 51; plan, 52–3;
extension to include lunettes, 53–6;
considered as a whole, 56–8, 73;
painted architecture, 58, 84; Brazen
Serpent, 58, 61, 71, 72, 143; Creation of
Adam, 58, 60, 69–70, 100, 134–5; of the
Creatures of the Sea, 70; of Eve, 58, 60,
69; of the Sun and Moon, etc., 70–1;
Crucifixion of Haman, 58, 61, 71, 143;
David and Goliath, 58, 61, 71–2; The Fall
and Expulsion from Paradise, 58, 60, 66,
68–9; The Flood, 13, 66–8, 153–4;
Judith and Holofernes, 58, 61, 71–2; Let
there be Light!, 71; Mockery of Noah, 58,
60, 66, 67, 68; Moses Receiving the Ten
Commandments, 51; Noah's Sacrifice, 58,
60, 66–7, 68; prophets (Daniel, Ezekiel,

Index

Sistine Chapel ceiling—*contd.*
Isaiah, Jeremiah, Joel, Jonah, Zechariah), 58–64, 82, 99, 143; sibyls (Cumaean, Delphic, Erythraean, Libyan, Persian), 58–62, 64–5
Sixtus IV, Pope, Capitol Hill bronzes, 17, 198; tomb, 41, 43, 75, 79, 285 n. 3; Sistine Chapel, 50 ff.; Old St Peter's, 184–5
Sixtus V, Pope, 202, 205, 207
Soderini, Pietro, and Grand Council, 25
Stern, Raffaele, Braccio Nuovo, 205
Strozzi, Giovanni, epigram on *Day* and *Night*, 101
Struggling Captive, 1, 76, 79, 80, 100, 123

Taddei Tondo, 34, 35
Tomb of Pope Julius II: first design (1505), 39, 40–3, 78, 84, 99, 172, 280 n. 13; siting, 44; and rebuilding of St Peter's, 44–5; postponement, 49, 75; link with Sistine ceiling, 58; with Medici Chapel, 96; Berlin drawing, 41, 76, 78, 79, 81, 82; *Moses*, 42, 62; *St Paul*, 42
second design (1513), 76–83, 88, 99, 172, 285 n. 3; contract, 75–6; unknown siting, 76, 286 n. 14; *Cappellata*, 78, 79, 286 n. 22; *Moses*, 79, 81–3, 99, 100, 258, 287 n. 37
project of 1516, 79, 83, 124; contract, 88; design, 88–9; figures, 89–91; link with S. Lorenzo, 90–1, 96, 289 n. 73; *Moses*, 89; *tribunetta*, 88, 90
final form, 109, 172; M.'s reluctance to complete, 120–1, 169–70; compromise agreement (1532), 121, 124, 125, 169; design, 121–2, 171–2; completion date, 141, 169, 171; last contract (1542), 170–1; contributory artists, 171; *Captives*, 122–3, 169, 173; *Madonna and Child*, 122, 170, 171, 173; *Moses*, 122, 169, 170, 171, 172, 175; prophet and sibyl, 122, 170, 171, 173; recumbent Pope, 171–2, 173; *Rachel* and *Leah*, 169–75 *passim*, 257
tondo form, 34–6

Tornabuoni, Giovanni, 9
Torrigiani, Pietro, 10
Traini, Francesco, Last Judgement fresco, 155
Triboli, 107, 117
Twelve Apostles (projected), 29–30, 46

Ubeda, S. Salvador, 165
Uccello, Paolo, Flood, 67; frescoes, 66
Urban, Günter, 209
Urbano, Pietro, assistant to M., 127, 243, 317 n. 41
Urbino, Francesco, Florence school, 9
Urbino, Duke Francesco Maria of, 76, 141
Urbino, Guidobaldo, and tomb of Pope Julius II, 169, 170

Vaga, Pierino del, 176–7, 190
Valdès, Juan, religious circle, 158
Valori, Baccio, 118; and *Apollo*, 129, 258
Vanvitelli, Luigi, 236
Varchi, Benedetto, 9, 10; *Due Lezioni*, 108
Vari, Metello, and *The Risen Christ*, 127, 296 n. 36
Vasari, Giorgio: and M. as artist, 1–2, 10, 46, 263, 272 n. 3; and discovery of ancient works of art, 17; reconstruction of Grand Council Chamber, 30, 31; on Leonardo's *Virgin and Child*, 25, *Last Supper*, 260
and M.'s works: *Pietà*, 20–1; *Battle of Cascina*, 32, 33; *Doni Tondo*, 35; tomb of Julius II, 40, 41, 42–3, 76; Sistine ceiling, 51, 56, 65, 70, 72; Medici Chapel, 97, 101, 102, 104, 107, 108, 259; *Apollo*, 129; *Last Judgement*, 142, 151–2, 152–3; *Brutus*, 168; Cappella Paolina frescoes, 177, 178; Palazzo Farnese, 194, 195; Cortile del Belvedere, 205; New St Peter's, 209, 213–14, 215; model of St Peter's, 221–2; S. Giovanni dei Fiorentini, 230; S. Maria degli Angeli, 235; Cappella Sforza, 237; *Rondanini Pietà*, 248; unfinished works, 258–9

Vatican Palace, 18, 31, 44, 157, 254; M. as chief sculptor, 213, 217; Appartamenti Borgia, 55; Belvedere, 180; Cappella Paolina, 169, 176–88; Cappella del Sacramento, 176; Cortile Maresciallo stairway, 176; Sala Regia, 176, 303 n. 2; Villa Montalto-Negroni-Massimi, 44

Vecchietta, *Man of Sorrows*, 127

Venice, 12, 15, 118, 155; Doges' Palace, 30, 31, 156; Procuratie, 203; St Mark's, 254; Torcello Cathedral, 155

Venusti, copies: of Annunciation, Mount of Olives drawings, 253; of *Christ and the Traders*, 188; of *Last Judgement*, 144

Verrocchio, Andrea del, 14, 22; *Christ*, 23

Victory group, 123, 126, 129; relation to

Boboli Captives, 126–7

Vignola, Giacomo Barozzi da, 215, 220, 311 n. 54

Villani, Filippo, *Chronicle*, 32

Virgil, 59–60; called *horrenda*, 64

Vitruvius, Pollio, 207

Volterra, Daniele da, 248, 255

Winckelmann, Johann, on M., 2–3

Wind, Edgar, 56, 59

Wölfflin, Heinrich, 6; and *Bacchus*, 19–20; Sistine Chapel, 54–5, 63, 65, 69; Medici *Madonna*, 104

Xenophon, qualities loved by the gods, 133

Zevi, Bruno, 240

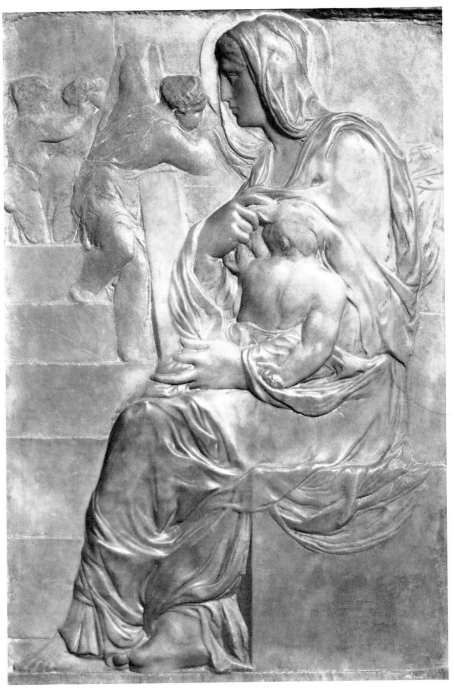

1 *Madonna of the Stairs.* Marble

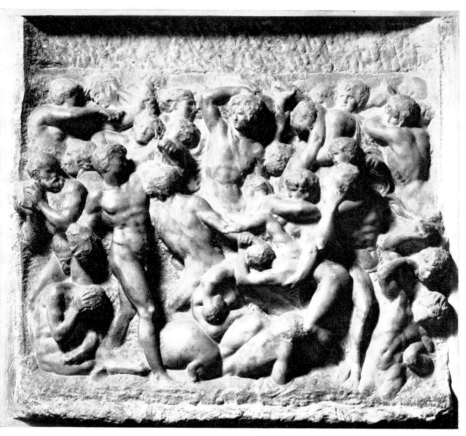

2 (above) *The Battle of the Centaurs*
Marble

3 Giacomo Rocchetti, design for
Pope Julius's tomb, 1513. Pen and
ink. Copy after Michelangelo, lost

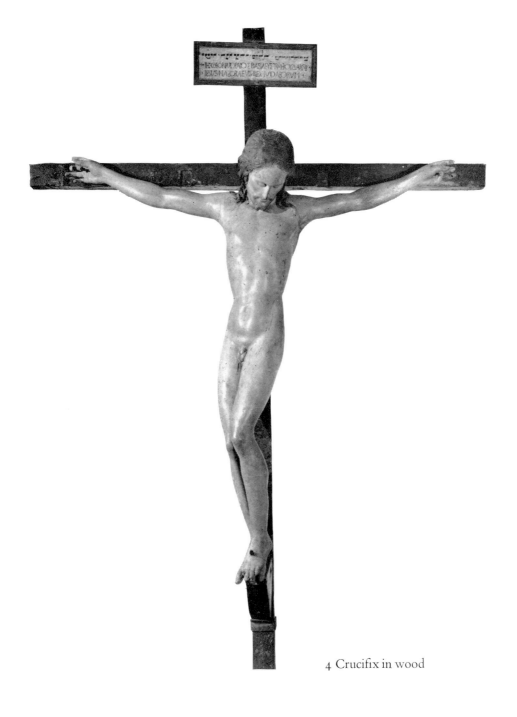

4 Crucifix in wood

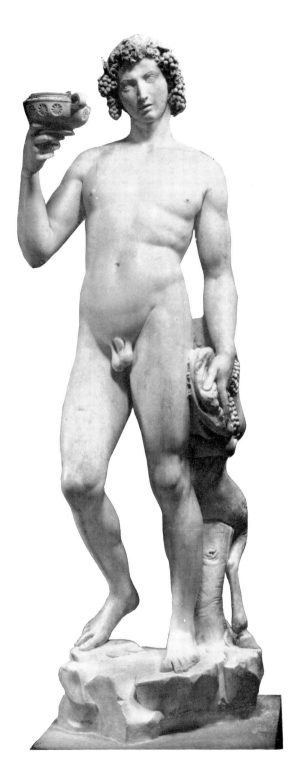

5 *Bacchus*. Marble

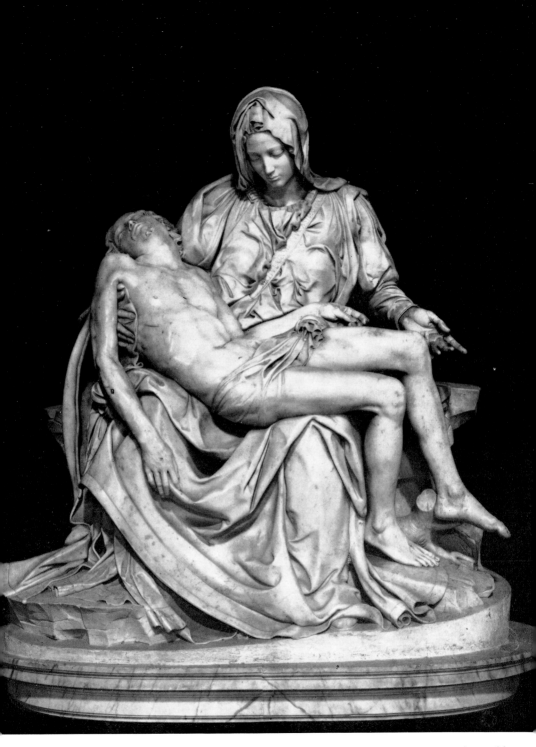

6 *Pietà*. Marble

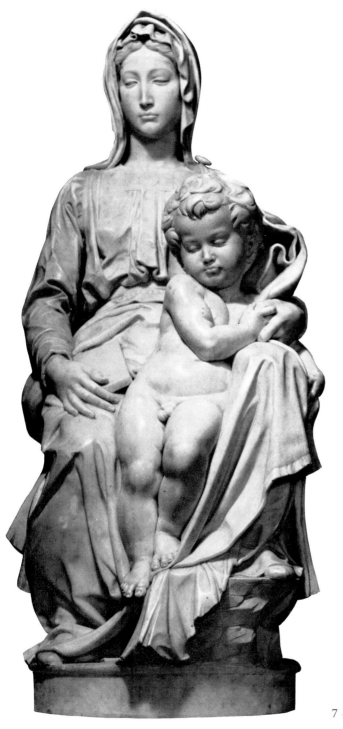

7 *Madonna and Child*. Marble

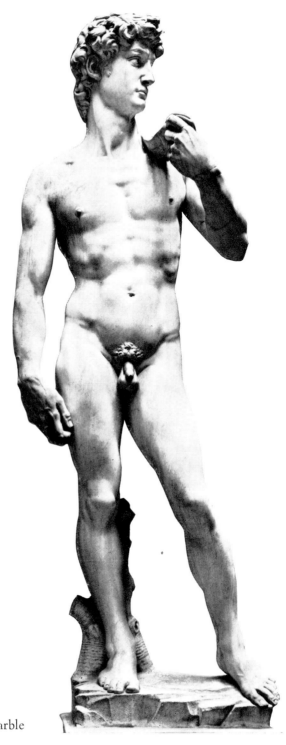

8 *David*. Marble

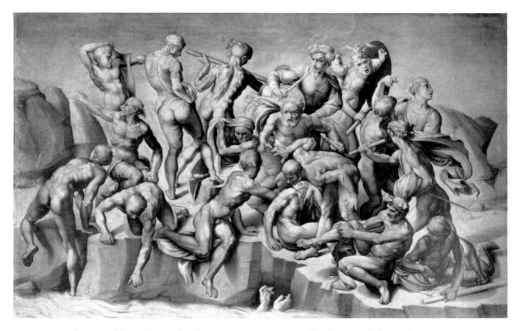

9 Bastiano da Sangallo, *The Battle of Cascina*. Copy (partial) after Michelangelo. Grisaille

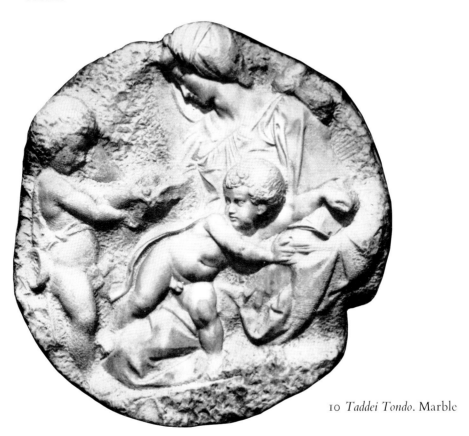

10 *Taddei Tondo*. Marble

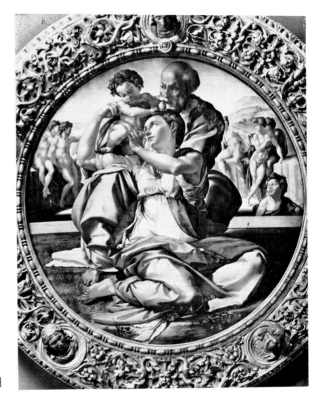

11 *Doni Tondo*. Tempera on wood

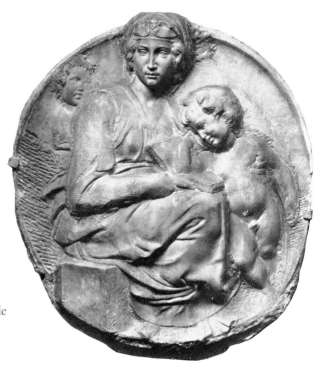

12 *Pitti Tondo*. Marble

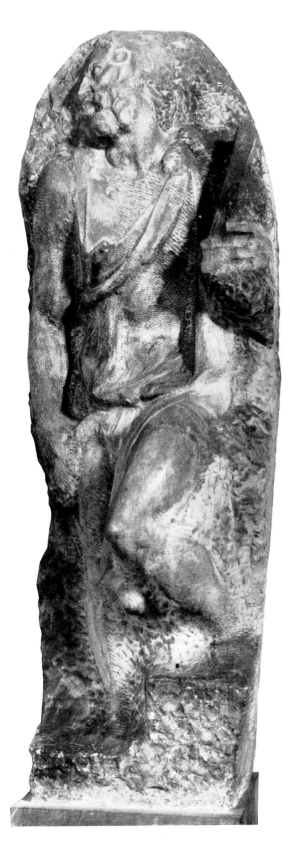

13 *St Matthew*. Marble

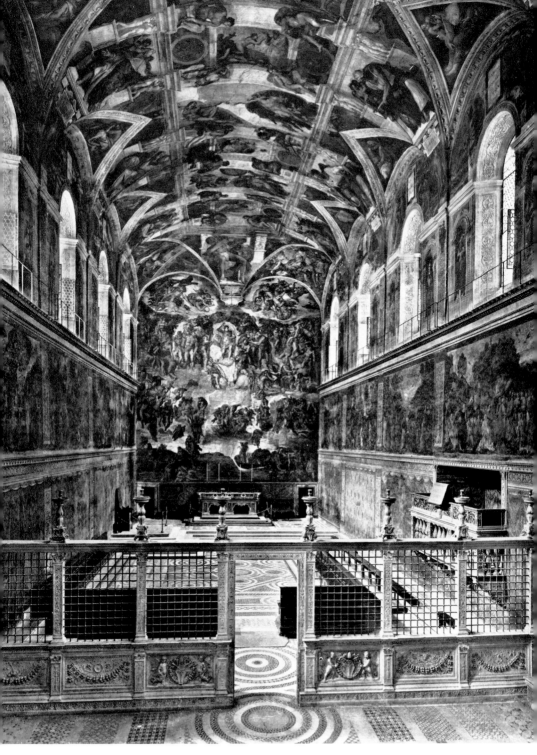

14 Sistine Chapel. Interior

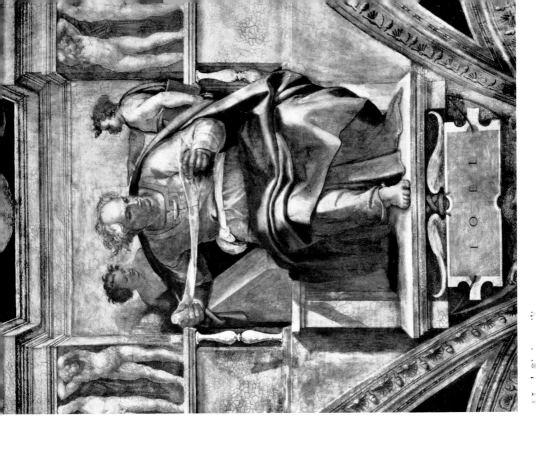

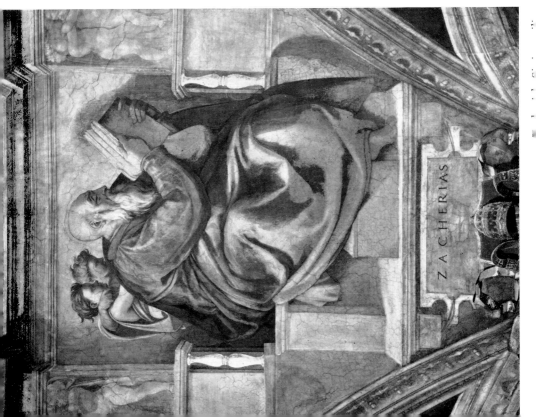

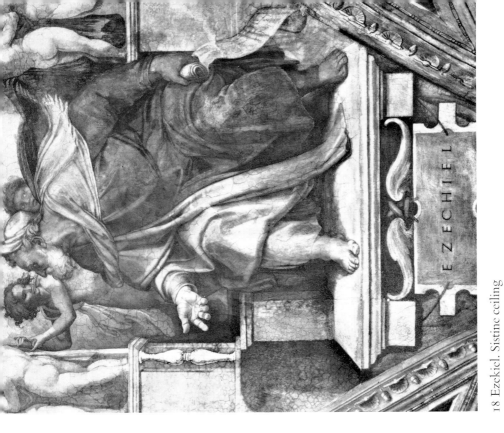

18 Ezekiel. Sistine ceiling

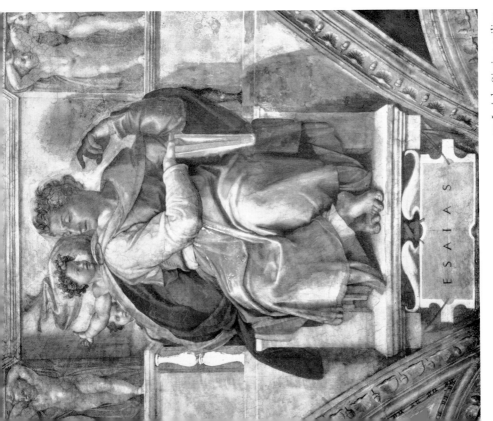

17 Isaiah. Sistine ceiling

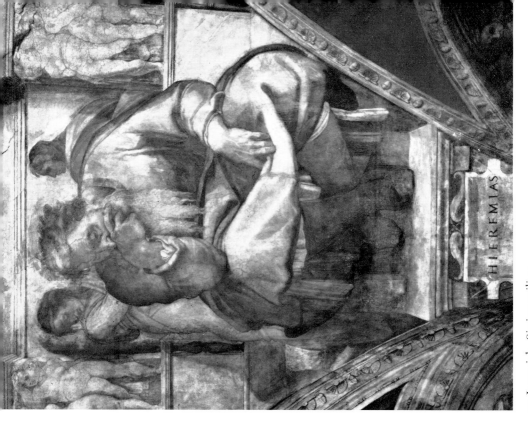

19 Daniel Sistine ceiling

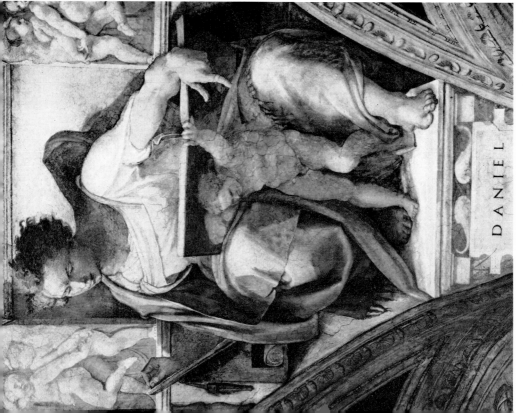

20 Jeremiah Sistine ceiling

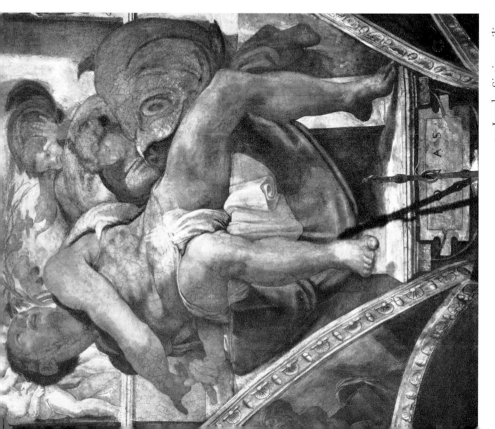

22 Delphic sibyl. Sistine ceiling

21 Jonah. Sistine ceiling

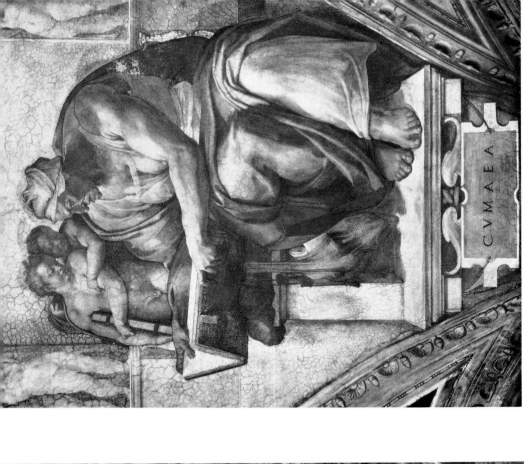

CVMAEA

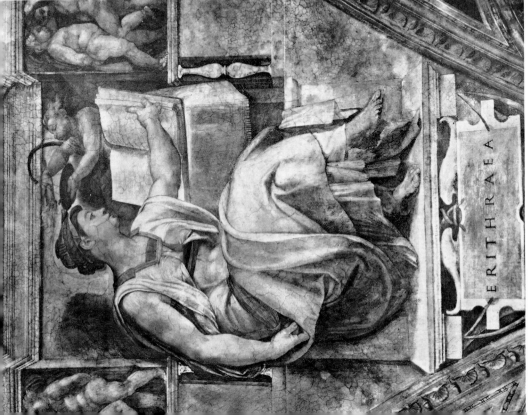

ERITHRAEA

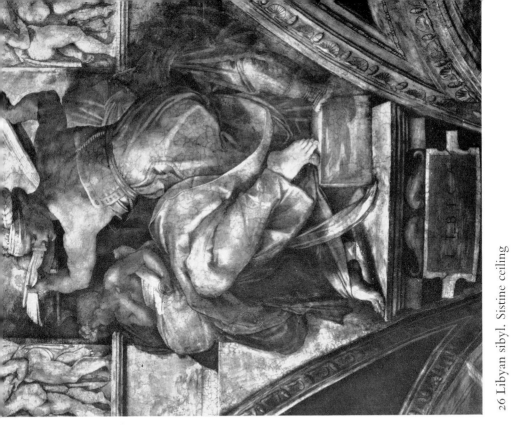

25 Persian sibyl. Sistine ceiling

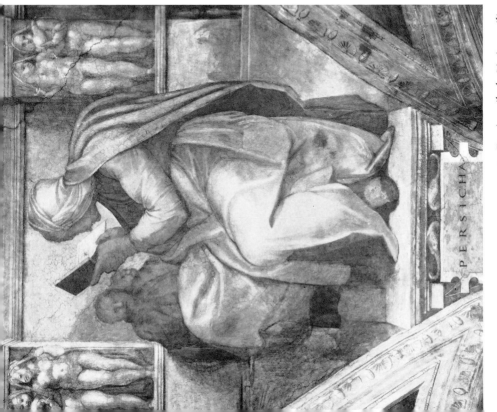

26 Libyan sibyl. Sistine ceiling

29 Youth on the left of Libyan sibyl. Sistine ceiling

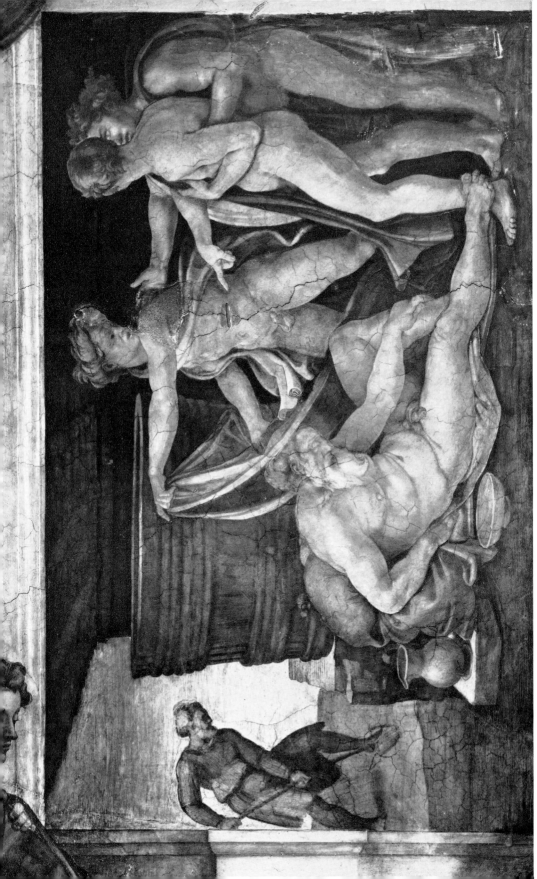

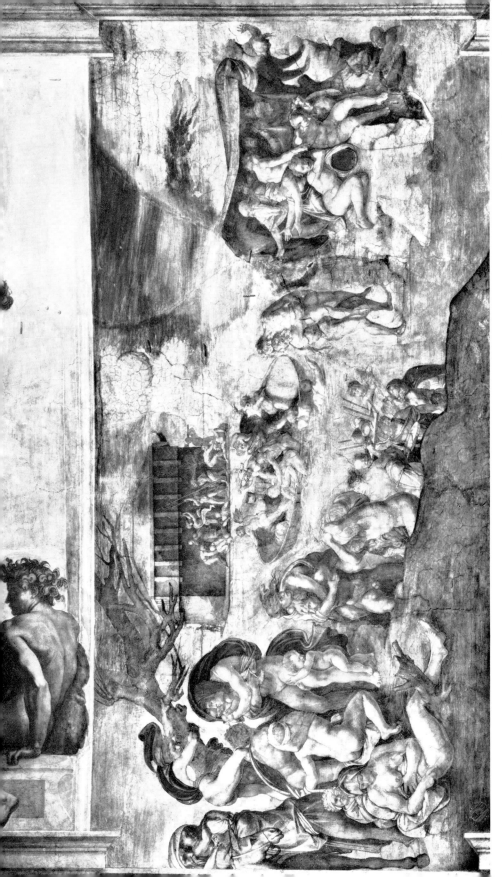

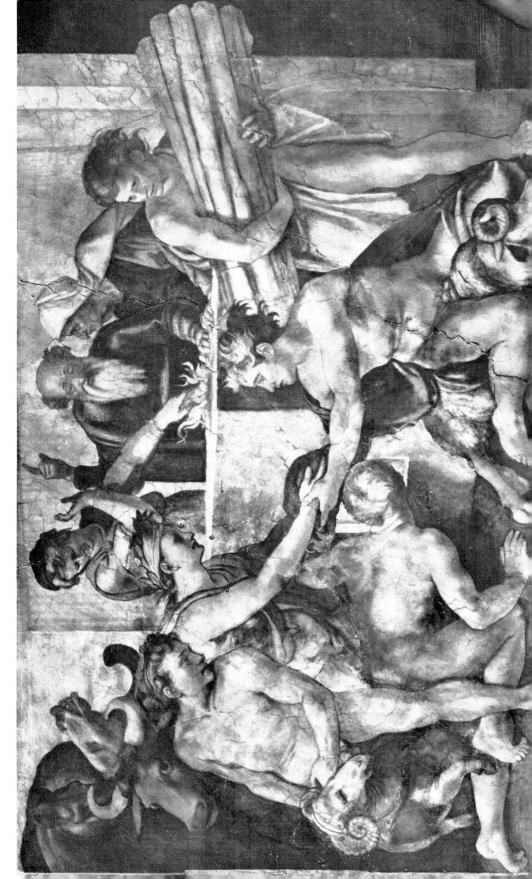

33 (below) *The Fall and the Expulsion from Paradise.* Sistine ceiling

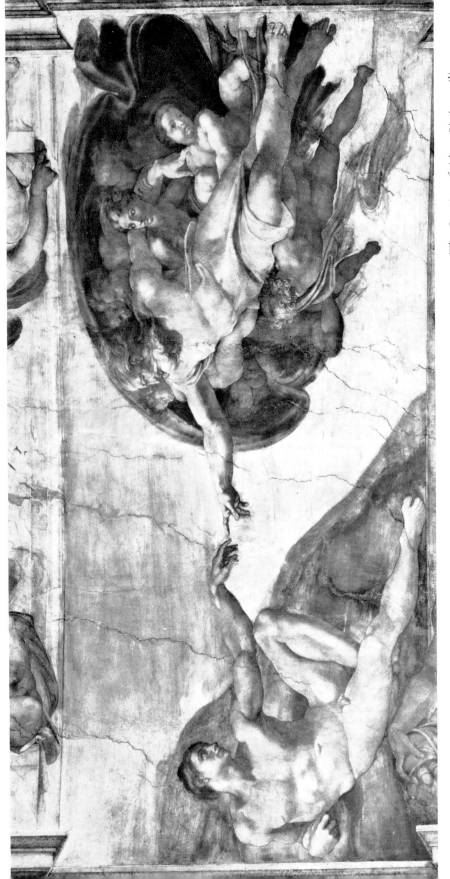

35 *The Creation of Adam.* Sistine ceiling

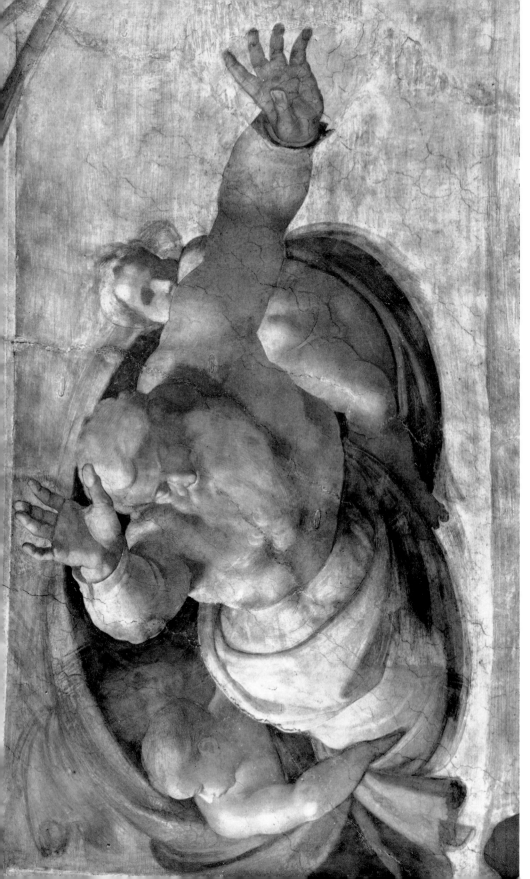

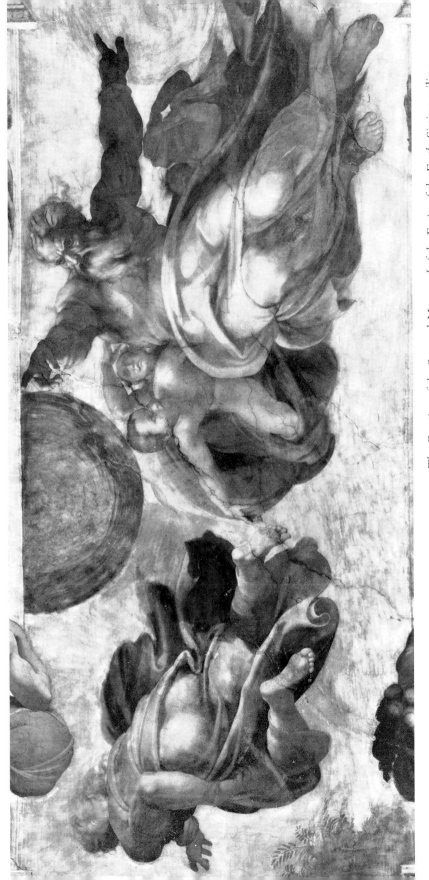

37 *The Creation of the Sun and Moon and of the Fruits of the Earth. Sistine ceiling*

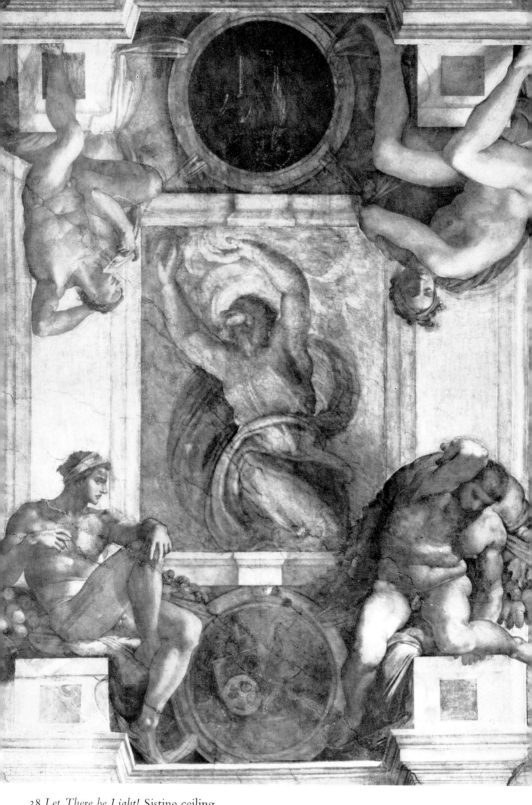

38 *Let There be Light!* Sistine ceiling

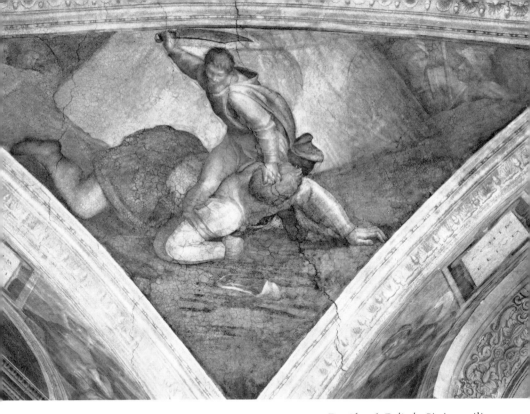

39 *David and Goliath*. Sistine ceiling

40 *Judith and Holofernes*. Sistine ceiling

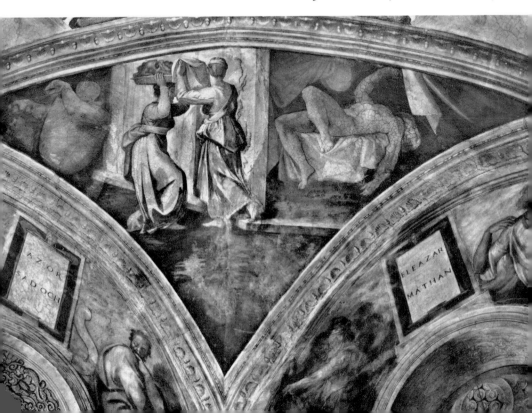

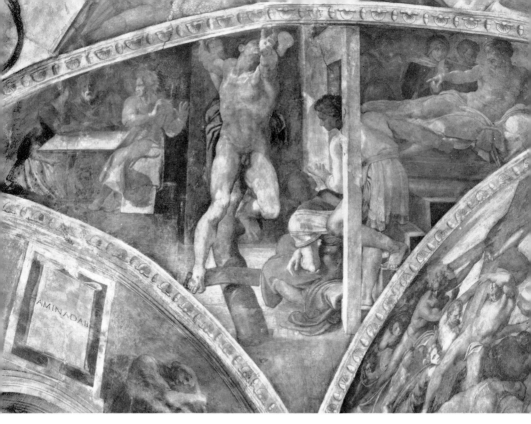

41 *The Crucifixion of Haman*. Sistine ceiling

42 *The Brazen Serpent*. Sistine ceiling

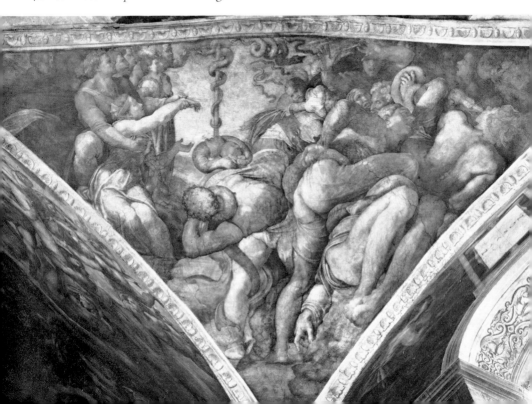

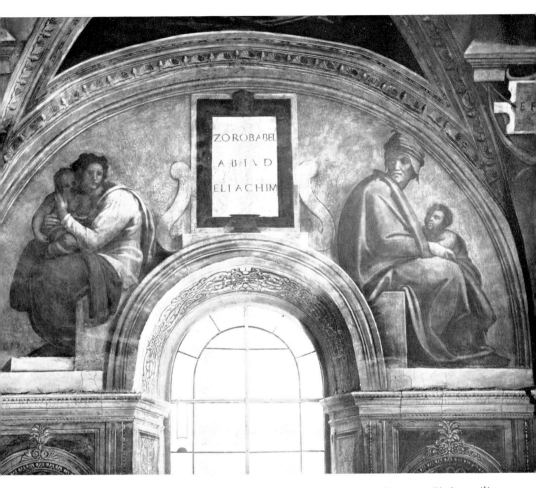

43 Lunette. Sistine ceiling

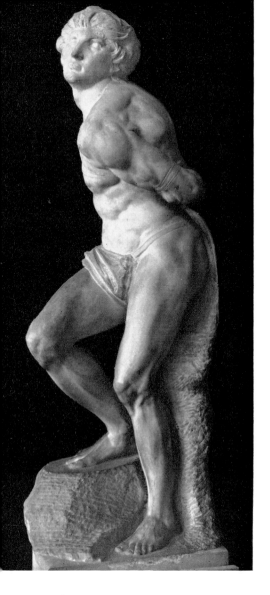

44 *The Struggling Captive*
Marble
For Pope Julius's tomb

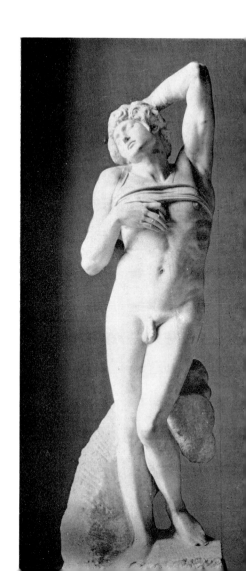

45 *The Dying Captive*
Marble
For Pope Julius's tomb

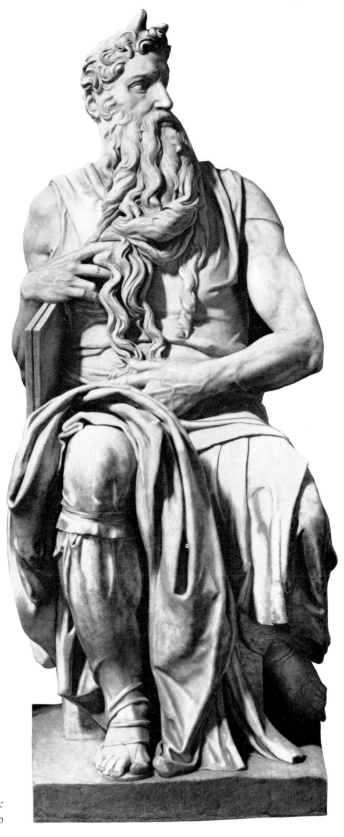

46 *Moses*. Marble
For Pope Julius's tomb

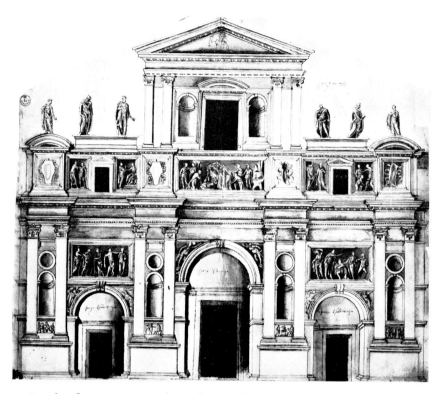

47 Façade of S. Lorenzo. Giuliano da Sangallo, drawing

48 Façade of S. Lorenzo. Michelangelo, sketch

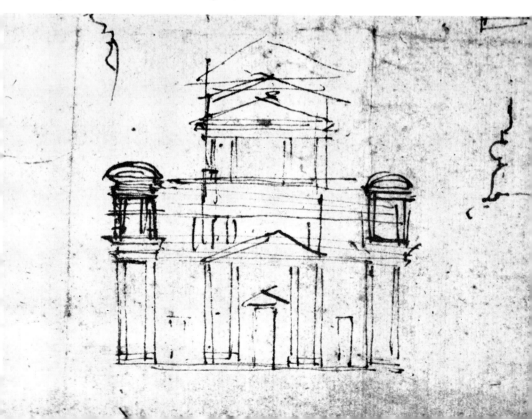

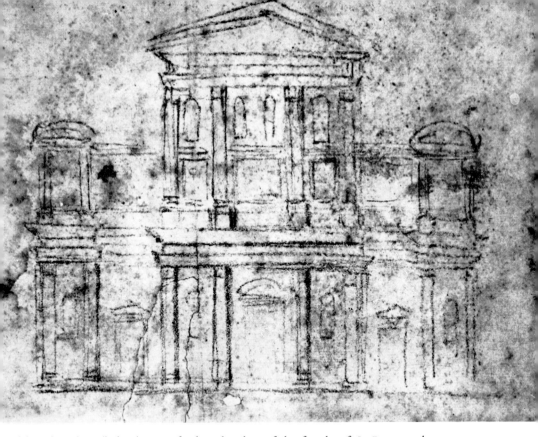

49 (above) and 50 (below) Two further sketches of the façade of S. Lorenzo by Michelangelo

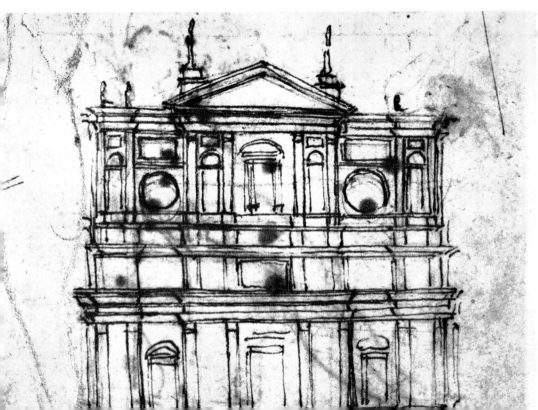

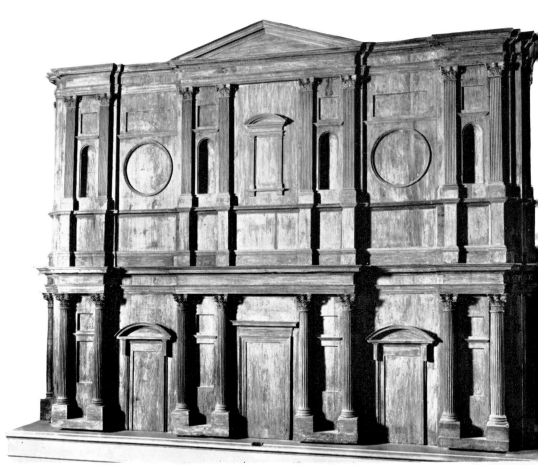

51 Façade of S. Lorenzo. Michelangelo, wooden model

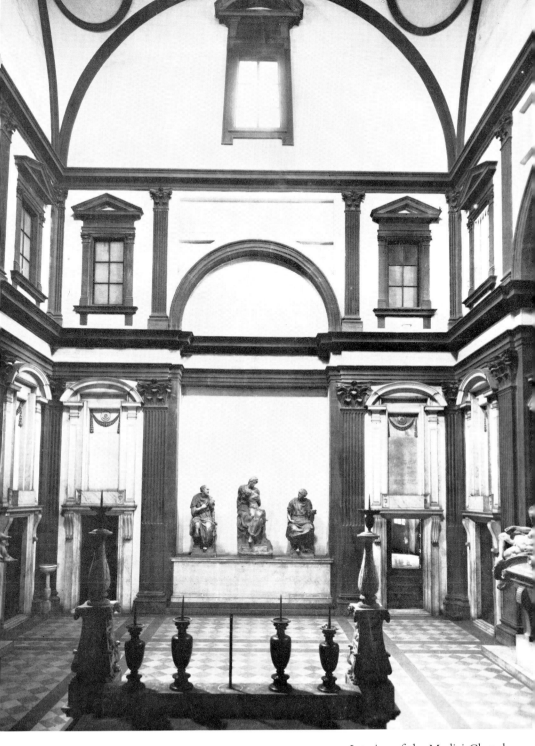

52 Interior of the Medici Chapel

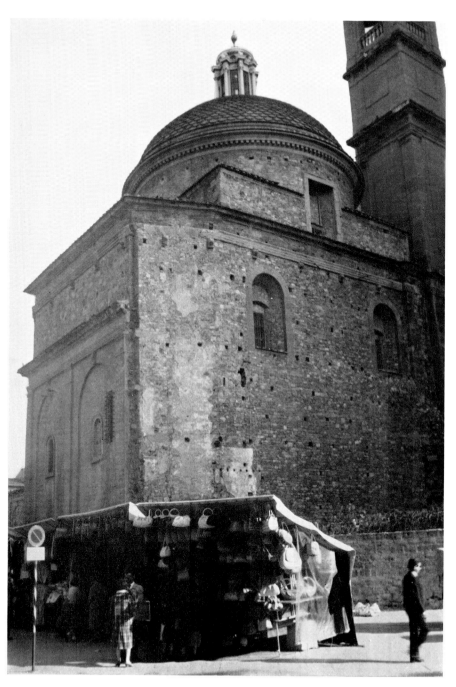

53 Exterior of the Medici Chapel

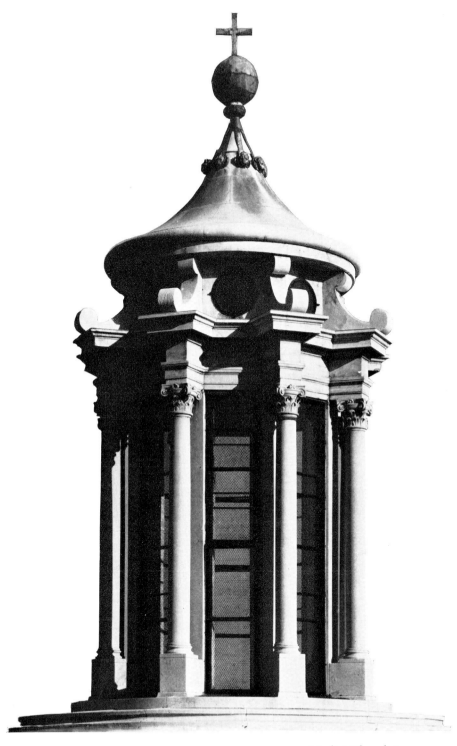

54 Medici Chapel. Lantern

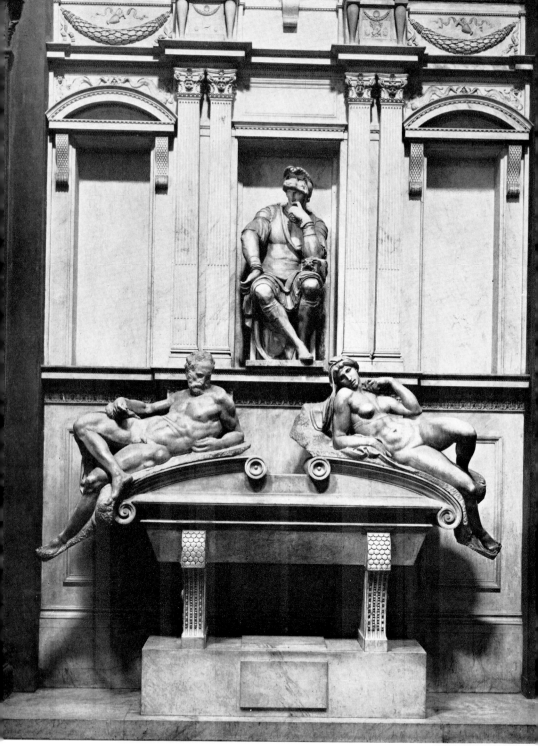

55 Tomb of Lorenzo de' Medici. Marble. Medici Chapel

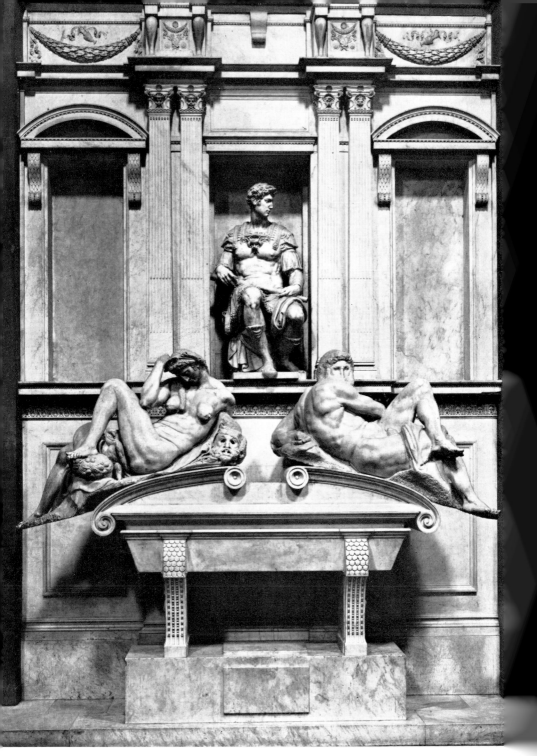

56 Tomb of Giuliano de' Medici. Marble. Medici Chape

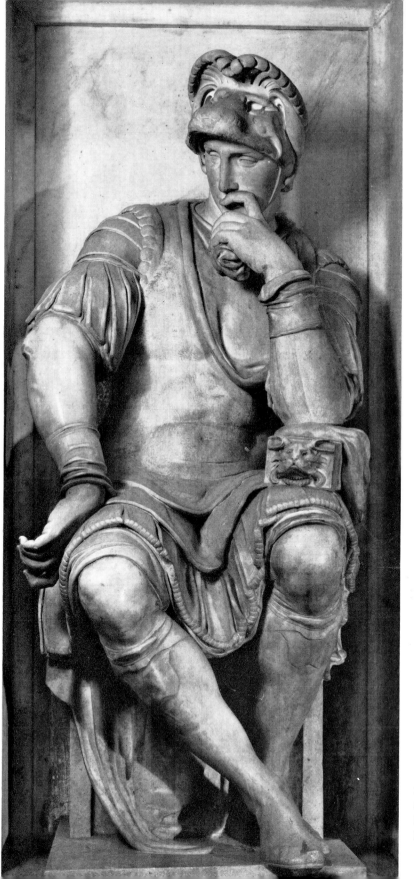

57 *Lorenzo
de' Medici*
Marble
Medici Chapel

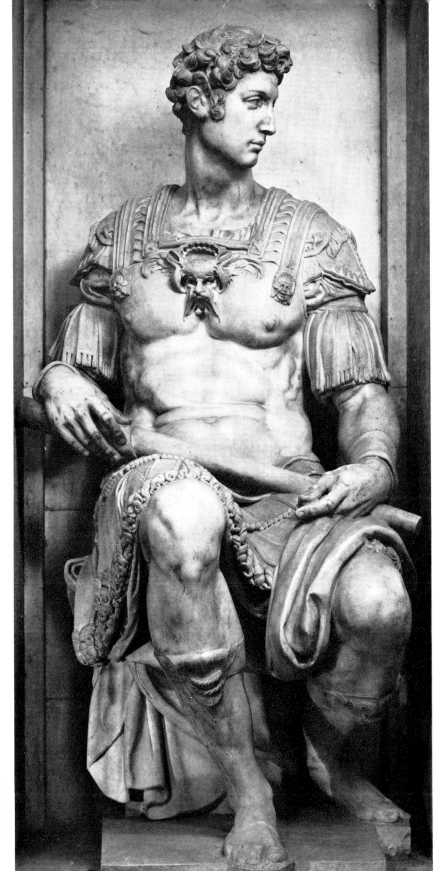

58 *Giuliano*
de' Medici
Marble
Medici Chapel

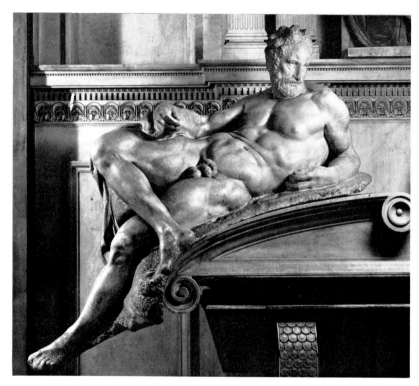

59 *Evening*
Marble
Medici Chapel

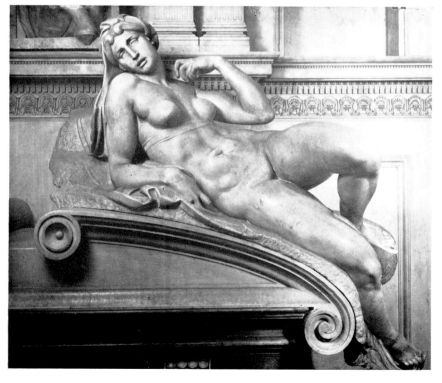

60 *Morning*
Marble
Medici Cha

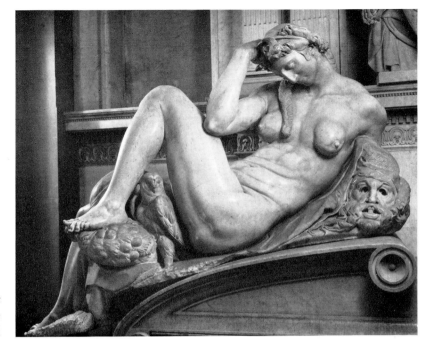

61 *Night*
Marble
Medici Chapel

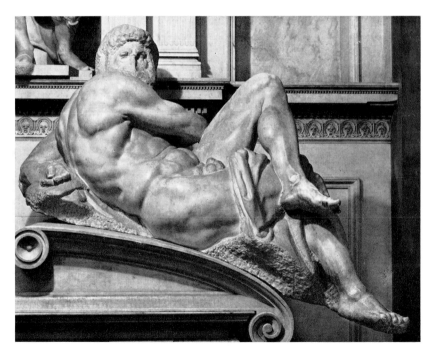

62 *Day*
Marble
Medici Chapel

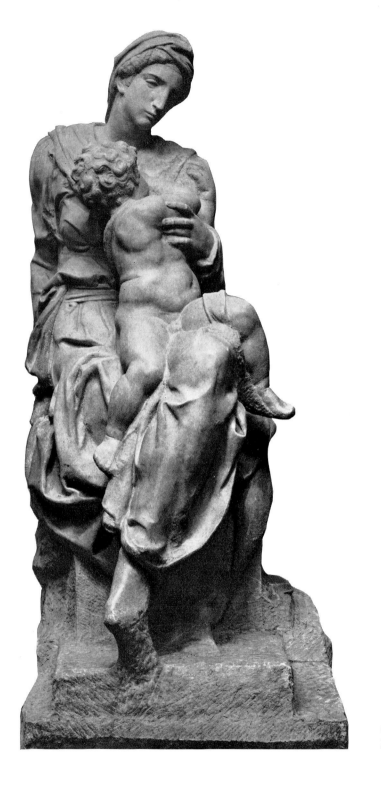

63 *Medici Madonna*
Marble. Medici Chapel

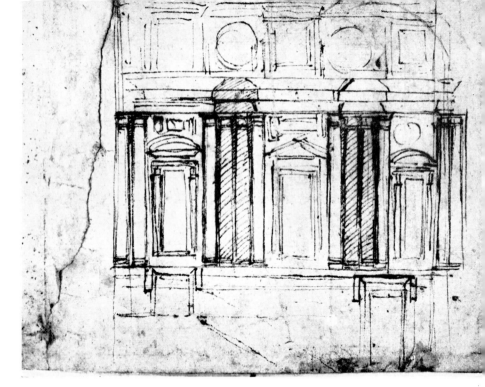

64 Biblioteca Laurenziana. Vestibule design

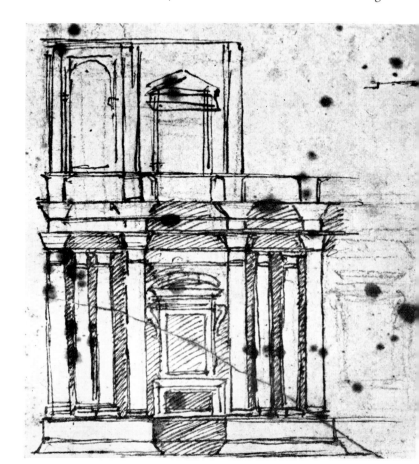

65 Biblioteca
Laurenziana.
Reading-room design

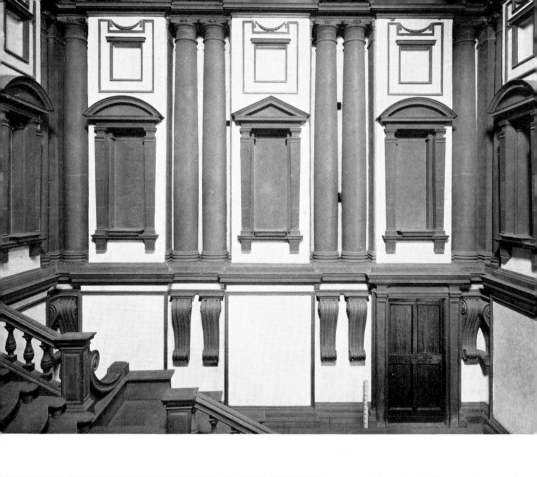

66 (above) Biblioteca Laurenziana
Vestibule, west wall

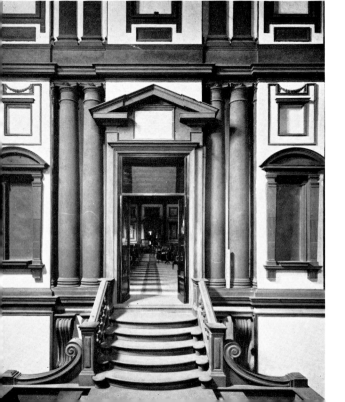

67 (left) Biblioteca Laurenziana
Vestibule, south wall

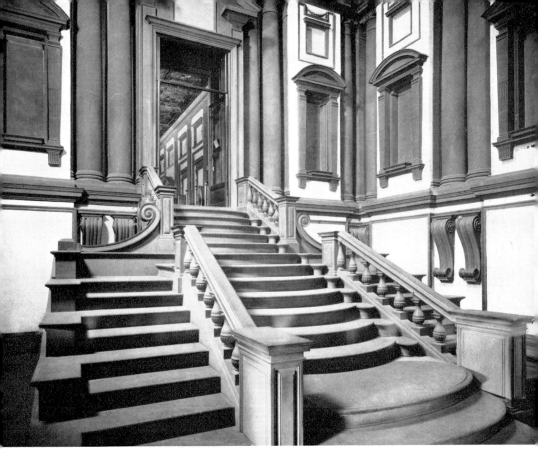

Biblioteca Laurenziana. 68 (above) Vestibule, staircase. 69 (below) Reading-room

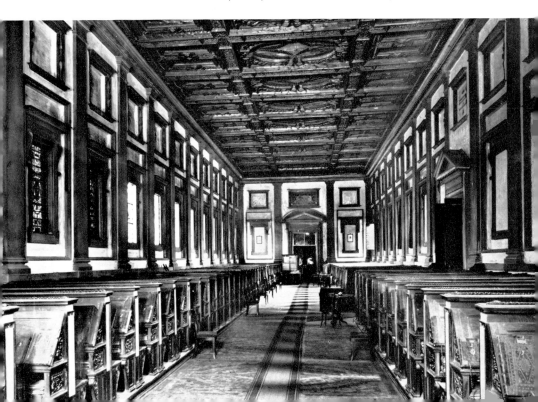

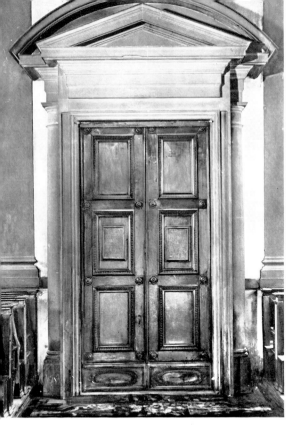

70 (left) Biblioteca Laurenziana
Reading-room door

71 (below) Cloisters of S. Lorenzo with
exterior view of Biblioteca
Laurenziana

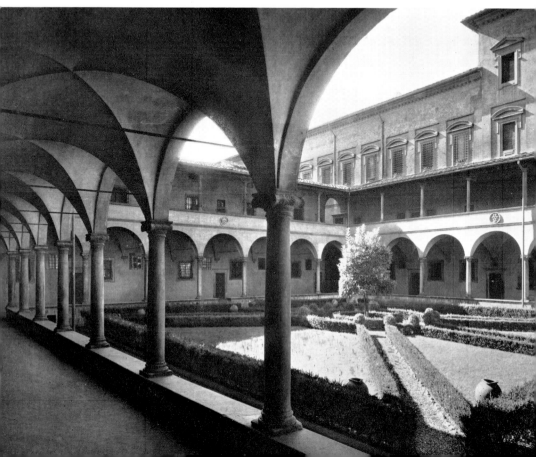

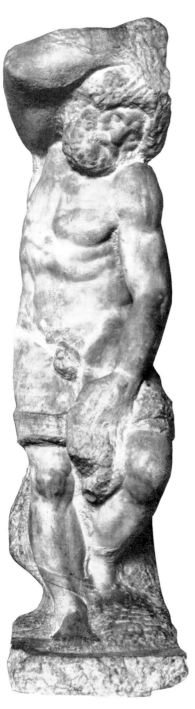

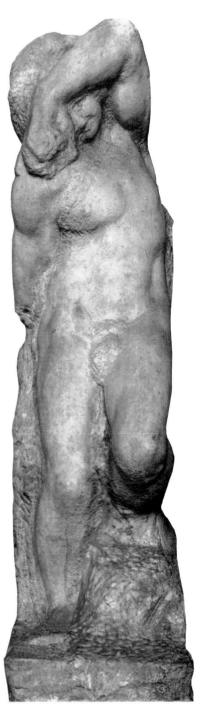

72 *Bearded Giant*
Marble
Boboli Captive

73 *Young Giant*
Marble
Boboli Captive

74 *Atlas*
Marble
Boboli Captive

75 *Awakening Giant*
Marble
Boboli Captive

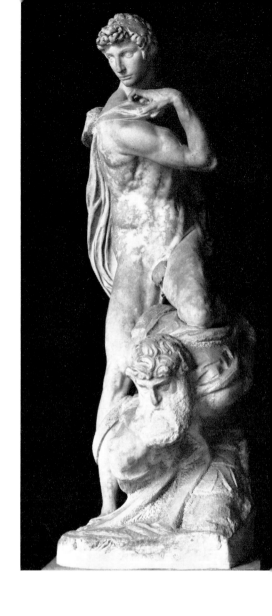

76 *Victory*
Marble

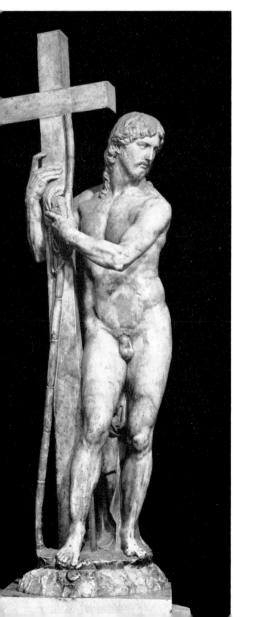

77 *The Risen Christ*
Marble

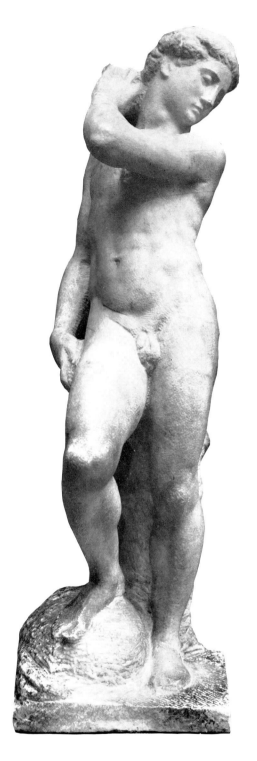

78 *Apollo*. Marble

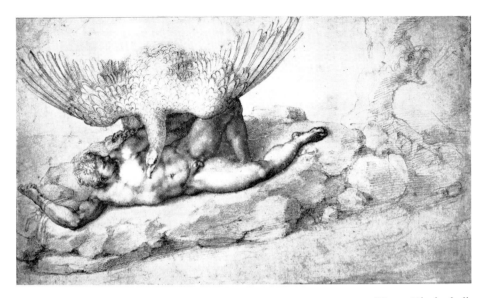

79 *Tityus*. Black chalk

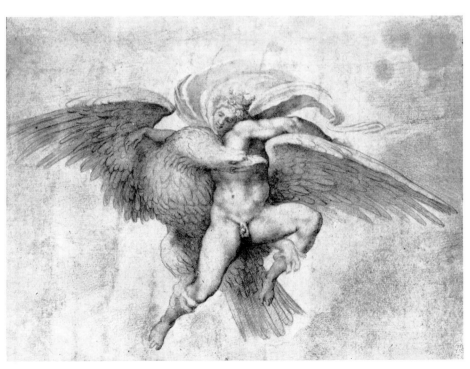

80 *Ganymede* (copy). Pencil

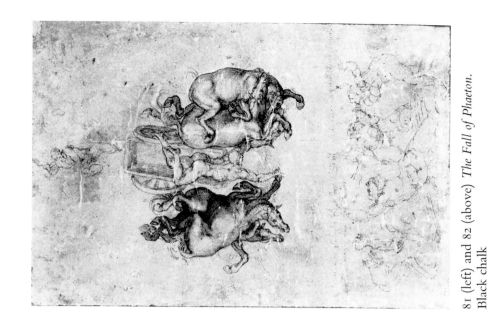

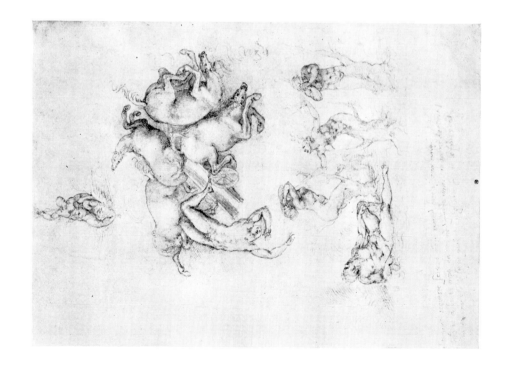

81 (left) and 82 (above) *The Fall of Phaeton.* Black chalk

83 (left) *The Fall of Phaeton.* Black chalk

84 (below) *Bacchanal.* Red chalk

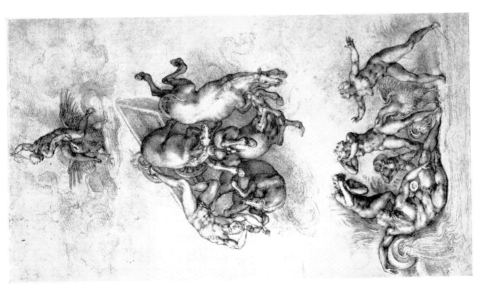

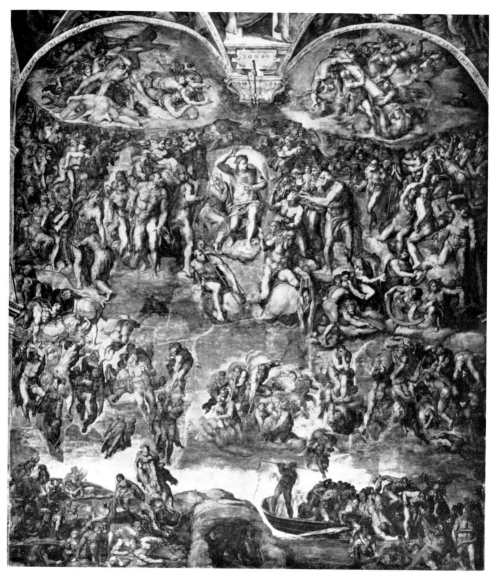

85 *Last Judgement*. Fresco, general view

86 (above) and
87 (right)
Black chalk
sketches for
Last Judgement

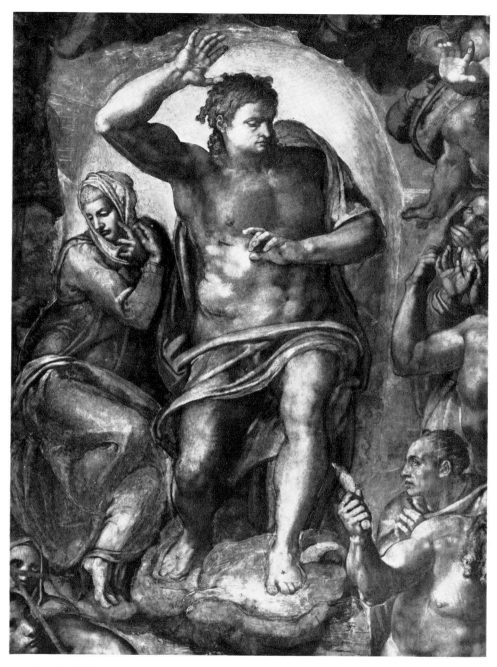

88 Christ in judgement. *Last Judgement*

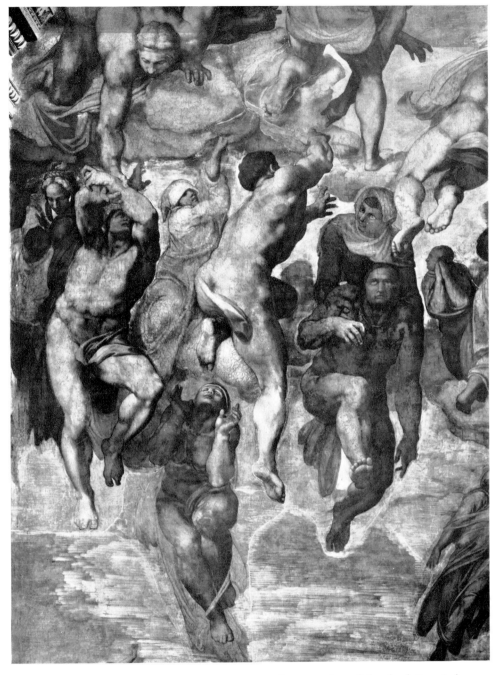

89 Resurrection of the dead. *Last Judgement*

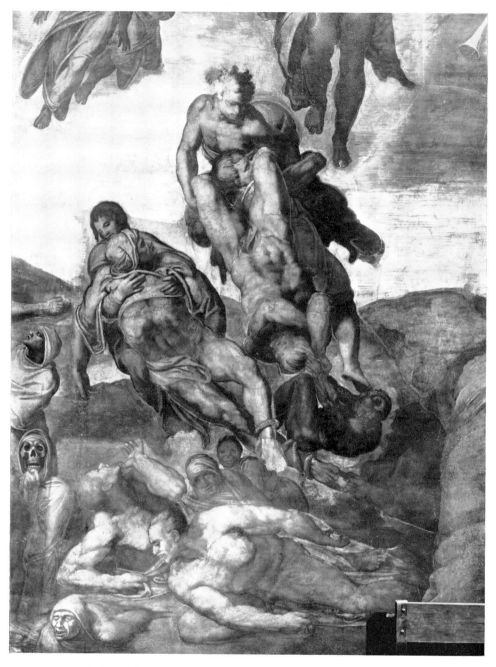

90 The damned. *Last Judgement*

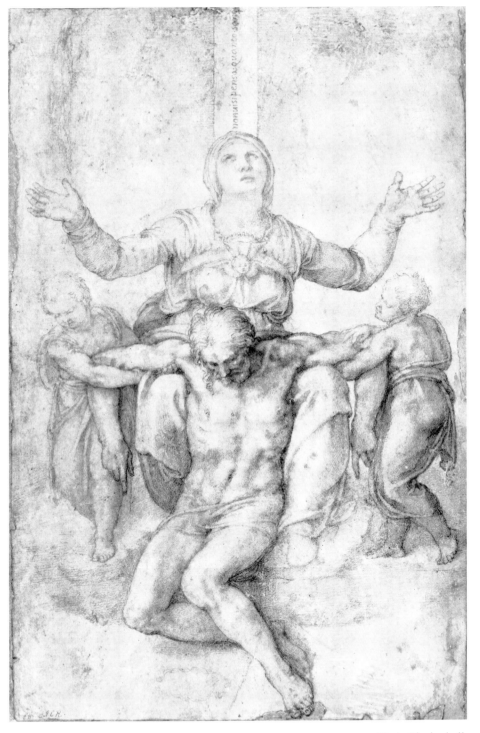

91 *Pietà*. Black chalk

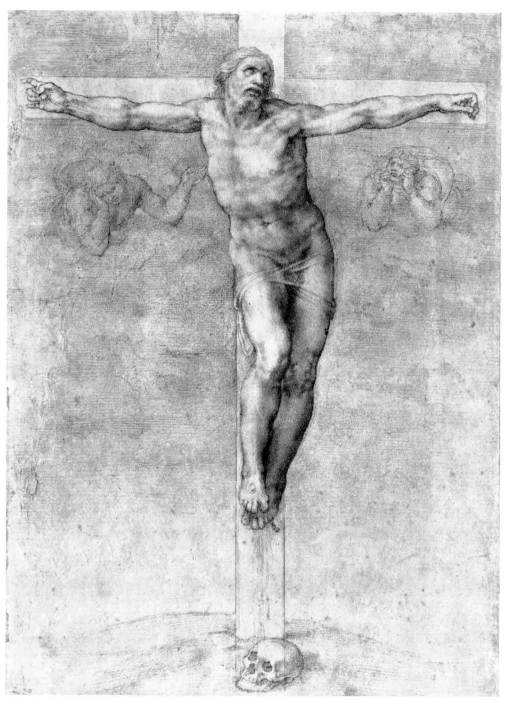

92 *Crucifixion*. Black chalk

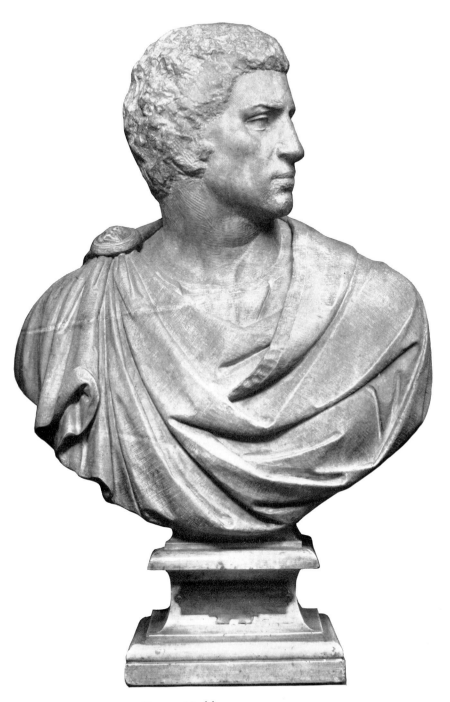

93 *Brutus*. Marble

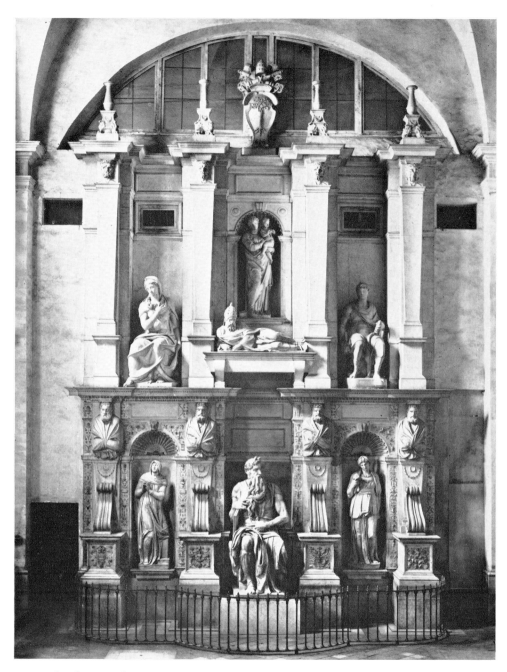

94 Tomb of Pope Julius. Marble. General view

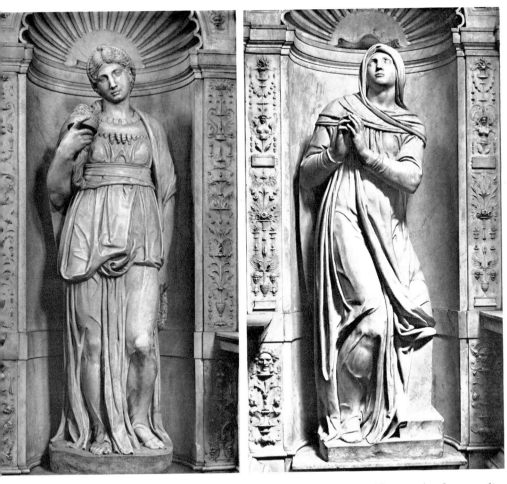

95 (left) *Rachel* and 96 (right) *Leah*. Marble. Tomb of Pope Julius

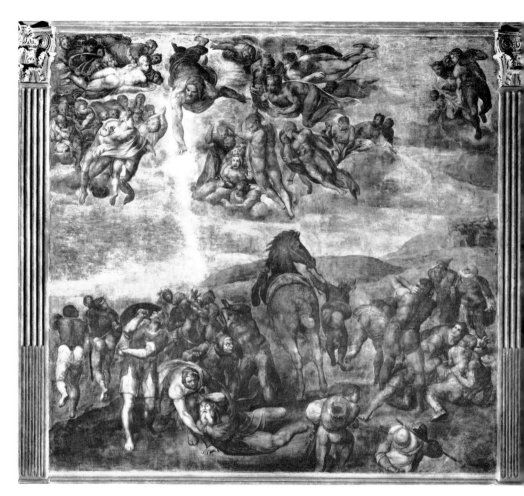

97 *The Conversion of St Paul.* Cappella Paolina

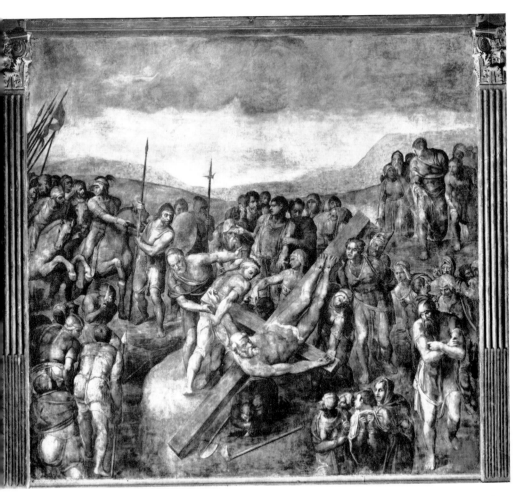

98 *The Crucifixion of St Peter*. Cappella Paolina

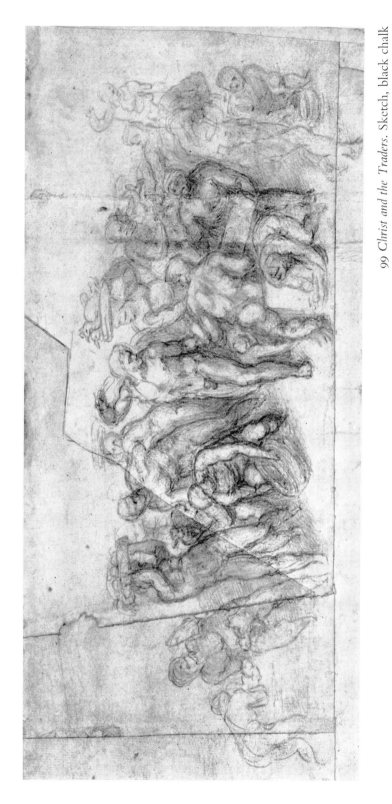

99 *Christ and the Traders*. Sketch, black chalk

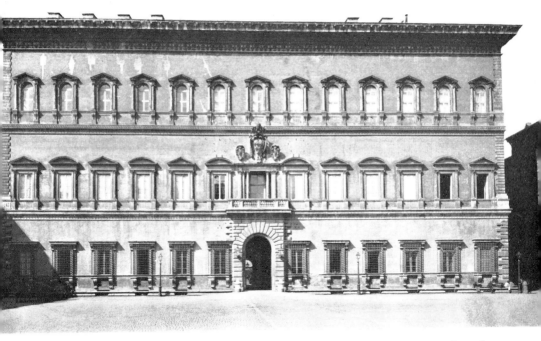

Palazzo Farnese. 100 (above) Main façade. 101 (below left) Main window above the portal. 102 (below right) Cornice

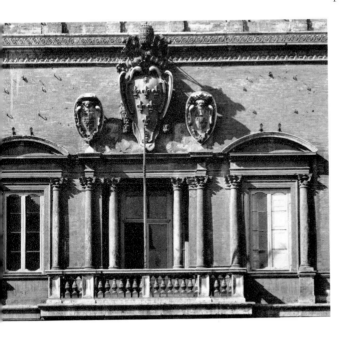

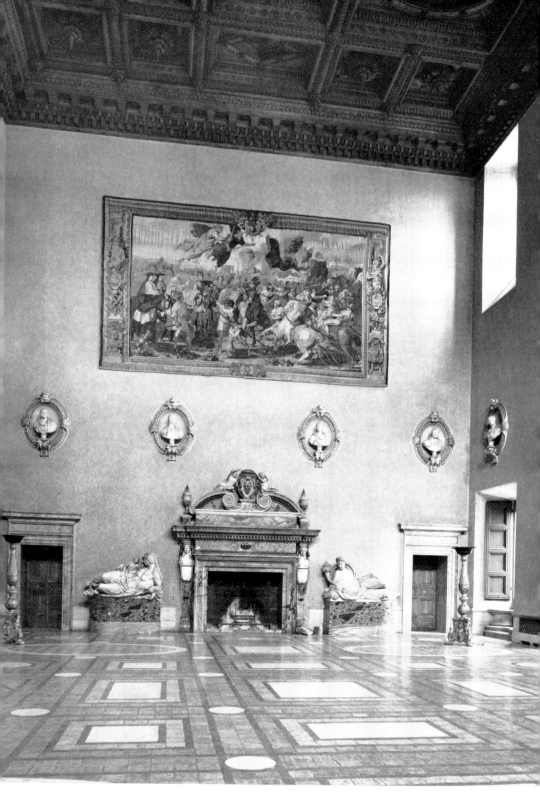

103 Palazzo Farnese. Hall

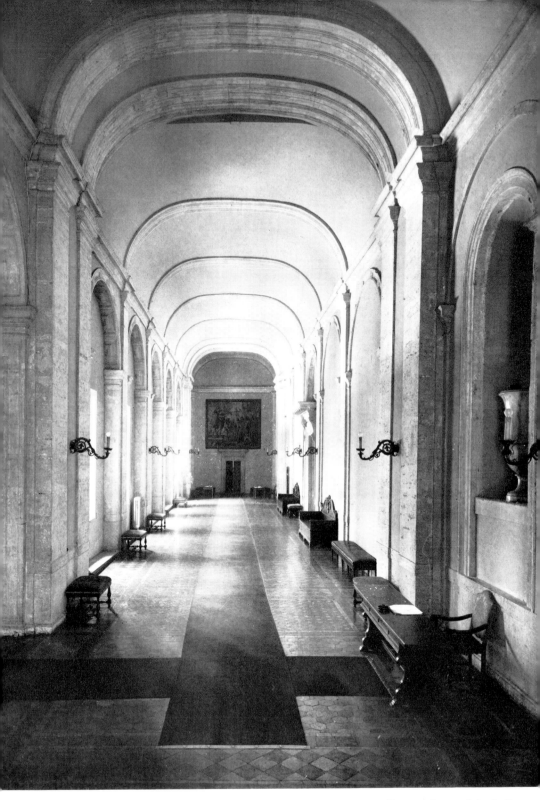

104 Palazzo Farnese. Gallery in front of the hall

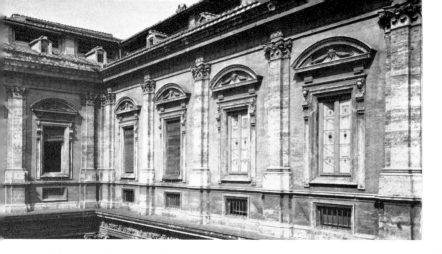

Palazzo Farnese
Courtyard
105 (left)
Side façade
Detail
106 (below)
Rear façade
Completion by
Giacomo
della Porta

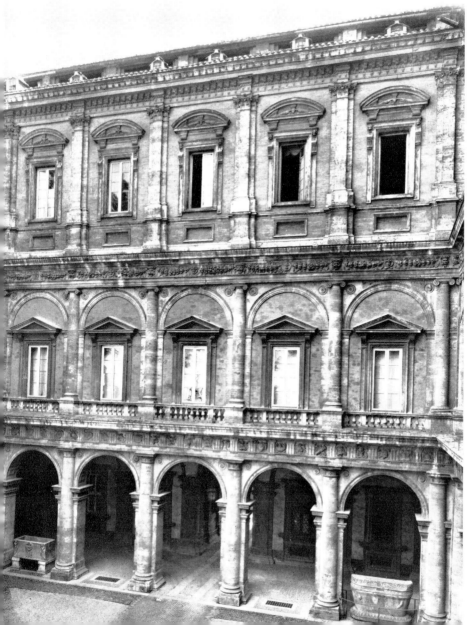

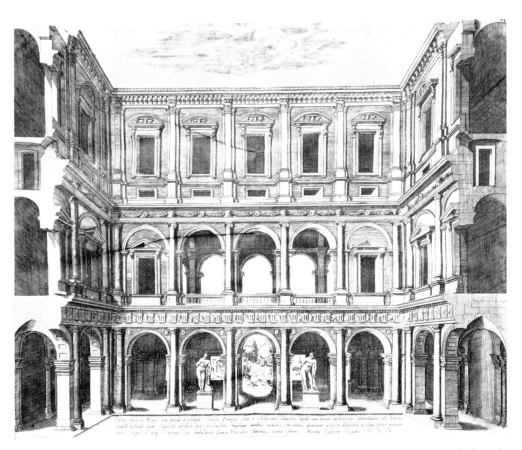

107 Palazzo Farnese. Courtyard, rear façade. Design by Michelangelo
Engraving of 1560

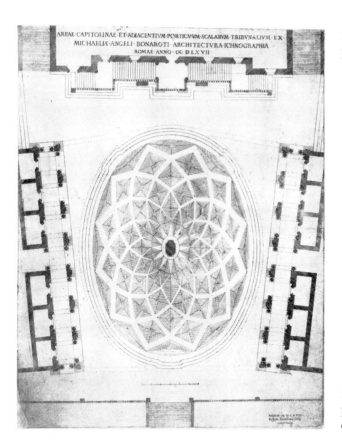

108 Capitol. Ground plan of the piazza. Engraving of 1567

109 (below) Capitol. Plan of the piazza. Engraving by Dupérac of 1569

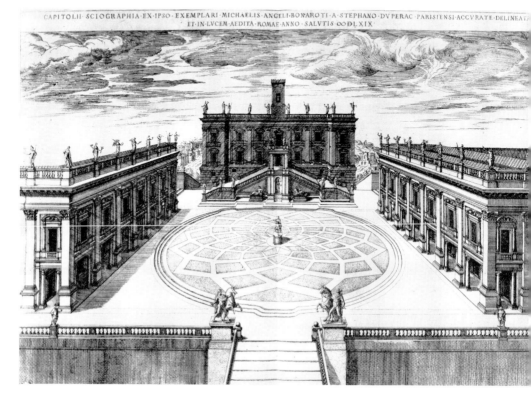

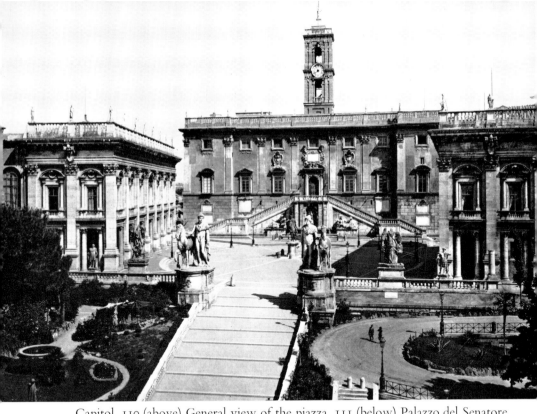

Capitol. 110 (above) General view of the piazza. 111 (below) Palazzo del Senatore
and portico of the Palazzo Nuovo

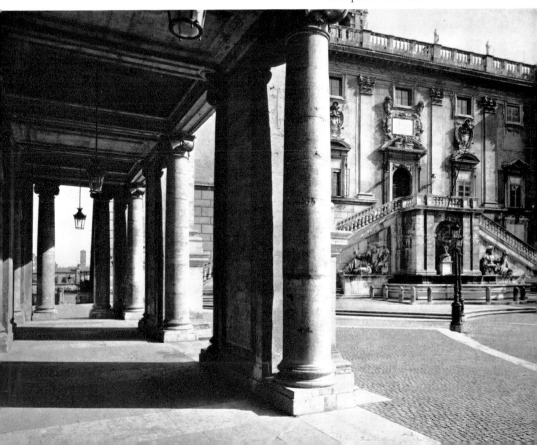

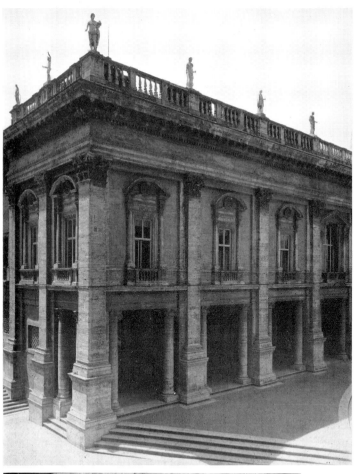

112 Capitol. Palazzo dei Conservatori

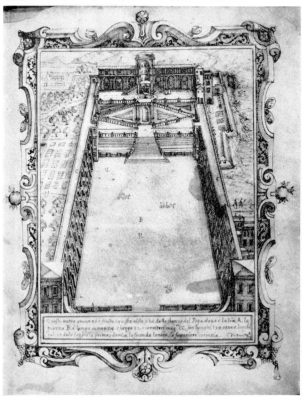

113 Cortile del Belvedere
Drawing ascribed to Dupérac

114 Porta Pia, Rome

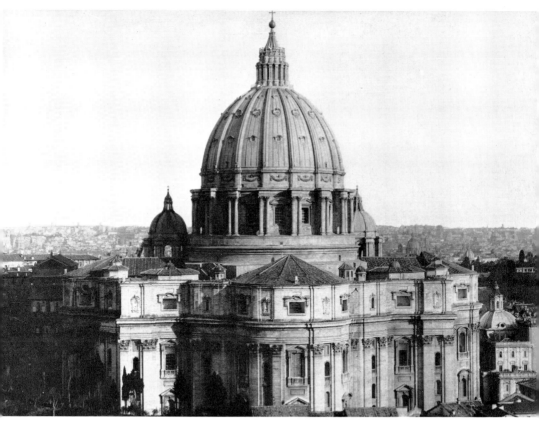

St Peter's. 115 (above) View from the Vatican Gardens. 116 (below) South side

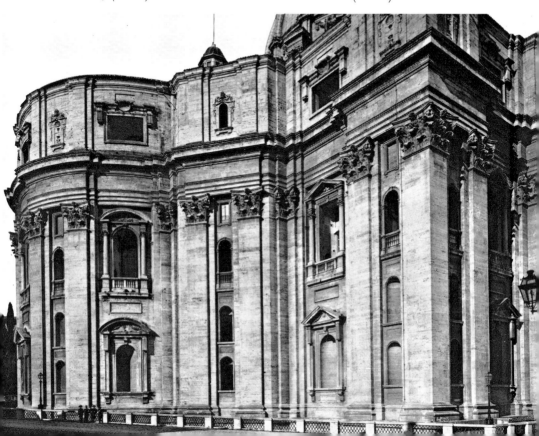

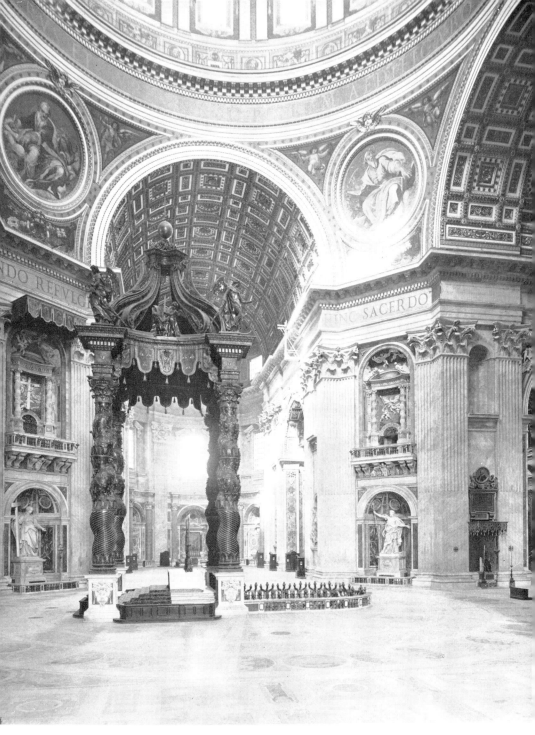

117 St Peter's. Interior of dome

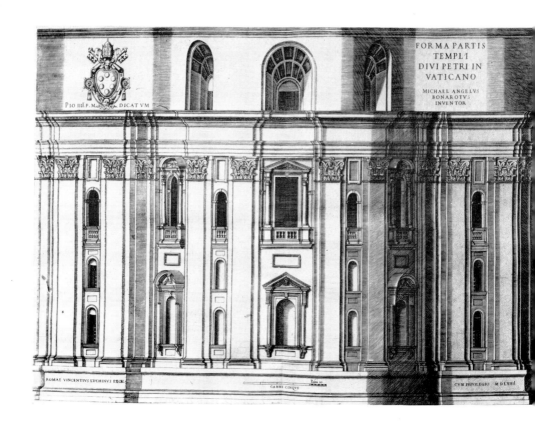

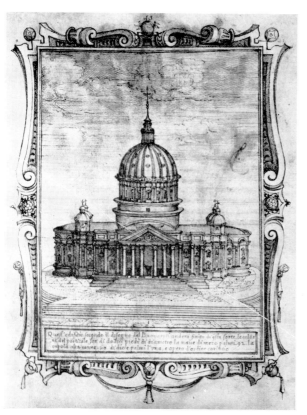

118 (above) St Peter's. Exterior elevation of the south wall Engraving by Vincenzo Luchino, 1564

119 (left) St Peter's. Façade. Drawing ascribed to Dupérac

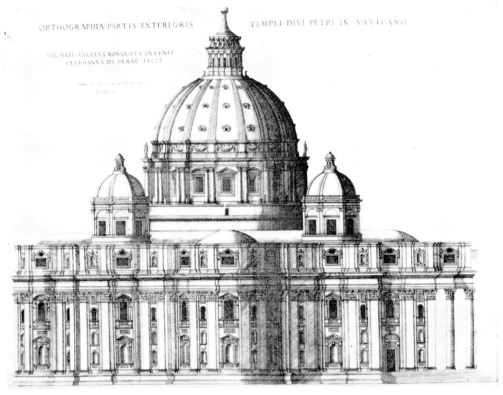

St Peter's. Engravings by Dupérac, 1569. 120 (above) South façade
121 (below) Section

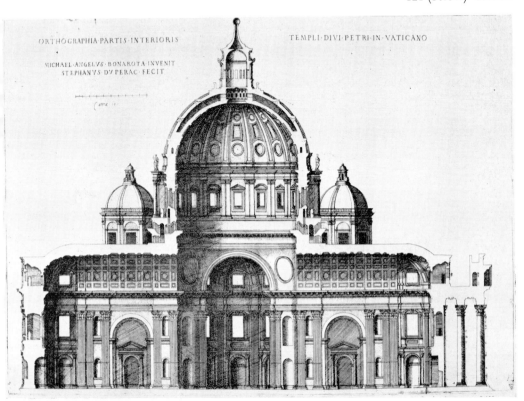

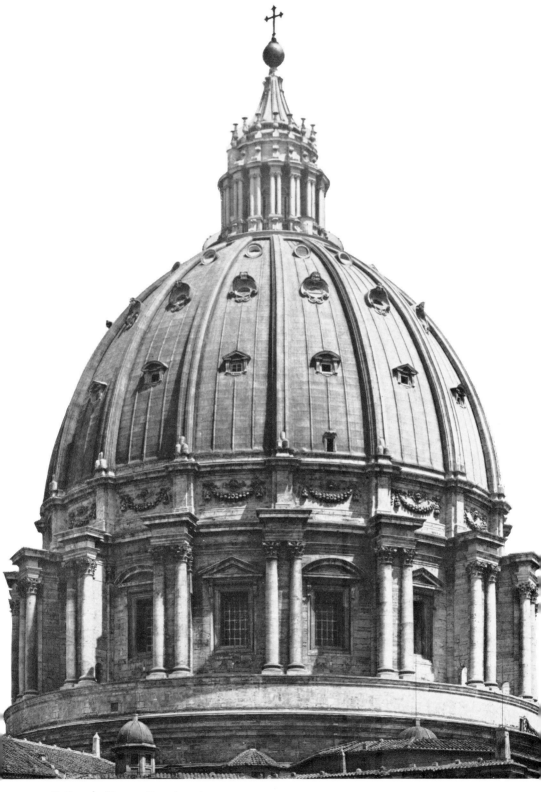

122 St Peter's. Dome. Exterior view

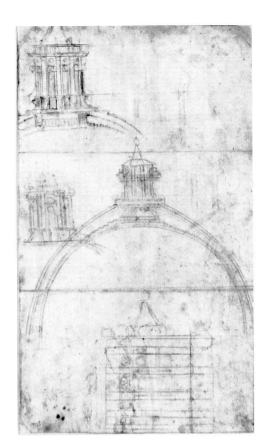

123 St Peter's
Study for dome
Drawing

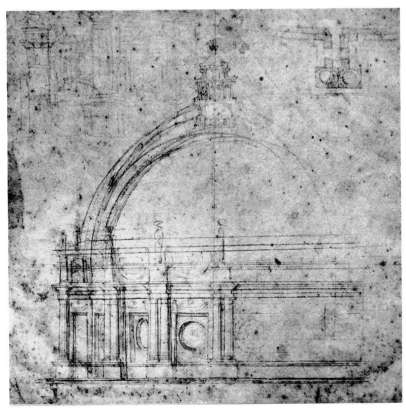

124 St Peter's
Study for dome
Drawing

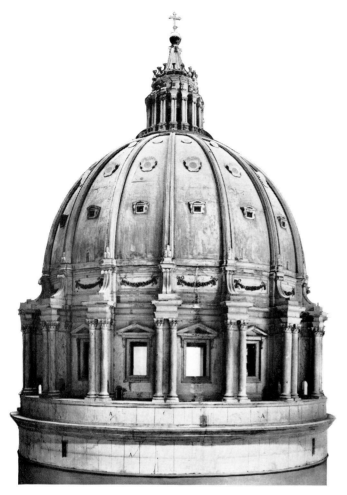

125 St Peter's. Wooden model
of dome

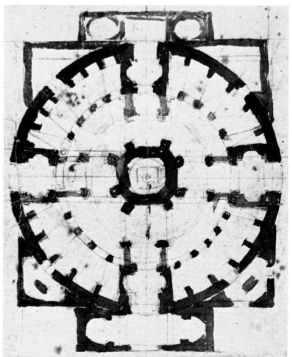

126 S. Giovanni dei Fiorentini.
First design, 1559. Drawing

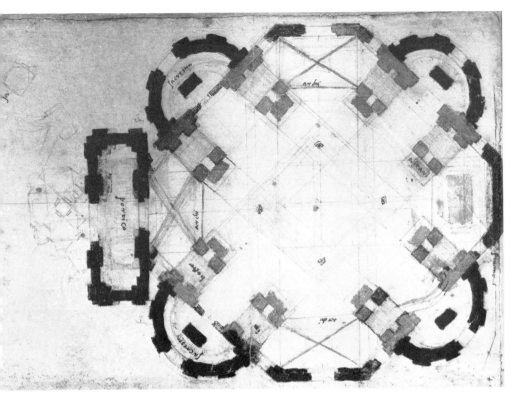

127 S. Giovanni dei Fiorentini. Second design, 1559. Drawing

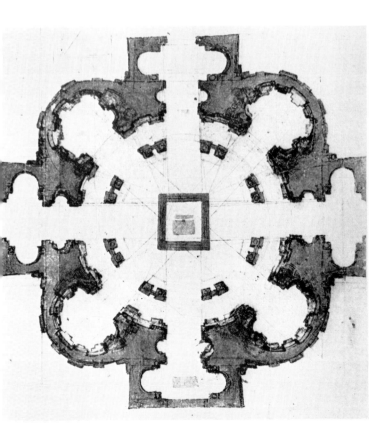

128 S. Giovanni dei
Fiorentini. Third
design, 1559.
Drawing

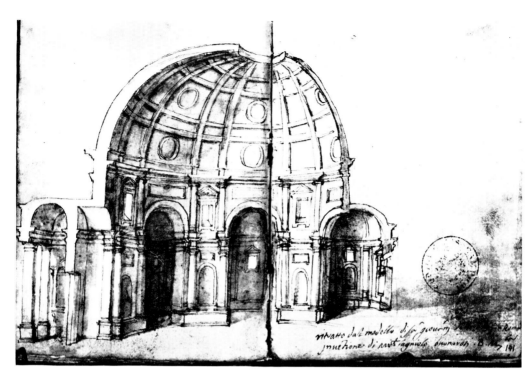

S. Giovanni dei Fiorentini. 129 (above) Drawing by Dosio of Michelangelo's model.
130 (below) Final model. Engraving by Régnard, 1684

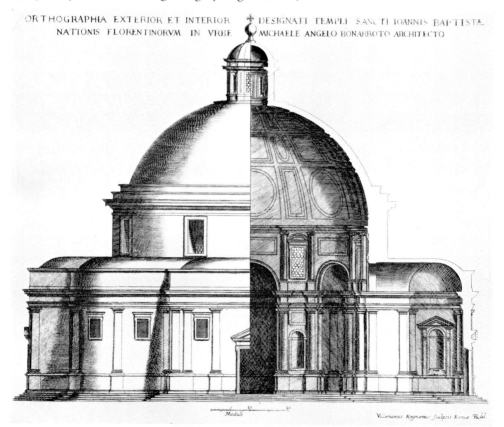

ORTHOGRAPHIA EXTERIOR ET INTERIOR DESIGNATI TEMPLI SANCTI IOANNIS BAPTISTÆ
NATIONIS FLORENTINORVM IN VRBE MICHAELE ANGELO BONARROTO ARCHITECTO

Moduli

Valerianus Regnartus sculpsit Romæ B. del.

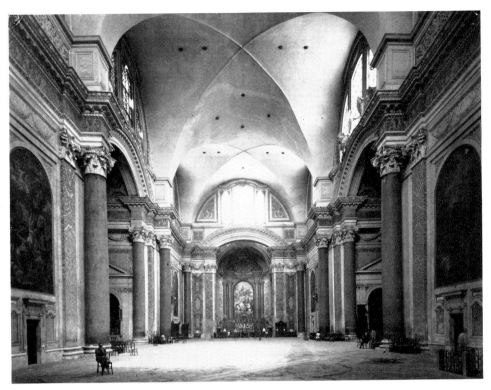

S. Maria degli Angeli. 131 (above) Interior view. 132 (below) Interior view
Engraving of 1703

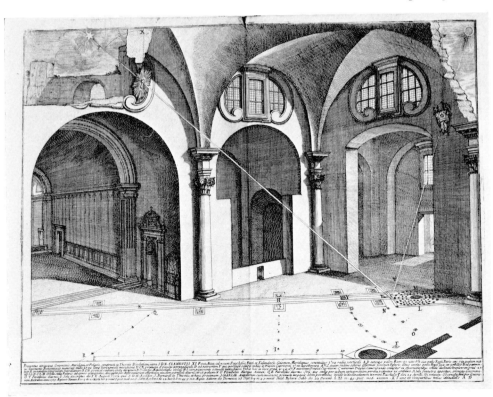

Cappella Sforza in S. Maria Maggiore. 133 (above) Interior view. 134 (below left)
Diagonally set piers and columns with side apse. 135 (below right) Diagonally
set piers and columns, detail

136 Cappella Sforza. View of an apse
and ground plan. Eighteenth-century
engraving

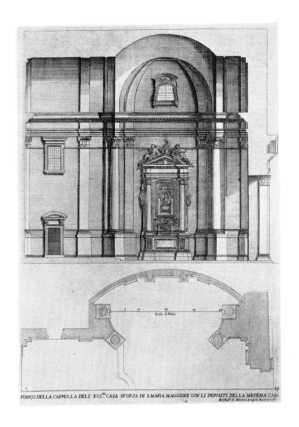

137 Cappella Sforza. Altar chapel and
ground plan. Eighteenth-century
engraving

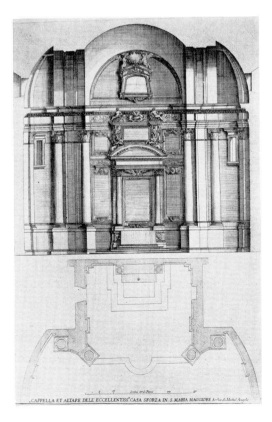

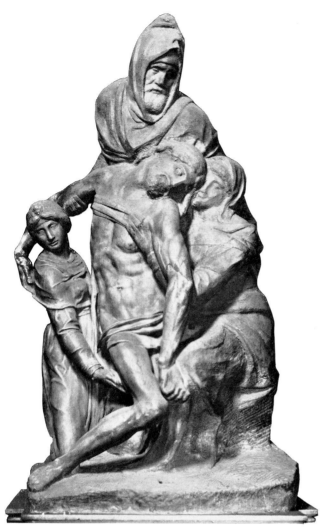

138 *Pietà*. Marble

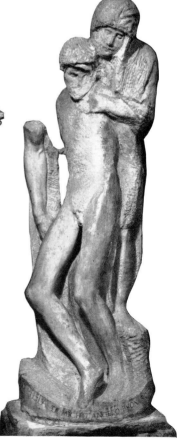

139 *Rondanini Pietà*. Marble

140 (above) Studies
of the entombment
and *pietà*. Chalk

141 *Crucifixion*
Charcoal

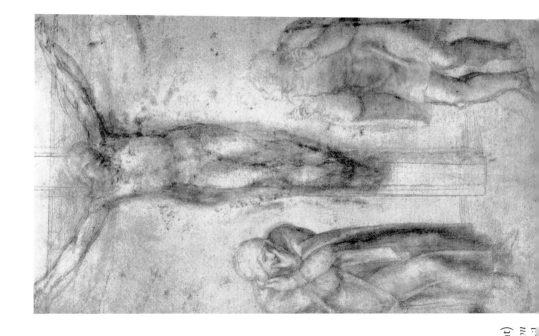

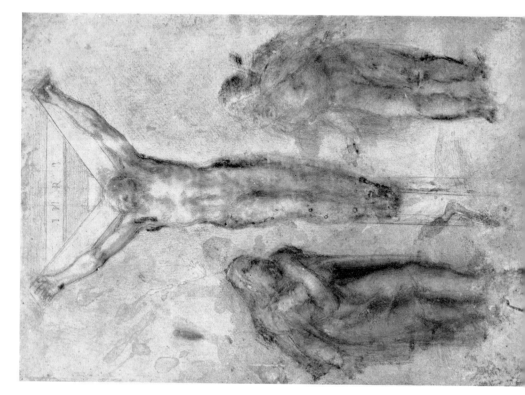

142 (left)
Crucifixion
Charcoal

143 (right)
Crucifixion
Pencil

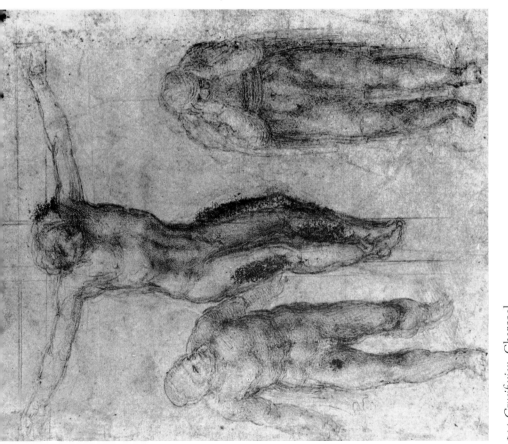

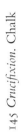

145 *Crucifixion*. Chalk

144 *Crucifixion*. Charcoal